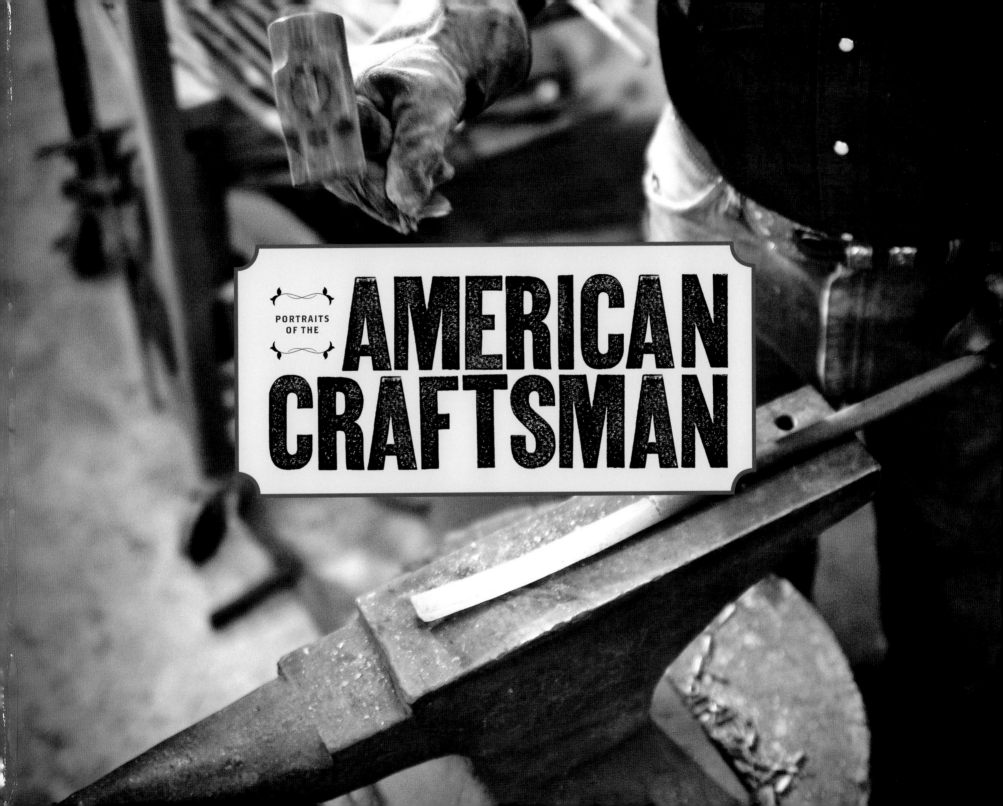

PORTRAITS OF THE AMERICAN CRAFTSMAN

PORTRAITS OF THE **AMERICAN CRAFTSMAN**

BY TADD MYERS

TEXT BY ERIC CELESTE

Lyons Press
Guilford, Connecticut
An imprint of Globe Pequot Press

Lyons Press is an imprint of Globe Pequot Press.

Project editor: Meredith Dias
Text design/layout: Maggie Peterson

Myers, Tadd, 1972-
 [Photographs. Selections]
 Portraits of the American craftsman / by Tadd Myers ; text by Eric
Celeste. — First [edition].
 pages cm

 ISBN 978-0-7627-9003-6 (hardback)
 1. Artisans—United States—Portraits. 2. Portrait photography—United
States. 3. Photography of handicraft. I. Celeste, Eric, writer of added
text. II. Title.
 TR681.A69M94 2013
 770—dc23
 2013015032

Printed in the United States of America

10 9 8 7 6 5 4 3 2 1

⭐

I dedicate this book to my father, Landis Wilson Myers, a true craftsman himself.
He was a woodworker, home builder, metalworker, guitar player, printing pressman, baseball player,
self-made businessman, and a "fixer" of almost anything. My father loved working with his hands
and would have felt a very deep connection to this book.

...TADD LANDIS MYERS

Contents

Acknowledgments ... **VIII**

Introduction ... **XI**

Chuck Lee Banjo Company ... **1**

Todd M. Johnson Pipes ... **9**

Steinway and Sons ... **17**

Optimo Fine Hats ... **25**

Nokona Athletic Goods Company ... **35**

Oxxford Clothes ... **45**

James Avery Jewelry ... **53**

The Carousel Works ... **61**

Fisk Knives ... **71**

Sorrell Custom Boots ... **81**

Bessell Surfboards ... **89**

Hastings Holsters ... **99**

Henson Broom Shop ... **109**

Maple Landmark Woodcraft ... **117**

Acadian Accordions ... **127**

Pawless Guitars ... **135**

Danforth Pewter ... **143**

Hull Historical Millwork ... **153**

Manuel American Designs ... **163**

Billings ArtWorks ... **173**

J. Wilson Stagecoach Works ... **183**

ScottyBob SkiWorks ... **193**

Cheaney Custom Saddles, Bits, and Spurs ... **201**

King Boat Works ... **209**

O'Farrell Hat Company ... **217**

Miller Long Rifles ... **227**

Danner Boots ... **235**

Rising Sun Jeans ... **245**

Warther Cutlery ... **255**

North Bennet Street School ... **263**

Company Index ... **272**

ACKNOWLEDGMENTS

Without the continuous support of many individuals, this project would never have come to exist. I would like to first thank each and every company that is featured in these pages. They are a testament to what they do, and their dedication to their craft should inspire all of us. The following companies and individuals have been vital to the success and completion of this book: Franconia Brewing Company (McKinney, Texas), Vicki Young of The Young Company, Scott Burnett and Lincoln Press, New Page Paper, Don Clampitt of Clampitt Paper Company, Coupralux Printmaking (Dallas, Texas), Graphic Converting LTD, Spook Bolt of Bolt Productions, David Culp, Alex Hamlin, Keith Bardin, Jess Dudley & Wonderful Machine, Jon Sternfeld and Lyons Press, my agent David Hale Smith of InkWell, and writer Eric Celeste.

I'd also like to thank the many mentors and friends throughout my life, including Mike Nebel for introducing me to photography and guiding and inspiring me in my early years; Stan Godwin, Jim Newberry, and all my college professors from ETSU; Dick Patrick for teaching me so much as a young photographer and always supporting me in my career; Liz, Jeff, and all the crew at Matchbox Studio for their amazing design skills including the launch of the American Craftsman Project and website in 2009; and Shane Kislack for the many years of assisting me with shooting these companies as well as your continued support and valued opinion. I'd also like to thank Pete Lacker and Jim Olvera for their integrity and honesty in helping me in the beginning years of my career.

Thank you to my mother Janis Myers, late father Landis Myers, and my sister Shannon Thornton for always believing in me and supporting all my dreams and endeavors. Thanks to my children Noah and Annalise. Simply your presence in my life has inspired me to do things that I could not have achieved without you. I have and always will cherish you.

Finally, I'd like to thank my beautiful wife Rebecca. You are the most intelligent, compassionate, and amazing person I have ever met. Your advice and counsel are always a trusted source for me and have played such an influential role in my career and everything I have ever accomplished.

A special thanks to the generous "backers" of the American Craftsman Project and book:

. Nokona Baseball Gloves, Texas
. Maple Landmark Woodcraft, Vermont
. John "The Grammy Man" Billings, Colorado
. Lori D. Vaughan/Oxxford Clothes Inc., Illinois
. Arturo and Hope Bejar, Texas
. Jeff Hoedebeck, Texas
. Alex Hamlin, Oregon
. Aaron Opsal, Texas
. Myk, Shannon, Jackson, and Beau Thornton, Colorado
. Janis Myers, Colorado
. Vicki Young, Texas
. Stefan Fraas, California
. Chuck Myers, Texas
. Dick Patrick, Texas
. Rob Walker, Texas
. The Workbook, California
. Matthew and Karine Maynard/Maynard Studios, Kentucky
. Jeff Barfoot, Texas
. Timothy J. McNamara, P.C., Texas
. Dane Taylor, Texas

. Adrian and Marisa Bejar, Virginia
. Brad Flood, Kansas
. Dave Banks, Kansas
. Audrey Plonk and Bill Woodcock, California
. Marla H. Bane and Michael L. Benson, Texas
. Janco Damas, Florida
. Frank Ciulla, New York
. Ralph and Kathy Martin, Texas
. Anna and Martin Jackson, Colorado
. Carol A. Bean, Maryland
. Robert Trzaska, Illinois
. Jill Andresecic, New York

INTRODUCTION

· ★ ·

Nearly five years ago I set off on a photographic journey to document the American craftsman—an overlooked but defining part of America. At the time, this project was simply a short-term way to pass the time while business was a bit slow due to the struggling economy. There seemed to be little discussion about products that were handcrafted in America, which piqued my curiosity and led me on a search for these fascinating companies and individuals. Little did I know how things would change in just five short years and how quickly this important story would grow.

Our country has seen many years of decline in American manufacturing, yet it is this sector of our economy that built this wonderful nation. *Portraits of the American Craftsman* is a celebration of the many men and women who still handcraft beautiful products right here in the United States of America. It has been an honor and a pleasure to shine a light on these companies and tell their story—a story that lives on inside the objects they continue to produce, day in and day out.

Throughout my career I've always searched for meaningful photographic projects that tell a story. However, none of these projects has ever touched me as personally as this one. I have learned so much from the many companies and individuals featured in these pages. The most valuable lesson was that money is but one sliver of what motivates these craftsmen. They have made many conscious decisions in their lives in order to reach their destination. It is these decisions that afford them many less-tangible benefits, such as being their own bosses, creating their own schedules, and being more in control of their own futures. They have found that this type of work contributes to their quality of life, creates a personal legacy, and provides a sense of accomplishment in a much more fulfilling way. They have also realized that if they put a piece of themselves into what they create, part of it stays in the work and yet another very important part continues to live inside themselves.

This is the very basis of what I have always wanted this project to be about: to challenge and inspire people to reevaluate the role that their work plays in their own life. I know that I have.

Tadd Myers

Tadd Landis Myers
Grapevine, Texas
August 2013

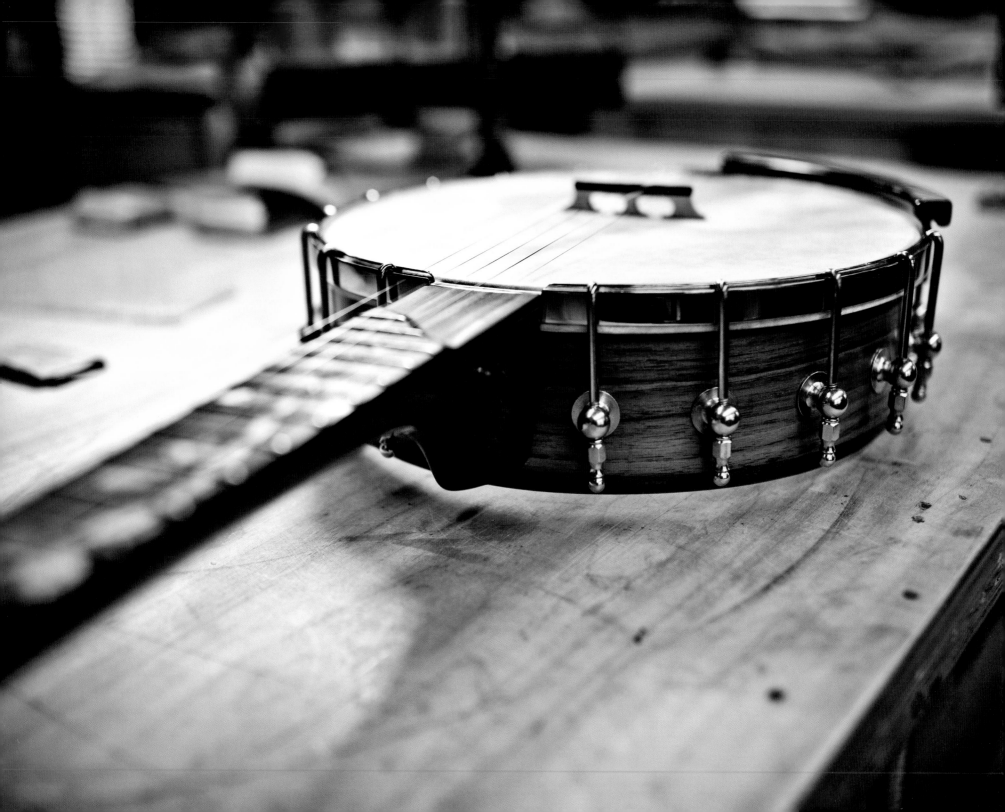

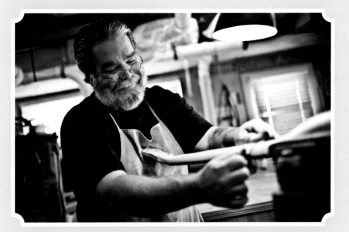

CHUCK LEE BANJO COMPANY

OVILLA, TEXAS

··· ★ ···

Chuck Lee was tired of waiting for his banjo. In the mid-1990s, Lee, a plumber since high school, did a job for a music store that paid him with instruments, which he gave out to his seven kids. But he kept the banjo for himself. Now he wanted to learn old-time music's "clawhammer" style of playing and therefore had ordered an open-back banjo, as the style required.

After two years the banjo still hadn't shown up; Lee was fed up, but also inspired. He told his wife he had a great idea for a retirement business: building open-back banjos.

"She said, 'Great,'" Lee recalls now. "I said, 'No, you're not listening. I want to redo the plumbing shop in the back *right now*.' She said, 'That's a good idea.' I said, 'No, you're not listening. I said I want to take our retirement and buy tools to build banjos.' She said, 'No, *you're* not listening. Do it.'"

In 2002 he did just that, creating the Chuck Lee Banjo Company. The first year, Lee produced three banjos. Having recently completed his six hundredth banjo, Lee now only builds banjos that are ordered and paid for.

Lee is able to connect with his customers in a way he never had in his previous career. That is in part because of the joy he sees in the musicians who benefit from his self-taught craftsmanship. When he started the company, he hadn't done any serious woodworking in two decades, and even then it was only furniture. So he purchased "the *only* book then" on how to build a banjo and made his tools by hand. He then began the nose-to-the-grindstone process of teaching himself.

The most important part to Lee was testing and reworking his banjos until they had the deep sound he was seeking. He realized that banjo making was a much more exact process than plumbing. In banjo making, being off even one-sixteenth of an inch greatly affects the instrument.

Now Lee has the process down. It begins with extensive interviewing of the client so Lee feels he completely understands what's desired. He gets started right away, as he keeps enough maple, cherry, and walnut on hand at all times. All the woodworking is done in the shop, and the metal parts are made as close to his Ovilla, Texas, home as possible. (The ebony and pearl come from overseas.)

It takes three to four months for a Lee banjo to be completed—a lot depends on the climate, particularly the humidity of the season, as it can easily warp the wood if precautions aren't in place.

Then Lee plays each banjo until he determines it's ready for the customer.

And it's that personal connection to each customer's story that gives Lee his satisfaction. Like the woman who recently lost a young daughter and took up playing the banjo as part of her mourning. Her joy with the banjo got her twin sister playing. Then her husband. Her father took up the piano. And now they get together every week to play music.

"I heard that," Lee says, "and said, 'Yeah, that's why I did this. That's why I'm doing this.'"

And that original open back he ordered? "The banjo was never made, as far as I know."

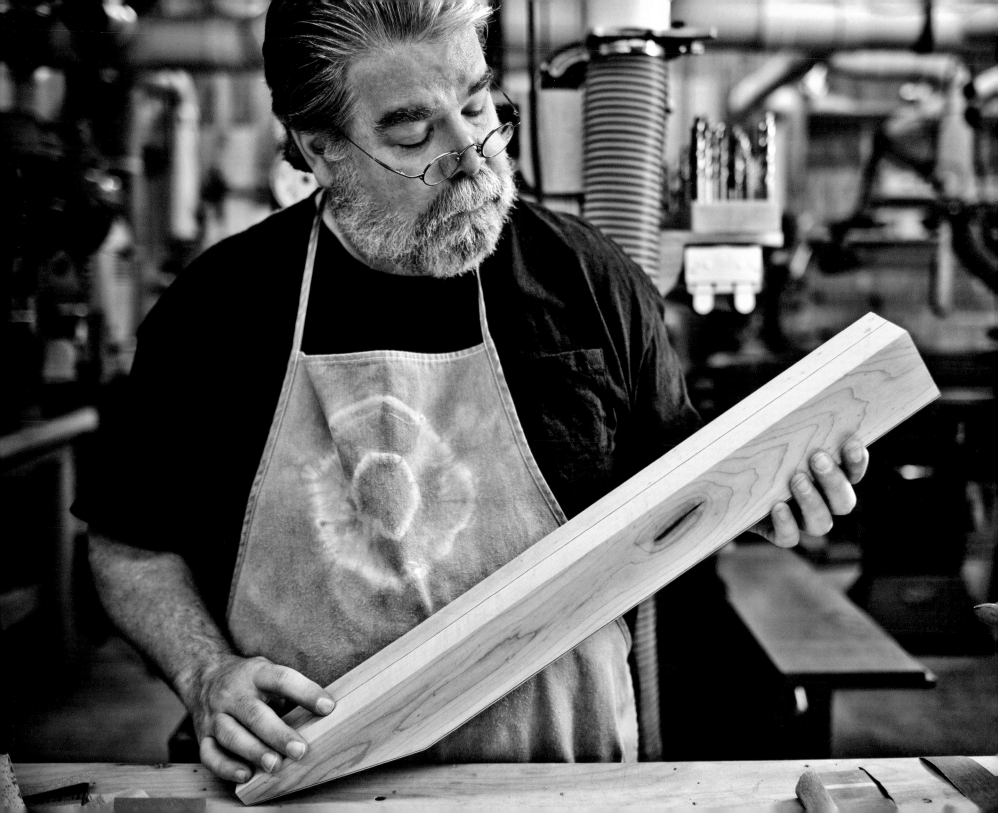

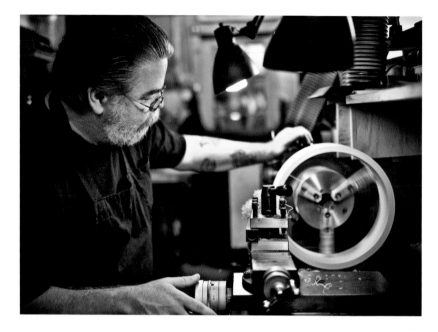

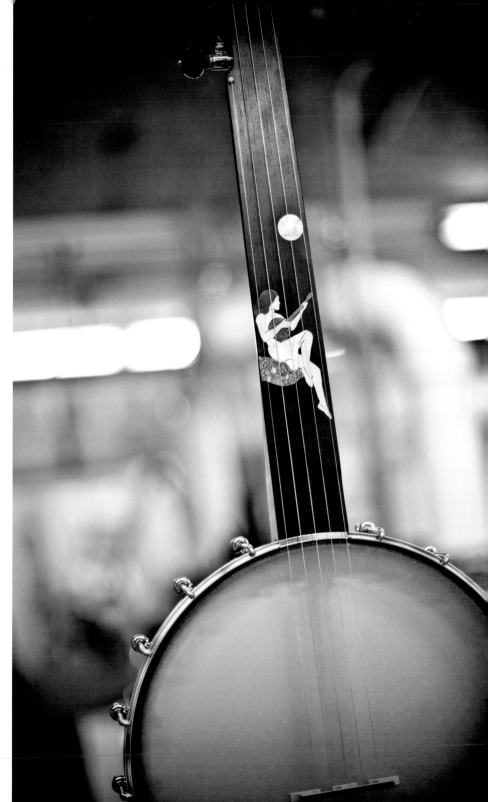

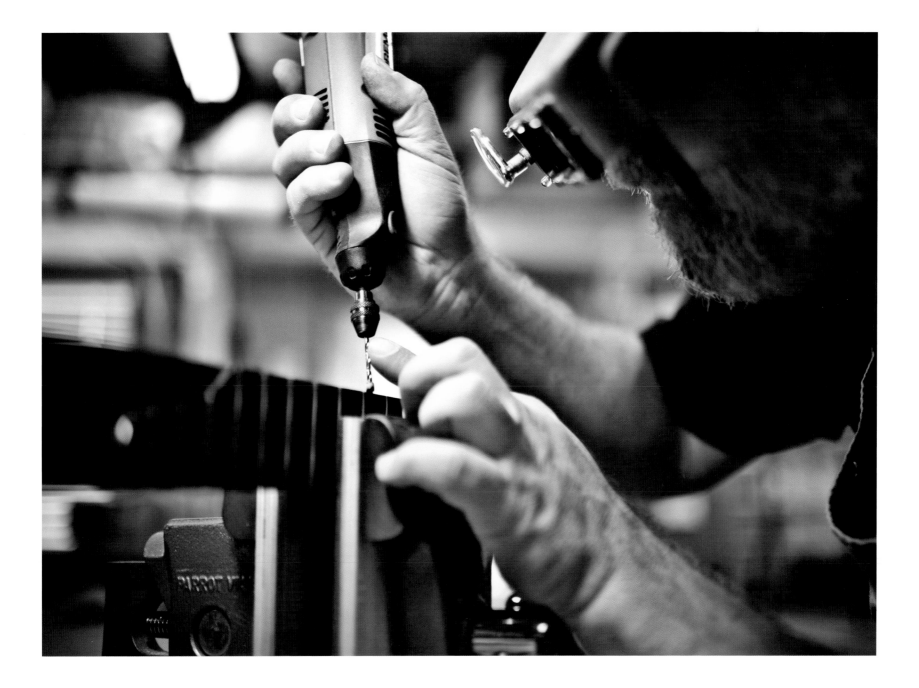

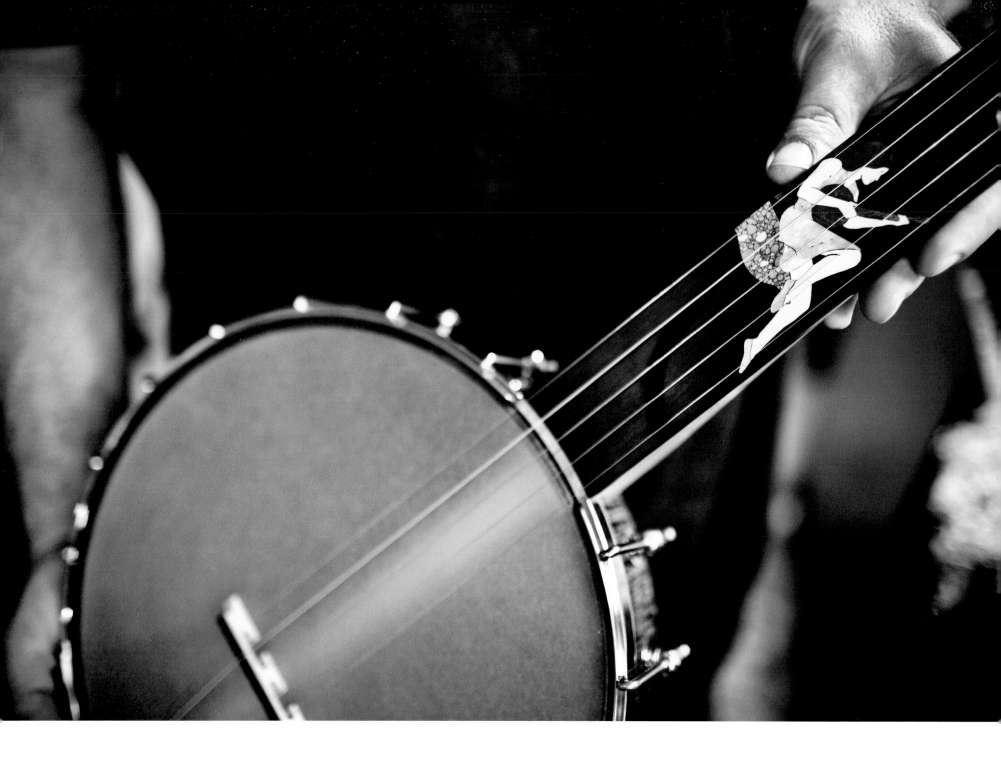

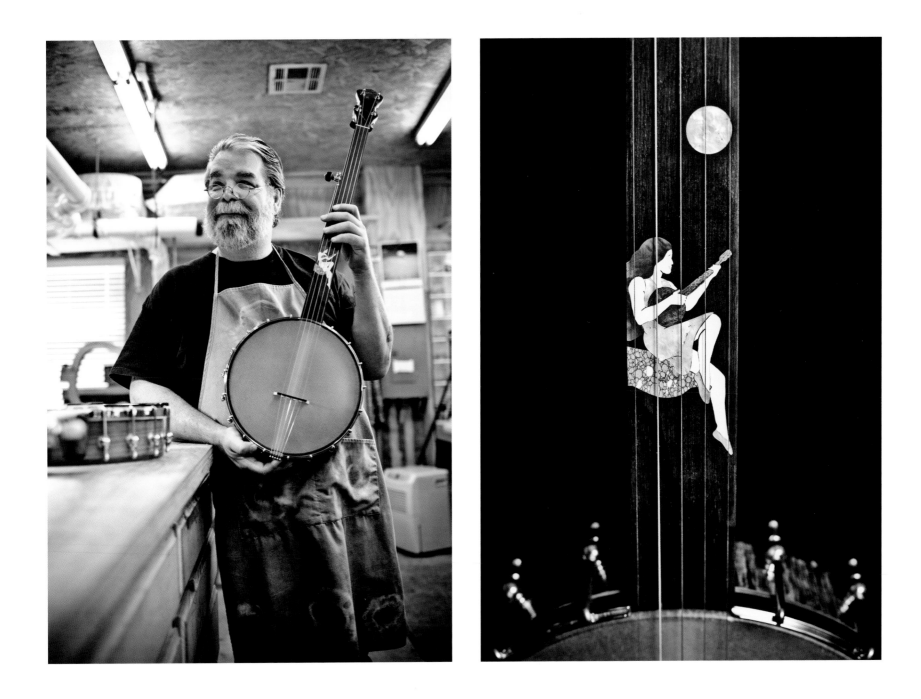

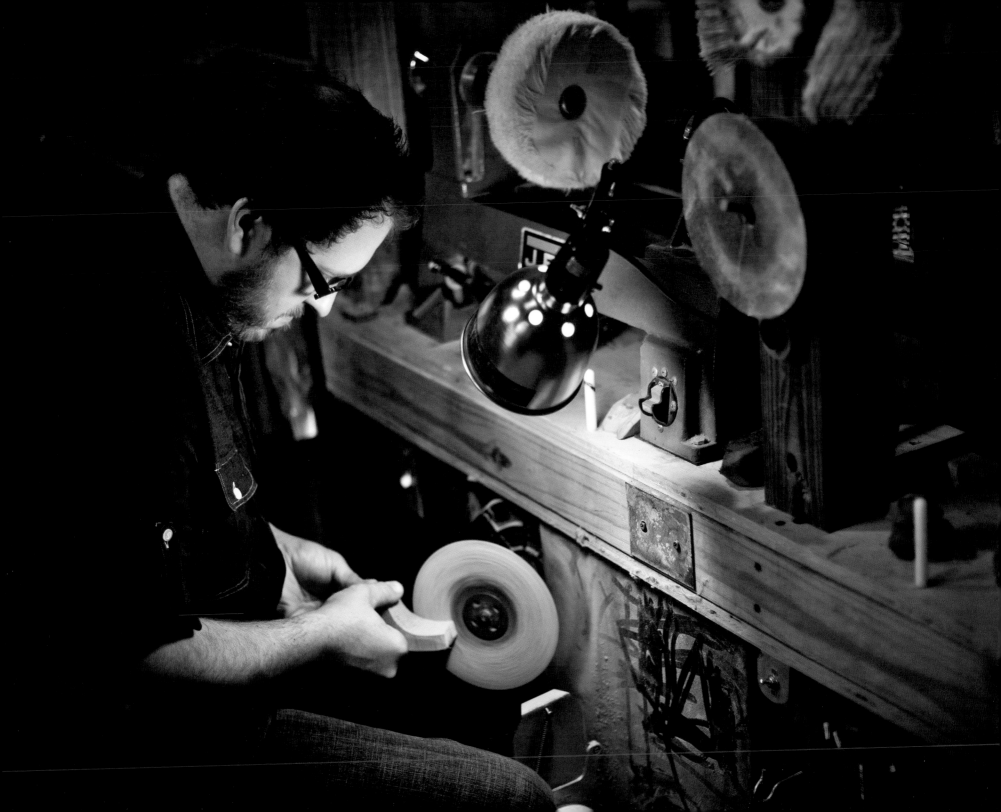

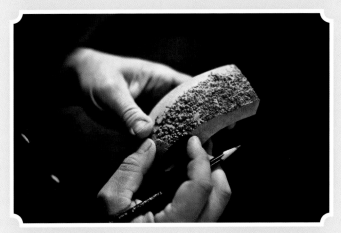

TODD M. JOHNSON PIPES

NASHVILLE, TENNESSEE

• ★ •

Todd Johnson's life changed because of a friend's smoke of choice.

Johnson was in college when he decided he wanted to make a friend a pipe for his graduation present. Johnson was already proficient with tools and woodworking. His father had a shop

where Johnson helped out on high-end pre-1948 cars and trucks.

Johnson figured he could fashion a pipe, given that much of the car work he'd done was creative, sculptural work. Even though Johnson had never held a pipe, he made one from walnut, with a

flat-bottomed bowl and wooden stem. His friend loved it. So did Johnson.

He made a few more for friends and later sold them in local shops. By 2001 his reputation was such that he was invited to visit with a master pipe maker to learn the traditional handcrafting of pipes in the Danish style.

Now, more than a decade later, he's grown and honed his craft into something unique, turning Todd M. Johnson into one of the world's premier custom pipe makers.

"I'm dedicated to this not only as a creative endeavor," Johnson says, "but also toward preserving the history of high-grade handmade pipes—and passing that along."

Johnson has trained a number of accomplished pipe makers in the United States, just as he was trained. He has contributed to the newfound respect that the world has for the United States as a place for high-quality handcrafted pipes.

"I wouldn't necessarily say that US pipe makers have developed their own style," Johnson says, "but . . . we've raised the bar for expectations of quality."

Johnson has developed a signature, expressive style that shows a depth of insight and maturity. This is tied to his process, which is forged from a desire for excellence over efficiency.

The process begins with his annual trip to Italy, where Johnson hand selects each piece of briarwood he wants to use. (Briarwood is from the root of the European tree heath, which has traditionally been used to make pipes.) He puts that aside for two years.

This gives Johnson a block of wood from the briar's burl, the round knotty growth from which the pipes are shaped, that has specific qualities (such as grain patterns) that speak to him. The piece's individual characteristics serve as the pipe's inspiration.

He then takes that block directly to the shaping wheel. "It's a very rough, somewhat *violent* process." Johnson says. He describes the process as bringing the shape out of the block instead of forcing a shape upon it.

As the rough shape of a pipe takes form, so begins the more delicate process to hone, shape, and align

the grain. He then cuts the mouthpiece from German ebonite (basically a solid rod of vulcanized rubber). The pipe is stained in seven steps and finally buffed and polished with carnauba wax.

Johnson makes 120 pieces a year—plenty, given that his work goes for three to twelve thousand dollars, and up. Most of his sales come from the Chinese market, where customers have a centuries-old culture of appreciating, and paying for, fine craftsmanship.

"It's not a utilitarian object," Johnson says. "The Chinese understand this because of their tea culture: sitting, reflecting, contemplating, sharing with friends, enjoying some of the finer things in life. That's where my work fits in."

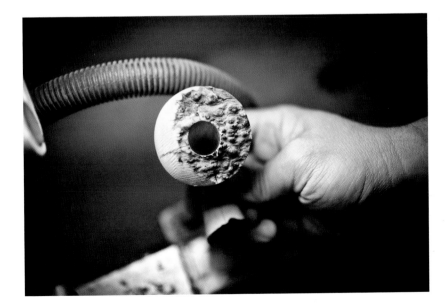

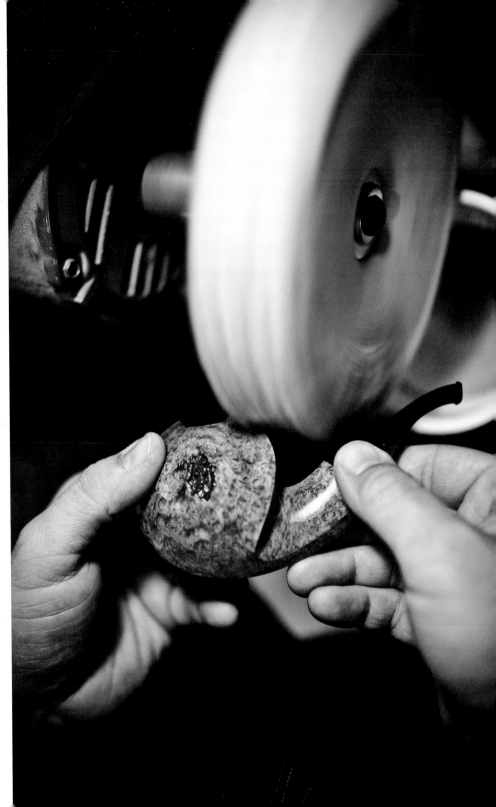

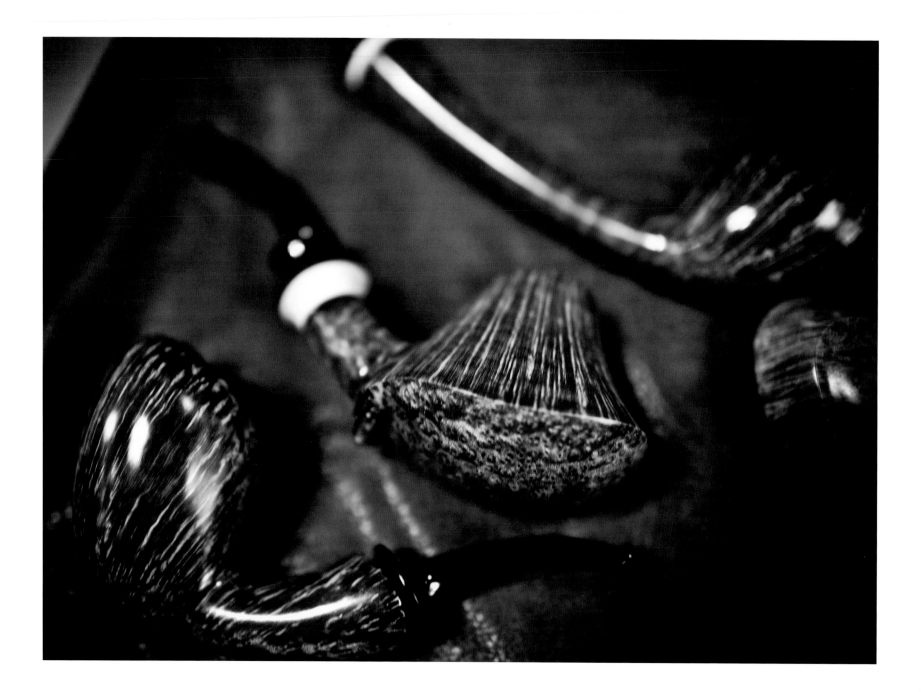

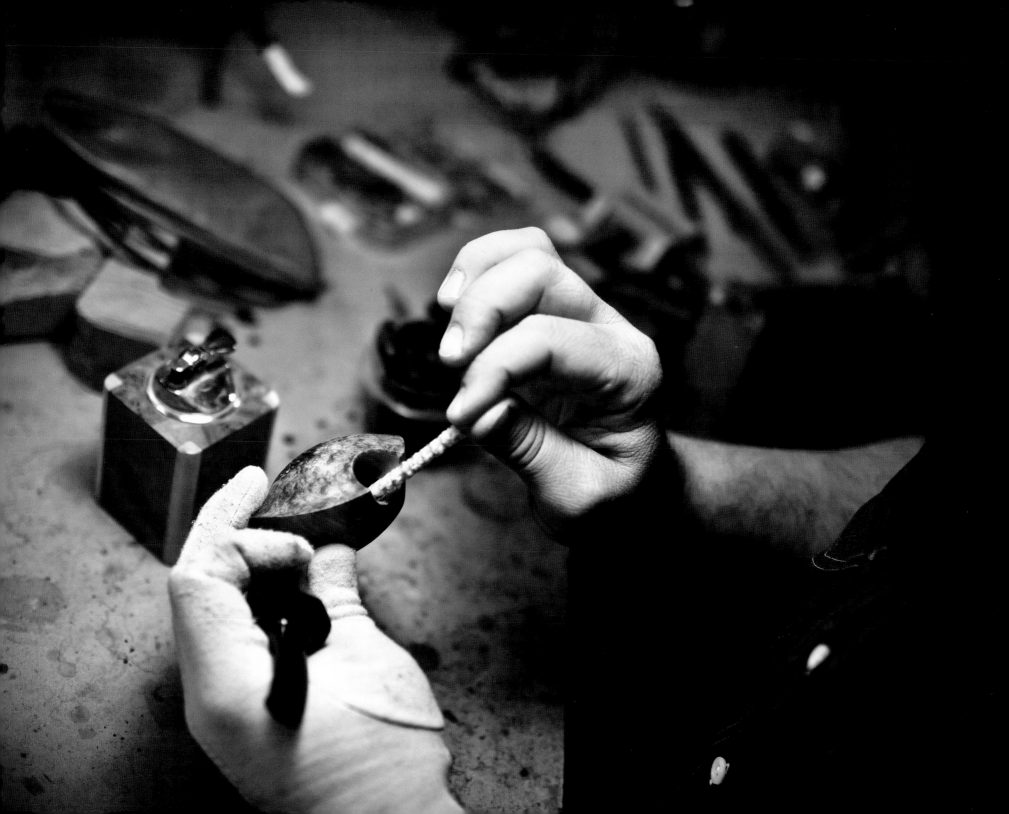

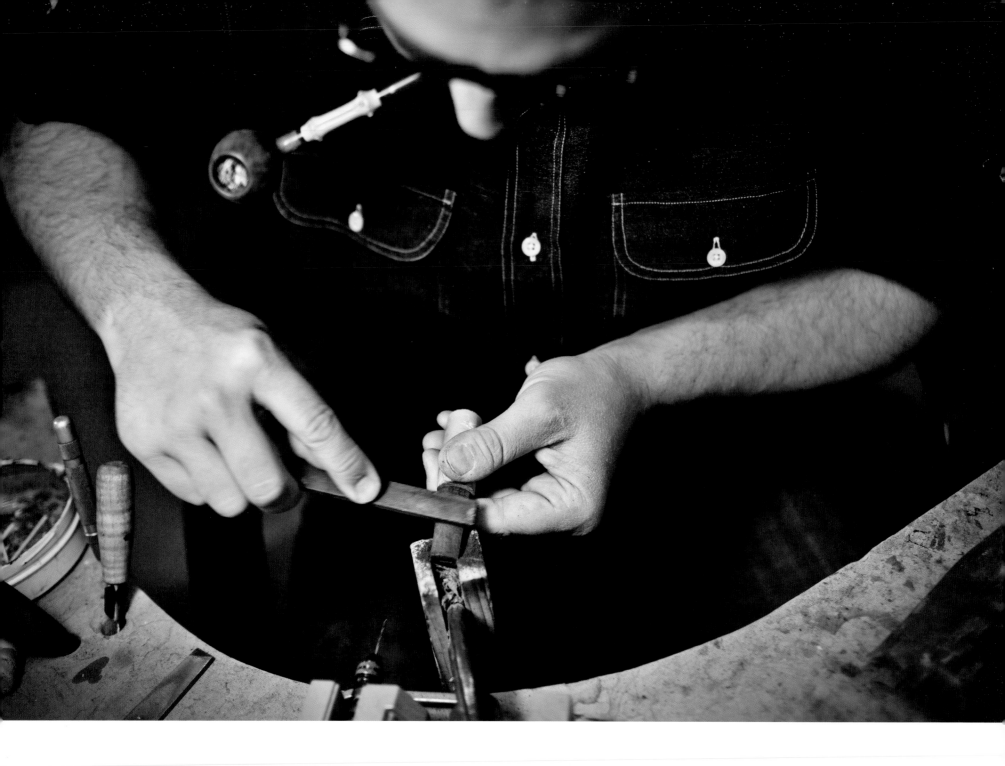

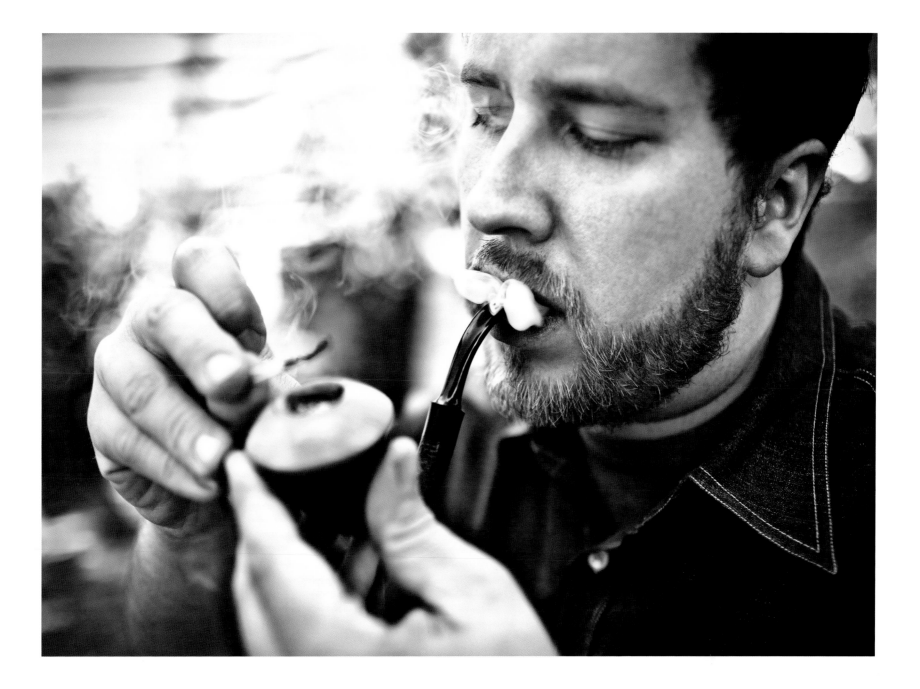

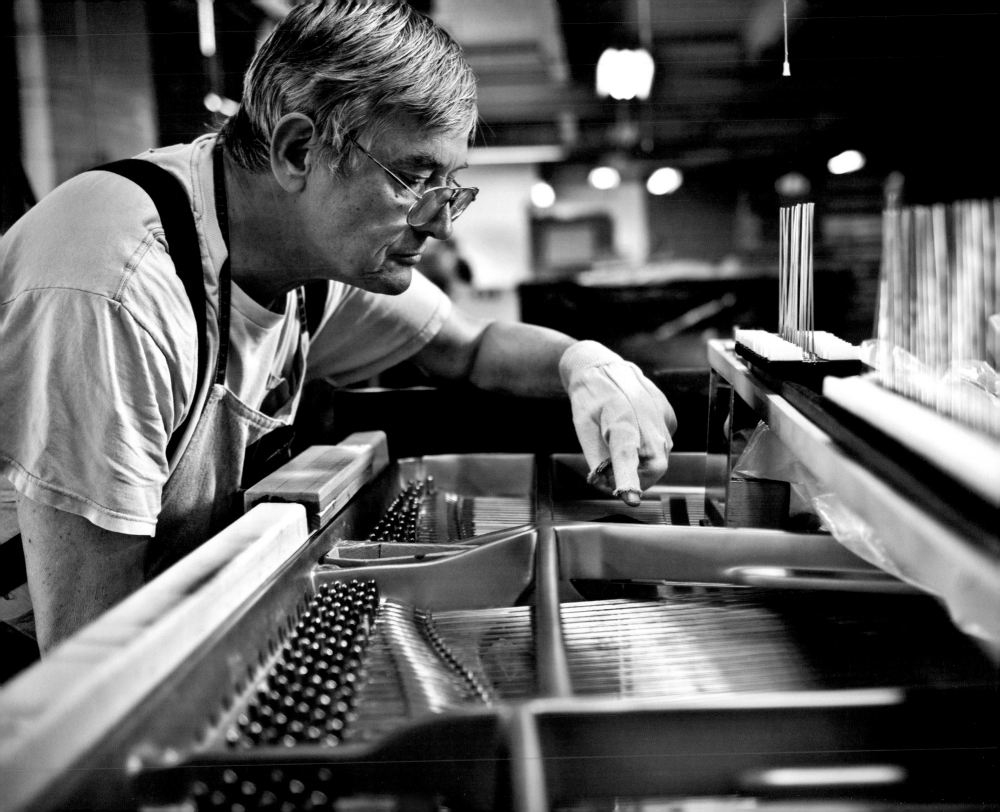

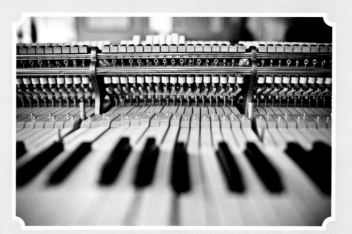

STEINWAY AND SONS

LONG ISLAND CITY, NEW YORK

★

For a company to last 160 years, it must learn to innovate. But the surprising thing is not that Steinway and Sons engages in the common social media practice of "crowdsourcing"—asking customers for feedback to improve the product—but that it first started doing so more than a century ago.

The legendary company started during the piano boom years in America, when every parlor had a piano and there were many companies vying for industry share. After just a few years, Steinway developed a form of market research by asking its best customers what they wanted in their piano. Within thirty

years Steinway's innovations rocked the piano world. Inventions like the single-bent rim (the curved grand piano rim made from one piece of wood) and the duplex scale (which produces a richer sound) transformed the craft, the company, and the music world.

As Steinway and Sons approaches its six hundred thousandth piano, they are the unquestioned leader of their trade. But they know better than to forget the importance of fine craftsmanship.

"Many parts of our process have changed little, others completely," says Anthony Gilroy, director of

marketing and communications. "We're not adverse to technology. We've always been an innovator. We were working with acoustic scientists in the 1860s and 1870s. But we only incorporate what won't impact the piano in any way. Some of the musical parts, however, like people hand-notching the bridges for the soundboard, those people are really artisans. It gives the piano its soul, a human element that you can't get from machines."

All Steinways are handcrafted, which is why some companies make more pianos in a week than

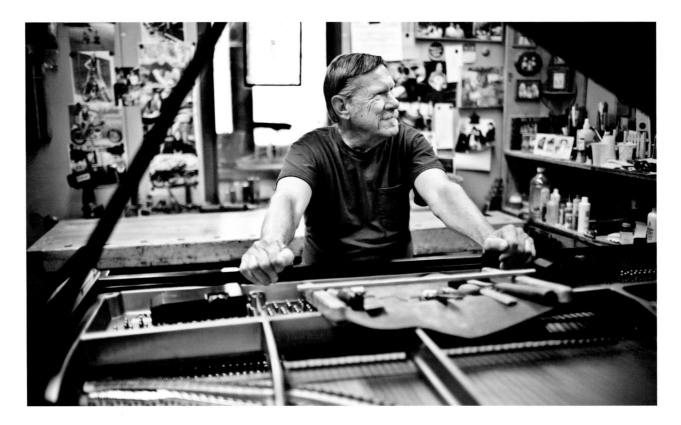

Steinway makes in a year. About 85 percent of a piano is wood, so every piece of lumber is inspected before being air-dried for one year, then kiln-dried to remove any warp. Hard-grain maple twenty feet long is pressed into one piece to make the inner and outer rim. Each rim is stored in a conditioning room for several months, after which the rest of the piano frame is attached.

Next, the soundboard (high-grade spruce) and bridge (the same maple as the rim) are intricately formed, taking into account the dynamics of sound transfer, vibration, and resiliency. A huge iron plate (cast by Steinway itself from bell-quality iron) is added before the steel strings are carefully assembled with the action assembly—where the hammers live— and the key frame is fit together and put into the piano. A number of intricate measurements and tests then occur, including eighty-eight rubber mechanical fingers playing the piano in a soundproof room.

It takes about eleven months for a Steinway to be constructed to tonal perfection from twelve thousand individual parts. "That's twelve thousand places other people can cut corners," Gilroy says.

Although piano players like the iconic Van Cliburn are no longer like rock stars in America, other markets are growing. China currently has thirty million piano students. Brazil is much the same way, Gilroy says.

"They appreciate the craft, and well-made tools," Gilroy says. "You'll never get better working with bad tools. Besides, they're no fun. It's fun playing on a great instrument."

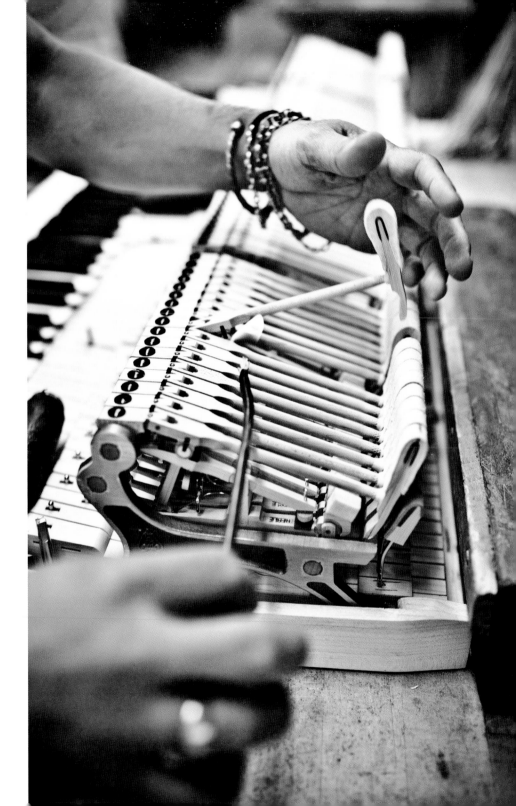

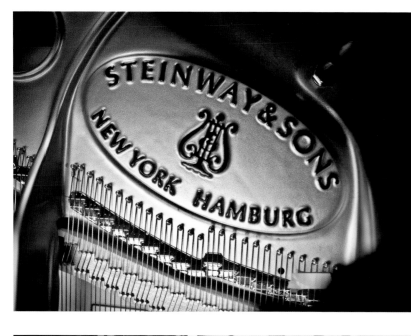

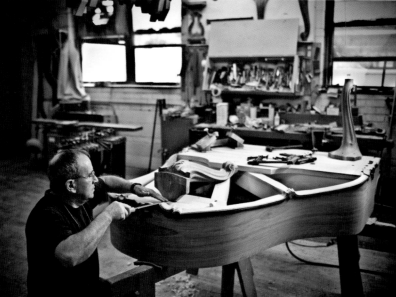

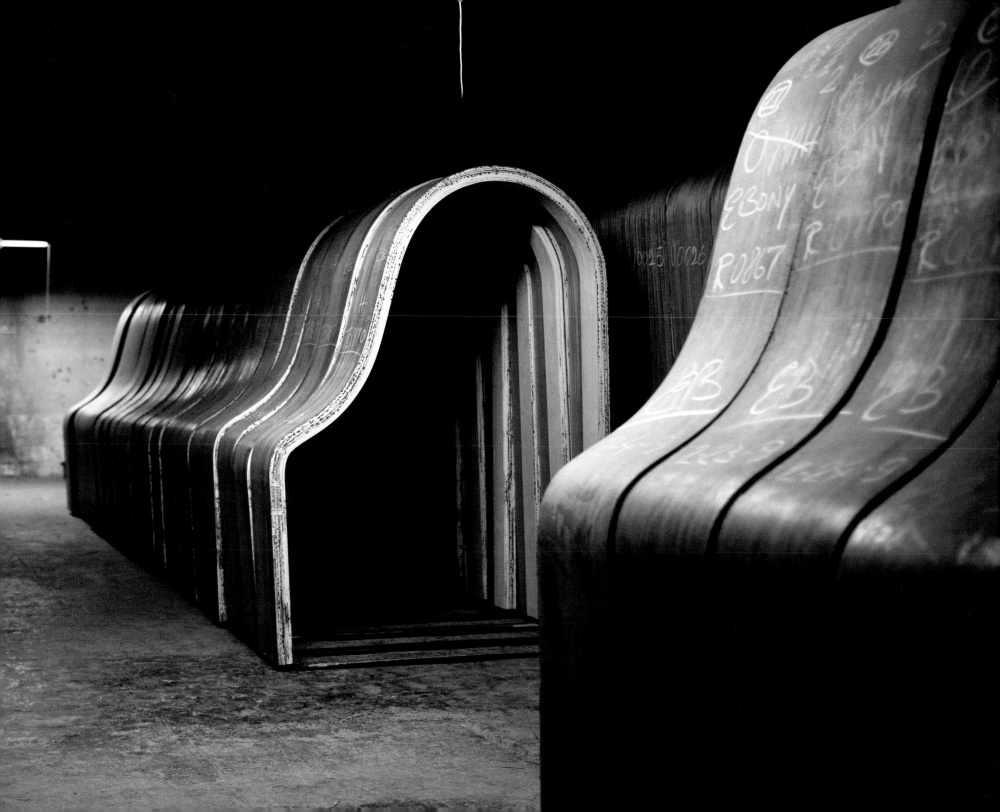

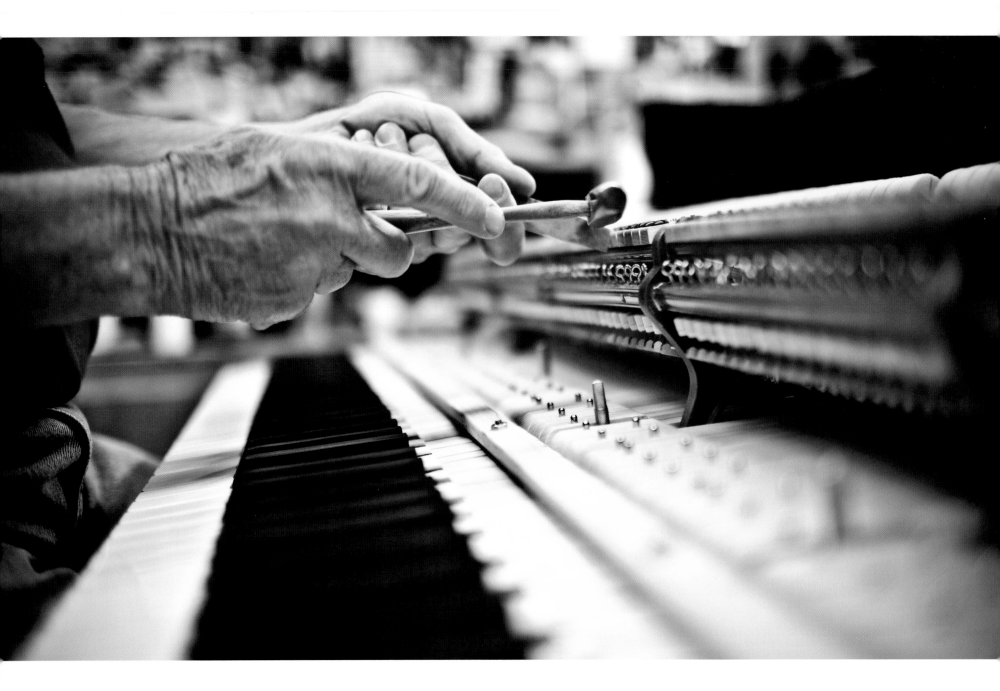

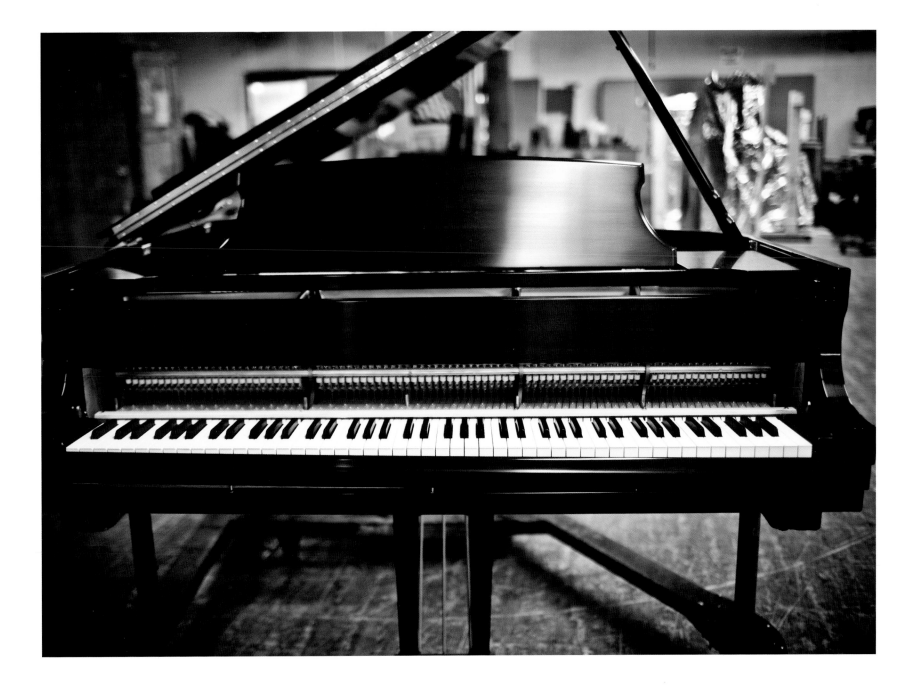

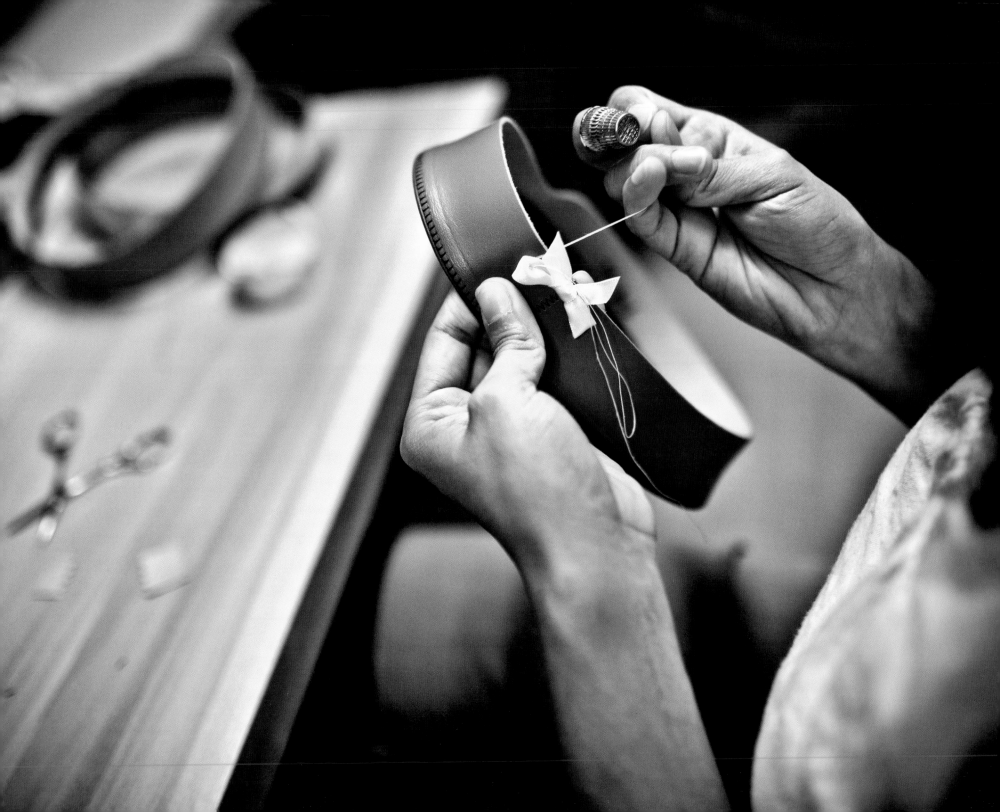

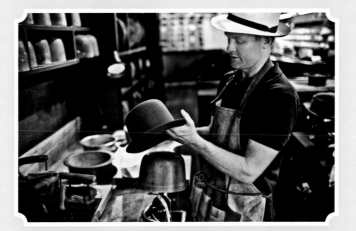

OPTIMO FINE HATS

CHICAGO, ILLINOIS

★

Graham Thompson's friends in high school thought he was crazy. He would frequent Johnny's Hat Shop on Chicago's South Side, not the sort of place teenagers typically spent their free time. But Thompson was an old soul trapped in a young man's body. He loved not only the idea of wearing dress hats—something he picked up from watching black and white movies with his father when he was younger—but the people who wore them as well.

"I was drawn to everything about it," Thompson says. "I thought Johnny and his shop were the coolest thing ever. And his clients! Old blues guys, businessmen in suits, the locals from the South Side. It was special."

So when Thompson graduated from college and returned to Chicago, the first thing he did was ask Johnny to make him a new hat. "He told me it would be the last one he could make for me, because he was retiring," Thompson recalls. "I was so sad. It was this huge part of Chicago's heritage. So I took it over."

Now Optimo Hats carries on the time-honored hat-making tradition in the same South Side location where Thompson apprenticed. Although he had to learn how to operate the decades-old machinery, it only added to his appreciation for classic, stylish headgear.

"I got into this business [in the mid-1990s], when appreciation for dress hats was at an all-time low," he says. "But even then, the fewer people that wear something, the cooler you are if you wear it. And now that such classic styles are back in fashion, it's not like a pocket watch, an affectation that doesn't make sense in modern times. It makes *sense* to wear them. Not wearing a hat when it's cold out makes as much sense as not wearing sleeves, and wearing a ball cap or cheap wool pullover with a nice topcoat makes as much sense as wearing tennis shoes with a suit."

All of Thompson's tools and machinery were made in the 1930s and 1940s, when hat-making was a big business and heavy demand resulted in a high mark for quality in the industry. The process hasn't changed much. It starts with using the best material—wool is most common—and making sure it's milled correctly. The material is then steamed, blocked (shaped), ironed, and shaved (sanding the crown). Thompson compares it to cutting a diamond—putting a fine finish on the hat through abrasive and polishing technology.

Thompson has a steady clientele of classic chapeau lovers, but he also sees people in his store every day who are new to dress hats. He says even novices can spot quality as soon as they hold it in their hands, well before experience tells them a well-made hat repels water, gets softer with age, is more durable, and fits better.

"Hats are just a classic piece of Americana," he says. "What will America be remembered by? Its great jazz, automobiles, and classic American style. Great hats symbolize that."

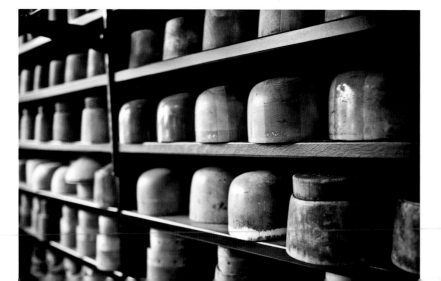
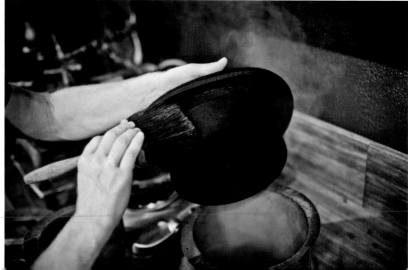

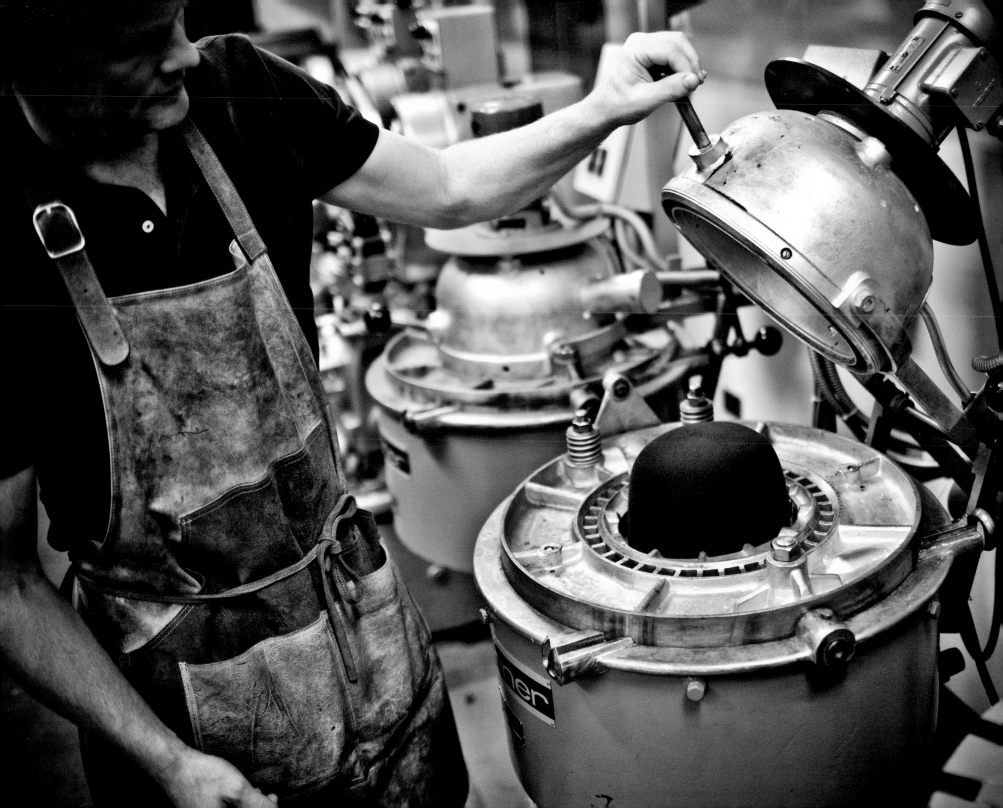

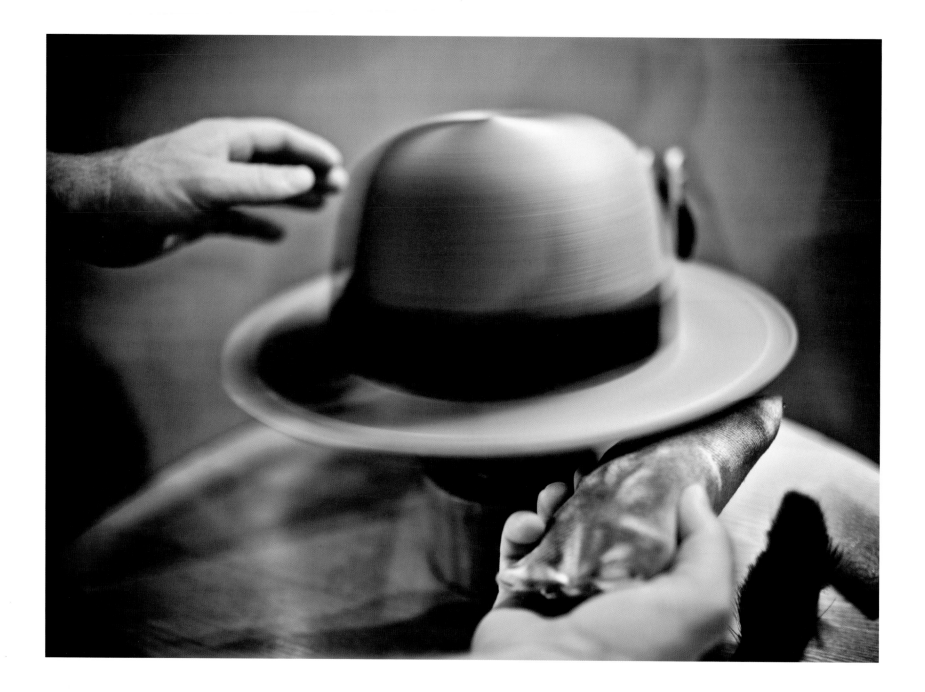

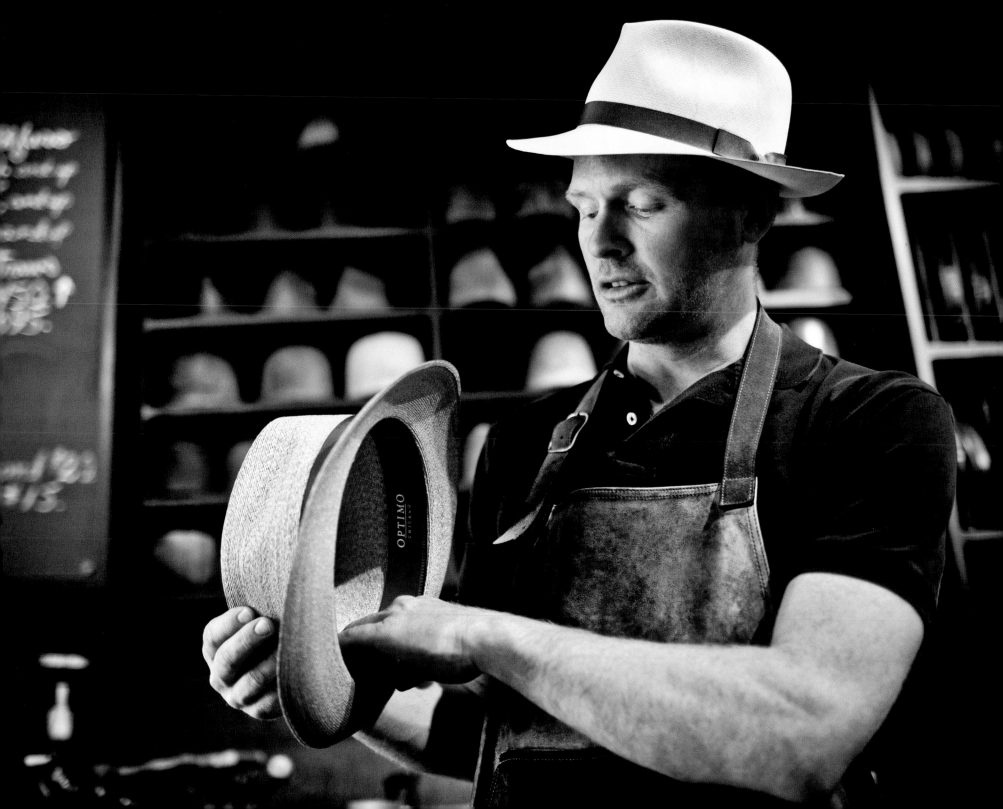

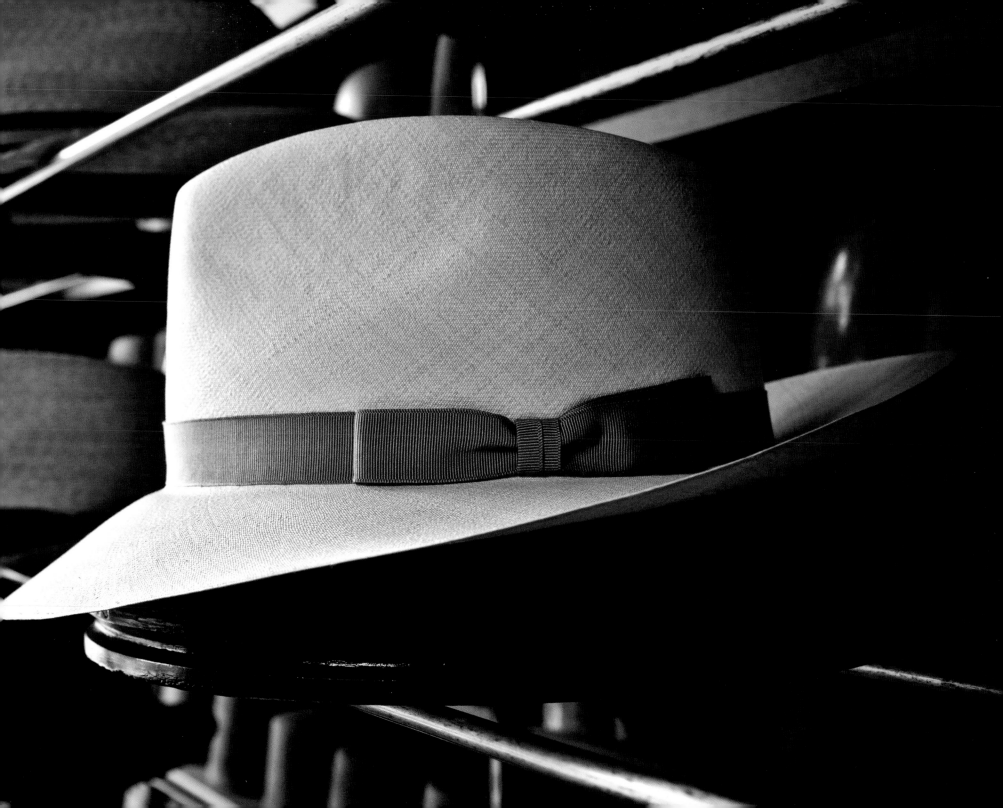

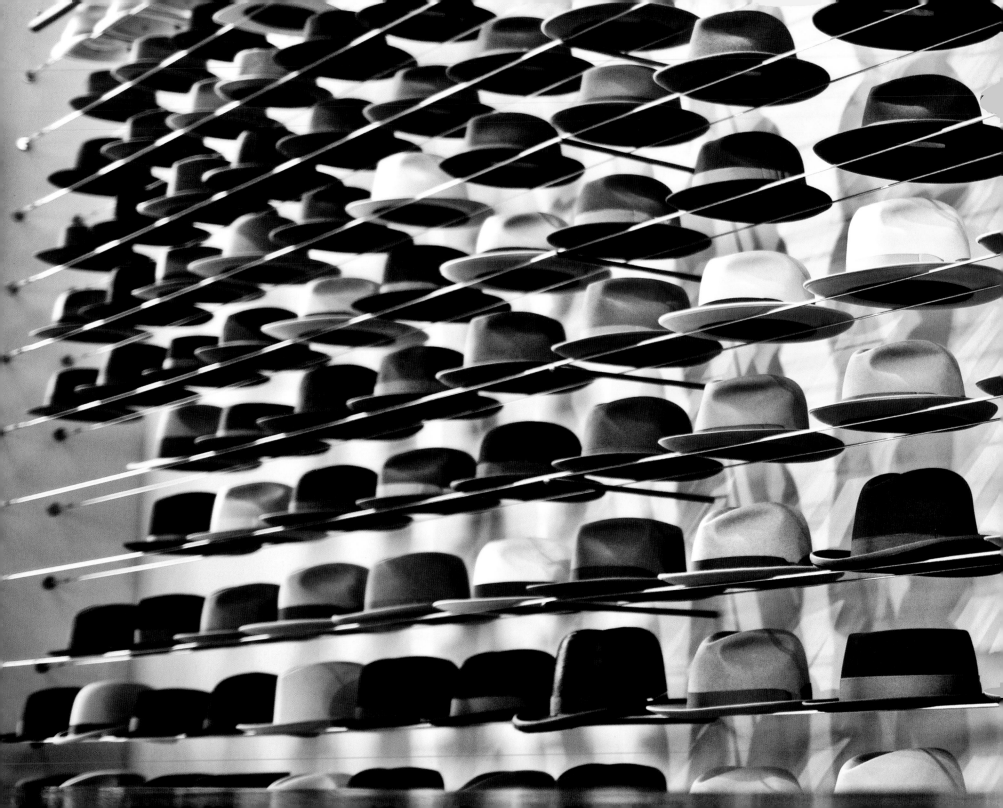

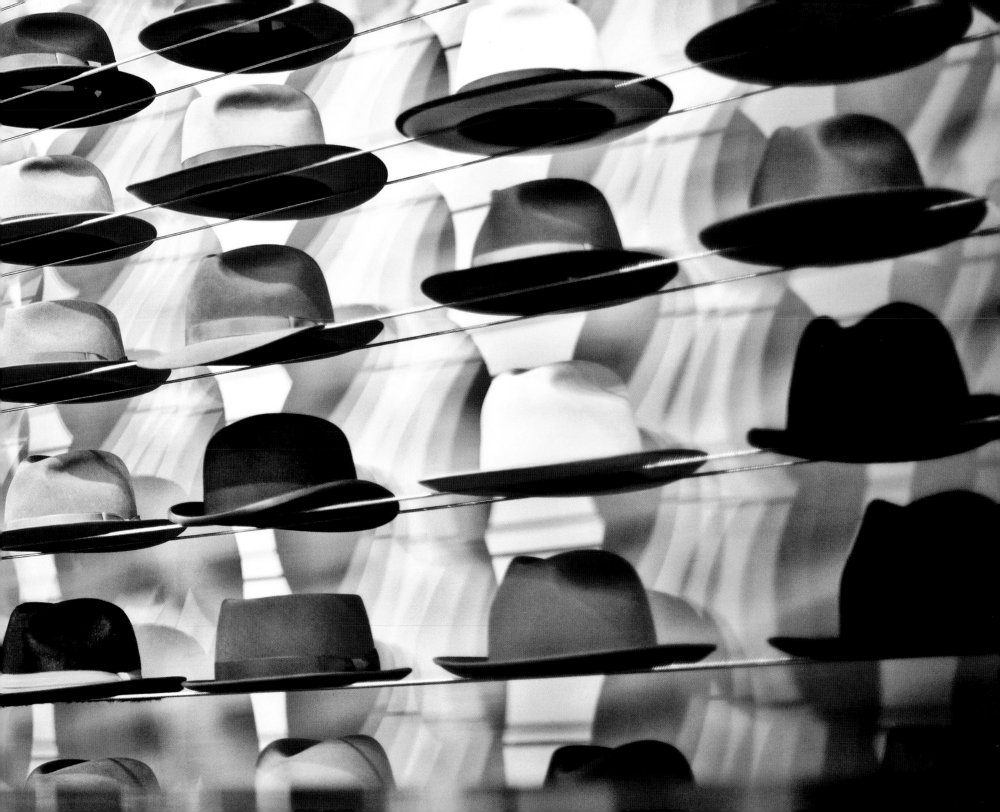

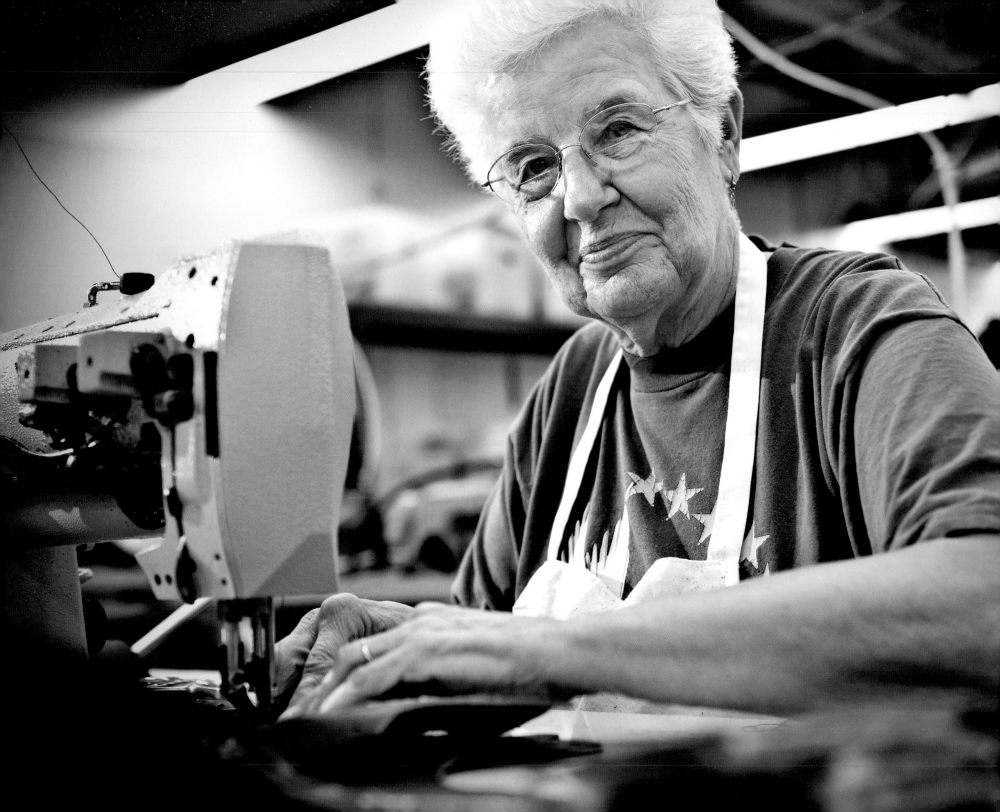

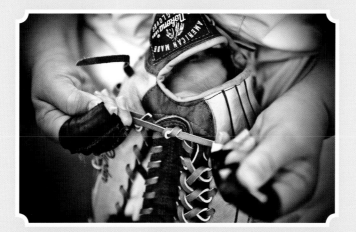

NOKONA ATHLETIC GOODS COMPANY

NOCONA, TEXAS

· ★ ·

The decision for Rob Storey was both difficult and personal. Nokona Athletic Goods Company, the company that his great-grandfather ran in the 1920s, where his father had worked, and that he now led—would give up its long-standing football line and concentrate on what it had done since 1934: make the world's finest baseball and softball gloves, bats, and accessories.

Unlike competitors, Nokona had historically resisted the cost savings of overseas production. Storey would not compromise on the idea that everything his small company produced stay American-made.

"If I have to import and send my employees home," Rob's father said in the 1960s, "I'd rather go home and go fishing." Rob Storey felt the same way.

He'd already seen that Nokona could overcome adversity, rebuilding itself after a devastating fire in 2006. Now he was adjusting to the vagaries of the sports-crafts market, and the reality that he had to concentrate on the one thing that differentiates him from his large corporate competitors. "We just needed to make sure it's first and foremost about quality," he says.

Since producing that first baseball glove (which can still be found on-site) nearly eighty years ago, Nokona products have been identified as an important piece of America's story. During World War II the

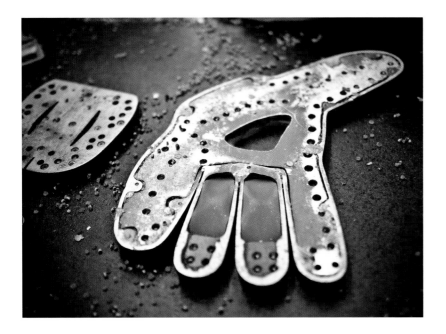

company produced a quarter-million gloves for US soldiers. Hall of Fame pitcher Nolan Ryan talks about buying his first Nokona as a boy in rural Texas. Even now they've affiliated themselves with the US Military All-Star program, providing gloves for its active duty, reservists, veterans, and first responders.

Storey says gloves have changed, and it's "technically more difficult" to make one now because they're more intricate. "In the 1970s, people started wanting big gloves, the size of tennis racket heads," he says. "But a glove should really be an extension of your hand." This is why Storey, who has coached Little League for twenty-five years, plays catch barehanded with his kids on the first few days of practice.

The process still begins with finding the right leather. Parts of a glove may be from cow hides, but Nokona also uses kangaroo, which is more expensive but softer. They test the leather to make sure there won't be too much elongation of the grains. They examine different portions of the hides to match the look and feel needed in certain portions of the glove. The glove's palm usually comes from the backbone of the hide. "It's about touch and feel," Storey says. "You've got to visualize that glove, match it to what you have in your hands, cut it, put it on the floor, really examine it. Nine out of ten times, it's still not right."

Once the glove is stitched and embroidered, they break it in with hot irons, mallets, and hammers. Getting that right is more art than science. "I call that

the 'three bears' syndrome," Storey says. The public used to like a stiff glove, but now they want it to be ready to take in the field that day. Too soft and broken in, though, means it won't form properly to the user's hand. It needs to be something in between—just right.

There are plenty of experienced workers at Nokona who instinctively know what "just right" feels like. Many employees have worked there for more than thirty years, a handful more than fifty. Storey himself has been there thirty-three years.

"I've never been interested in finding the cheapest labor possible," he says. "I like working with these people too much. There wouldn't be a company without them."

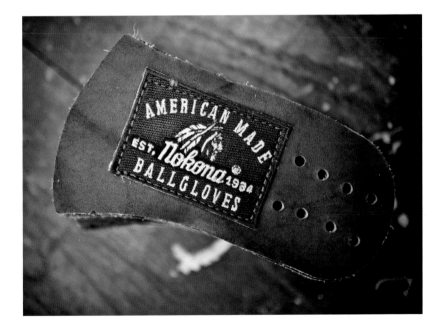

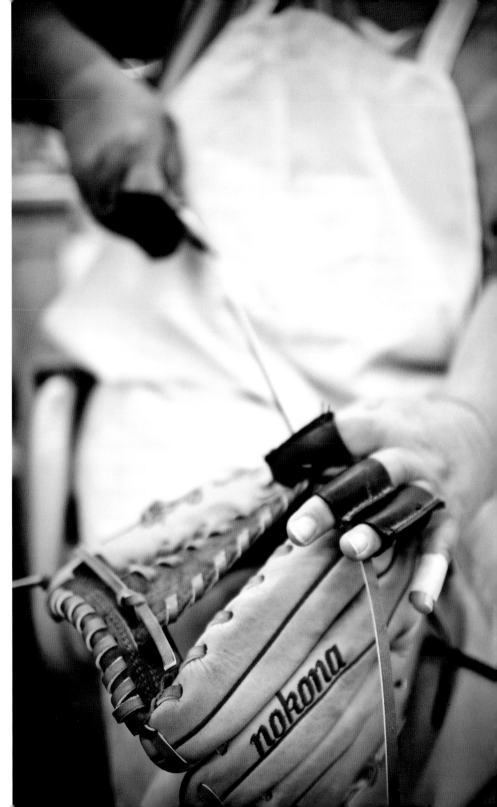

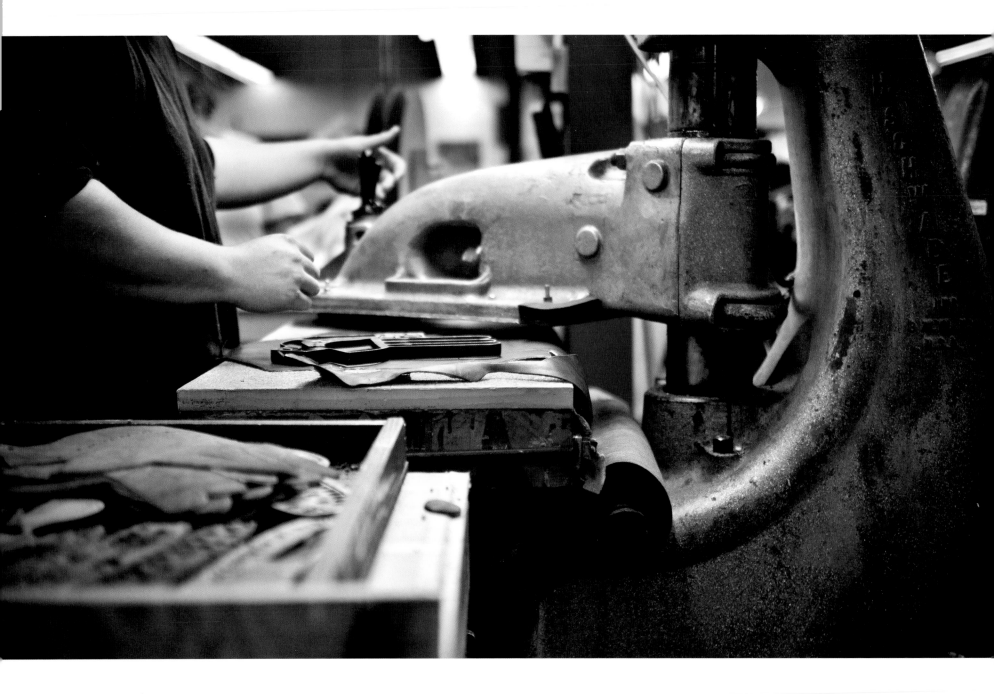

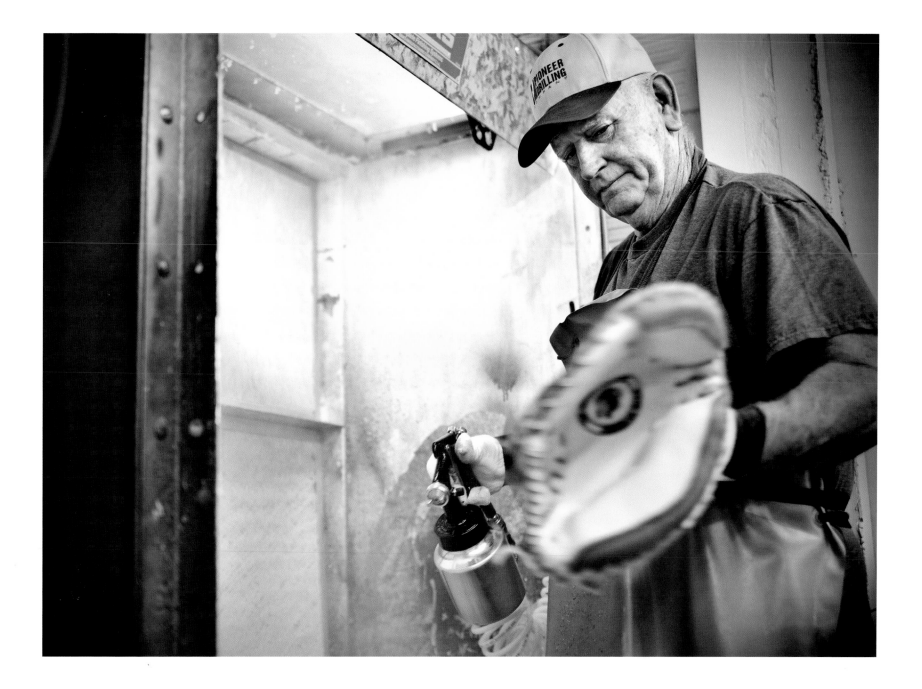

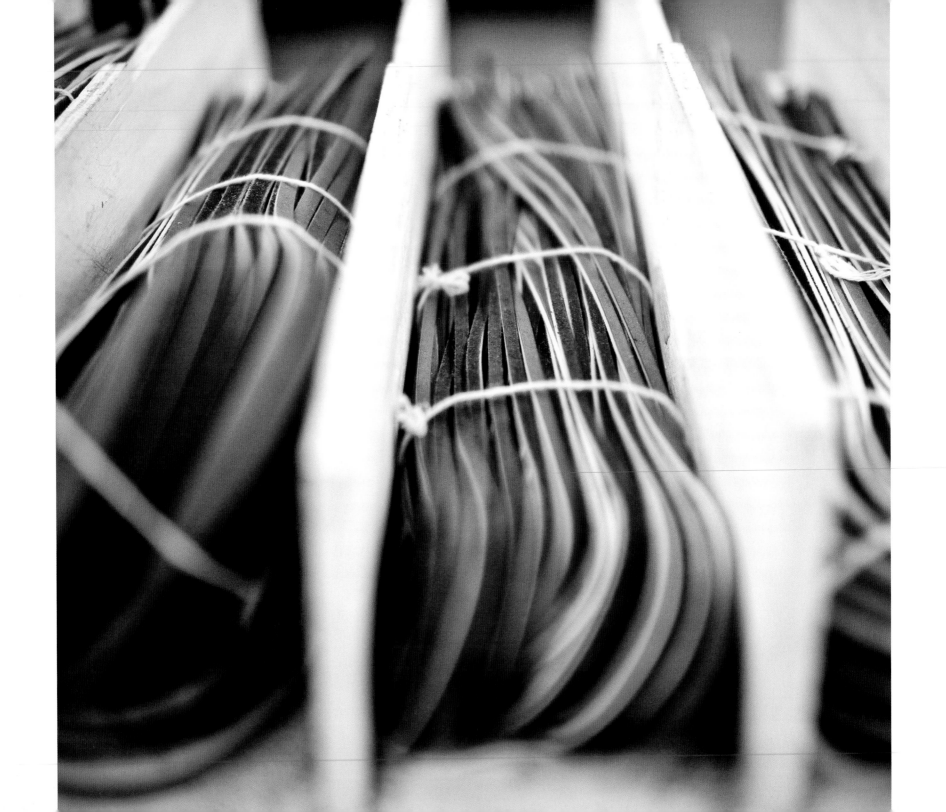

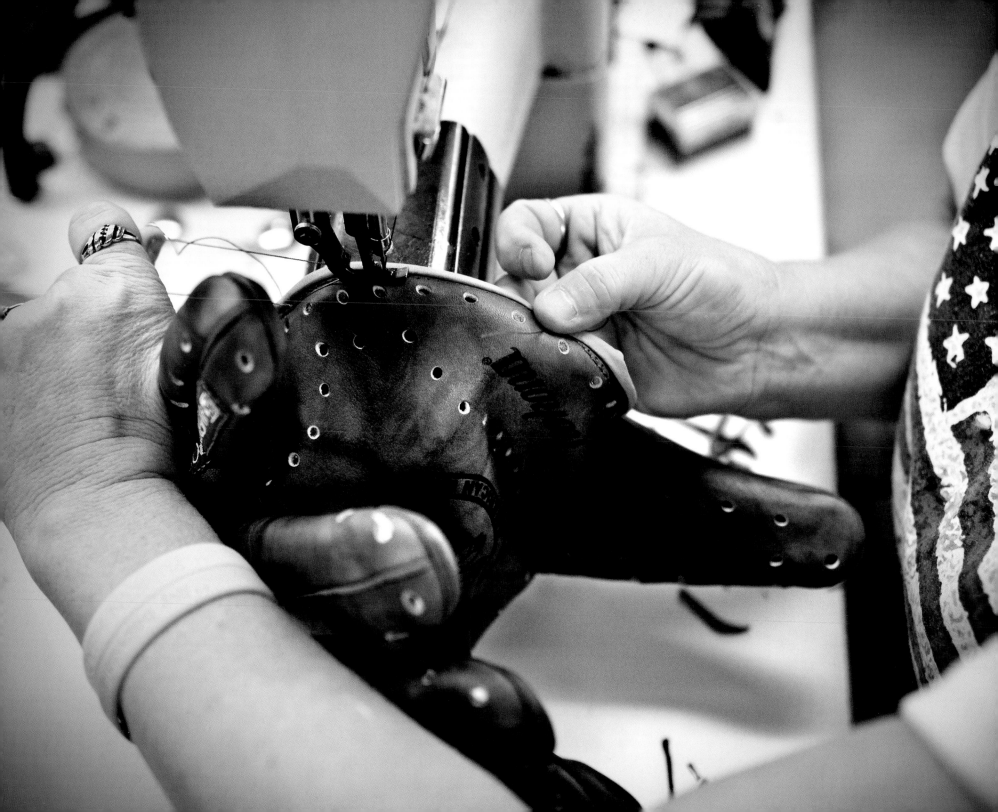

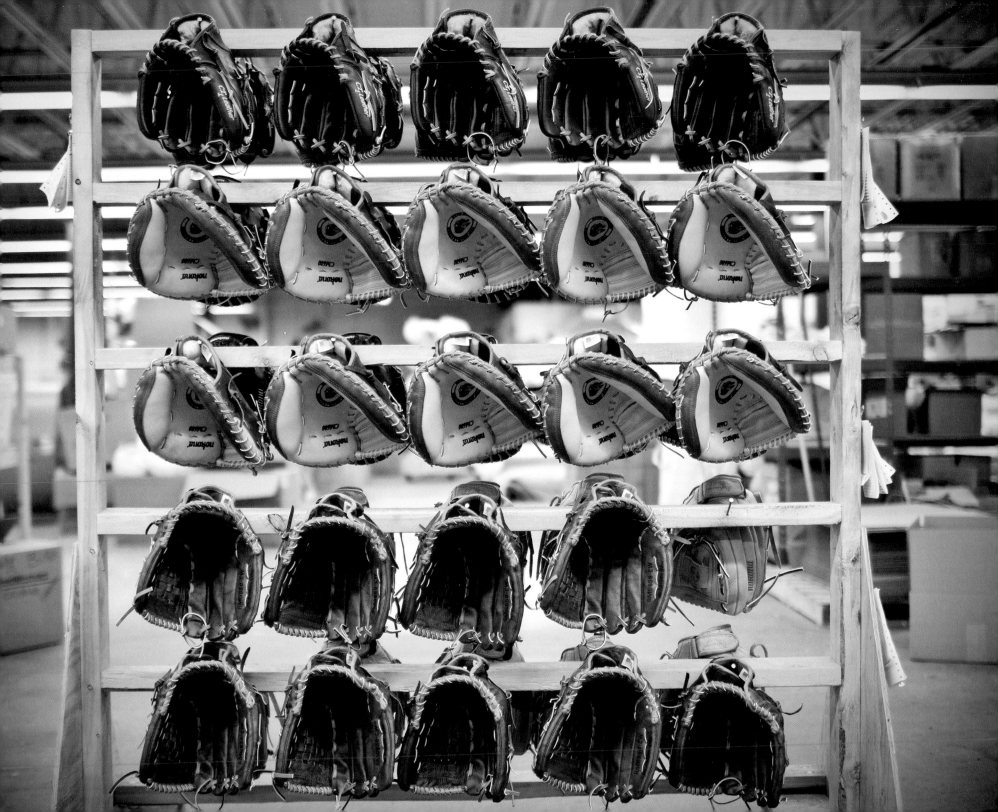

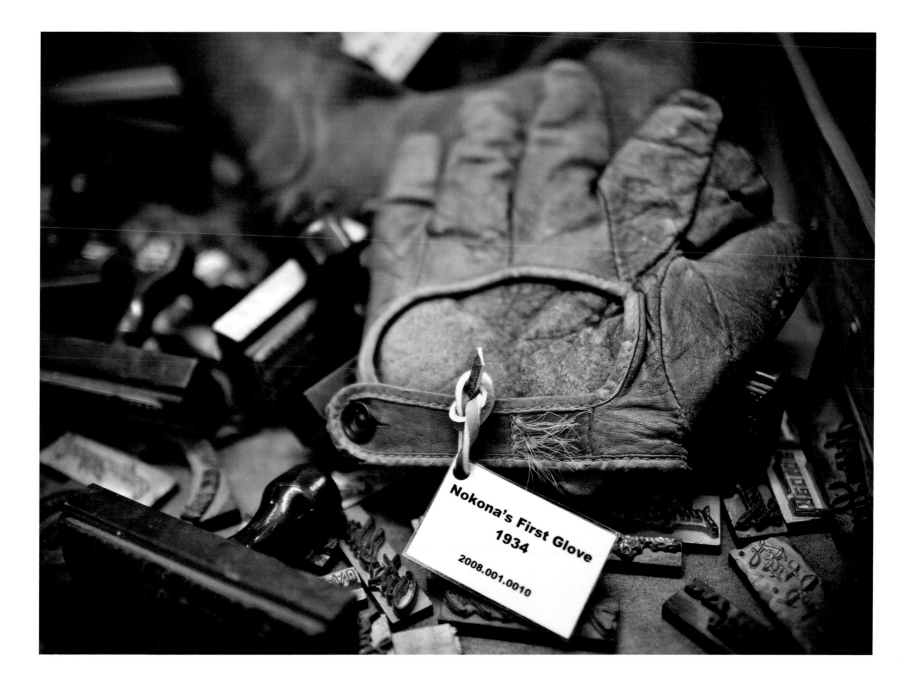

Nokona's First Glove
1934

2008.001.0010

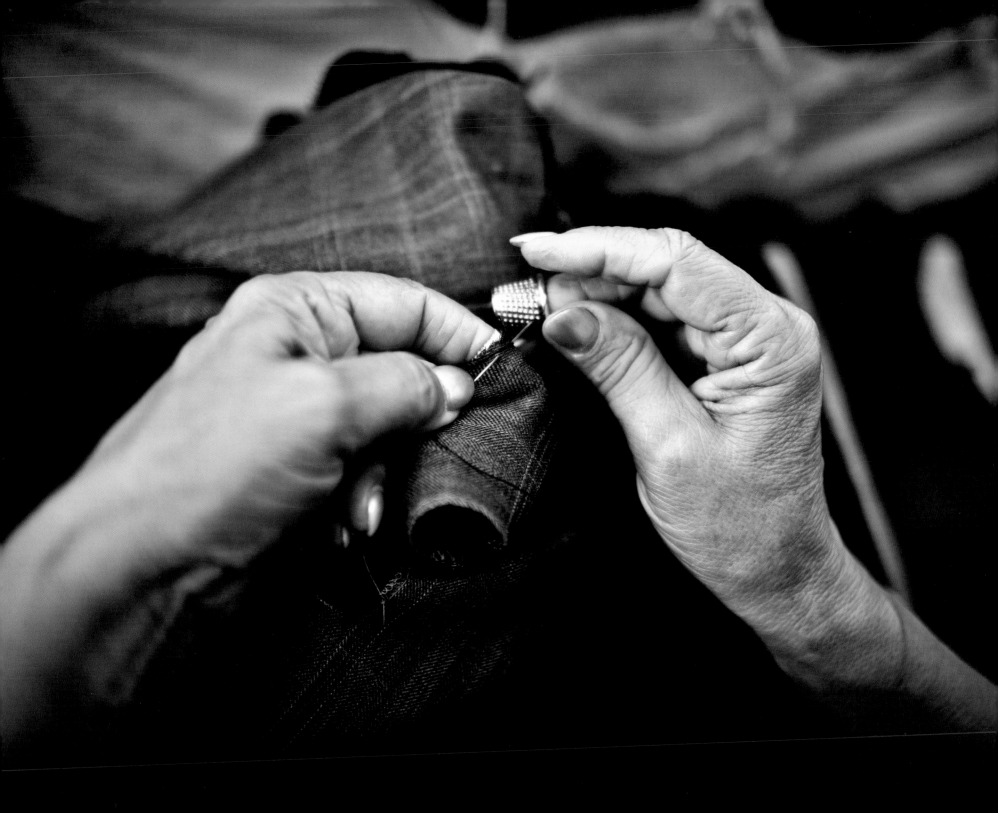

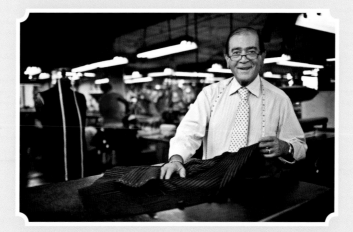

OXXFORD CLOTHES

CHICAGO, ILLINOIS

· ★ ·

By the time Don Deisch got the call from the CEO of Oxxford Clothes in 2007, he'd seen just about everything there was to see in the world of men's custom suits. From the time he'd taken his first tailoring course in high school to working in a custom clothing house cutting room as a teenager to nearly three decades in men's retail, Deisch knew the industry like he knew a finely stitched lapel.

So there was little hesitation when he was offered a career at Oxxford, the last factory in the United States that was still tailoring custom suits by hand.

He'd loved Oxxford's clothes since he first encountered them in 1992 as a salesman.

Five years later Deisch is now Oxxford COO, and he's seen the ninety-seven-year-old clothier adapt to a more demanding, better-informed marketplace. But he has seen no change in the exquisite craftsmanship in Oxxford suits.

"To see firsthand the level of detail that goes into an Oxxford suit is incredible," Deisch says. He has been in plants that produce a suit coat in three or four hours. That's not the case at Oxxford, where they recheck every pattern before it's cut, use "one-directional" lays on cloth (which uses more fabric), match the inseams to the sleeves, hand-sew with precision the tape and lapel padding, and construct the armholes so they move with you—it all creates a custom feel that can't be replicated by machines.

It used to be that everyone bought his suit off the rack, an average pattern for an average frame. Even when a ready-to-wear suit is altered, the tailor is limited in what can be done. For older gentlemen, this meant that the typical changes the body goes through—head forward, shoulders more rounded—would not be reflected in the suit jacket's fit.

Because of this, and because the Internet has made customers more knowledgeable about the benefits of custom tailoring, and because costs can be better controlled by waiting to make a suit to custom order, more retailers are selling custom-made. This put time pressure on Oxxford, which used to require eight weeks to finish a custom suit.

"There were companies producing well-made suits in two or three weeks," Deisch says. "So the biggest pressure on our business has been to make things faster. It turns out you can save time without taking the quality out."

Oxxford was able to save time on the front end by keeping a steady supply of fabrics available and by doing tasks concurrently. What was once a step-by-step process now happens simultaneously, meaning a world-class suit can be produced in just five weeks.

The process itself can't change; it's too integral to the quality. The cutting and bundling, the pressing stations (by machine and by hand), the tough-eyed examiners and the quality control stations—none of that has changed. It's essential to the exultation one feels when slipping on an Oxxford for the first time. "It's like wearing nothing, it molds to you, like fine custom shoes," Deisch says. "It falls right into your body."

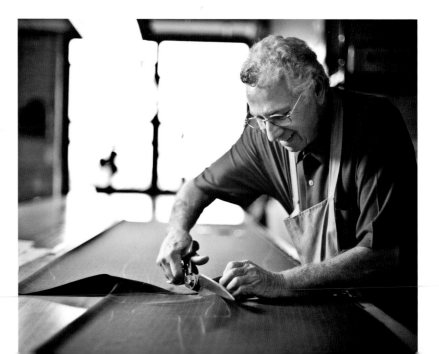

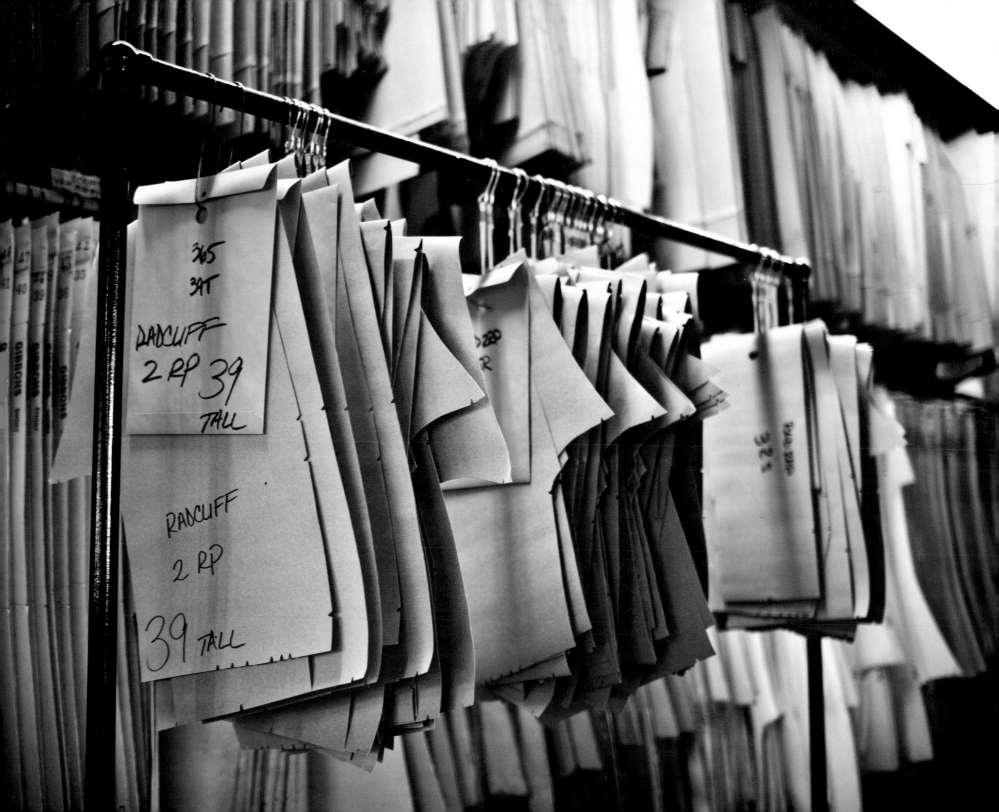

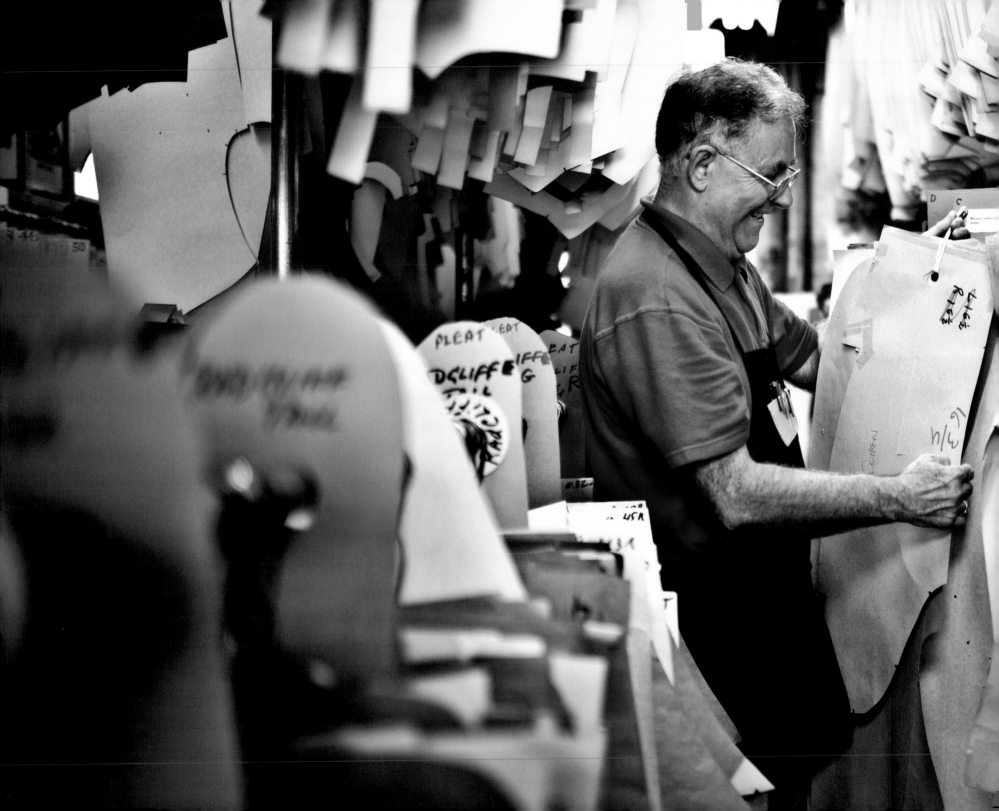

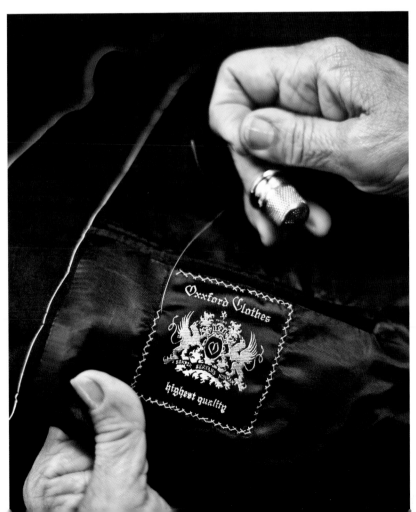

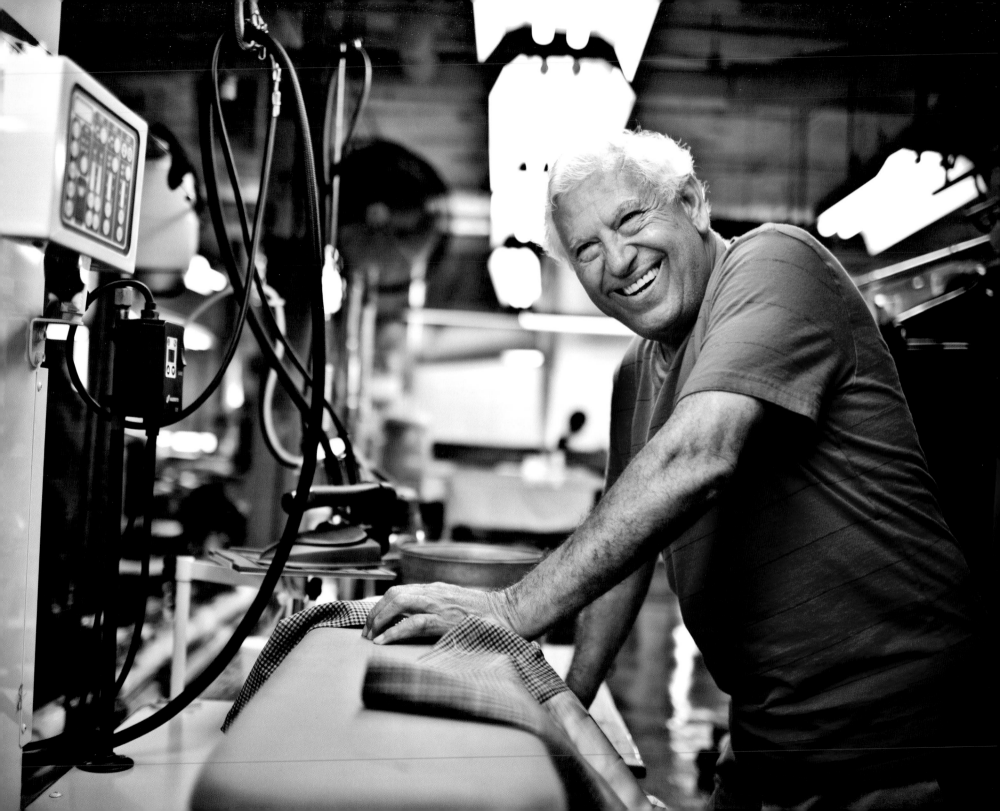

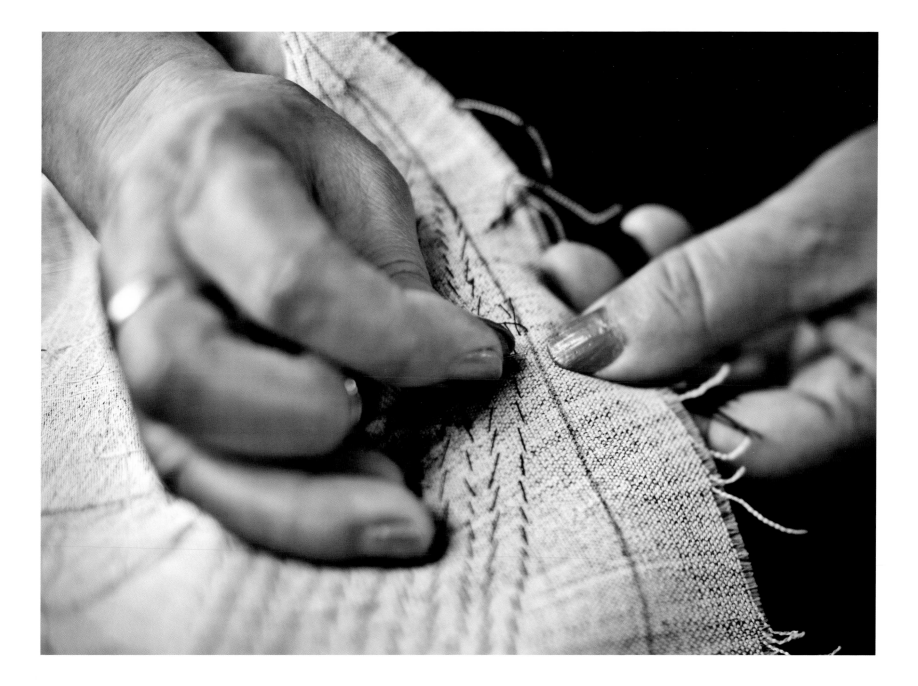

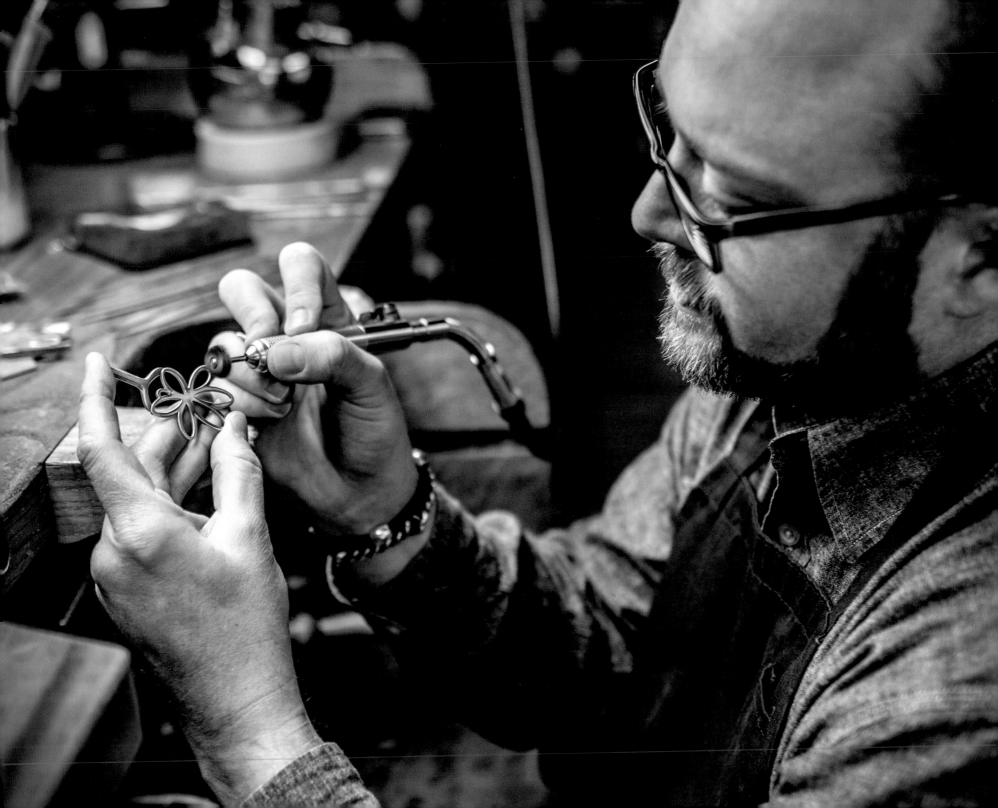

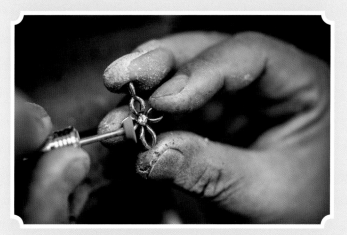

JAMES AVERY JEWELRY

KERRVILLE, TEXAS

★

It wasn't long before James Avery went from crafting jewelry in a two-car garage to being the head of a large company. Once that happened, he realized that managing that success the right way meant instilling in his company the values he brought to his craft—hard work, a mastery of form and function, clean lines, and an understanding that jewelry was *not* the company's core business.

"He knew we're in the 'connection and meaning' business," says Howell Ridout, who has worked with the company for thirty-eight years. "We create symbols that connect people with each of their family

members, with their friends, with their faith. If you give a keychain with a soccer ball to your child's coach at the end of the season, you're expressing thanks to that person for sharing the best parts of your life together."

Now ninety-one years old, James Avery still helps guide the company, though it's run day-to-day by his two sons, Chris and Paul. The sons say it's paramount that they foster a culture that stays true both to their father's artisanal vision and his belief that they offer symbols of society's connective tissue. "When you foster that belief in your company, you really get buy-in from employees," Chris Avery says. "And not in a superficial way. They care about what they do, about what we do together."

Paul Avery talks about the "values that drive our design approach . . . designs that are lasting." That approach has stayed consistent for decades. The simple nature of the designs belies the quality in the process. (Check the finish on the back of a piece, or the weight it has because it's not hollow—two areas where other jewelry designers cheat on quality to meet mass-market demand.) And as was James Avery's desire, the company designs not just the jewelry but everything associated with its stores, from the catalogs to the display cases and sales counters (built in the company's own millwork shop) to the gift cards.

This means that the company often rejects paths to rapid growth to maintain its mission of quality. They ask instead: How much growth can the company absorb without sacrificing something essential?

"We still balance handcraftsmanship with technology," Chris Avery says. "We still use a lot of hand skill in design and metalwork. But in some cases, the technology gives you a better-quality product." Paul Avery adds, "Like in mechanical finishing. A lot of our jewelry is still hand cleaned and filed, but then polishing now can be more consistent and beautiful."

There's no doubt, though, that the company values quality over growth. It also insists that its five manufacturing shops be located in the United States (all in Texas, as a matter of fact).

"Could we save money overseas? Sure," Chris Avery says. "But it's not worth it. We've got 450 American manufacturing jobs here, 1,600 employees

overall. And we're proud that we can provide great American jobs, have a great product, and not have to make that sacrifice. It was important to our father. It's important to us."

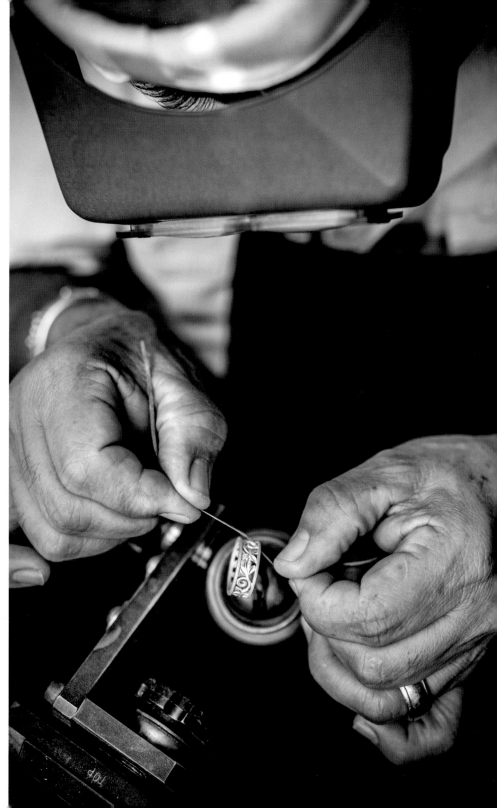

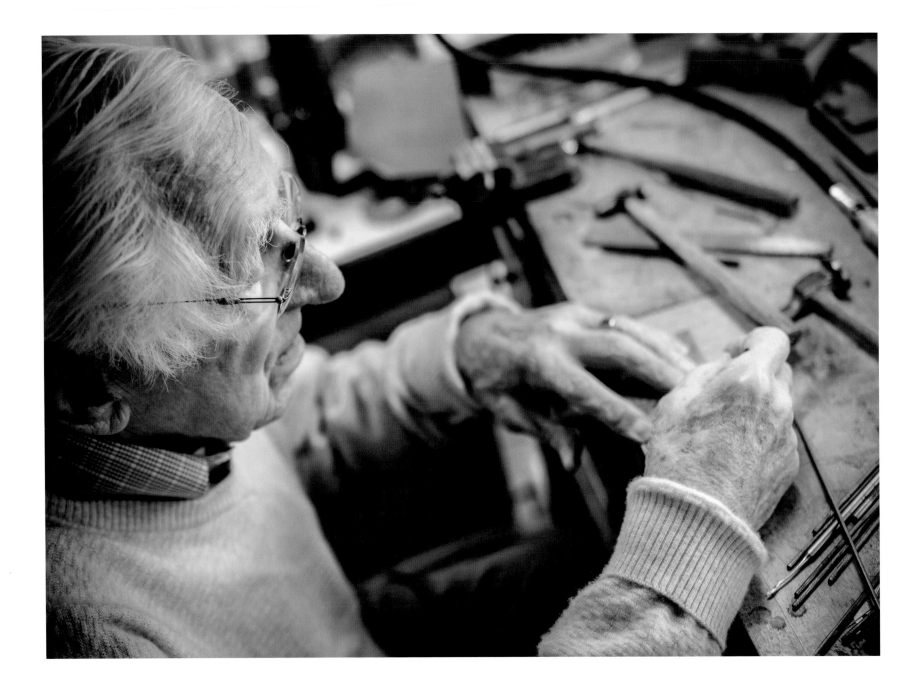

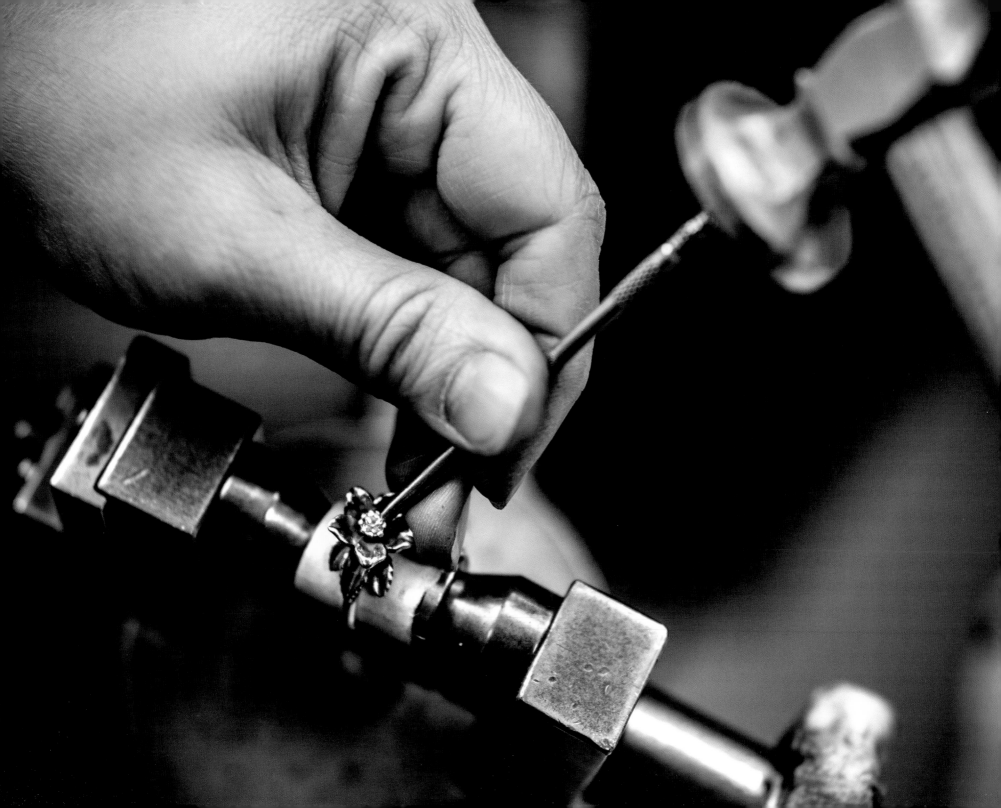

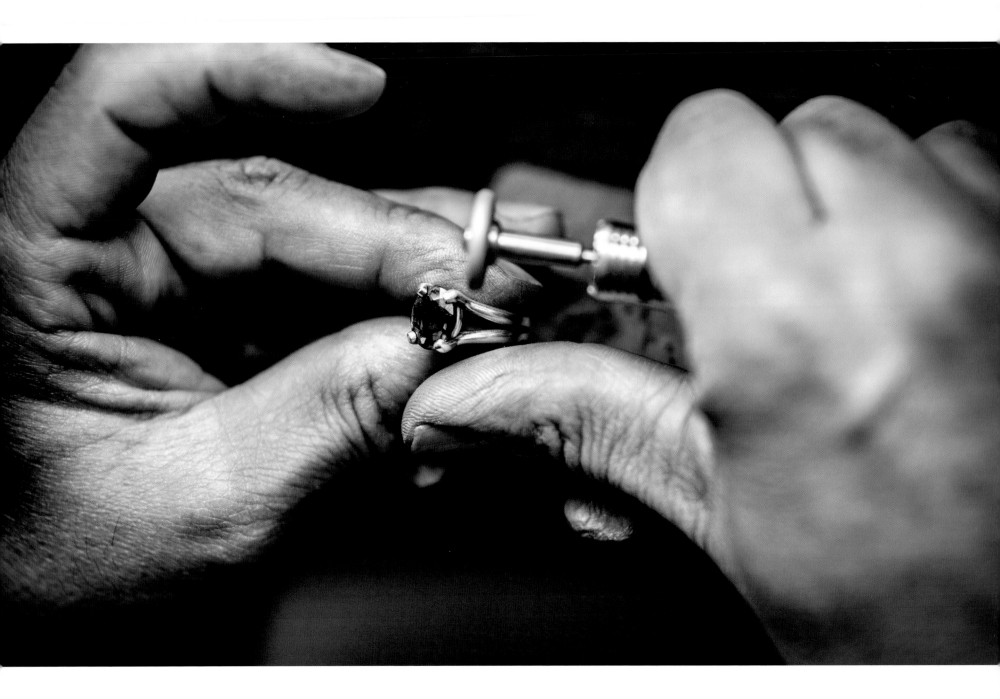

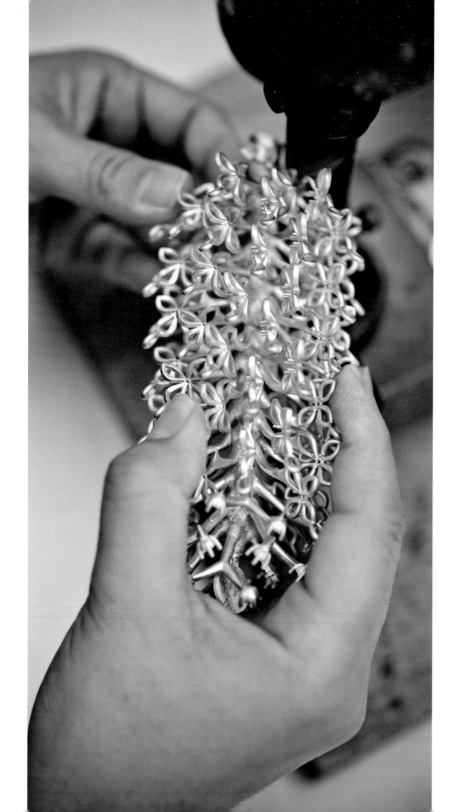

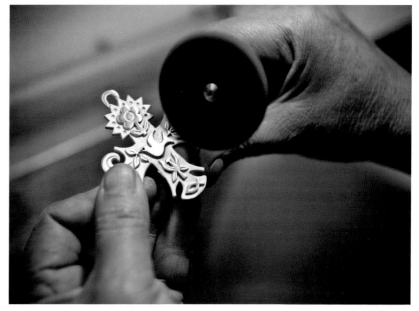

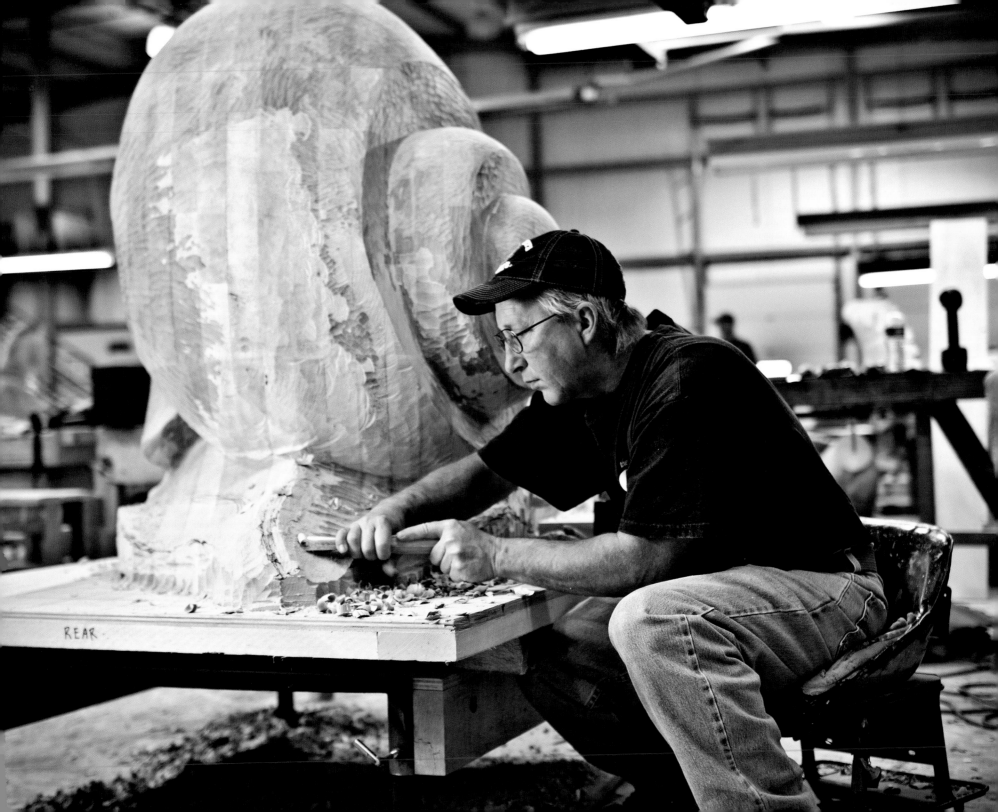

REAR

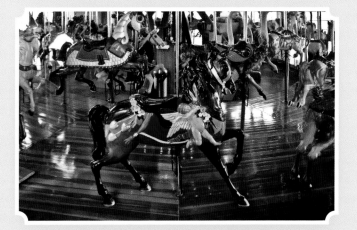

THE CAROUSEL WORKS

MANSFIELD, OHIO

⋯⋯⋯⋯⋯⋯⋯⋯⋯⋯⋯⋯⋯⋯⋯⋯⋯⋯★⋯⋯⋯⋯⋯⋯⋯⋯⋯⋯⋯⋯⋯⋯⋯⋯⋯⋯⋯

Art Ritchie realized that he would one day build the country's best carousels. It came simply because he did the math.

By happenstance, Ritchie, who had been carving professionally since 1973, struck up a conversation with a man who had just purchased an antique carousel (cost: $450,000). The man told Ritchie he planned to restore it ($400,000), then have it shipped and installed ($150,000). When Ritchie asked what a new fiberglass carousel cost ($250,000), he saw it all laid out. "A quarter million or a million dollars. . . . That was a big gap to slide into."

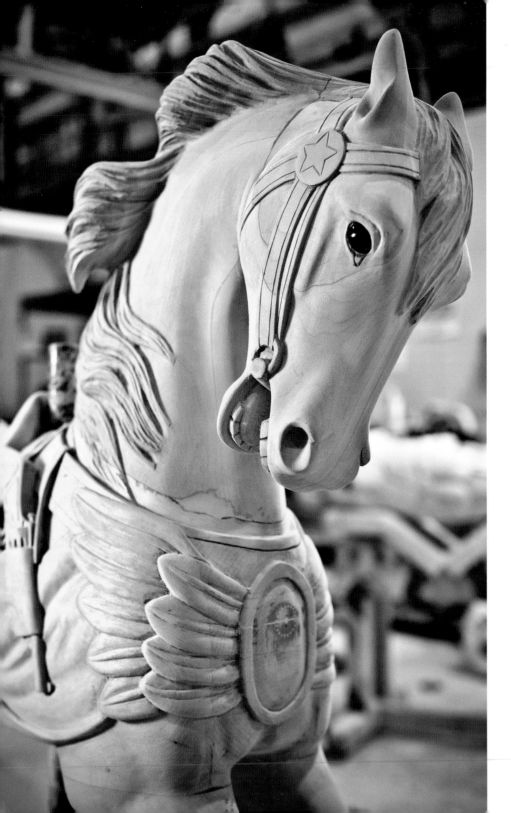

He slid into it headfirst. In 1986 he and his partner, Daniel Jones, opened The Carousel Works to design, build, and install custom-made carousels. The goal was to take a carousel from the customer's rough-sketch vision to a spinning work of public art.

Ritchie and Jones spent their first few years restoring antique carousels, an expense that zoo and park managers felt comfortable green-lighting. This allowed them to reverse engineer the classic carousels, many of which had been built in the carousel's heyday of the early 1900s. They determined which mechanisms stood the test of time, which treatments led to disrepair, which areas of construction could be bettered with new technology.

For example, antique carousels often lost five to ten legs a year. Ritchie took note during his restorations, challenging himself to solve this problem when someone finally took a chance on a from-scratch carousel.

That was in 1991, when Ritchie and his team built their first carousel for a carousel park in the company's own town of Mansfield, Ohio. Soon after, he built the carousel that helped his business bloom—a ride for the zoo in Fort Wayne, Indiana.

Building a brand-new carousel for a zoo was an important step. Zoos are not cutthroat competitors. They share best practices, and if an innovation works at one zoo, other zoos will follow suit. The director in Fort Wayne was worried, knowing that he was taking a chance by commissioning a new carousel.

His worry vanished when the Fort Wayne director's granddaughter took a ride on the carousel's Malaysian tapir, a type of pig with a short prehensile snout. At another zoo, his granddaughter spied a tapir and couldn't stop sharing the facts she had learned from Ritchie about the animal's coloring—the director was sold.

Other zoos followed Fort Wayne's lead. Ritchie has put carousels in twenty-eight zoos around the country, including his first solar-powered carousel in the Smithsonian National Zoo. Featuring sixty-four animals found on-site—everything from a cuttlefish to a naked mole rat—it's a striking example of carousel artistry.

The manufacturing process is a delicate mix of old- and new-school techniques. Up to twenty-two people, in a 2,400-square-foot space, work on two to three carousels at a time—in the frame shop, the machine shop, the carpentry shop. The skills are time-honored ones: carving, painting, fitting, inspecting. But the design work comes from a process both hand-made and cutting-edge, taking sketches and turning them into 3D digital models that can be examined before production is complete.

But Ritchie reminds himself that sometimes he just has to keep it simple. For example: How does he test the construction of the legs and tails? (Rather than losing five to ten a year, Ritchie's carousels haven't lost five legs *total* since he began.)

Simple. He takes them to the batting cages and "goes nuts" on them with a Louisville Slugger.

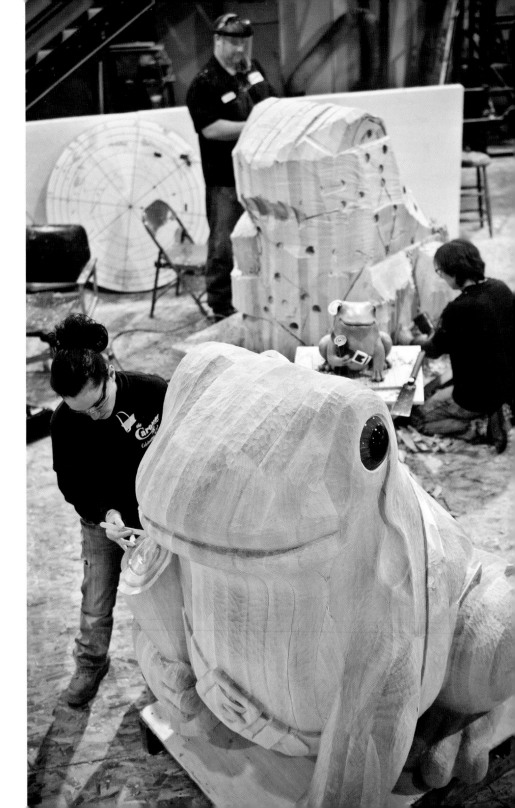

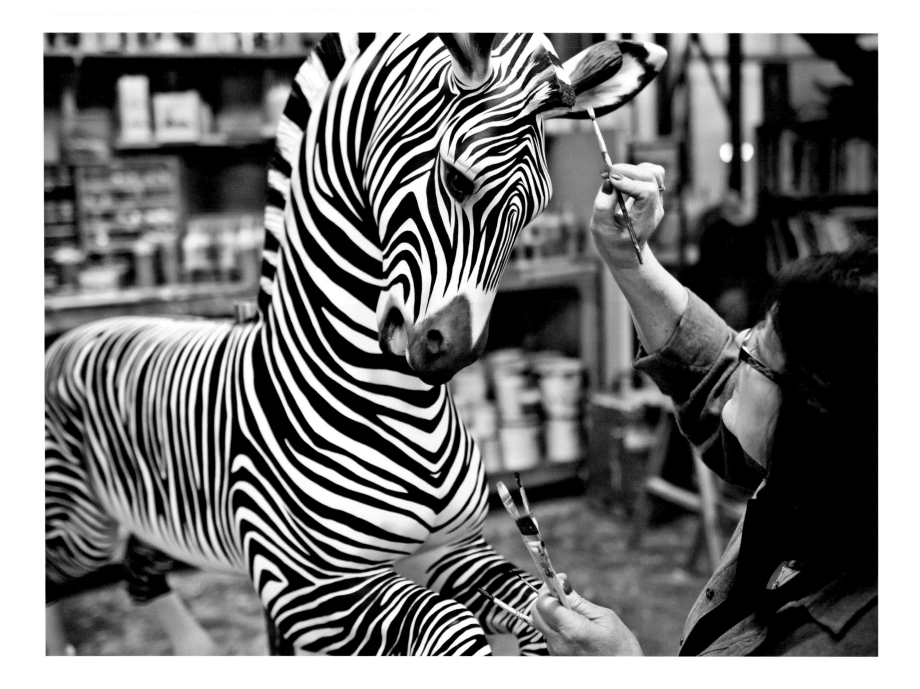

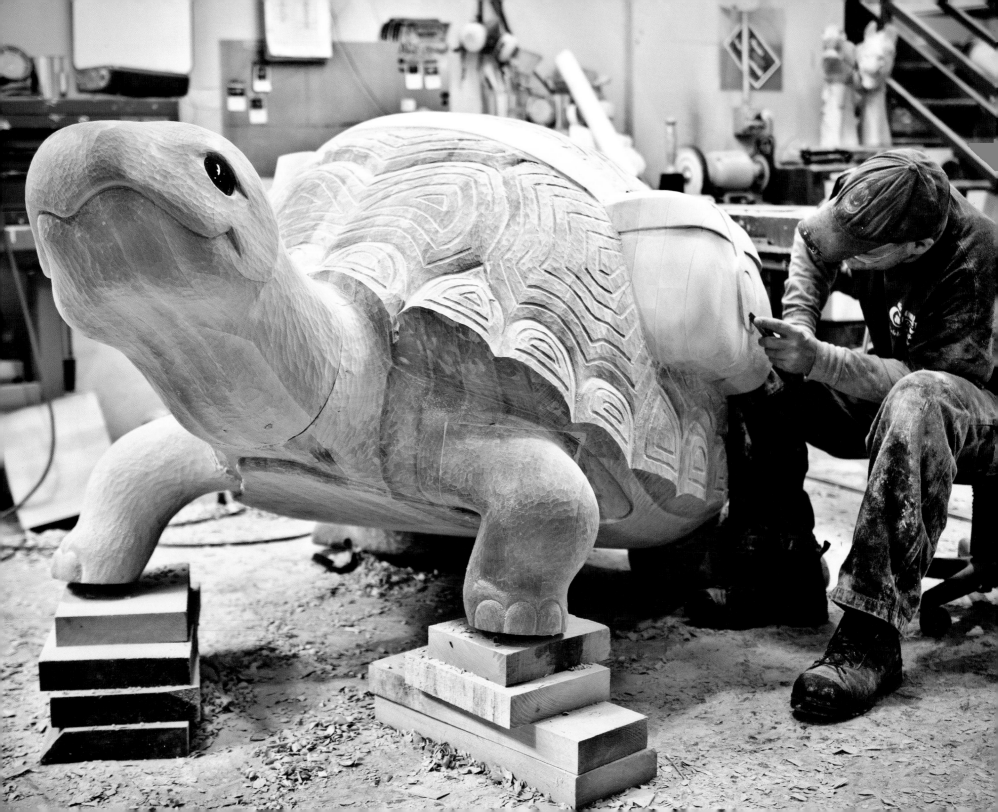

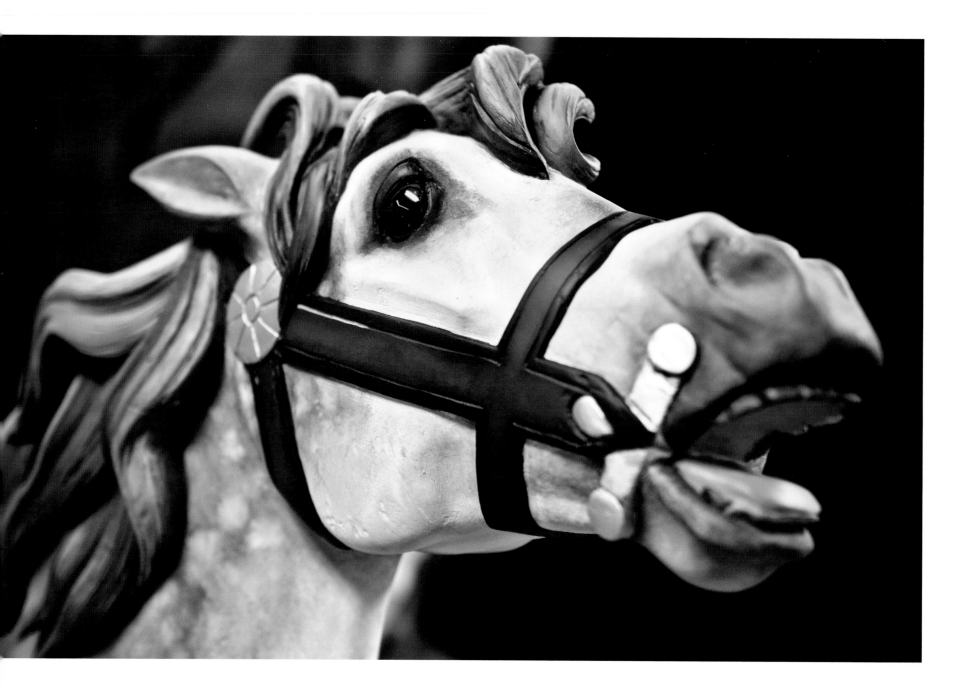

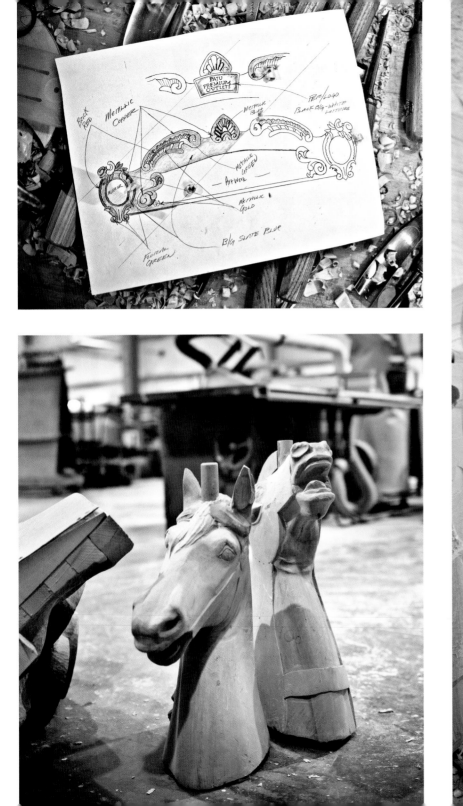

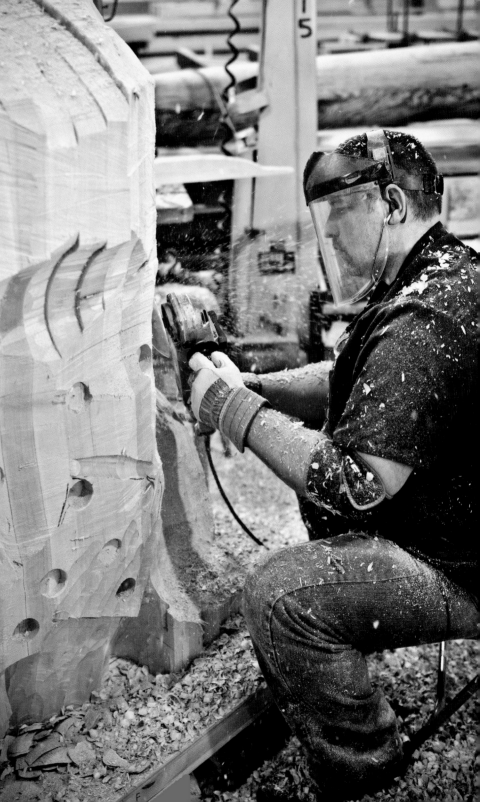

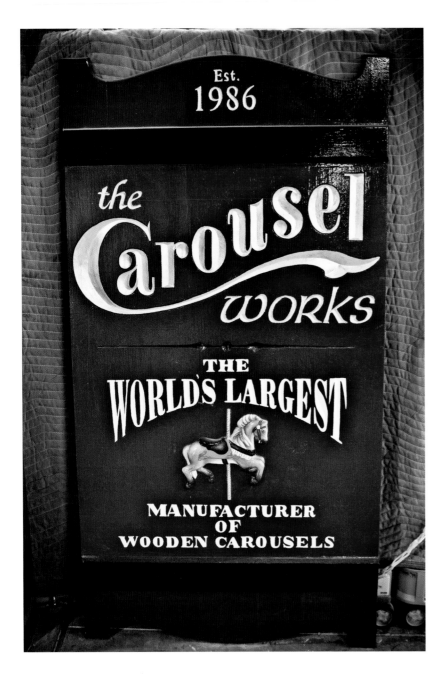

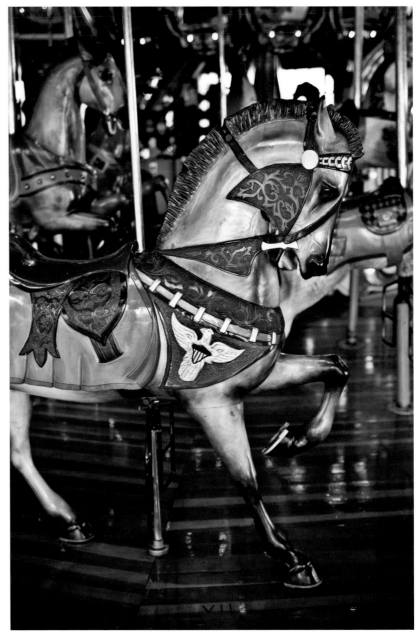

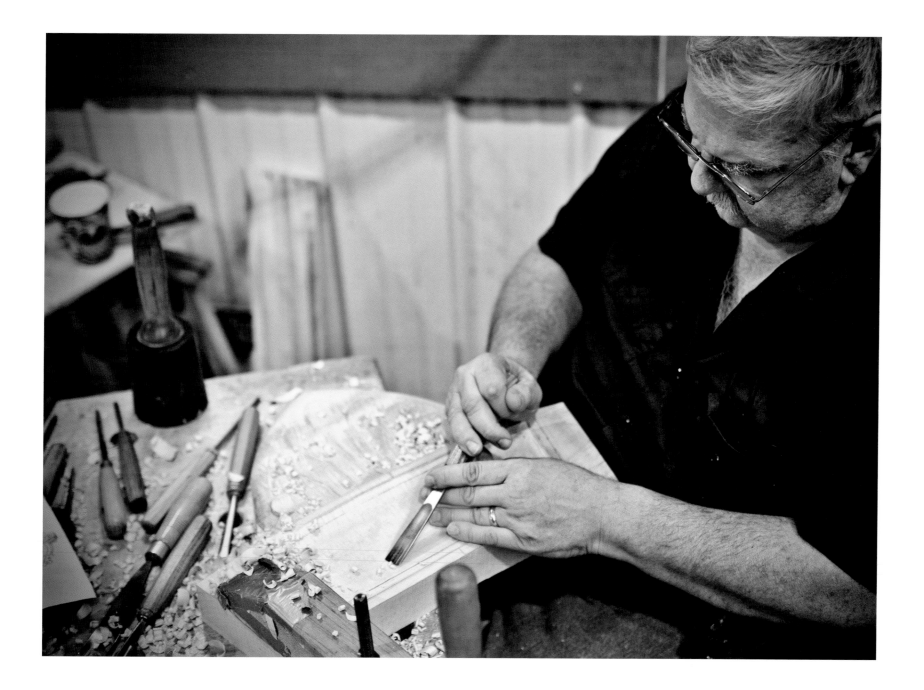

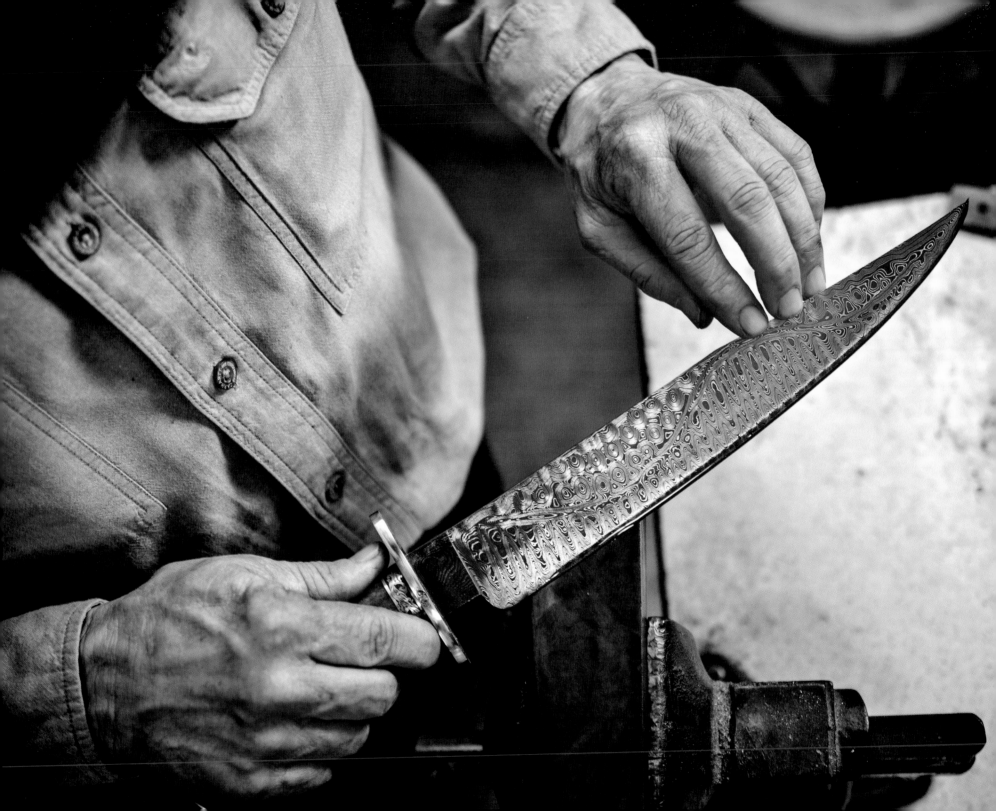

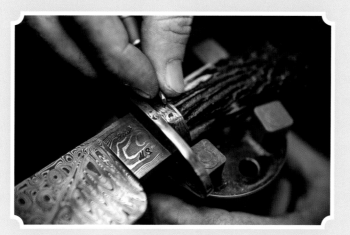

FISK KNIVES

NASHVILLE, ARKANSAS

⋆

Jerry Fisk is the first to tell you about his background. He grew up very poor, with no art in his home, and just two books—a Bible and a study Bible. He had no mechanical training whatsoever. His job was to take care of the family's farm animals. And he finished twenty-first out of twenty-two students in his high school.

"I barely got out of school, and things didn't look great in terms of a career," he says.

It was then he learned the value of the books he'd

ignored in school. There was an opening for a machinist at the mill where he was shoveling glue, but he was told he'd need to know math. So he purchased some of those textbooks and got the job. Once he merged his newfound forging skills with his lifelong love of knives, a profitable hobby was born.

Largely self-taught, and combining techniques he picked up from knife makers all over the world, Fisk is now considered one of the premier bladesmiths in America, a maker of everything from Bowie knives to swords. Fisk says he never worried about not having the best tools after he became a student of knife history. "I'd go to the museum and see wonderful knives five hundred years old," he says. "And they didn't even have the tools I had."

Fisk's hybrid, multiethnic style leads to what he calls "unusual approaches" in knife making. Once Fisk has an order—the wait list is considerable—he figures out where the steel and the handle material will come from. He can use store-bought steel, make his own, or take a piece of interior steel the customer suggests: a car's hood, a metal bucket, pretty much anything.

The steel's origin and the knife's design determine the steel-forging process. He might add sugar to the steel while folding it, or he might use a Japanese method of brushing it with rice straw. The handle material also determines how long and in what way he will work the material, whether it's stag or walrus ivory or something custom.

Fisk forges all his blades one at a time; it's a painstaking process (and one reason he only makes a few dozen knives a year). He'll layer the steel as necessary, then shape it to within 95 percent of its finish. That's when he grinds and files to get a nice flat blade. At that point the blade is hardened, which is important in determining how well it can hold its edge. It's then put together with the handle—he even uses his own screws.

It's been tough on him physically. He's often five feet from a 2,400-degree fire. His shoulders and elbows are worn down, his fingers and joints often inflamed. He gets cold easily. "You gotta really wanna do it," he says. "It's not worth the money. I don't care, though. If I couldn't sell 'em, I'd still be making them."

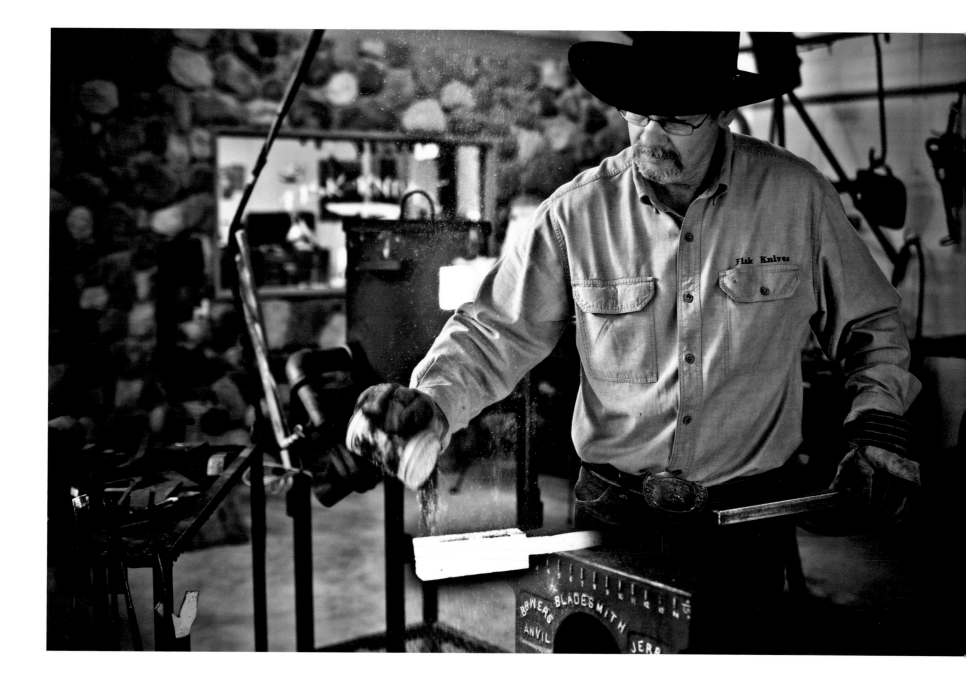

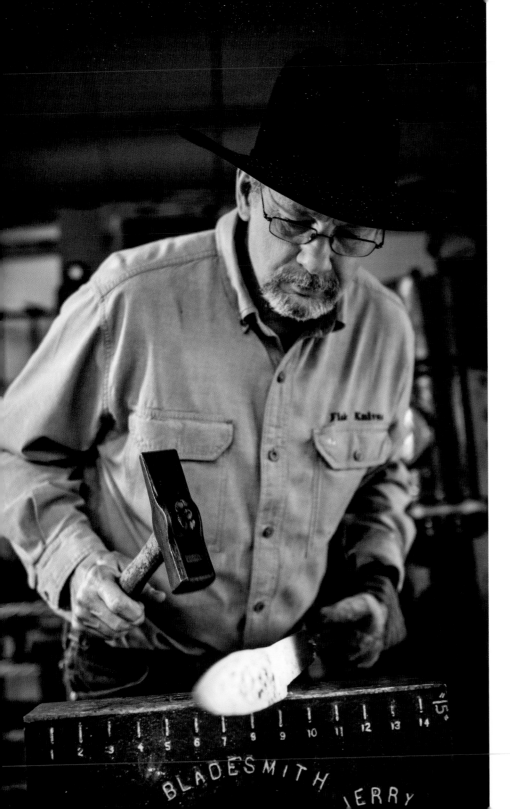

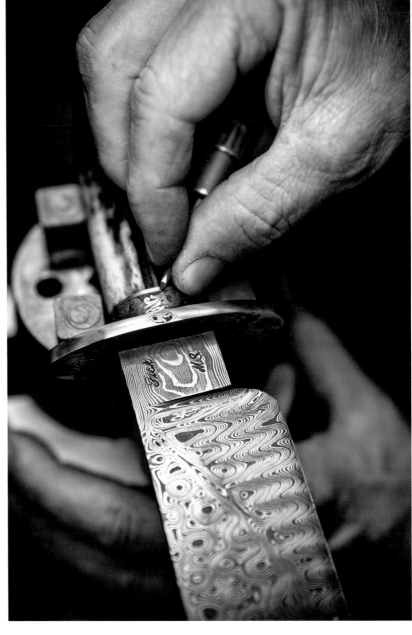

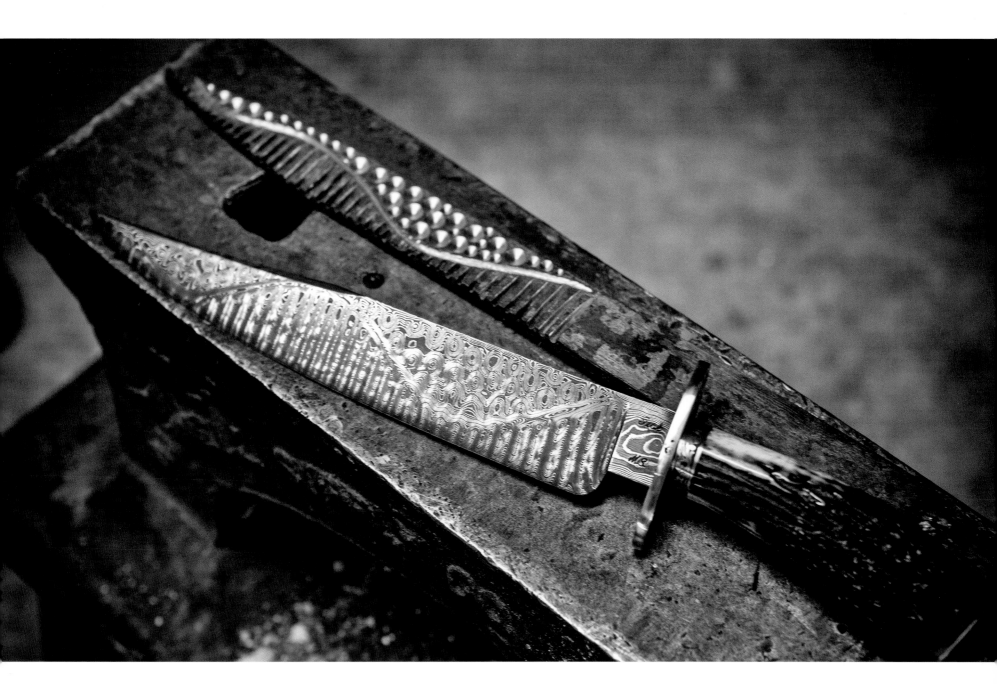

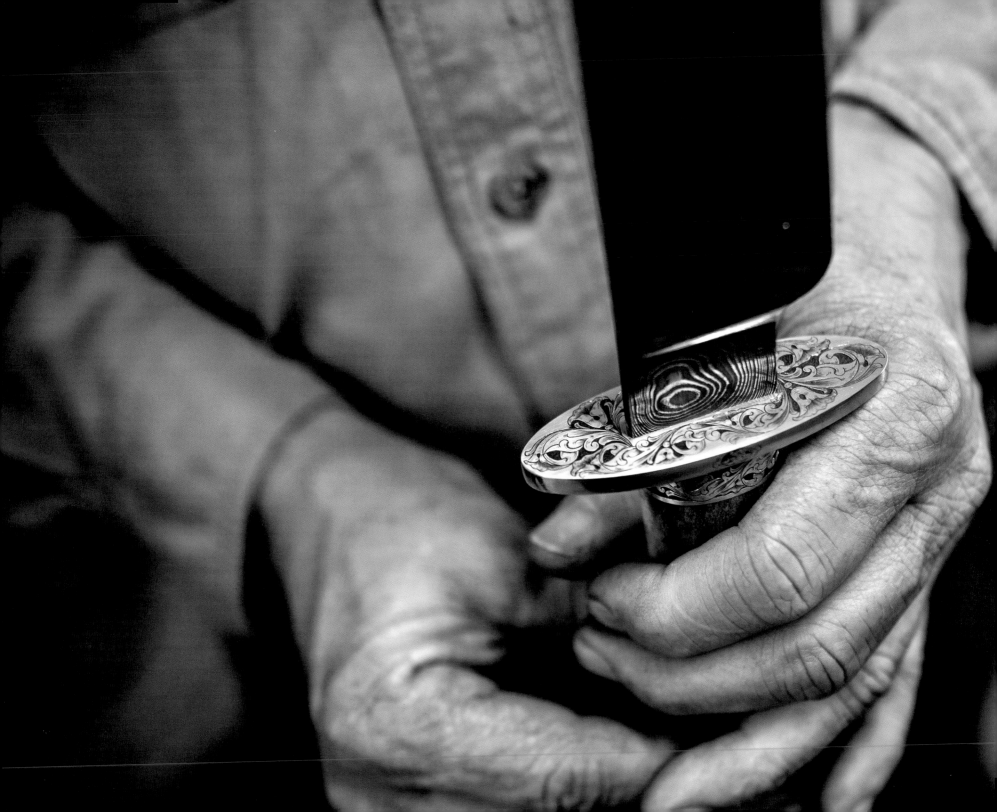

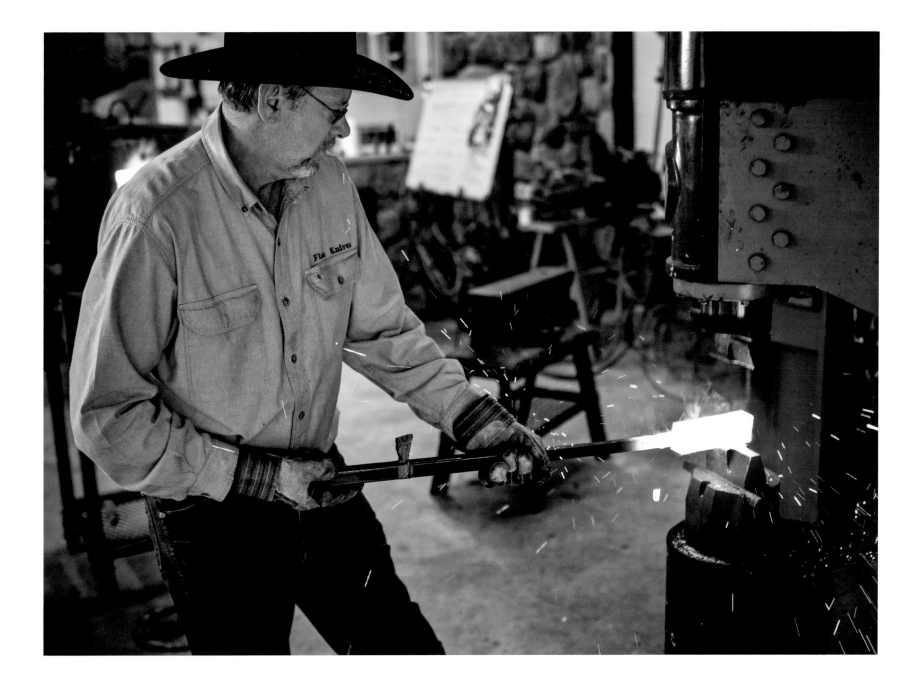

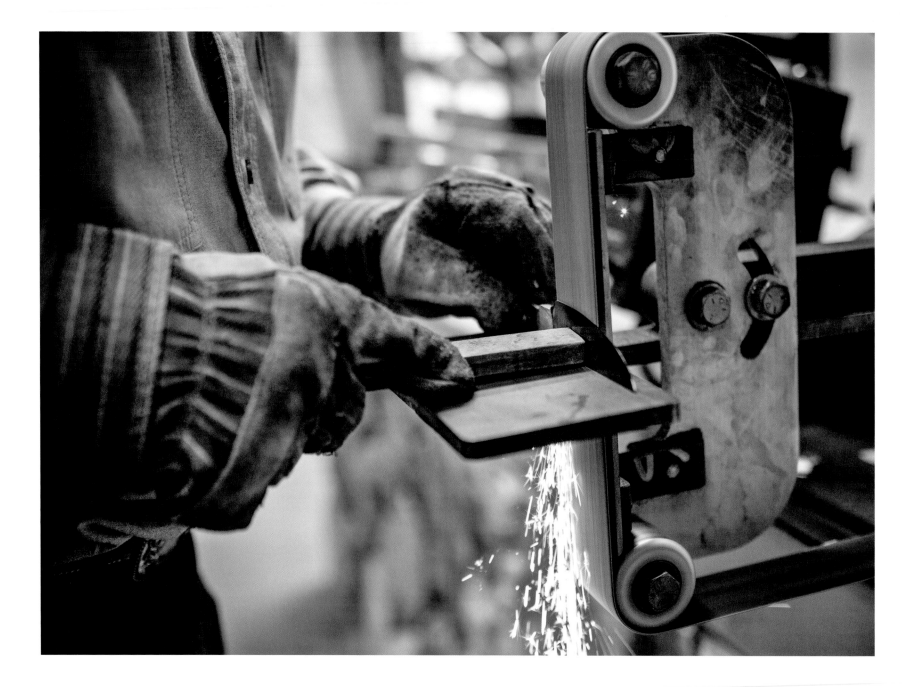

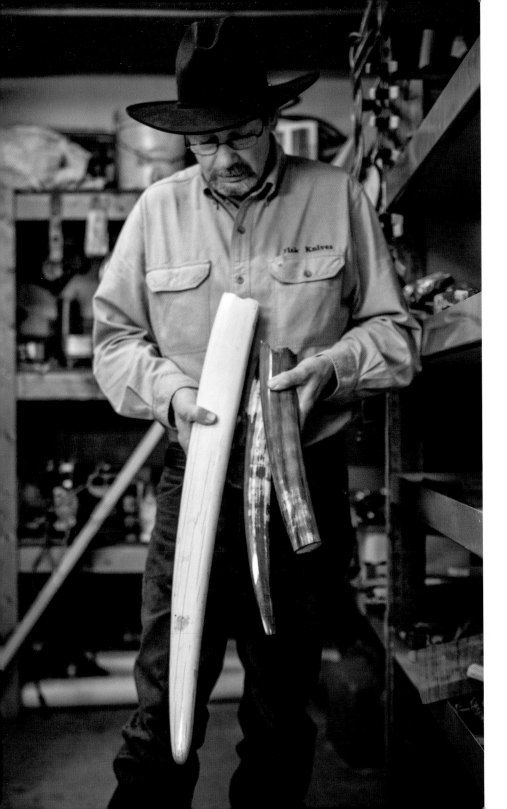

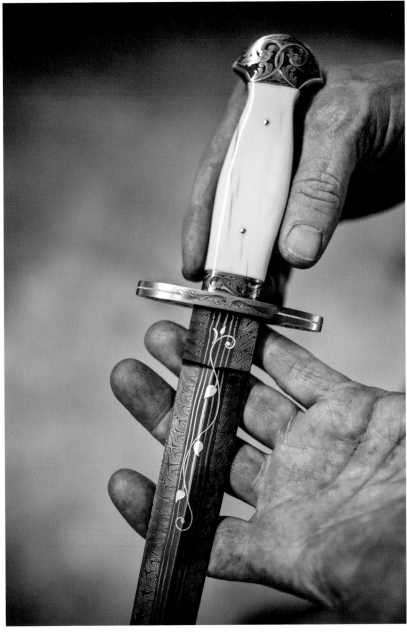

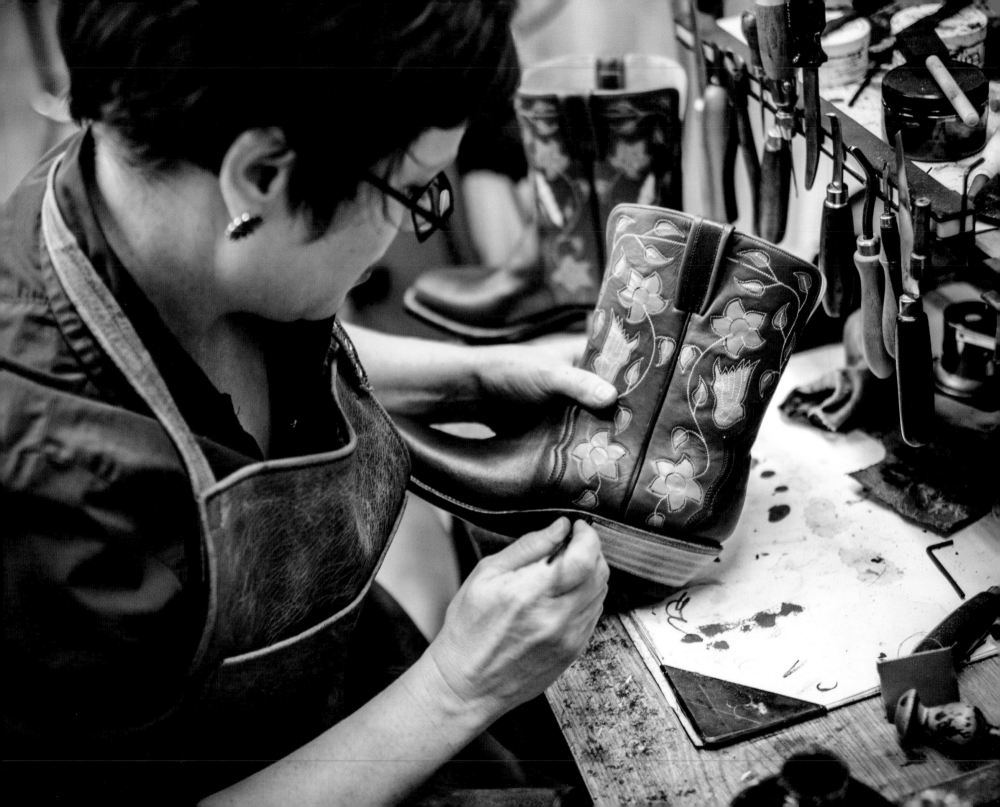

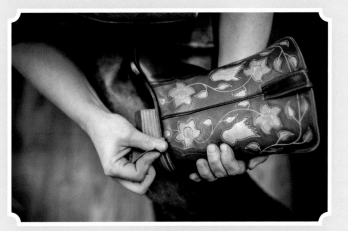

SORRELL CUSTOM BOOTS

GUTHRIE, OKLAHOMA

★

Lisa Sorrell spent decades becoming an overnight success.

From the age of fifteen, Sorrell sewed for women in her small Missouri church. She got married, moved to Oklahoma, and took up boot making as an apprentice. Then in 1996, when she was two months pregnant, she opened her own shop. Three years later she was featured in the influential book *The Art of the Boot,* which gave her and her boots some unexpected fame.

Sorrell could make any and all styles of men's and women's boots. But because of the book, she would

become most known for her intricately stitched works.

"It helped my career take off," Sorrell says. "It was the first thing that made me realize I could define myself, because after it came out, everyone wanted the boots they featured in it: the fancy, intricate designs."

Sorrell recognizes the value of the serendipity that led to her current success. "I wasn't raised cowboy at all," she says. "I'd never worn boots. What attracted me was *the craft*. And that I could sew, create designs, hammer, and make things for both men and women." In her church, Sorrell says, "Girls did girl things, boys did boy things. I didn't like that."

Now the process is the same for men and women. She meets and measures all her customers, asks them what they're looking for, and takes inspiration from what they say.

Then she begins the process by creating a wooden "last"—a form of the customer's foot. ("The last is first," as boot makers say.) Once the last is fit, Sorrell draws her pattern on poster board so she has the exact size and dimensions that the leather needs to be.

After the leather is cut, she can do decorative work on the boot's tops. She'll shape the vamp (the part that covers the foot)—crimp, stretch, and fight with it as needed. The rest of the boot's leather requires only gentle folding before the parts are sewn together and the sole and heel are added.

Sorrell has slowed down her production in recent years, as the practice has taken a toll on her hands. "When I first started, it was all about getting it done,

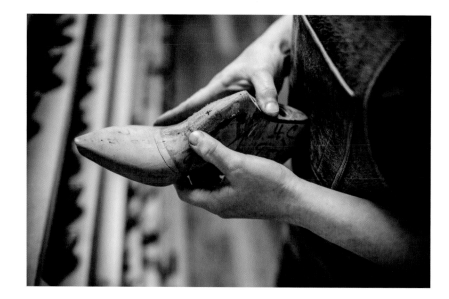

getting a paycheck," she says. "Now I'm trying to slow down and enjoy the craft, and put that passion and love into my work now."

When she first got into boot making, she says, it was the art that spoke most clearly to her. But at the time it was not appropriate to speak of such real-world poetry. Now she feels more confident and has no problem talking about the less-than-practical aspects of her life and work.

Like how she fell in love with the sound of an American straight-needle machine the first time she heard it hum and clack. Like how the sound her shop's machines make soothes her daughter, who heard those sounds in the womb, long before Lisa Sorrell was famous for her intricately stitched boots—years before she became an overnight success.

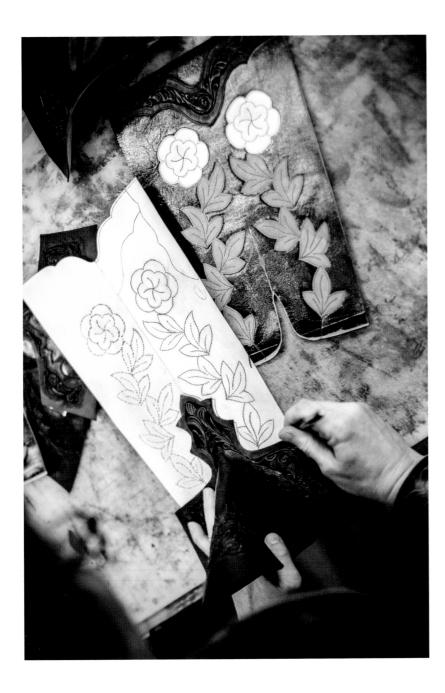
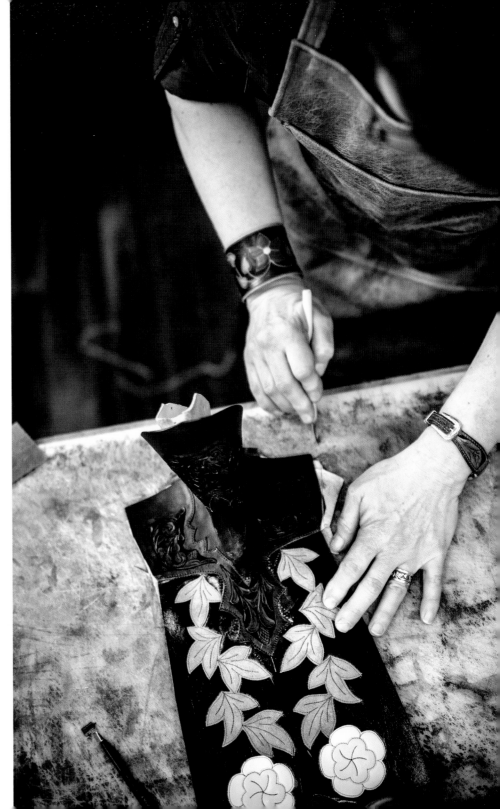

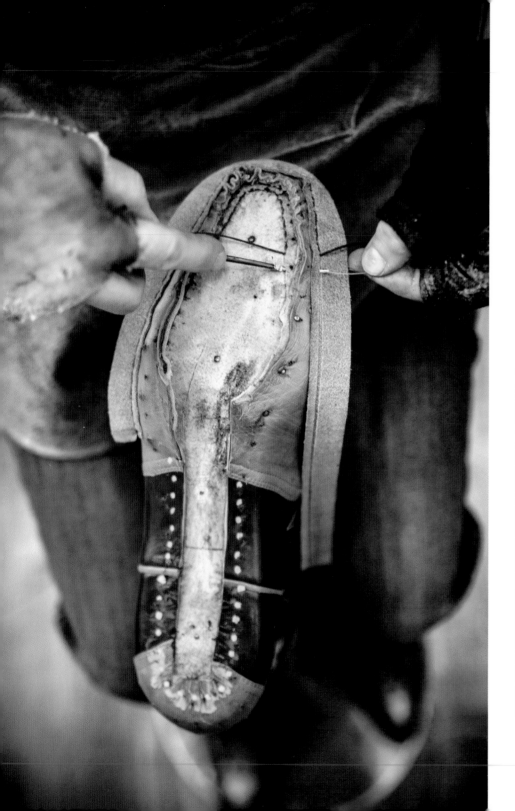
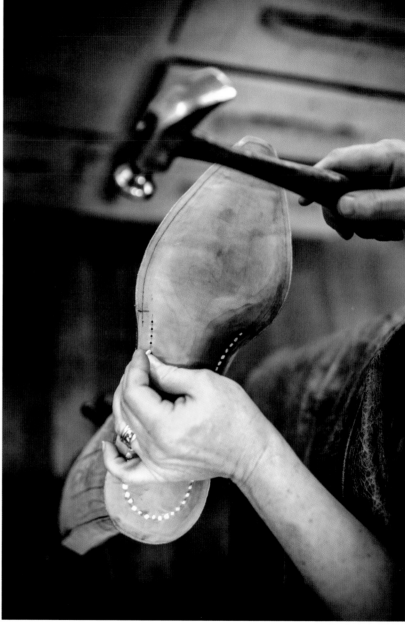

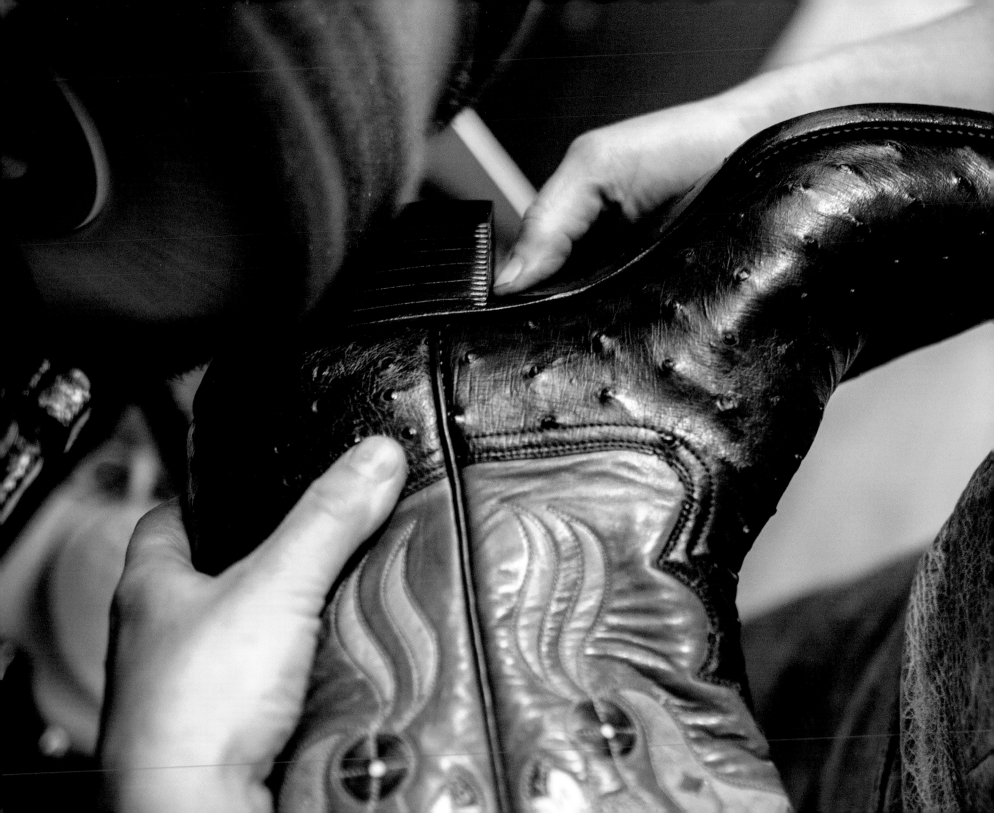

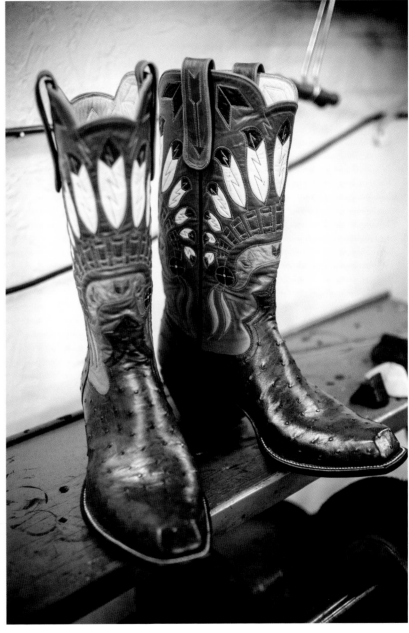

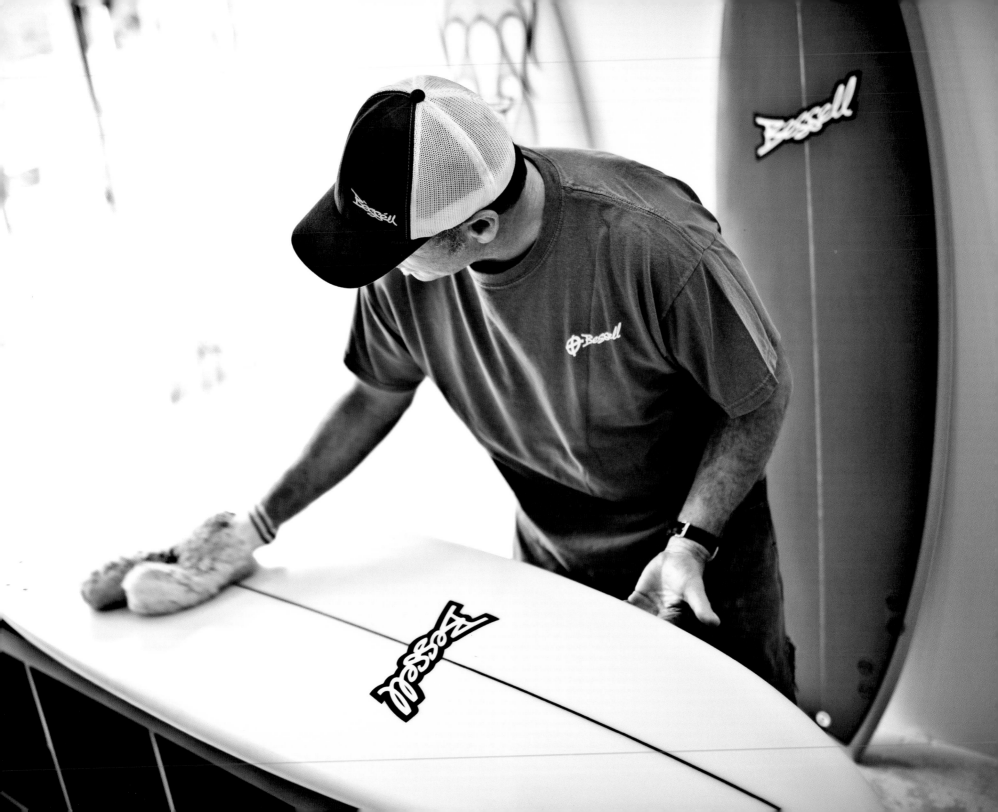

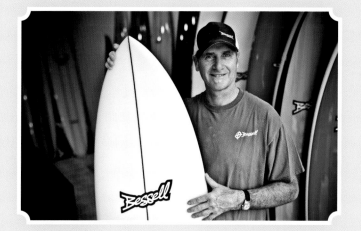

BESSELL SURFBOARDS

LA JOLLA, CALIFORNIA

★

Tim Bessell immerses himself in his work. Right now, that's a literal statement.

"I was just shaping an eight-foot gun," says Bessell, covered in sawdust. "Give me a second to clean off!"

By "gun" he means one of the five styles of surfboards Bessell makes (also: longboard, high-performance shortboard, funboard or paddleboard, and fish-shaped). After a long, thorough air-hose spraying, Bessell is ready to proselytize, eager to

convert any and all to the benefits of creating and surfing with "the best boards in the world."

"I shape and surf every day," Bessell says. "The [mass-production] technology now has taken away the craftsmanship. I make functional art. I believe functional art is better because of the energy and soul you put into the board. Your love comes through, and the standards you set for yourself are higher. And that positive energy will transcend to the surfer."

Bessell began surfing at age nine, and he quickly fell in love with not just the sport but also the tools. He loved everything about surfboards except their weight. Forty years ago the boards were usually more than fifty pounds, and carrying one was difficult for a "scrawny kid."

He knew he wanted to make his own custom board, one that even a kid could carry. On his thirteenth birthday his brother gave him a longboard "plank" (the stripped-down beginning of what is then shaped into a custom board). He shaped it himself—and a lifelong career was born.

Bessell is largely self-taught, but he had a willing mentor in his grandfather, an aerospace design engineer for Boeing. Bessell would spend the summers with his grandfather—using his drafting table to design, learning about woodworking in his basement, asking questions about the value of composite materials.

Soon after, he got his first job in a surfboard factory, learning to shape and resin boards. It gave him invaluable experience. He learned the three basic phases of crafting a board: design (imagining the final product), roughing (taking the saws and planes and sanders to the plank), and refinement (measuring, fine sanding, wrapping it in resin).

Bessell says now that he didn't learn as much as he thought he did.

"When I had done my first five hundred boards, I thought I was the king. I thought I knew everything," Bessell says. "But by the time I'd done five thousand boards, I realized I didn't know anything. Then I got to ten thousand, and I got more introspective. I realized I *really* didn't know anything. It takes forever. It wasn't until I made thirty thousand surfboards that I felt I really knew how to make a great board." Bessell now makes one or two a day as he approaches his fifty thousandth board.

"Right now the only goal is to make the best surfboards in the world," Bessell says. The industry has become more mass-produced, which has only set in greater relief the quality and craftsmanship he brings to the discerning surfer.

"Surfing is a sport. And as in every other sport, the elite athletes, 100 percent of them, demand the best custom-made equipment. There's a reason for that."

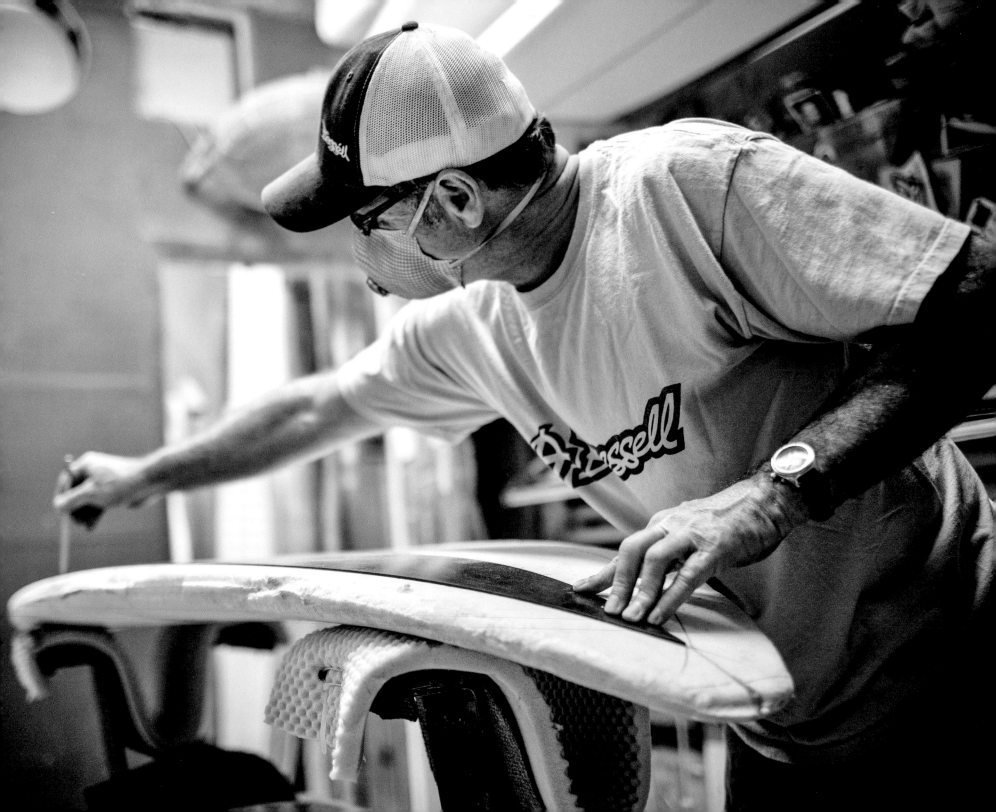

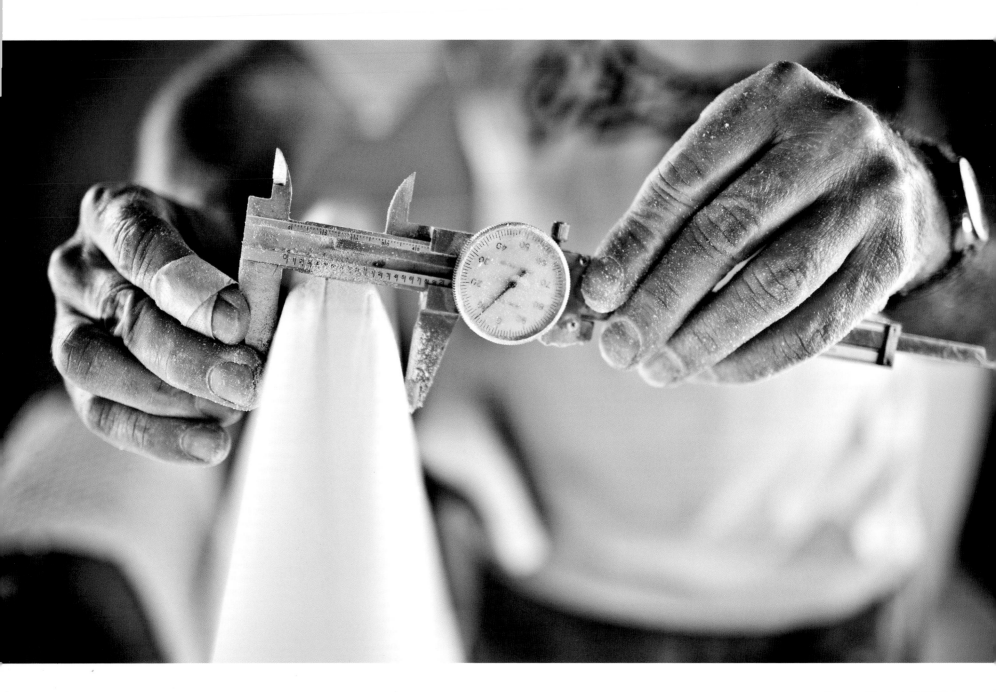

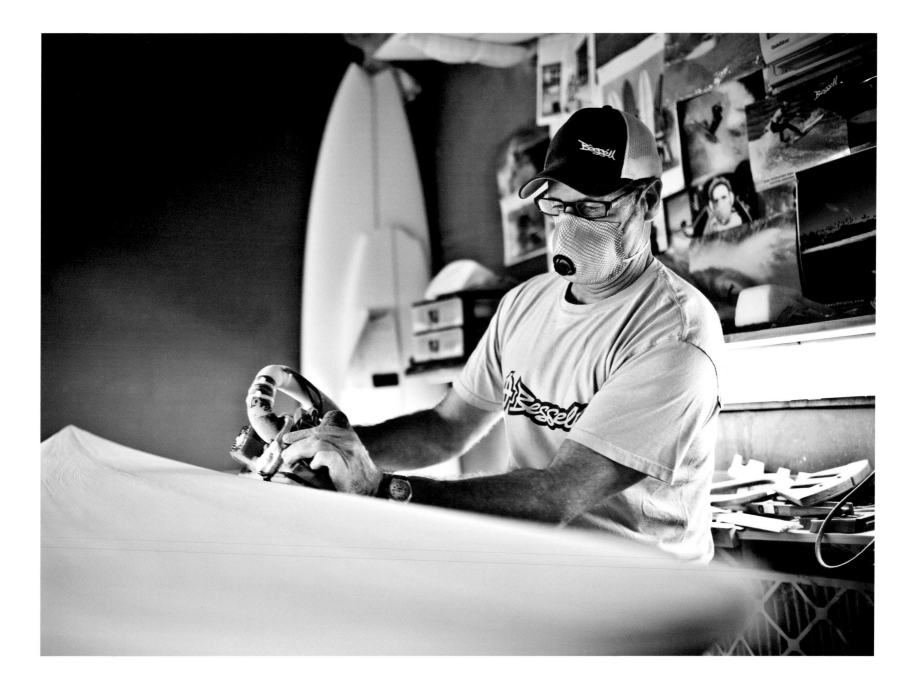

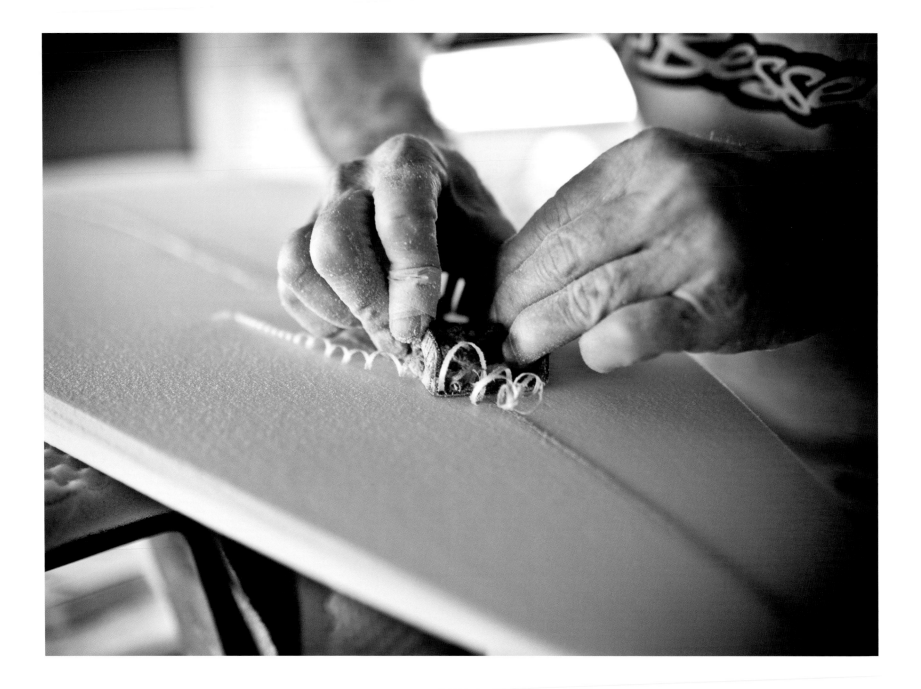

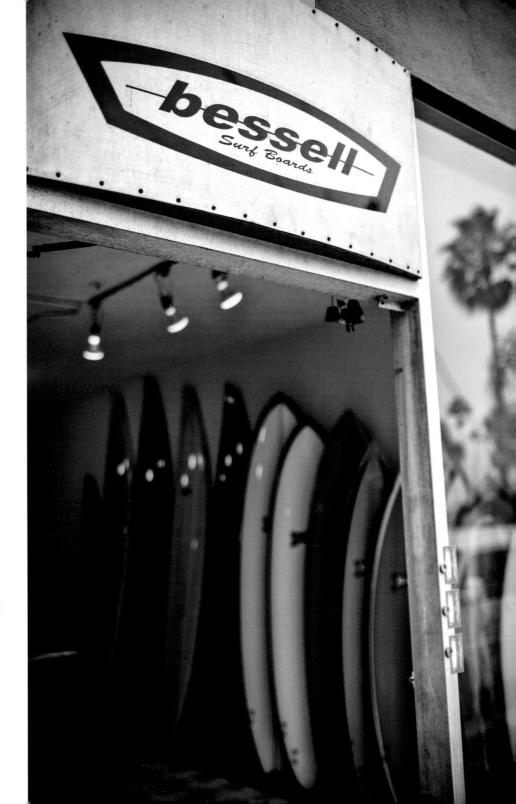

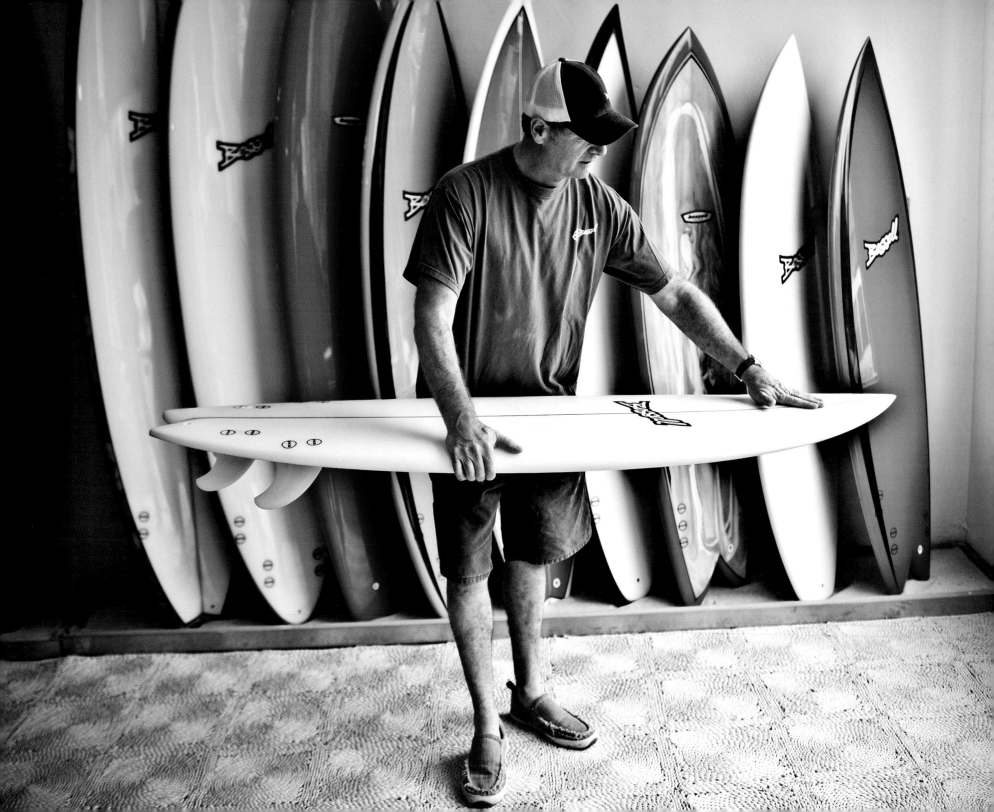

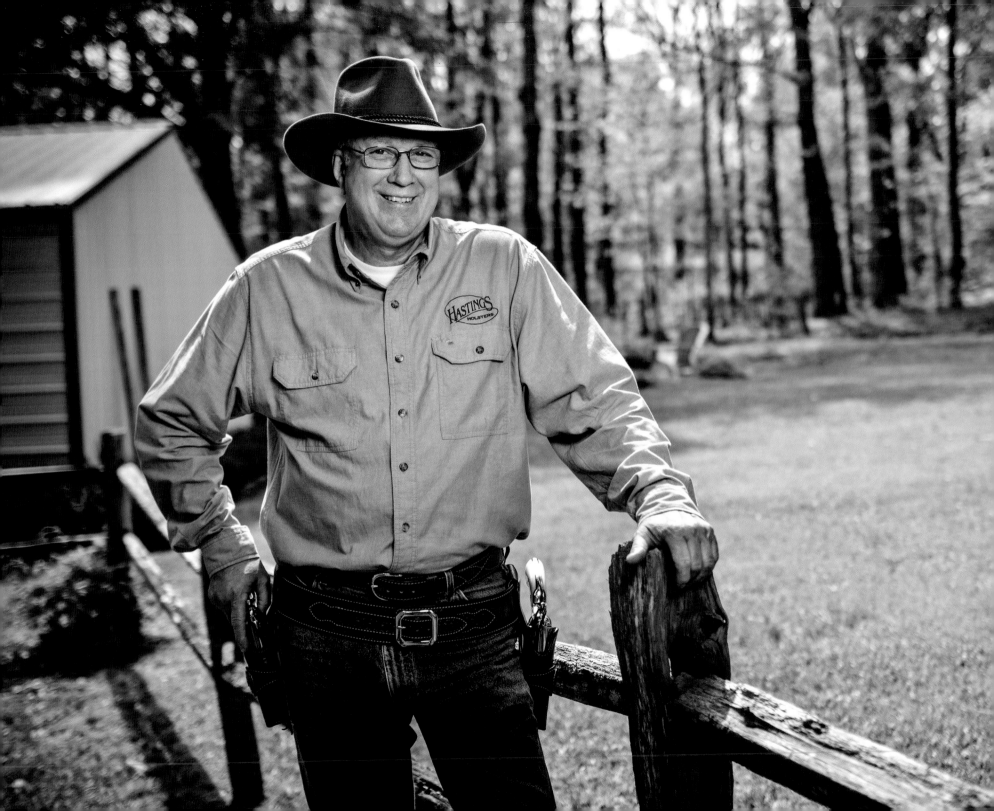

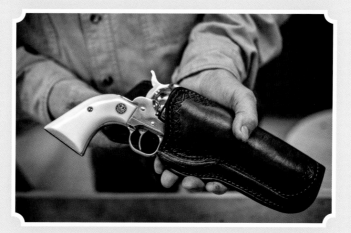

HASTINGS HOLSTERS

CORINTH, MISSISSIPPI

* * * ★ * * *

Like a lot of kids who grew up in the 1950s and 1960s, Jim Hastings loved Westerns. But instead of trying to fashion a Lone Ranger mask or find a vest like Nick and Heath wore on *The Big Valley*, Hastings says he wanted "one of those good-looking gun belts like they all wore." He especially loved the particular style of holster worn by his idol, John Wayne. It rode high, and would work well for a young man like Hastings, who liked to hunt deer.

But you couldn't find Old West–style holsters and gun belts very easily back then. So Hastings made his own. "People would see me wearing one, and they'd say, 'Where did you get that? What will you charge

to make me one?' And just like that, I started making holsters and gun belts."

It was a poor-paying hobby until about two decades ago, when two things happened: First, he started finding a better source of leather, which dramatically improved the holsters. The second was the cowboy action shooting (CAS) craze that swept through America. Largely because of that, Hastings's small business grew, and now he's one of the best-known holster makers in the country.

Up to five hundred shooters may descend on a CAS event. They'll flock to Hastings, who will be fitting people for gun belts or discussing the finer points of holster design. Many seek out Hastings for a custom holster because of his ability to make something aesthetically pleasing that is still responsive to the needs of a serious CAS shooter.

Many aren't sure exactly what style they want, so Hastings has models they can try on. Once the customers are fit and measured and they've chosen their model, Hastings goes over other details: what color, whether they want a border stamp or a floral carving on the leather, or maybe a knife sheath or pouch for cartridges.

Then he gets to work. He buys cowhide by the side (about four-by-eight-foot sections). He cuts the pattern from the leather, dyes it the appropriate color (he makes his own dyes), and stitches it together using a heavy machine that can sew through three-quarters inch of leather. He works on the belt in the same manner, attaching cartridge loops or other items as needed.

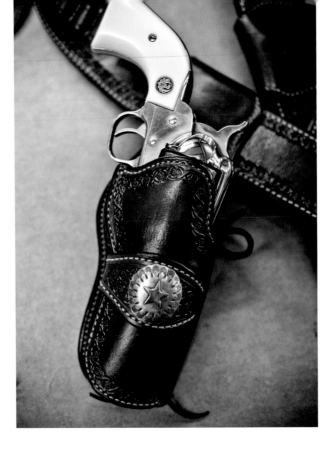

He then "wet molds" the holster by submerging it in water, the gun (wrapped in cellophane) in place. After removing it from the water, he takes the gun out and allows the leather to dry in the shape of the gun that it will house. While the holster dries, he sews the belt together, rounds its edges, attaches the buckle, and then does any stamping or trim work still needed.

It takes Hastings about a week to make two holsters and a belt, before he ships them to his customers. He doesn't yet ship out of the country, although the demand is certainly there.

"I get a lot of interest from all over the world," he says. "You'd be surprised how many people in Russia and South America are interested in cowboy things."

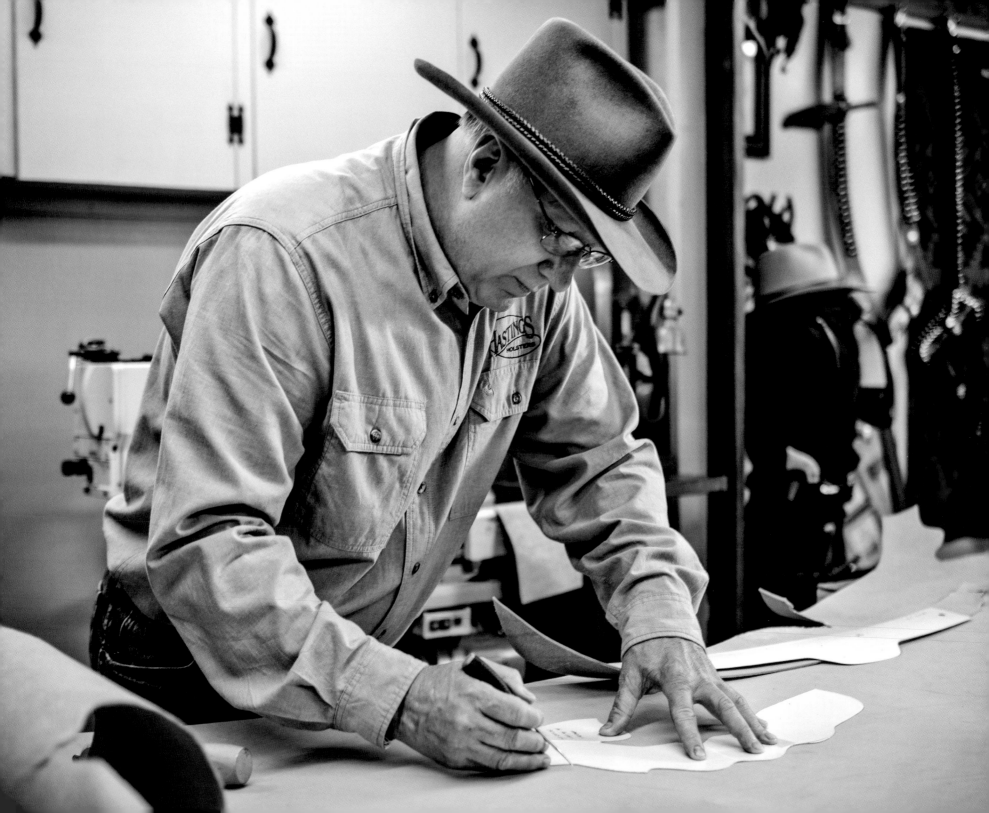

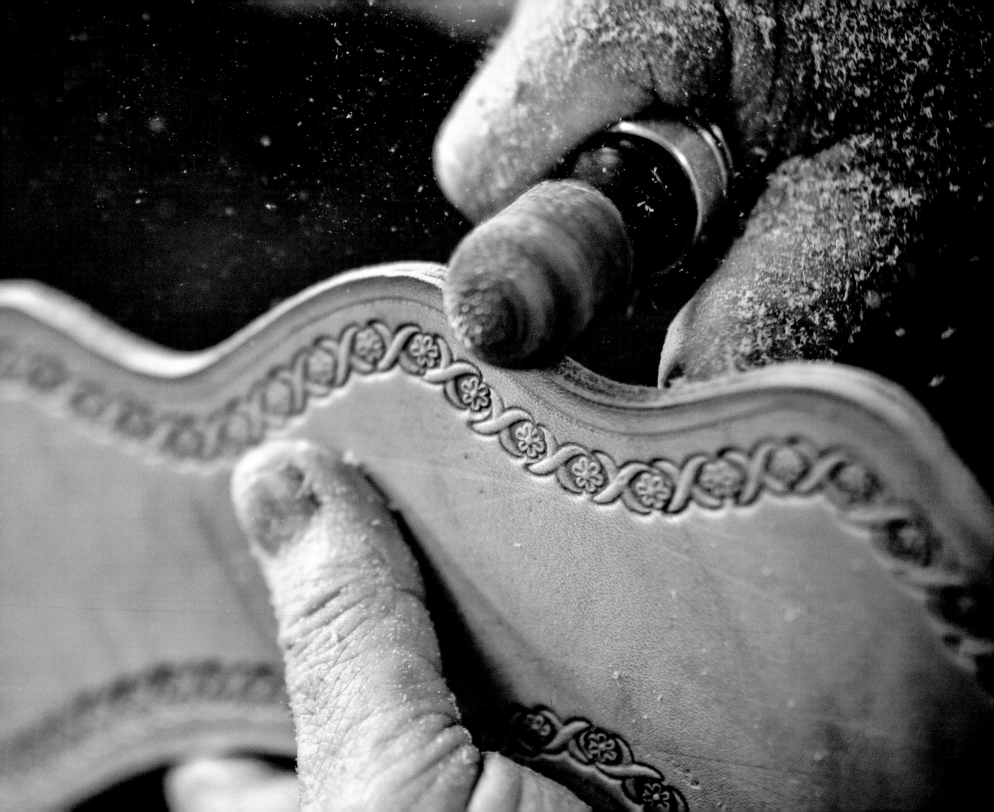

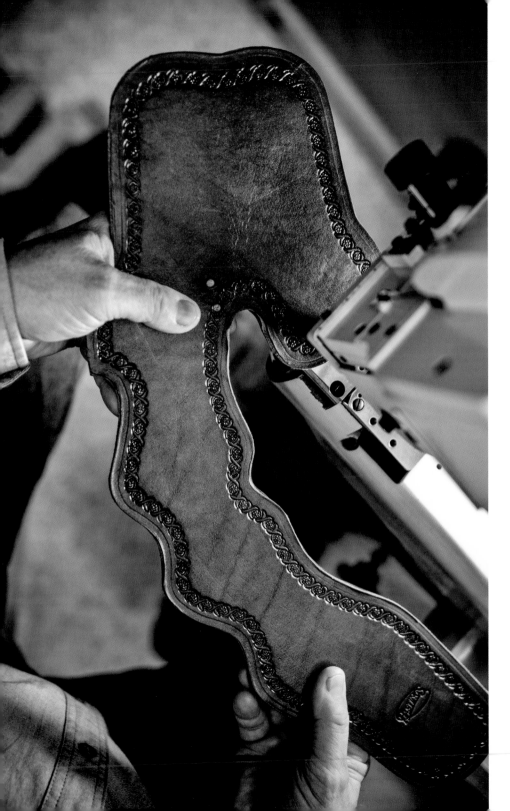
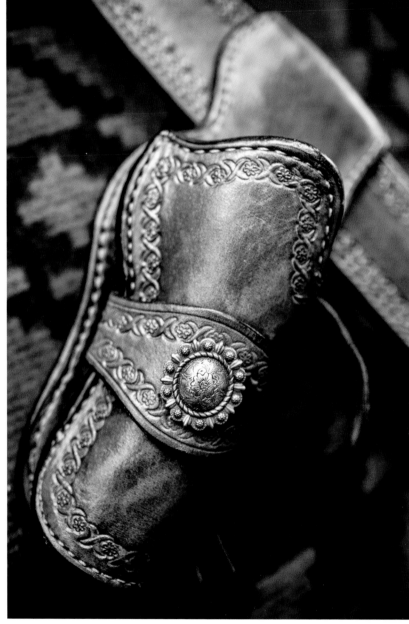

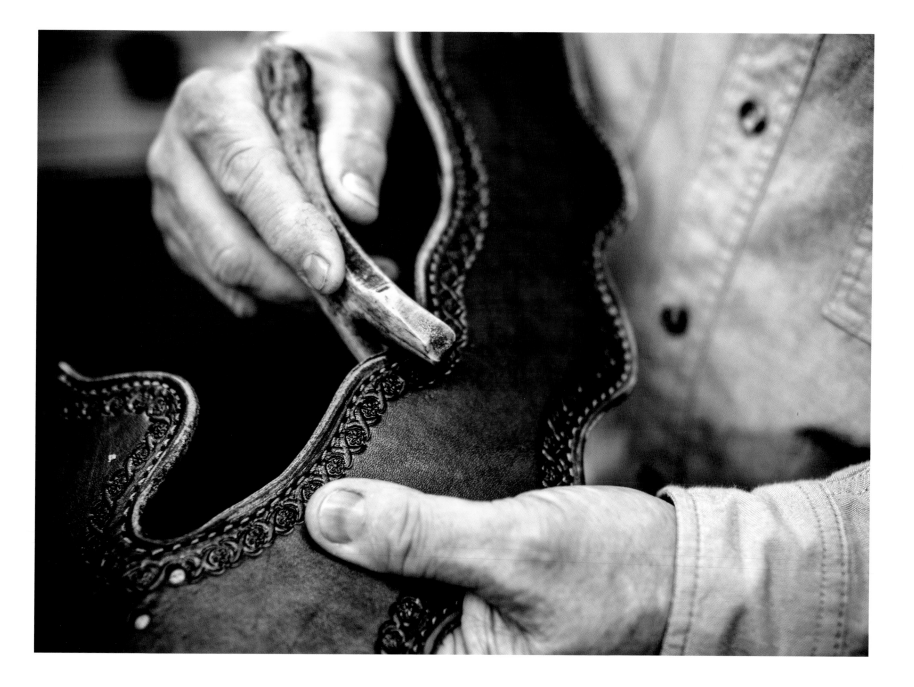

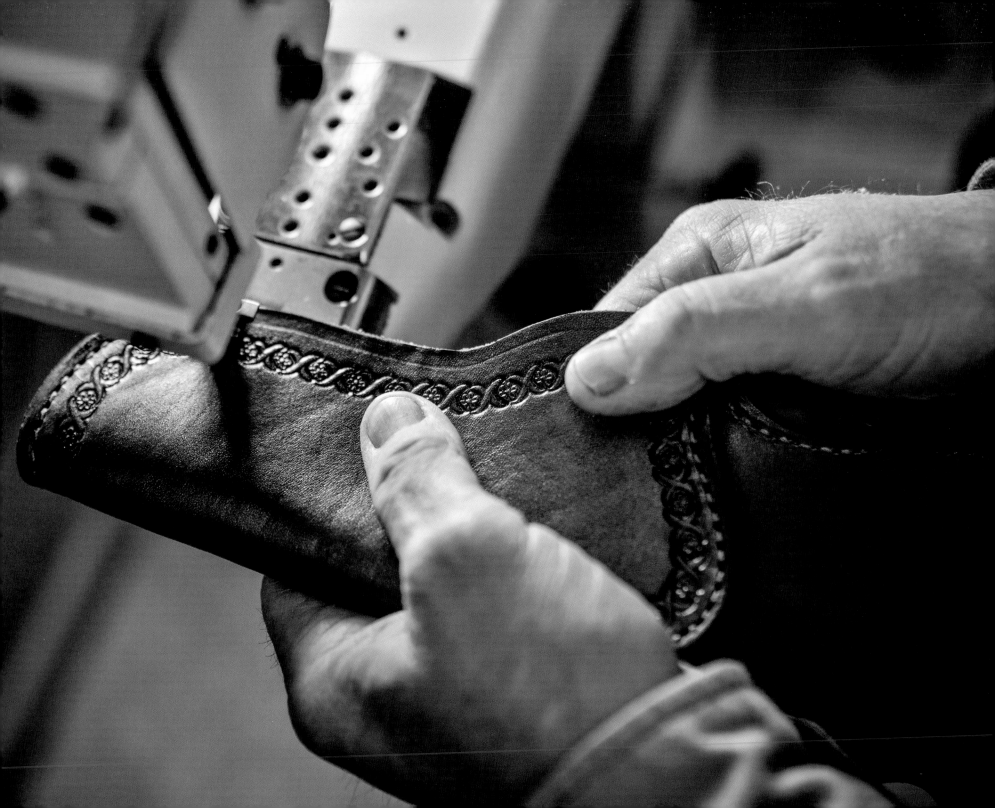

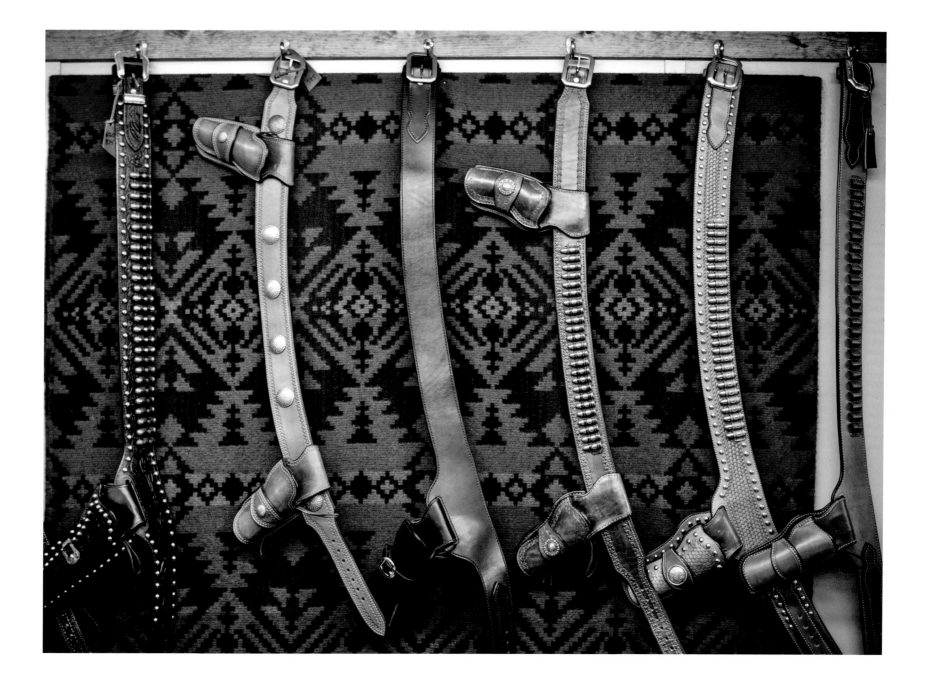

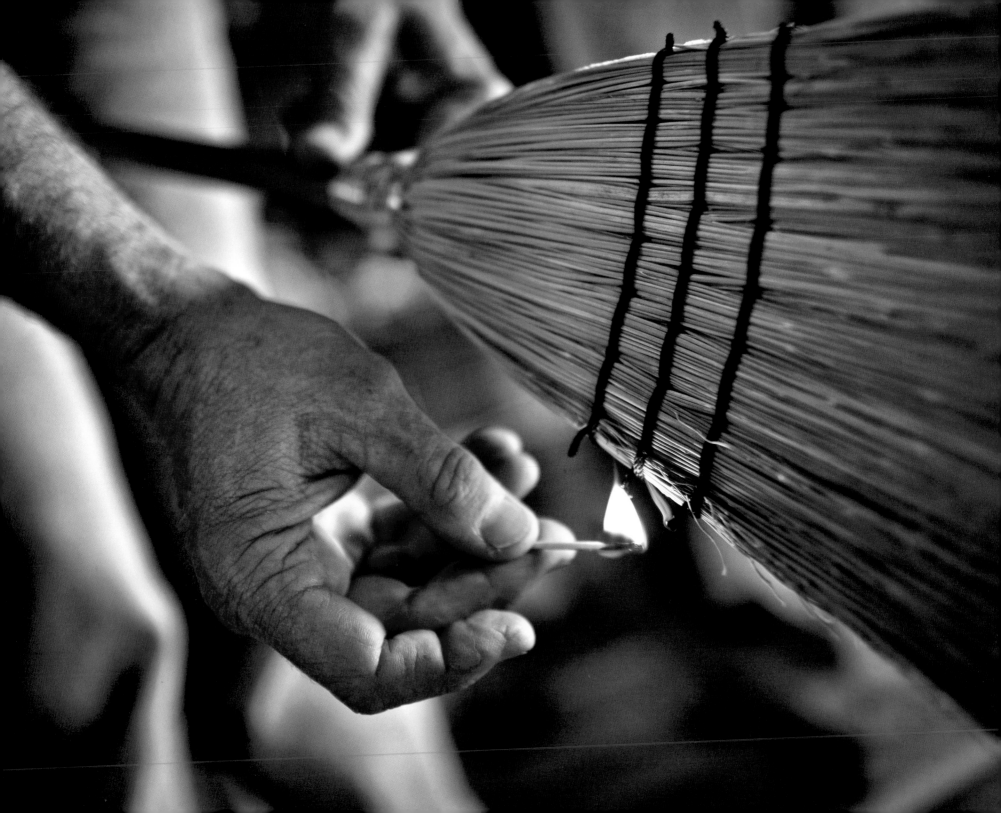

HENSON BROOM SHOP

SYMSONIA, KENTUCKY

·· ★ ··

Richard Henson remembers well the last words his grandfather spoke to him. It was Thanksgiving 1981, a few days before Rollie "Bootsie" Henson would pass. Rollie had opened a broom-making business during the Great Depression, and he and Richard's father had been making brooms ever since.

Richard had taken a different route with his life. He was a principal and basketball coach nearby, a former athlete and educator not interested in taking over

the family business. Then his grandfather spoke those final words to him.

"He simply told me, 'If you were to learn how to make a broom, you'll always have a job,'" Richard Henson says. "And I knew that's what I needed to do."

Seven years later Richard Henson took over the family business, and today he makes brooms every day, often in front of admiring tourists who step off the buses that make stops at Henson Broom Shop and General Store—folks who come to see one of the last master broom craftsmen at work.

Henson says that as soon as he stitched his first broomcorn, "I *instantly* knew this was for me. I had the hands for it, the skill and imagination that's needed. And being a coach and an athlete, I had the competitive zeal to excel. I knew exactly that this was my calling."

Henson still uses the tools his grandfather used more than eight decades ago. Although he makes

twelve types of brooms, the process is similar on most of them. First he gets his broomcorn "in order." (Broomcorn is a tough annual grass in the sorghum family; the part that you see on a broom is the long, fibrous panicle of the plant.) "In order" means he dampens it slightly by taking a bunch in his hand like spaghetti, dipping it in a barrel of water, and letting it drip partially dry.

Assuming someone wants the broomcorn to remain "natural" in color (Henson also can dye it black or brown), he begins attaching it to the handle—which itself is stuck in a vise so that it's parallel to the ground and easy to work on. He sticks a wire through the hole at the handle's lower end, ties it on, and proceeds to stitch, sew, and tie the broomcorn as needed.

The handle is either pre-cut, or—if someone has ordered a twisted handle, like the ones Henson used to make for the TV show *Dr. Quinn, Medicine Woman*—Henson has already cut, shaved, sanded, and finished the handle to its final knotty look. The entire process takes between fifteen and forty-five minutes, about the time it takes for a tourist to finish a Moon Pie, a bag of peanuts, and an RC cola from the general store next door.

"We have a lot of folks who come from all over the world to see our brooms," Henson says. "They've seen me on TV or in magazines, or talking about it onstage. They see the joy I've found in the work. They don't see the hard work and sacrifice behind it. But that's okay. They still get a great broom."

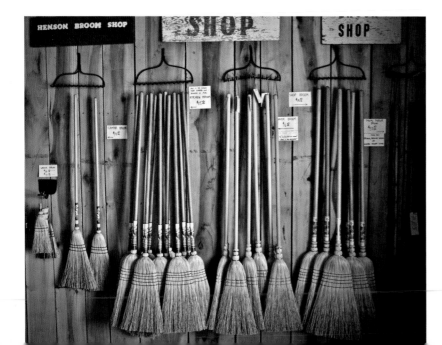

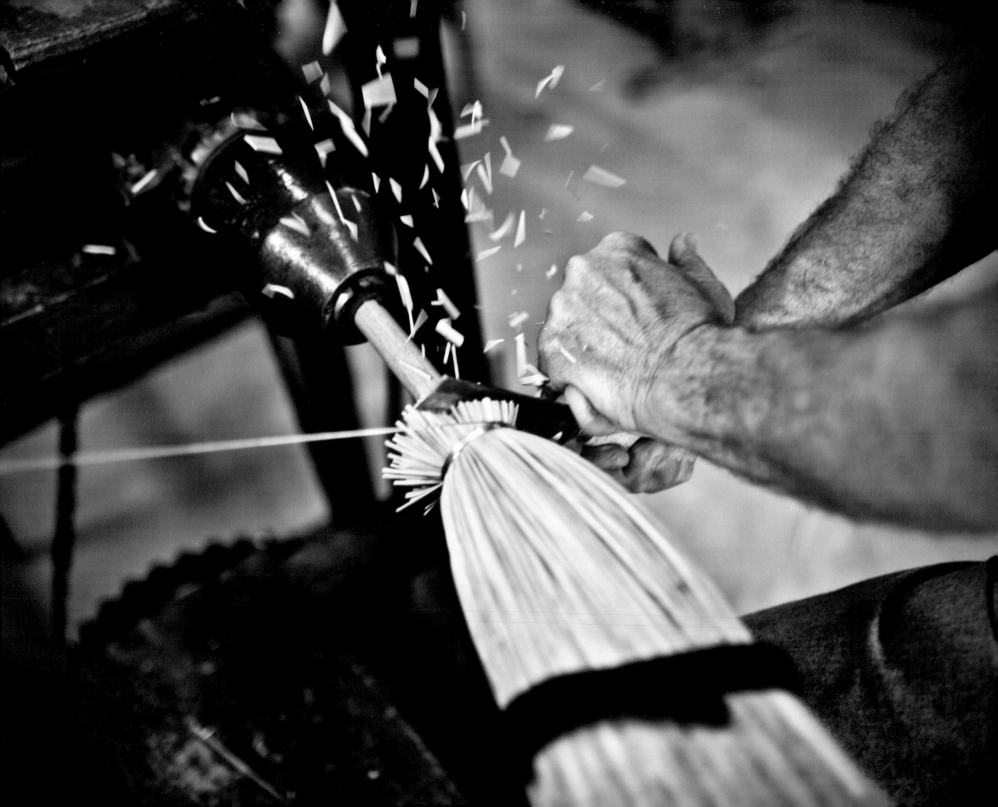

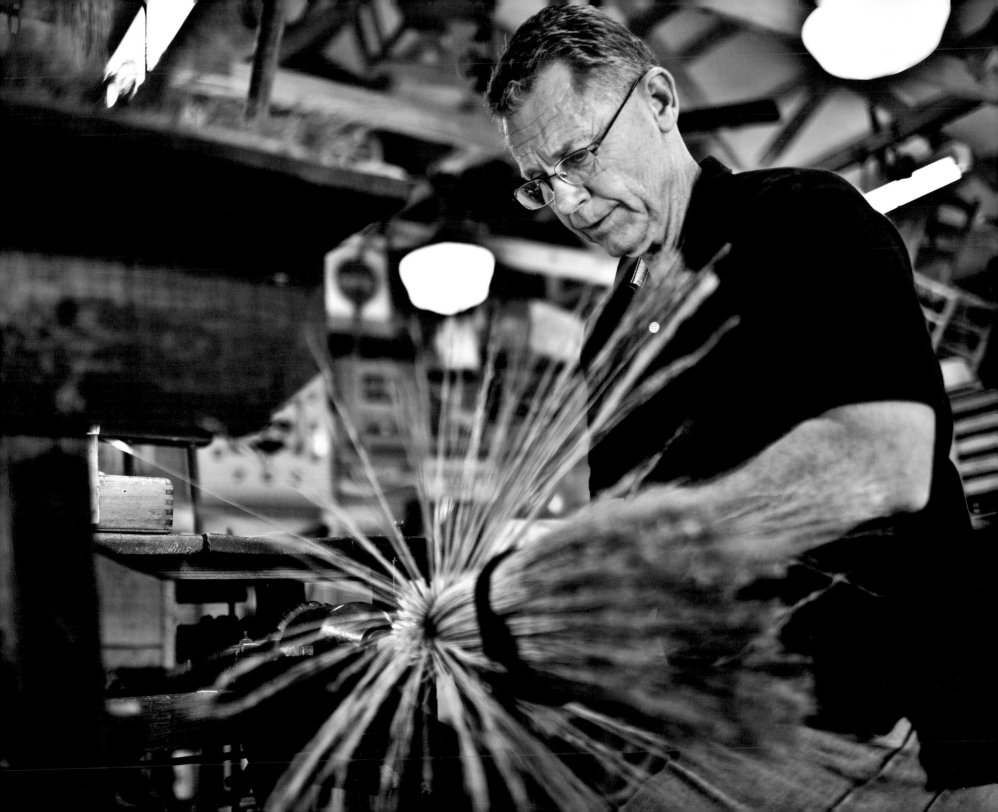

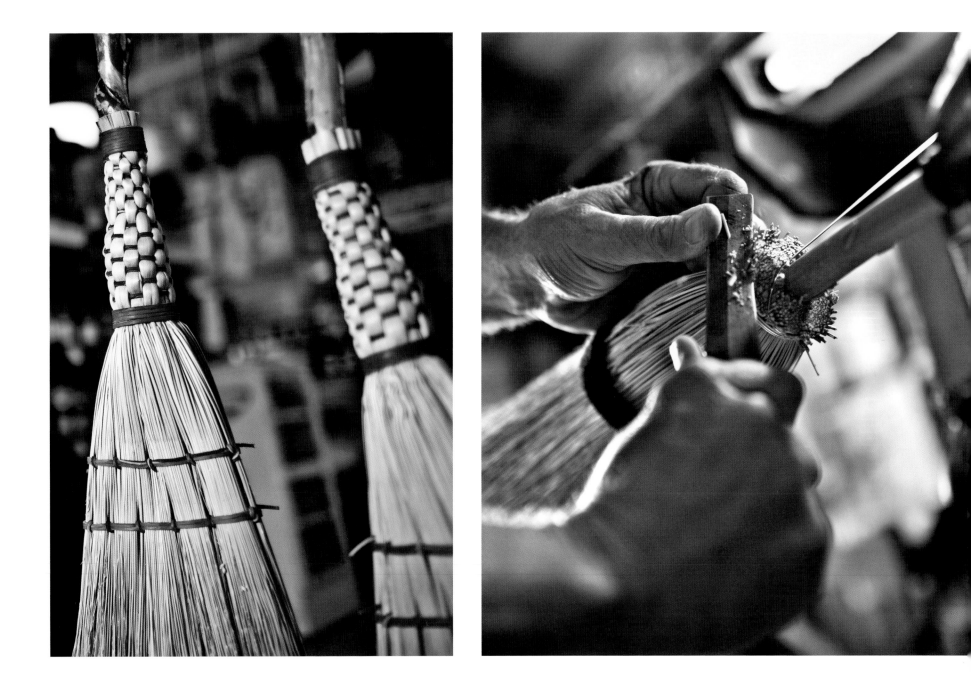

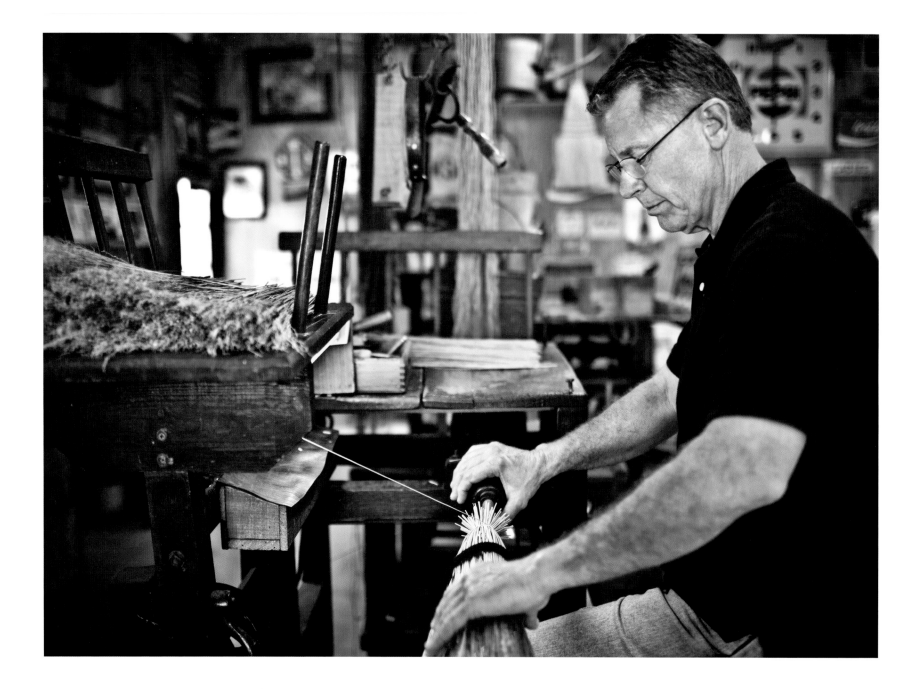

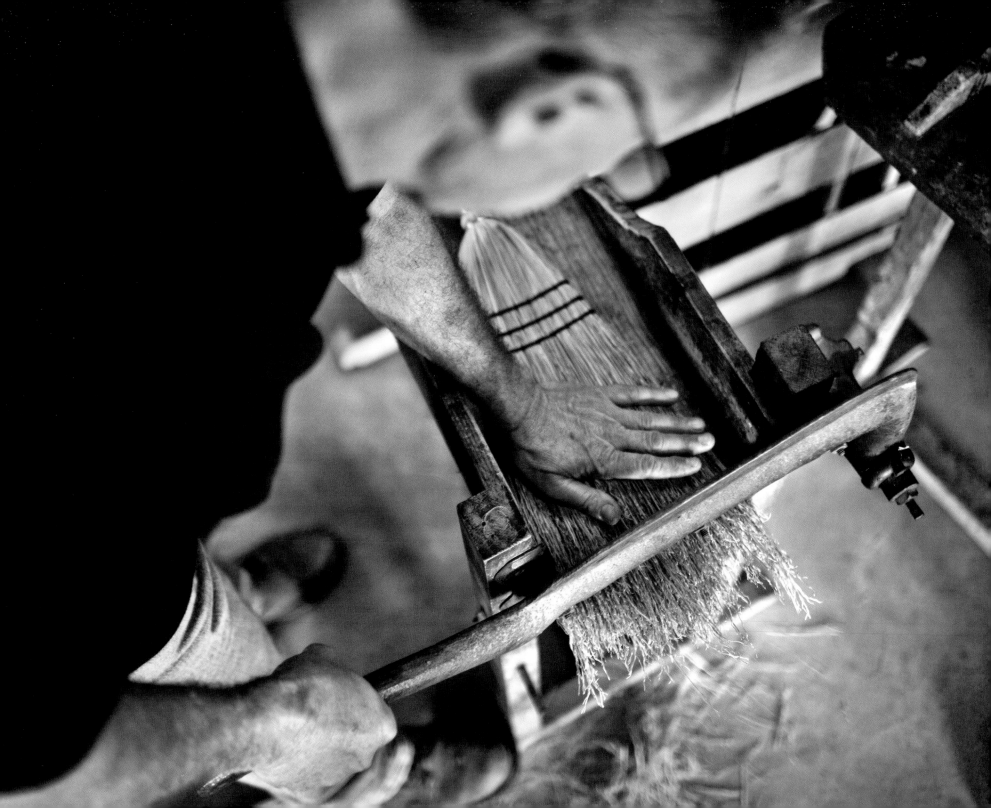

MAPLE LANDMARK WOODCRAFT

MIDDLEBURY, VERMONT

......................... ★

The regulars who frequented the Rainvilles' general store in Lincoln, Vermont, knew young Mike's story. His parents had given him a corner to sell the small toys and knickknacks he built after school.

In junior high, bored and restless, Mike was given a block of wood by his mother and told to make a cribbage board. He took to the work quickly, fashioning it using only a coping saw, a hand drill, and a sanding block. His grandparents, who owned a maple

syrup farm, helped him buy more tools to fashion wooden cars and toys, shadow boxes, even bobbin and spool holders for the town's seamstresses.

The one person who *didn't* know young Mike Rainville's story was the traveling salesman who, upon examining the teenager's handcrafted collection, announced he'd be happy to sell the toys to his retail customers. Like that, the seeds of a three-decade business were planted. Now Maple Landmark Woodcraft employs forty people and makes more than a thousand toys and knickknacks—everything from blocks, trains, and yo-yos to games, puzzles, and bookends, sold in more than two thousand stores across the United States.

Even as a young man, Mike Rainville was establishing patterns that would carry him through the future. Decades before the term "buy local" became fashionable, he was not only using the wood from nearby forests but also taking pride in producing the work from his hometown. He wood-burned "Lincoln, Vermont" along with his initials on early pieces; today "Made in Vermont" runs across his company's logo.

"Even early on, I would try to figure out what would be the best way to make not just one cribbage board, but twelve cribbage boards," he says. "Then quickly try to figure out how to best make twelve dozen." His first solution: hire family. Not only were his father and grandfather carpenters, but working with loved ones also seemed the best way to achieve a life balance.

Today Mike's wife, mother, and grandmother work at Maple Landmark in Middlebury, Vermont. The company moved down the road from Lincoln because their space had to be big enough (sixteen thousand square feet) to not only produce the most popular products (chatterbox blocks, toy cars, etc.) but also the occasional special orders—like during the Cabbage Patch craze when a New York couple wanted a custom-made twin crib for their daughter's dolls.

Mike Rainville still gets his lumber locally. It doesn't matter to him that the maple is harder to work with than what he could find farther south. It's more important that he supports those nearby. "Customers want to know I'm buying it from here," he says. "It's an honest story."

That "honest wood" usually enters the prep department first, where it's cut to size, planed, and molded, depending on the project. It then goes to the cutting area, then to the sanding department. If it needs holes drilled, or slots put on for train tracks, this occurs before it hits the finish room. There the piece is sprayed, dipped, or silk-screened. Once the graphics department finishes any final engraving, cutting, or other decoration, the folks in assembling and packaging get the piece ready for shipping.

"We start with raw material in one door and finished product out the other. Making that in-between happen is the fun part," Rainville says. "In crafting toys we are making things that will live an active life, not collect dust somewhere."

In fact, you can still see some of the first toys he made, right on his bookshelf. "I didn't keep them," he says, laughing softly. "But I find 'em around town at garage sales now and then. And I always buy them when I do."

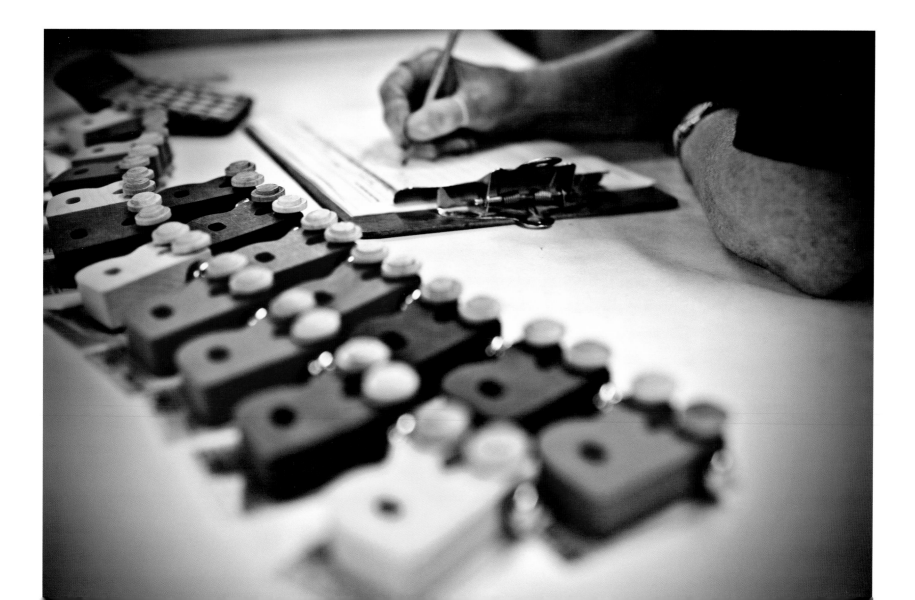

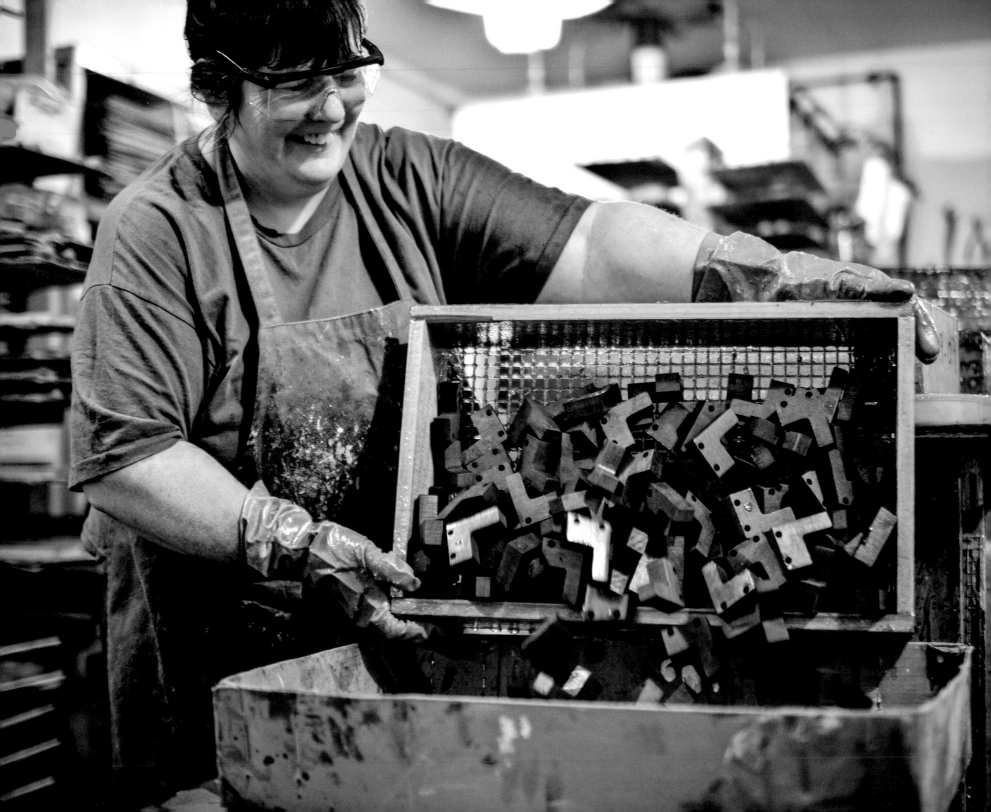

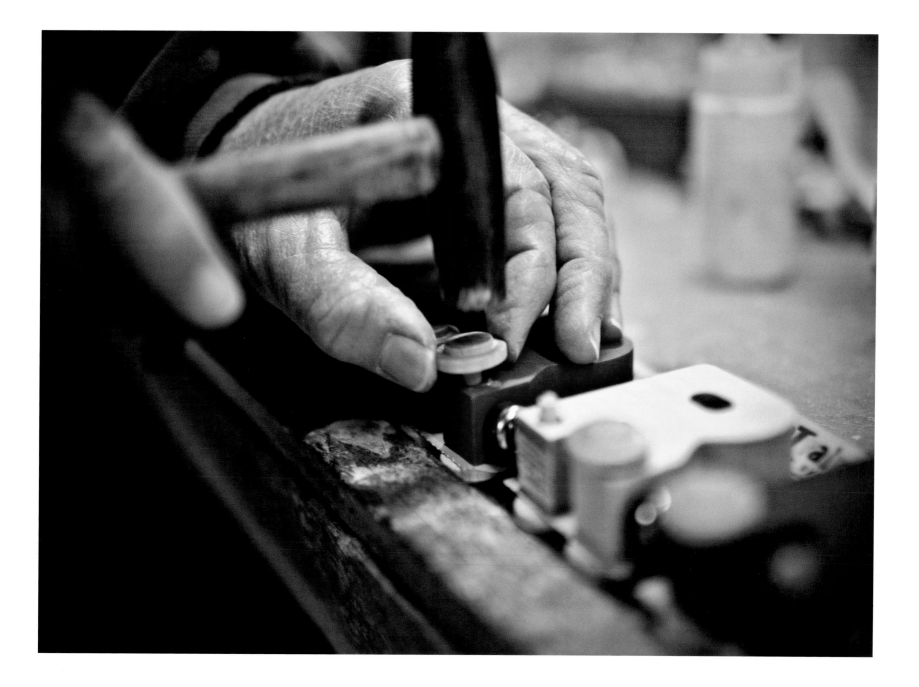

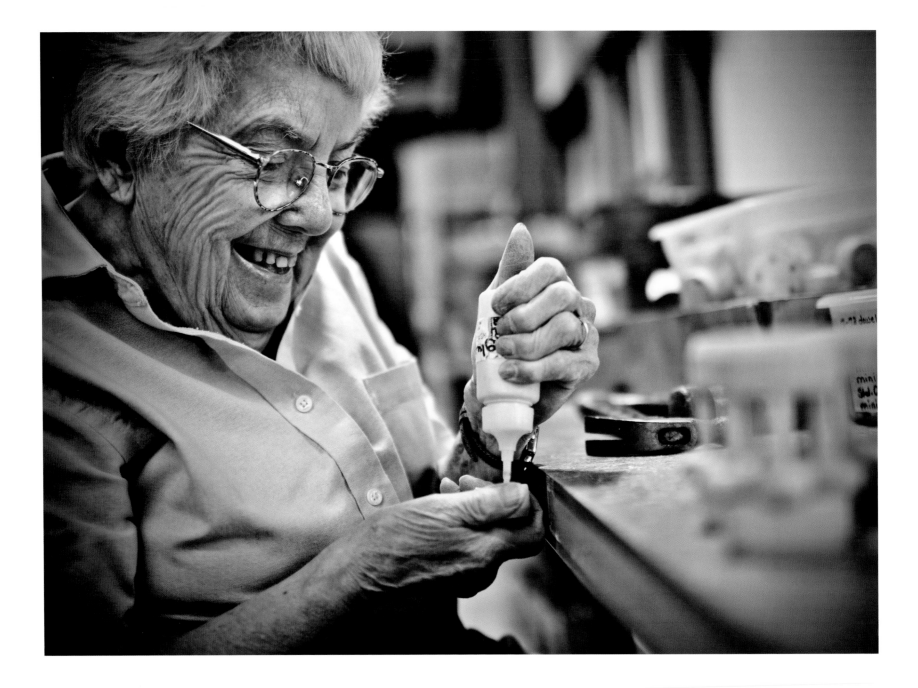

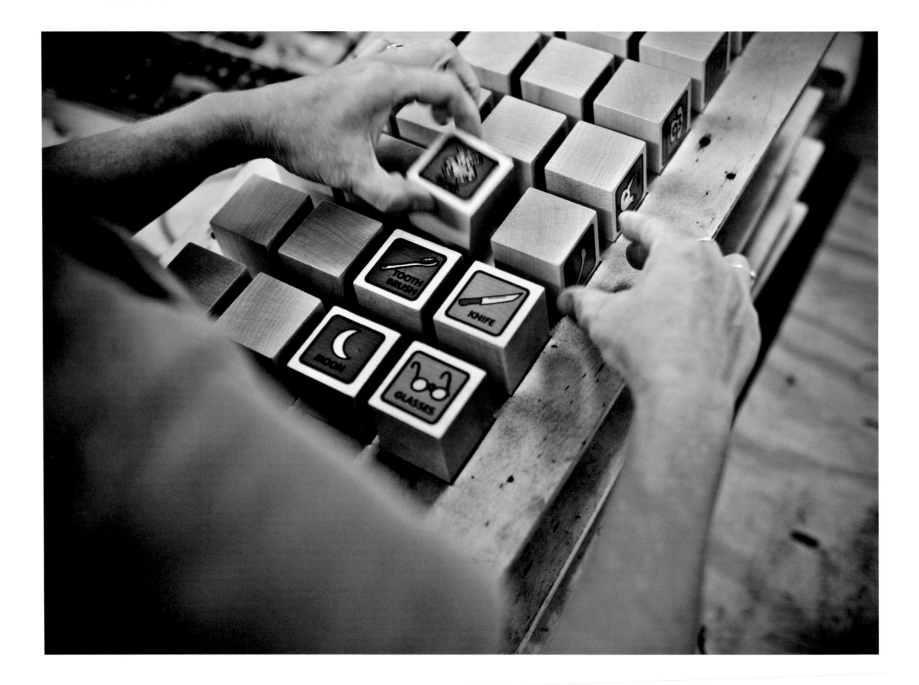

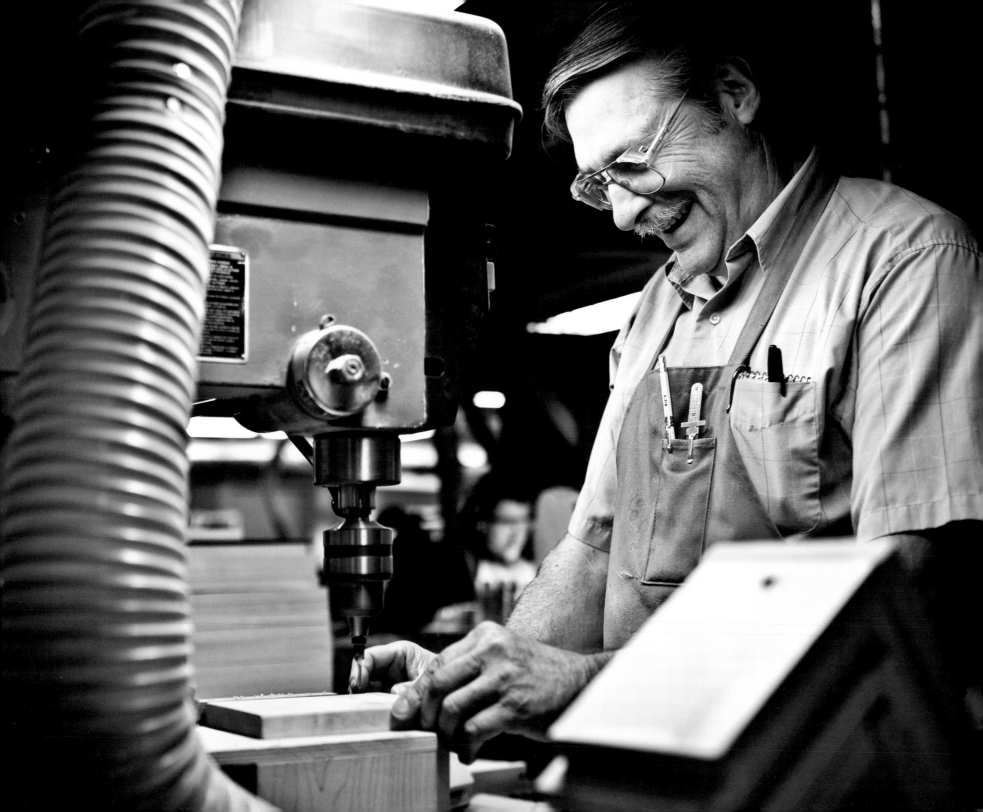

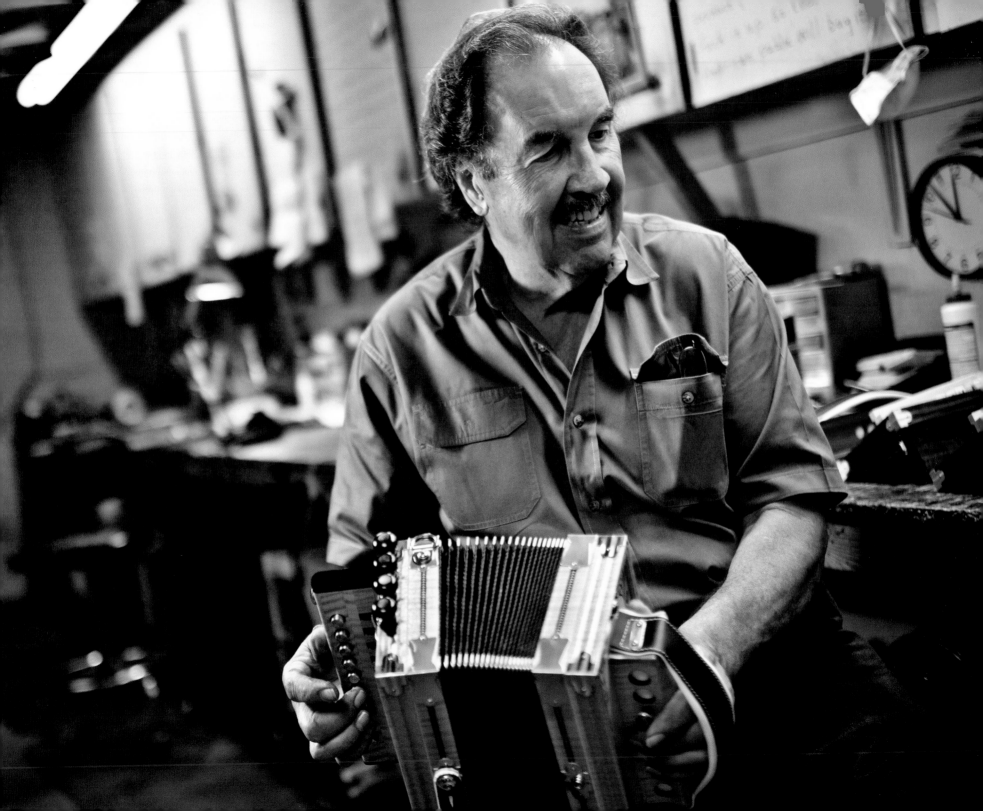

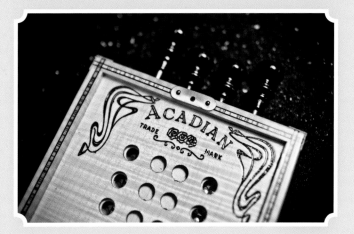

ACADIAN ACCORDIONS

EUNICE, LOUISIANA

······································ ★ ·······································

As a young Marc Savoy looked at the accordion he had made by hand, he knew he could do better. He had nursed the idea of building an accordion for years, ever since he was twelve years old, when his father bought him an accordion, a Hohner 114, from a department store. He cherished it, teaching himself to play a song right away. Growing up poor in rural Louisiana, such a thing was a luxury. "To me," Savoy would later write, "owning an accordion was about as far-fetched as owning the moon."

It was eight years later now, and he'd made his

own accordion. He wanted to show it to Sidney Brown of Lake Charles, whom Savoy had heard made wonderful accordions, but he was too embarrassed. He had few tools and didn't know much about woodworking. He threw the accordion in his father's barbecue pit and watched it burn.

He did do better, of course. In 1960 he established the Savoy Music Center in Eunice, where he has spent more than half a century making some of the world's finest, most authentic Acadian accordions.

For Savoy, who today makes about six accordions a month, the making of an accordion connects him not only to the Cajun music of his heritage, but also to the people who've championed the instrument

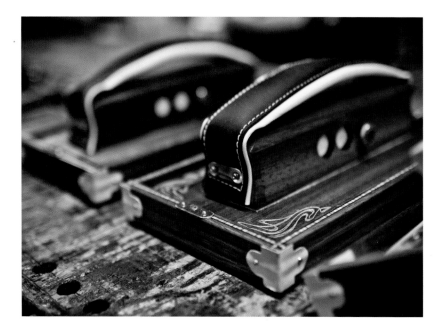

throughout history. (The instrument's heritage, Savoy says, is actually Chinese.) Today Cajun and Creole musicians form his primary customer base.

Listen to Savoy talk about the process of connecting the disparate parts of the accordion—the reeds, the maple, the mother-of-pearl inlays, the buttons and springs and bellows—and you hear the detailed mind of an engineer. Unlike string instruments, Savoy says, the type of wood chosen makes no discernible difference in the sound. (That's why you can order the type that you find most attractive, from walnut to maple to cypress to 150-year-old Louisiana red pine.) The reeds are handmade Italian reeds of the highest quality, and the bellows' length helps determine the instrument's sound potential.

The skill then comes in its tuning, an intricate process that electronic tuning devices simply can't duplicate. The sound of a properly tuned Acadian accordion "pours out of the instrument and grabs your ear," Savoy says.

Savoy and his family's Cajun band still play on occasion, usually at Saturday morning jam sessions at the Savoy Center, where people can come hear them. The shows honor everything that Savoy holds dear: family, heritage, craftsmanship, and authentic Cajun music.

"What we have here in Acadian has always been the best," he says. "We have the best food, the best lifestyle, and the most beautiful language. They belong to us."

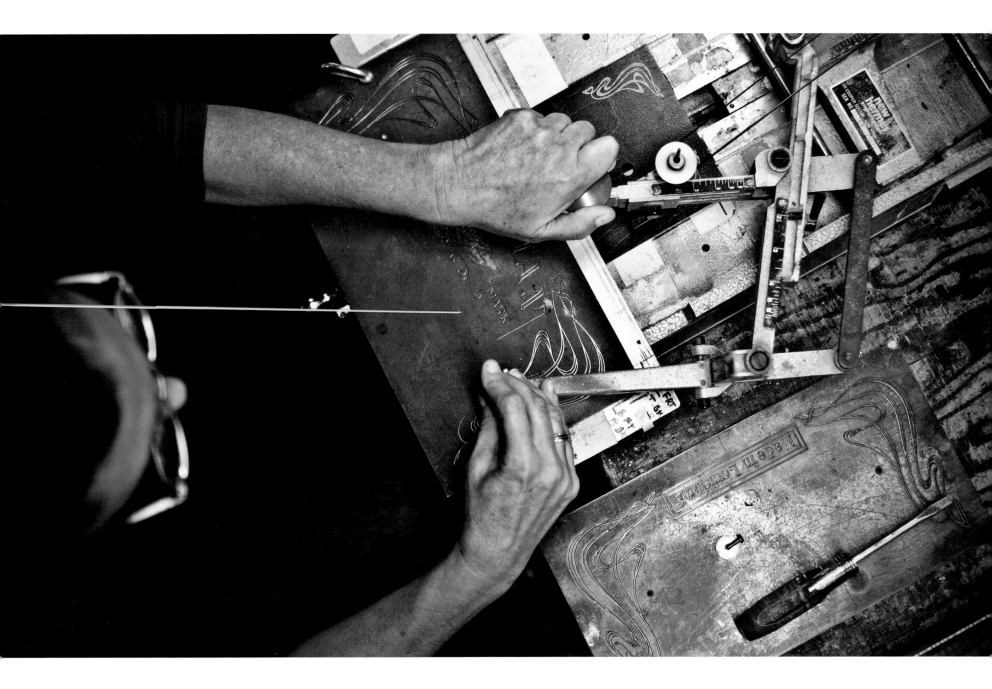

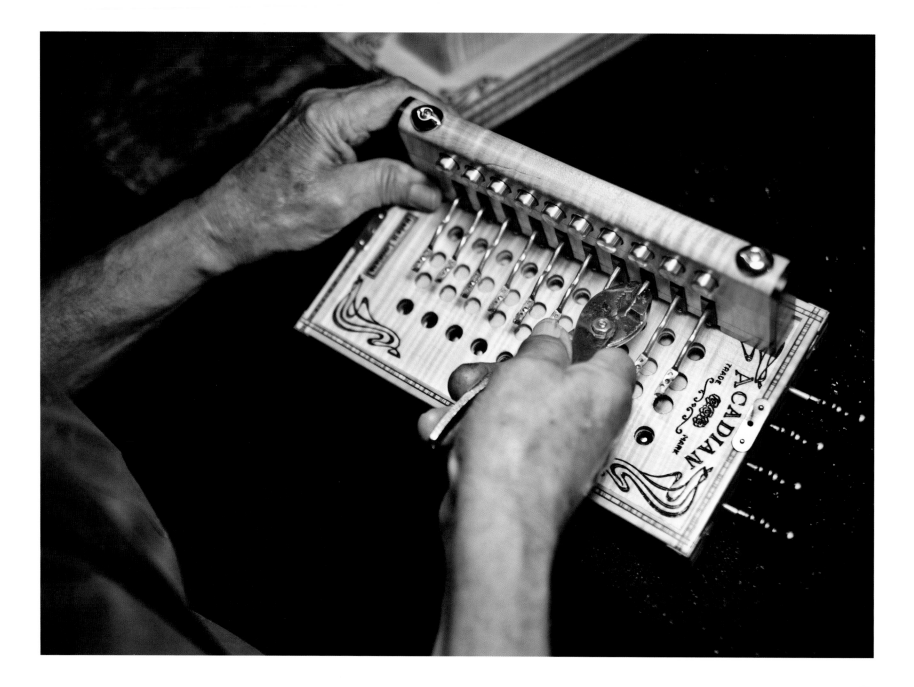

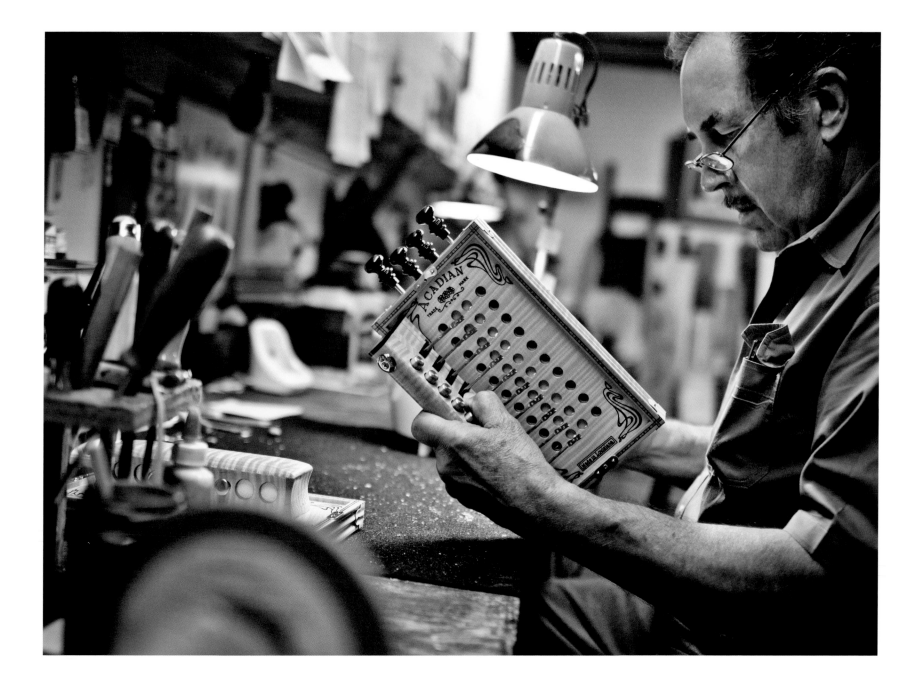

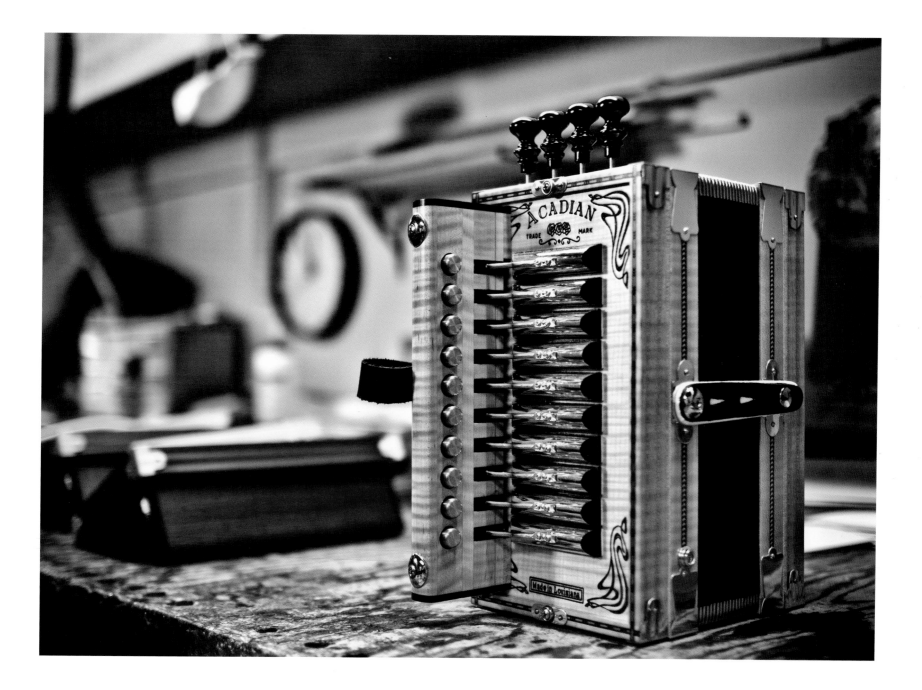

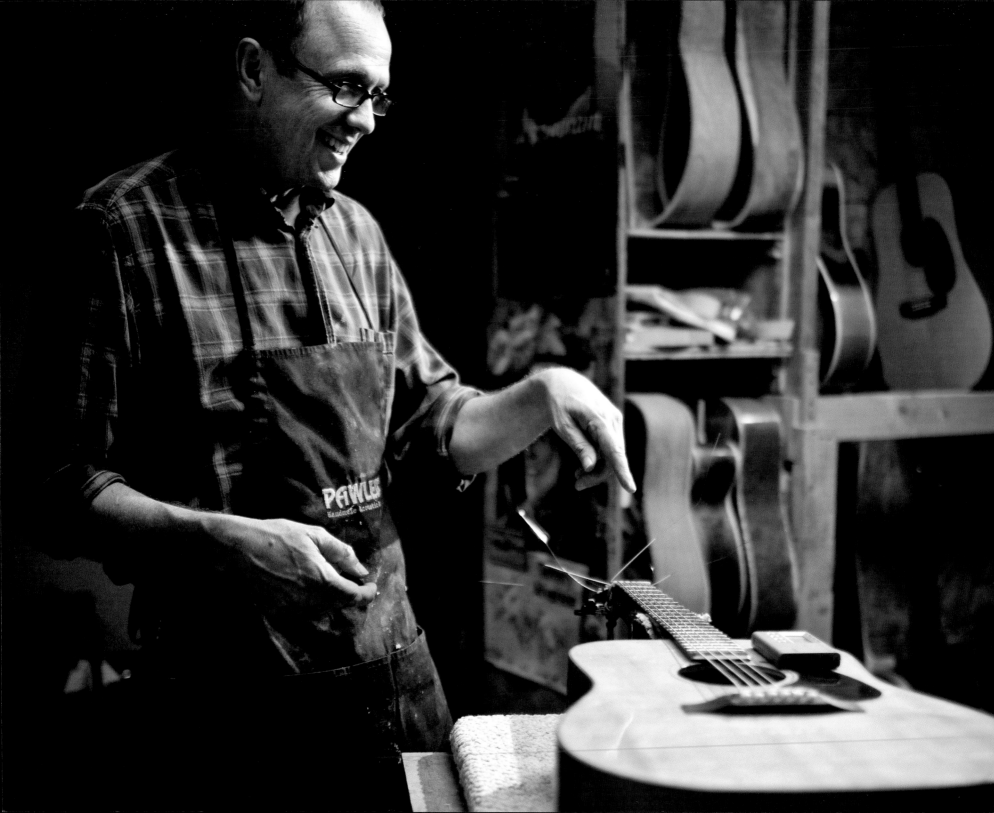

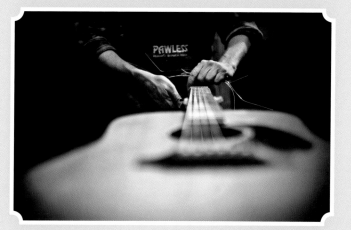

PAWLESS GUITARS

GAINESVILLE, TEXAS

⋯⋯⋯⋯⋯⋯⋯⋯⋯⋯⋯⋯⋯⋯ ★ ⋯⋯⋯⋯⋯⋯⋯⋯⋯⋯⋯⋯⋯⋯

It started, as so many left turns in life do, because of a friend. Vince Pawless had a buddy who bought a guitar-making kit, and Pawless was fascinated by the process. So he bought himself the same kit and went to work on his own guitar. His friend soon gave it up, but it sparked a lifetime passion for Vince. "I got the bug," Pawless says now, "and he didn't."

It was 1995, and Pawless threw himself into the craft—reading books, visiting other guitar makers, procuring wood, learning the basics of guitar construction. Then he took it a step further: He asked

the Texas singer-songwriters themselves what they loved about their guitars, perfecting and modifying his vision of the perfect guitar.

He'd sell one guitar and use the money to make two more—one for sale, and one to give to an artist. In this way Vince Pawless not only became a master guitar craftsman but also someone who endeared himself to the music makers. Now Pawless works on one new guitar a month as he catches up on the twenty or so he has on back order.

"I don't do a lot of measuring when I'm building a guitar," Pawless says. "A lot of it is feel. My tops aren't sanded to a certain thickness. I sand it to where I feel it has the right flex to produce the sound I'm looking for."

Pawless says that's because each piece of wood reacts differently, affecting the way the guitar ultimately sounds. (The top of the guitar itself is the soundboard, and the sound it produces is shaped from the sound's reflection from its back and sides.) And each piece of wood has its own transfer and reflective characteristics. Measuring wood isn't good enough to compensate for these inconsistencies, so Pawless has to go by eye, touch, and ear.

Pawless works on guitars while also helping with his father's farm, so much of the work is done in batches in between farm chores.

Pawless usually builds one of three standard guitar shapes, although he can do just about any custom job. Once the shape is decided, the process is similar for most orders: The soundboard is "book matched"

(sliced and opened up like a book, for consistency on both sides) and glued together, as is the back. The side woods are soaked in hot water before a hot bending pipe is used to shape them, after which they're glued to form the guitar's shape. The sides are braced and kerfed (a series of cuts, or "kerfs," are put in the corners to help it bend) and glued. The guitar is sprayed, the neck and fingerboards are attached, finishing and detailing occurs, and finally the bridge and strings are attached.

At that point, the final test: Pawless plays his work, looking for that "warm" sound for which his guitars are known. "Some I play and the sound just knocks my socks off," he says. "And that's what's important. Because I always want the next guitar to be better than the one I just finished."

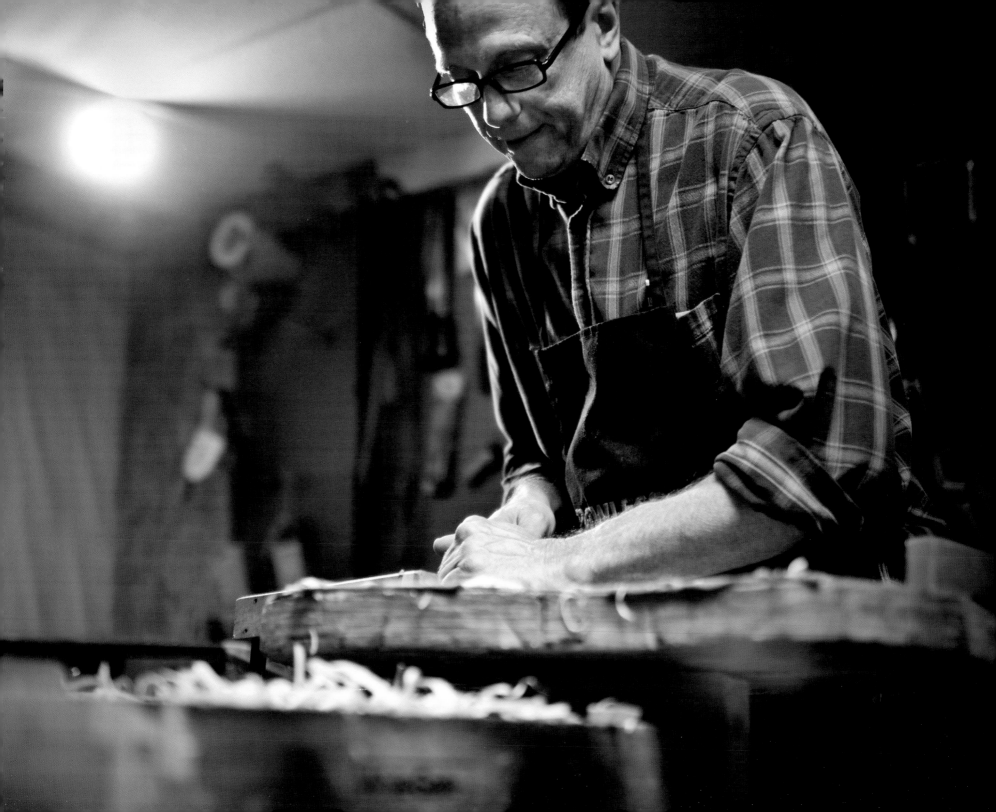

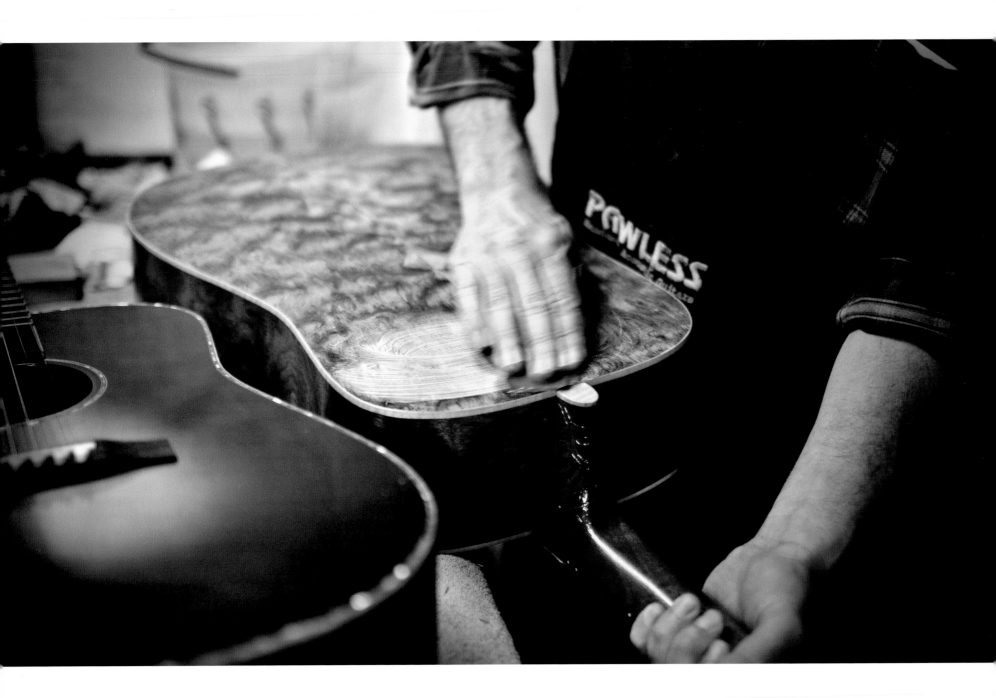

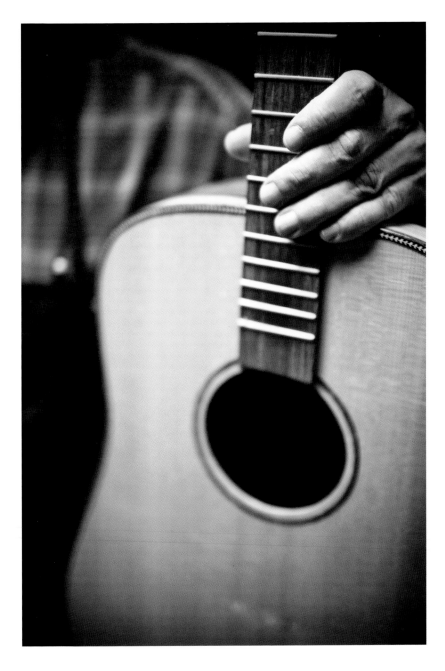
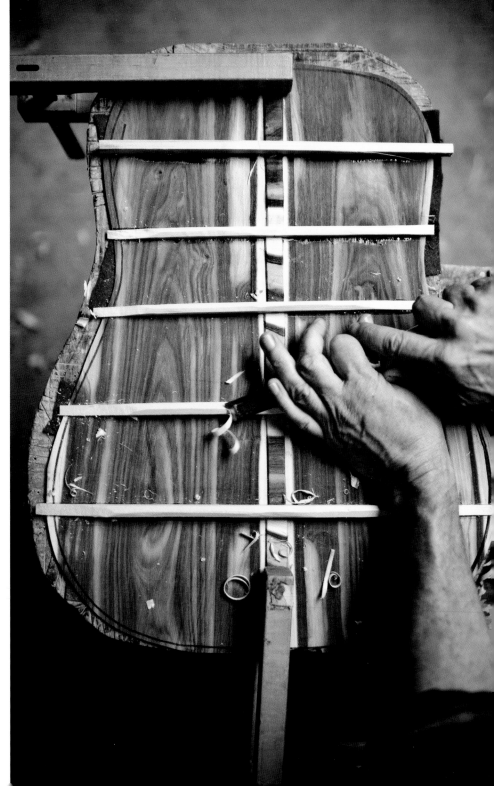

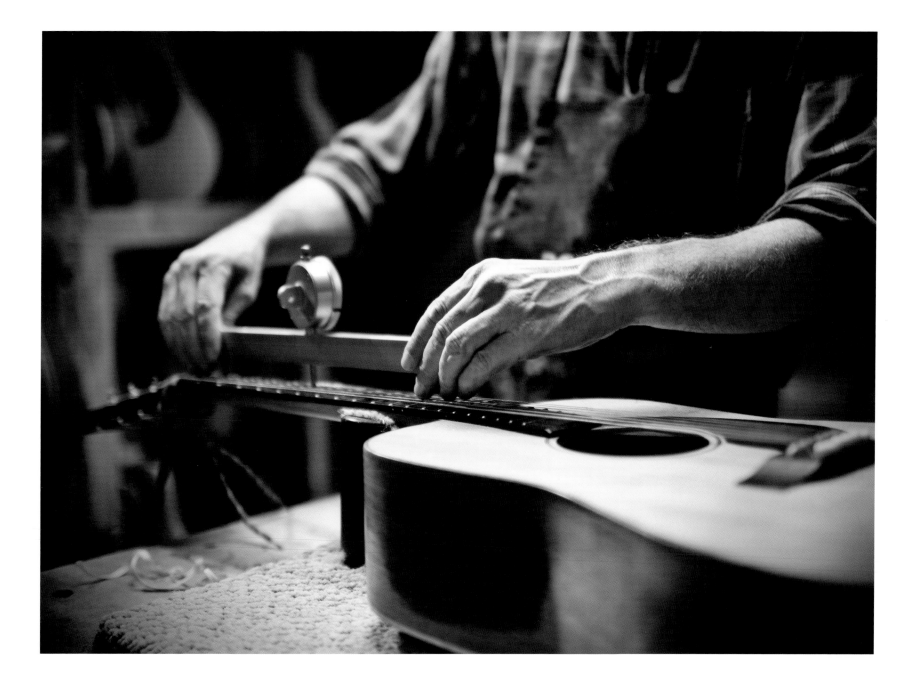

DANFORTH PEWTER

MIDDLEBURY, VERMONT

· ★ ·

hen Judi and Fred Danforth finally hung their shingle—that is, when the pewter-smiths first opened a shop in an old Colonial-era Vermont barn—they told no one their secret.

In 1975 the couple had just moved back to the states from Nova Scotia, where Judi (pronounced "Jude-eye") had been apprenticing. Upon returning to the United States, she and her husband, Fred, a former woodworker, opened Danforth Pewter. They

made traditional items of pewter—candleholders, oil lamps, dresser boxes, kitchenware, etc.—but they didn't reveal their deep connection to the craft's history.

Fred Danforth, it turned out, was a great-great-great-great-great-grandson of Thomas Danforth II, the colonial-era business pioneer considered one of the preeminent pewtersmiths in US history (and whose offspring continued the family-run business for 118 years, ceasing in 1873). One hundred and two years later, the Danforths were once again molding, spinning, and shaping the beloved alloy.

"Even though we named the company 'Danforth,' even though we used the [family's] lion touchmark, we wanted to build a business that relied on our own design and our own skills," Judi Danforth says now. "We didn't want to rely on history. So we didn't talk about history for years."

Now, nearly four decades on, she says, "It's very much a part of our story."

It's a story that has taken them from that old farmhouse to their current workshop and store in Middlebury, Vermont. Here visitors can come watch Fred spin the metal as he works it into shape before they buy something next door. (The shape is usually from one of Judi's vulcanized rubber casts, which can transfer greater detail than bronze.)

In Fred they can see a self-taught master craftsman working with "the most wonderfully malleable, forgiving, and useful material." Working with a flat disc of pewter, spinning the metal, working on his lathe—it's a fluid, mesmerizing process, like watching someone work on a pottery wheel. "The people watching, they get enthusiastic about it," Fred says. "Its energy seizes us."

Judi has become a master carver over the decades. Because of her skill and the unique rubber-mold techniques they've incorporated into the process, the Danforths are able to take almost any object from concept to completion. As Fred notes, "We were able to take a craft that is hundreds of years old and apply mid-twentieth-century technology to it. A part of the art, skill, and aesthetic is in the detail of that mold. It answers the question, 'What does a Danforth piece look like?'"

Judi continues, "We talk about these things every day. They're decisions that give our work meaning. As a company, we think of an idea, we design it, we make models, the tooling, the molds, the pieces, we design the packaging, we keep it all in-house."

And when schoolchildren tour the Middlebury store, they see not only the casting and the spinning but also a husband and wife who have now embraced and expanded upon the family history. In fact, today customers can buy "Woodstock" candleholders, named after the town where Fred and Judi Danforth first hung their shingle—still the most important part of their story.

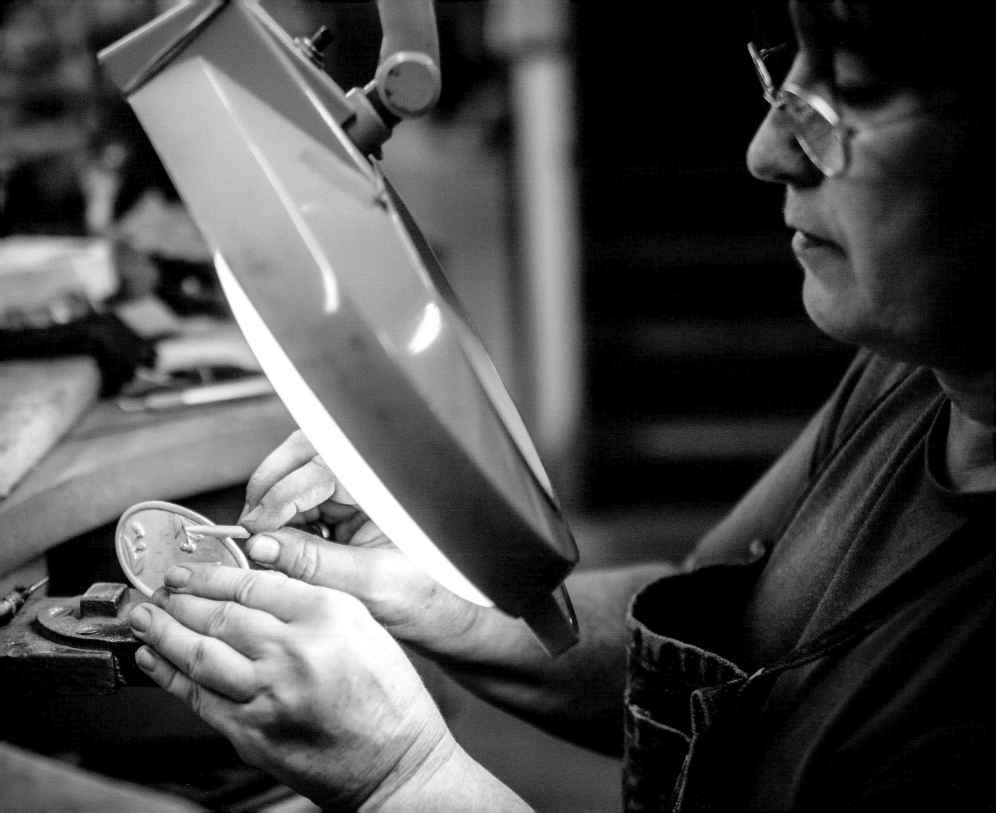

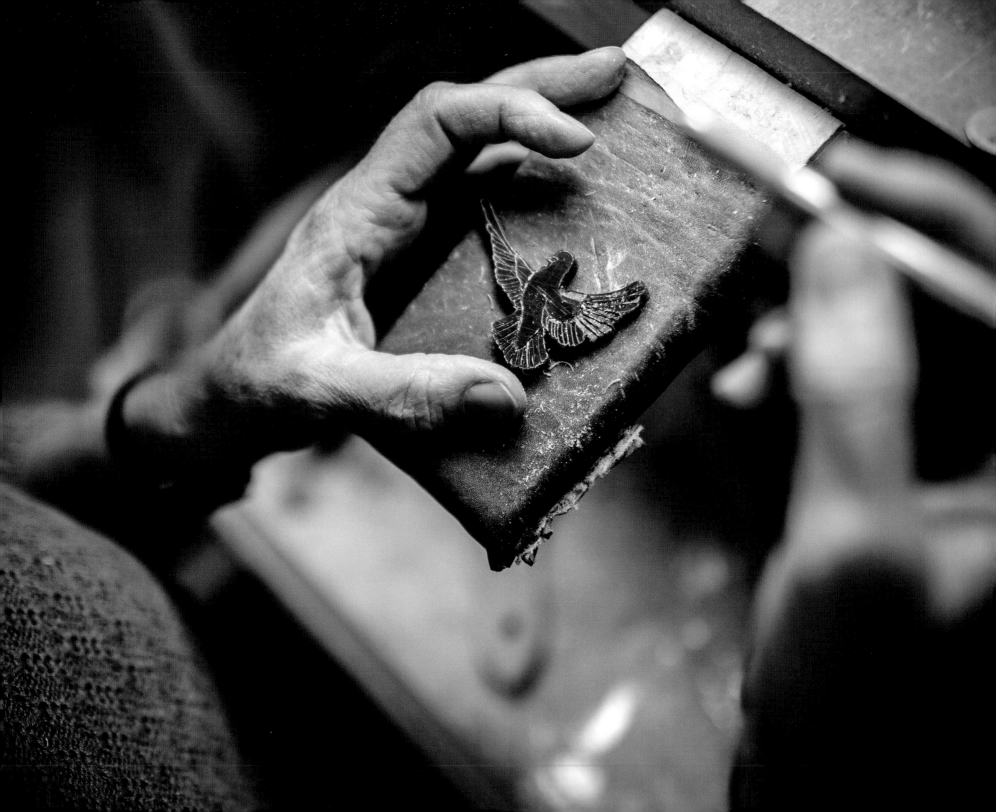

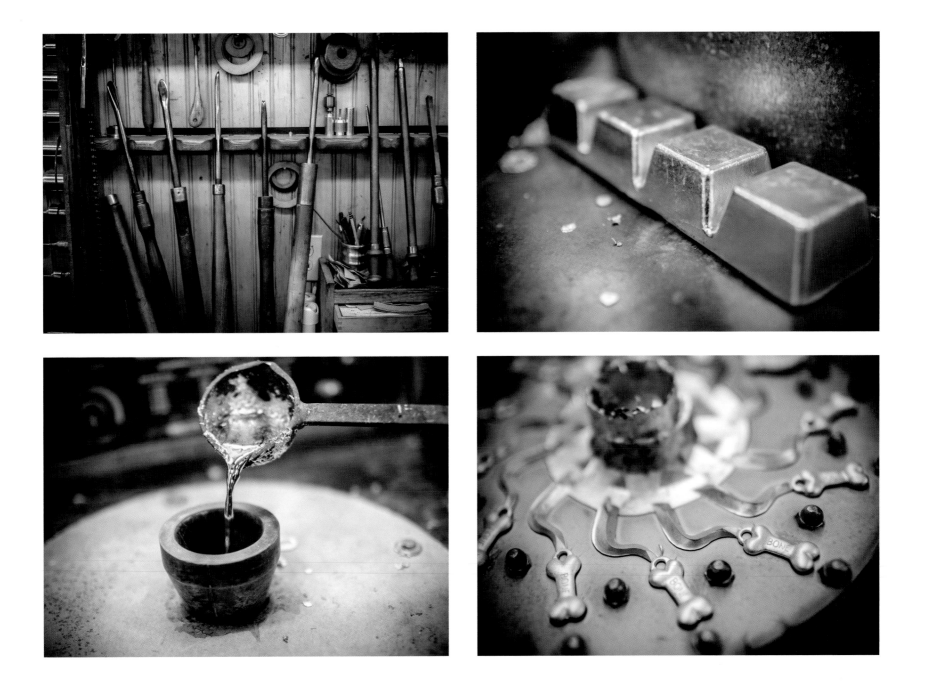

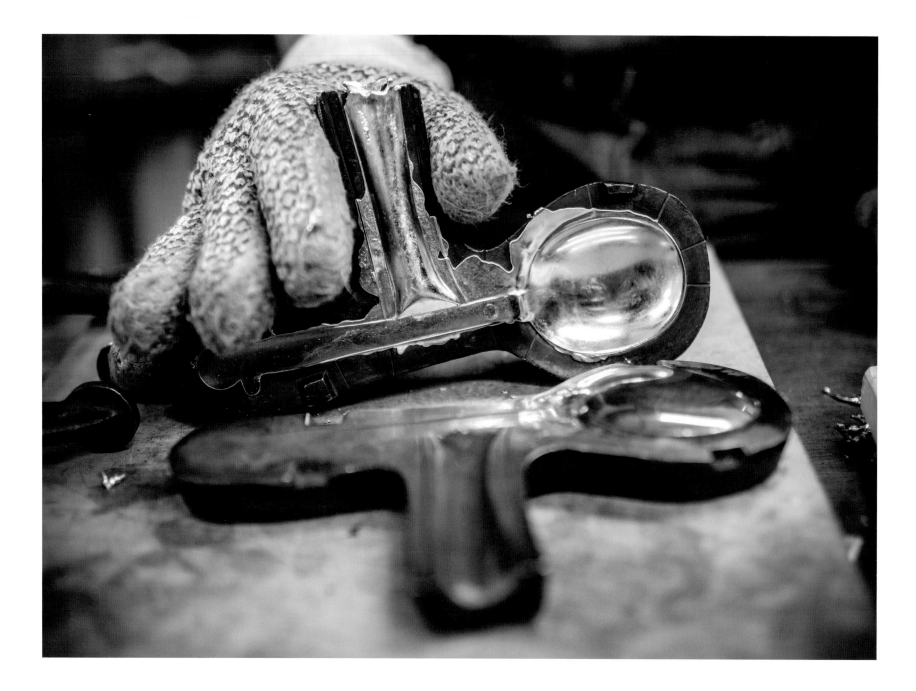

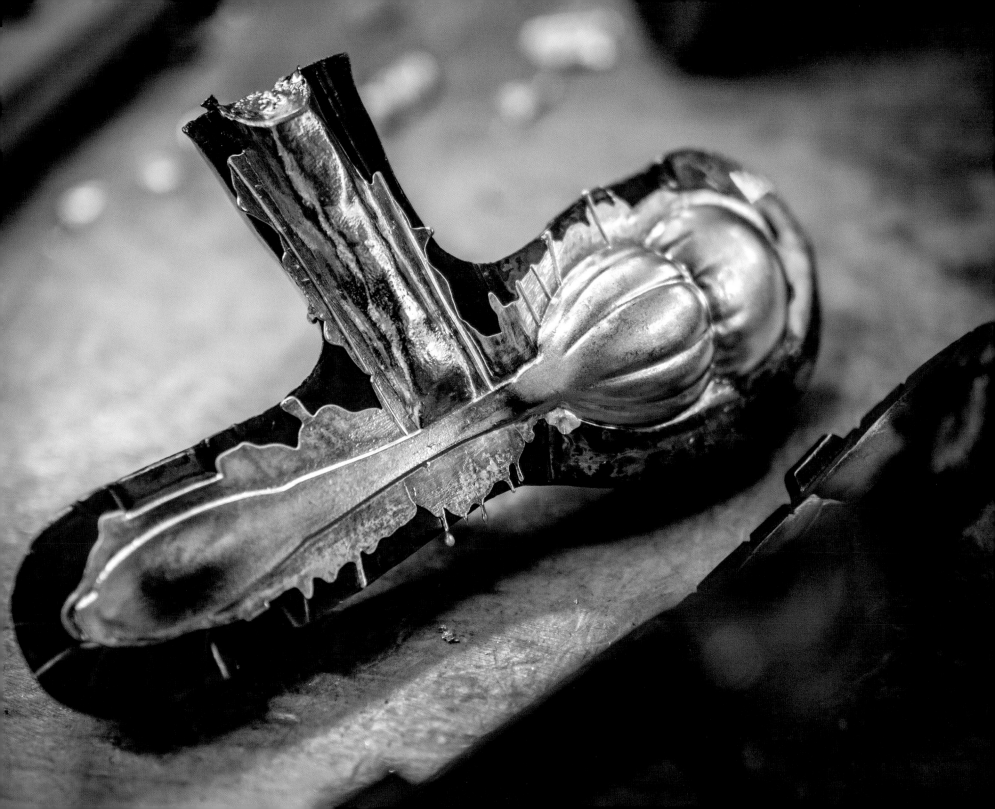

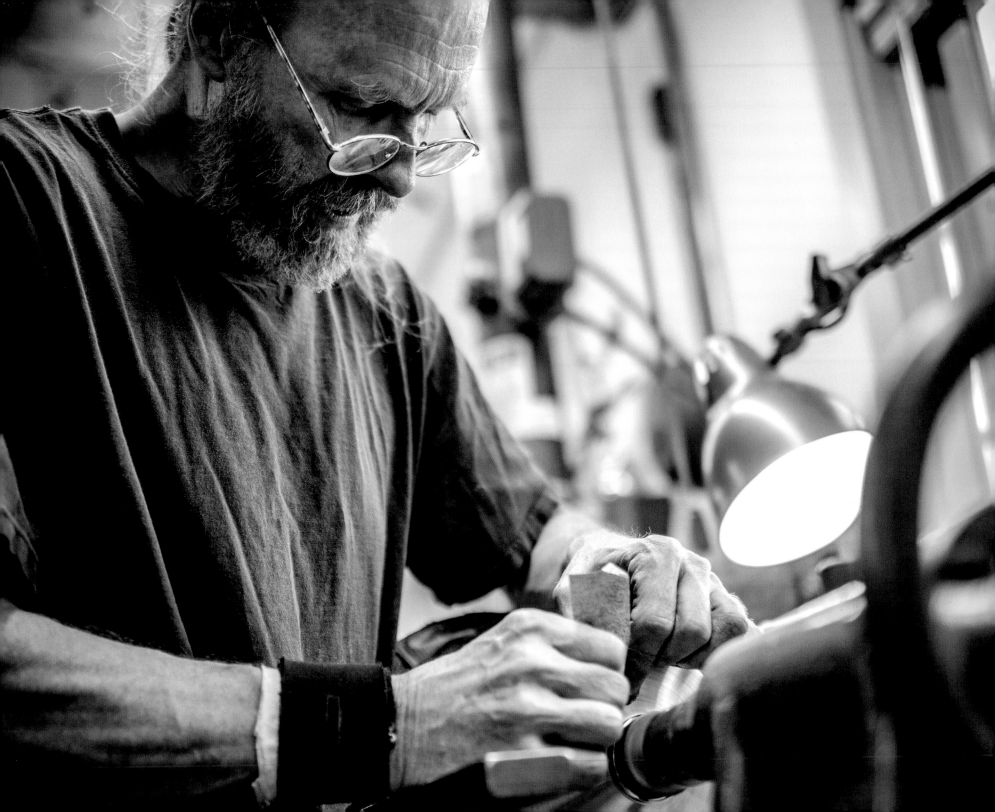

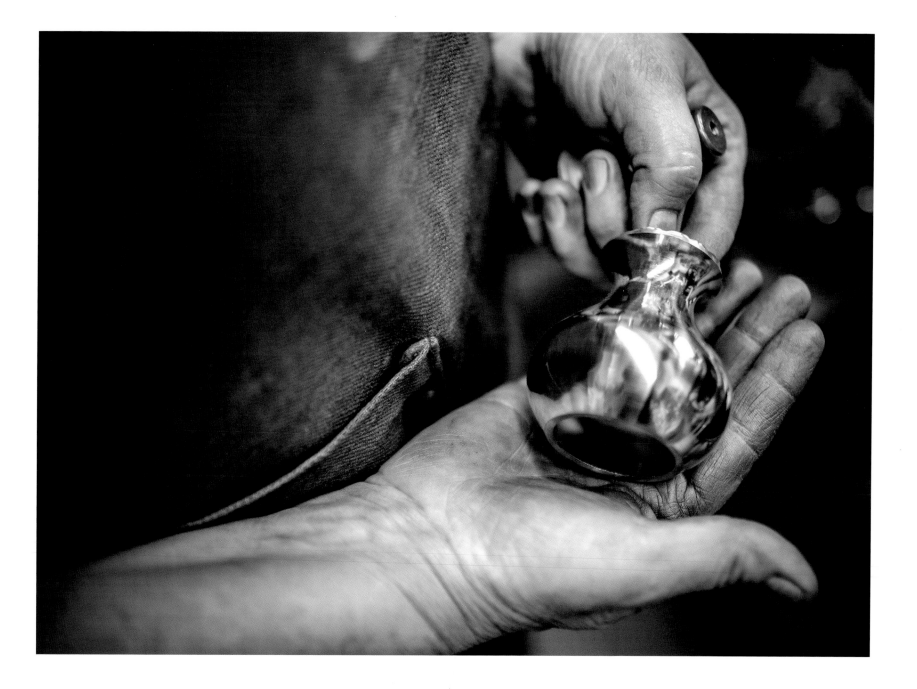

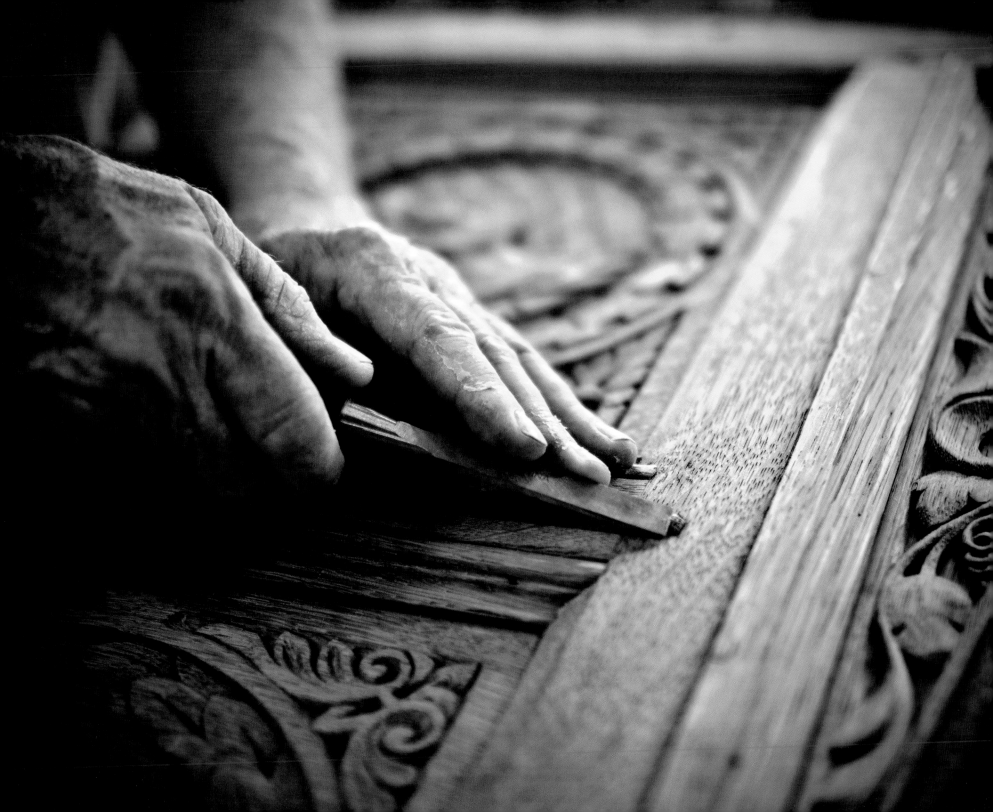

HULL HISTORICAL MILLWORK

FORT WORTH, TEXAS

★

hen Barbra Streisand called, Brent Hull knew he had made it. He'd been doing restoration and millwork for more than a decade, ever since he started his business in his brother's garage in Fort Worth, Texas. He'd built it steadily, like most craftsmen: repairing historic homes, doing residential remodels, working on a historic courthouse renovation after it had burned down.

But it was his 2003 book, *Historic Millwork,* that fortified his reputation enough for an icon to ask him to work on her home. By the time Streisand called, "I knew I'd developed a name. But I still don't feel like

I've made it. I still have work to do; there's so much I don't know, so much I'm still learning."

Many think Hull already knows as much as one can about historic millwork and molding. Not only did he literally write the book on it, but his company now employs more than fifty people, and his design and renovation projects take him to places far beyond North Texas. That doesn't even factor in the speaking, teaching, and writing Hull does regularly on the subject. "It's my job, but it's more than that," he says. "It's my passion."

Hull always liked making things with his hands—pottery and crafts, LEGO sculptures, even a mini-boat with a motor attached. (This last project led to his degree from the North Bennet Street School in Boston, which also gave him a distinguished alumni award.)

Most of the woodworking projects the company takes on now have a common theme: They require an understanding of and appreciation for old-world craftsmanship. "We bring focus to details that are historical, that were prominent historically," he says. "We bring that because people want it today, and they can't find it anywhere else."

Hull believes an integral part of what he does is helping to tell the story of a building. This could mean hand-carving detail the way it was done over a century ago to helping the architect on a restoration project understand the style of millwork that was originally used in that region. (Hull has a two-thousand-piece library of historical reference books.)

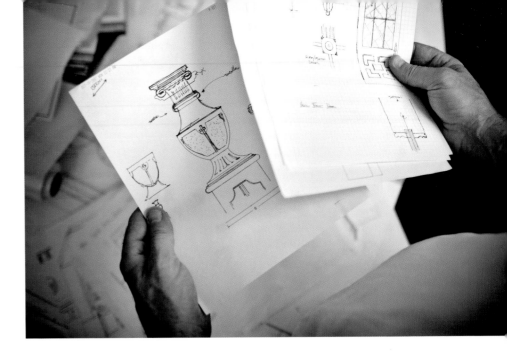

"So if someone says, 'I want a French-style house,' the questions begin," he says. "We go to our French books and ask, do you want high-style Parisian, or simple French country? What materials, what region, how ornate? Then we suggest millwork packages and moldings based on historical precedent. So we'll make suggestions, they'll respond, and we'll get a taste for what they like. We show them how their decisions influence the rest of house. We explain very carefully that the decisions we make determine how the story of that house will be told."

Hull knows his passion for detail and authenticity isn't for everyone. "The people I work with want to build something with purpose, with meaning, something that makes sense. They want to have a conversation in the new world with an old-world master craftsman. And that's where we want to be."

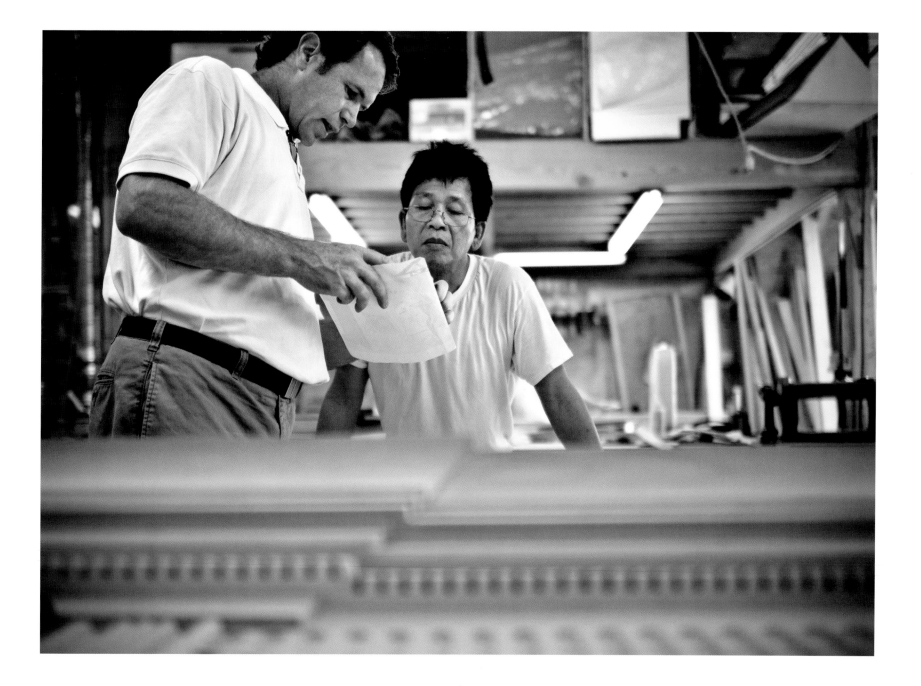

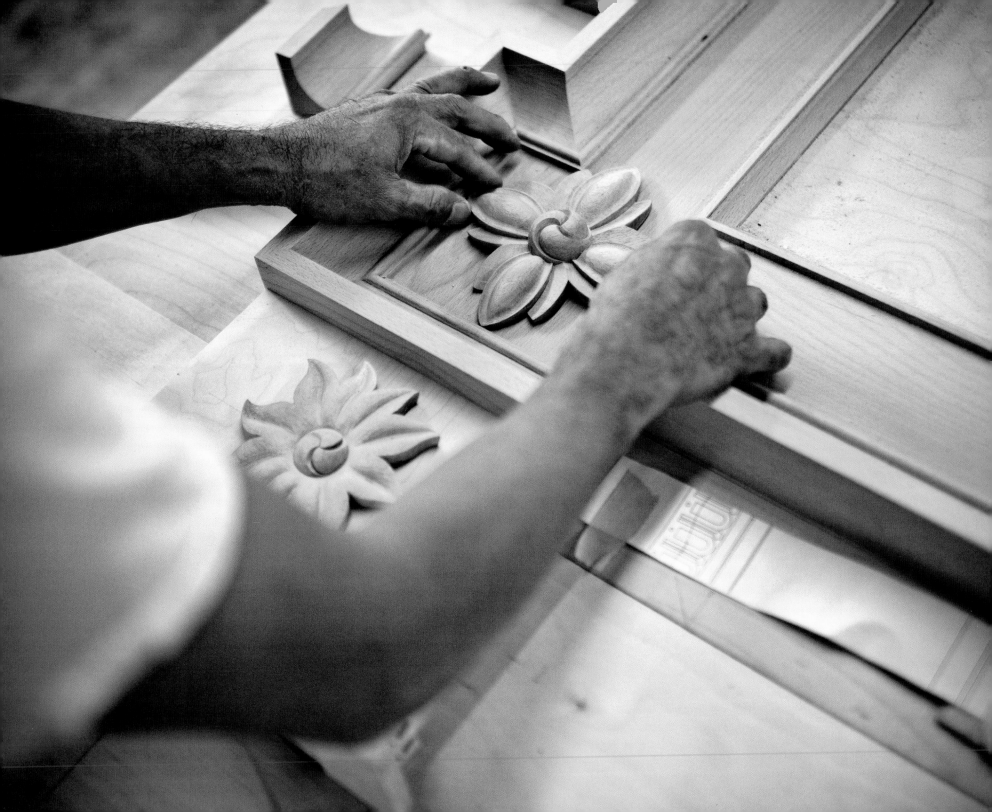

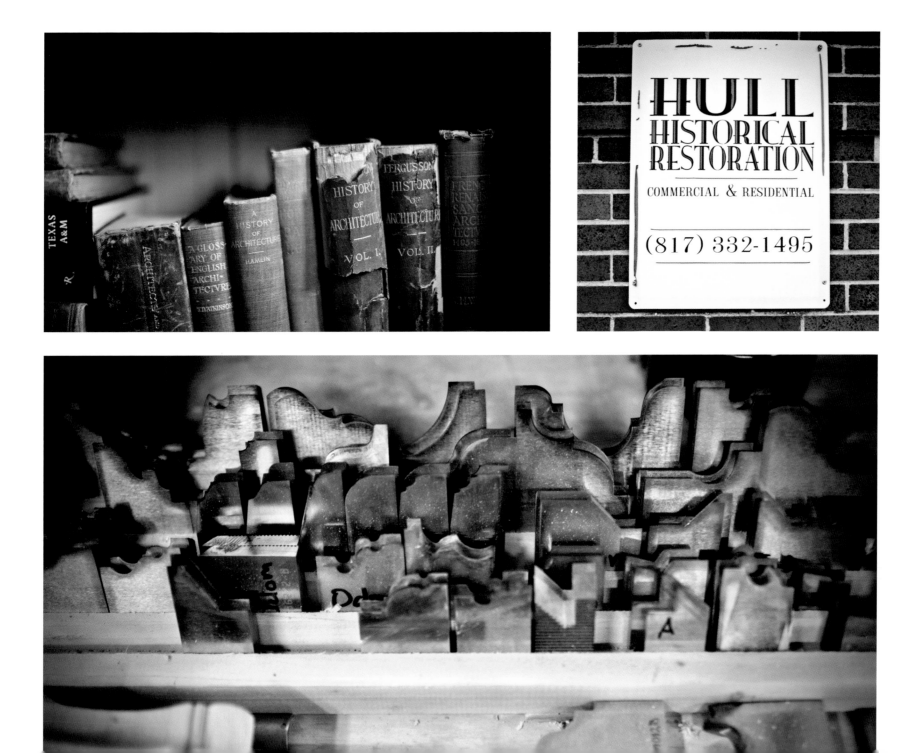

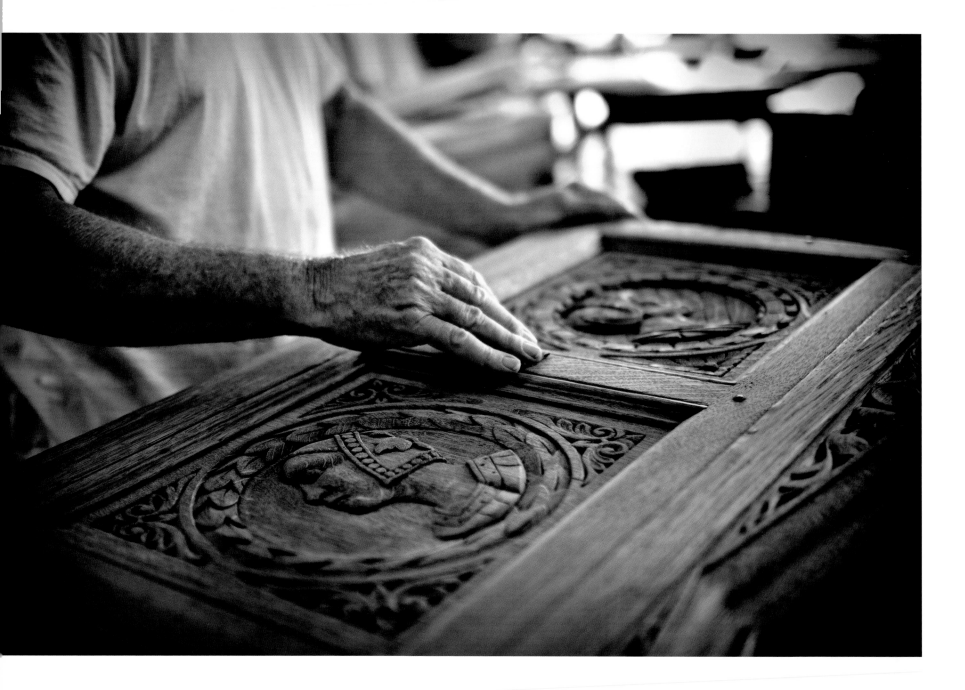

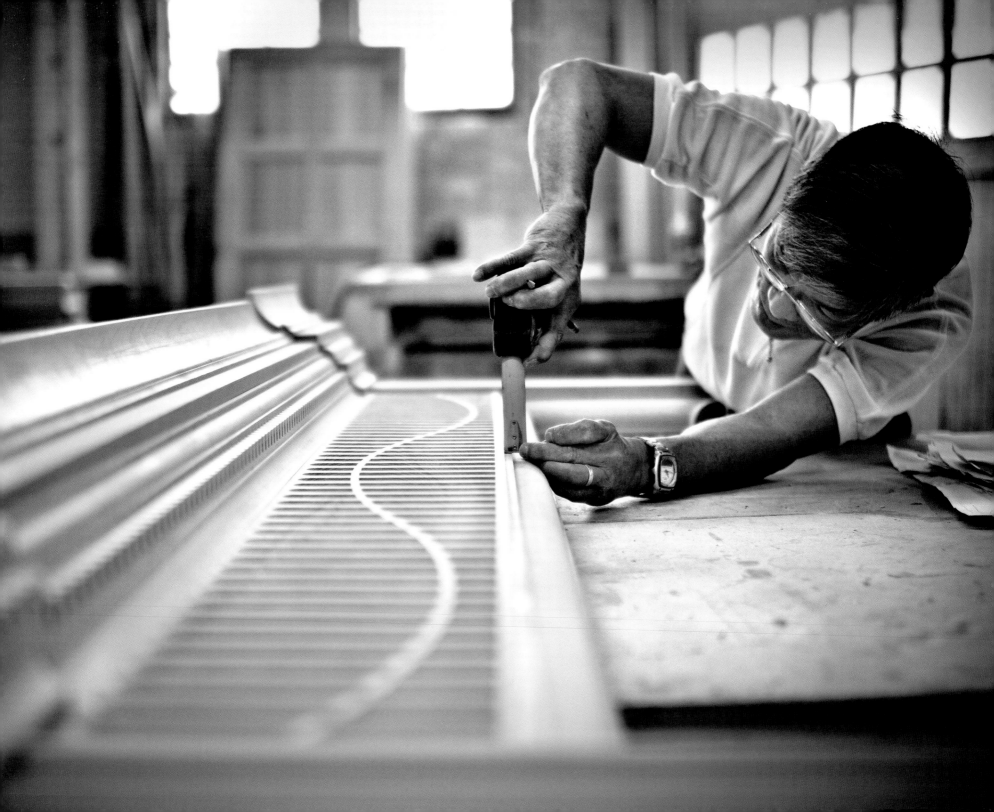

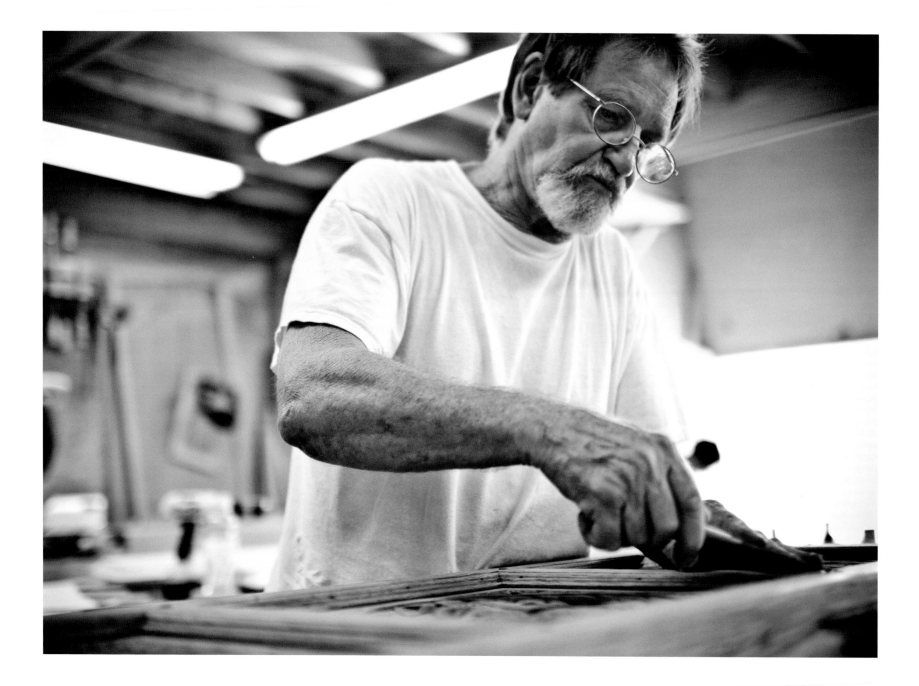

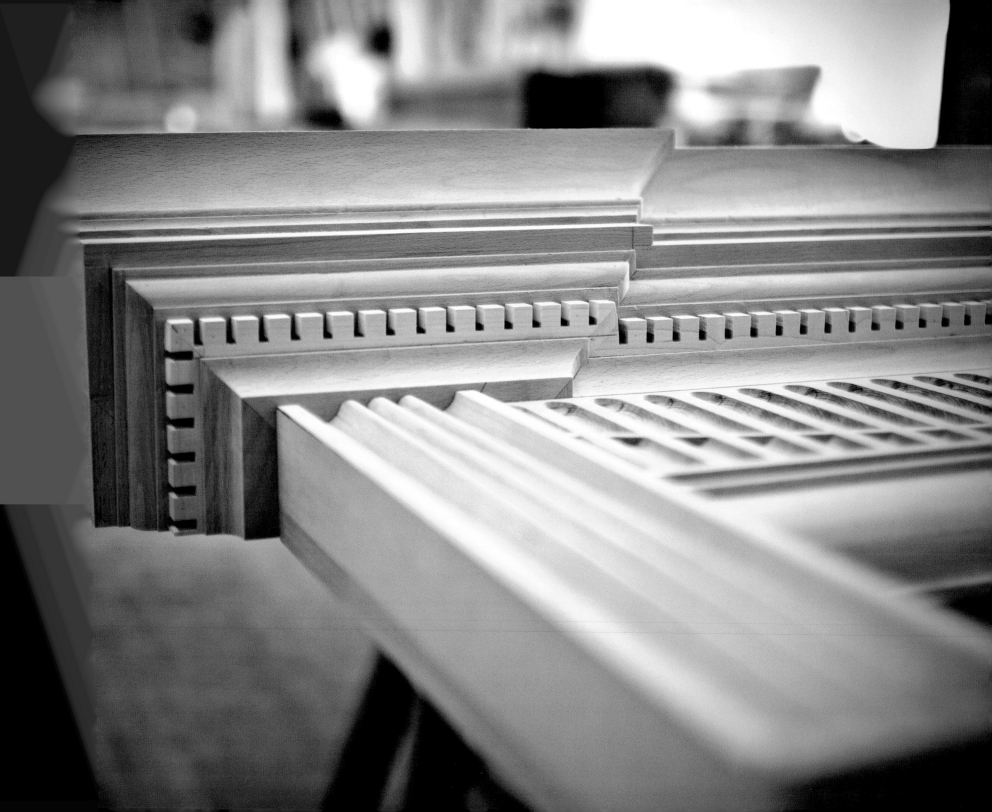

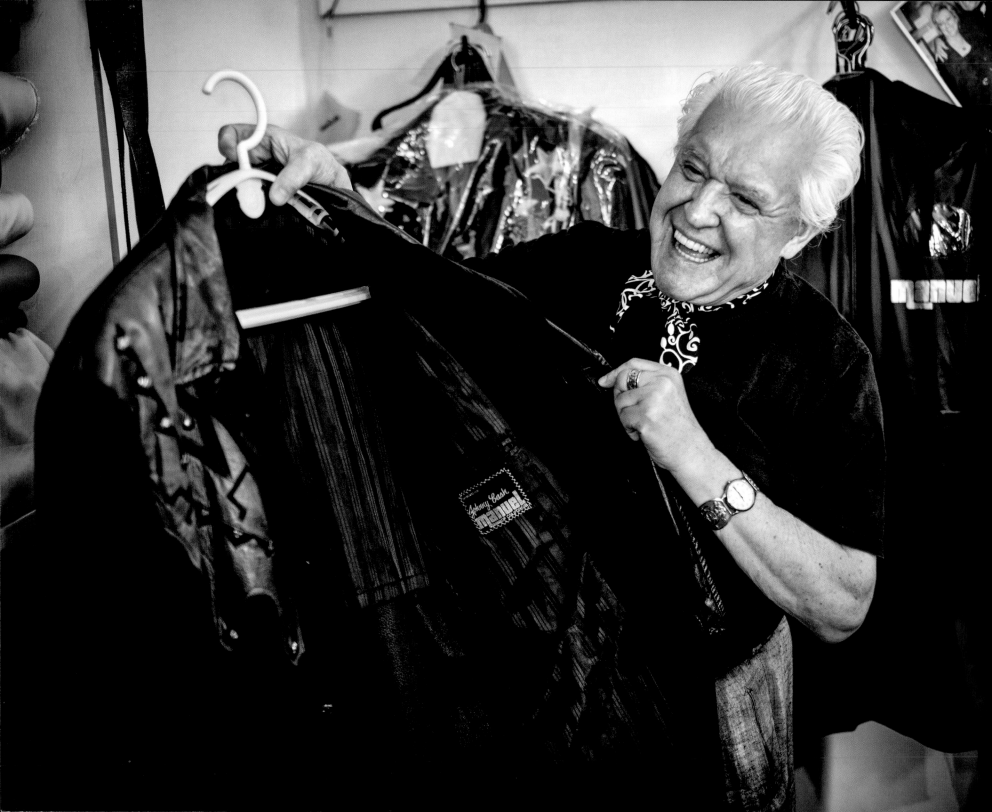

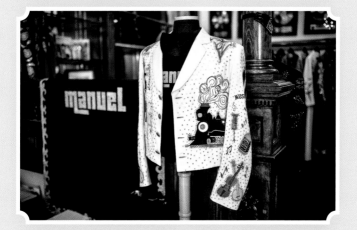

MANUEL AMERICAN DESIGNS

NASHVILLE, TENNESSEE

★

anuel Arturo José Cuevas Martínez Sr. crossed the border in his new car with forty thousand dollars in his pocket. Everyone told him he was crazy for leaving Mexico. He had a thriving tailoring business with a business partner, making "hundreds of thousands of dollars,"

Manuel says. But he wanted to make it in the United States. The country's outsized dreams more neatly matched his world outlook, his outgoing personality, and his desire for proper recognition and fame.

"I just said, 'Hell, I'm gonna see if I can do it,'" Manuel says.

And he did. Nearly sixty years later, Manuel is known as the man who put Johnny Cash in black and Elvis in gold lamé. He is considered the outré designer of music stars around the world, handcrafting looks for everyone from Kid Rock to Jack White, Bob Dylan to Hank Williams I through III.

Manuel's work is adorned with the color and flash of the man himself. From his earliest days in Hollywood, Manuel felt comfortable with stars, and they with him. An experienced tailor—he learned to sew from his older brother at age seven—he went to work for master embroiderers of the era, eventually on to the wardrobe departments of movies, and finally to crafting the finely tailored look of the Rat Pack.

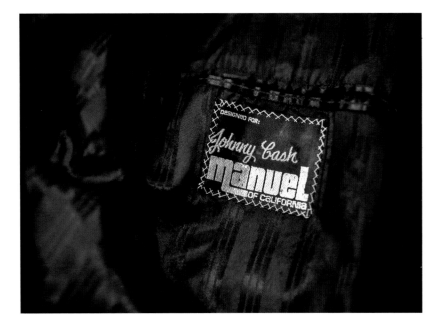

Although seemingly locked into the Hollywood scene, Manuel was a restless, wandering soul. A trip to Pasadena to see the Rose Bowl gave him new direction: the colors, the pageantry, the glitz and the glam told him he needed to add high-end embroidery to his repertoire.

In 1975 the "Rhinestone Rembrandt," as he would later be christened, opened his own clothing store using a dozen sewing machines purchased from a store going out of business. He was already a fixture in country music when in 1989 he moved his store to the center of the country music universe: Nashville.

Manuel's singular skill goes beyond his fine craftsmanship, unique designs, and flashy embroidering. He is able to capture the essence of what makes a performer special and reflect it in the clothing.

"Fashion is what you find in the store," he says. "But style is what you keep in your closet. That's different. I'm able to see what gives stars their style. So I know them, I can read them. I create for them something unique, from my heart, but also it fits with what they are, who they are, not what they think they need."

Although the flamboyant Nashville couture icon has slowed down—he now works ten hours a day instead of fourteen—he doesn't see himself retiring anytime soon.

"I'm seventy-five years old!" he says with mock outrage. "This is my castle. My creative place. It's what I do and what I love. It's my art . . . What the heck else am I going to do?"

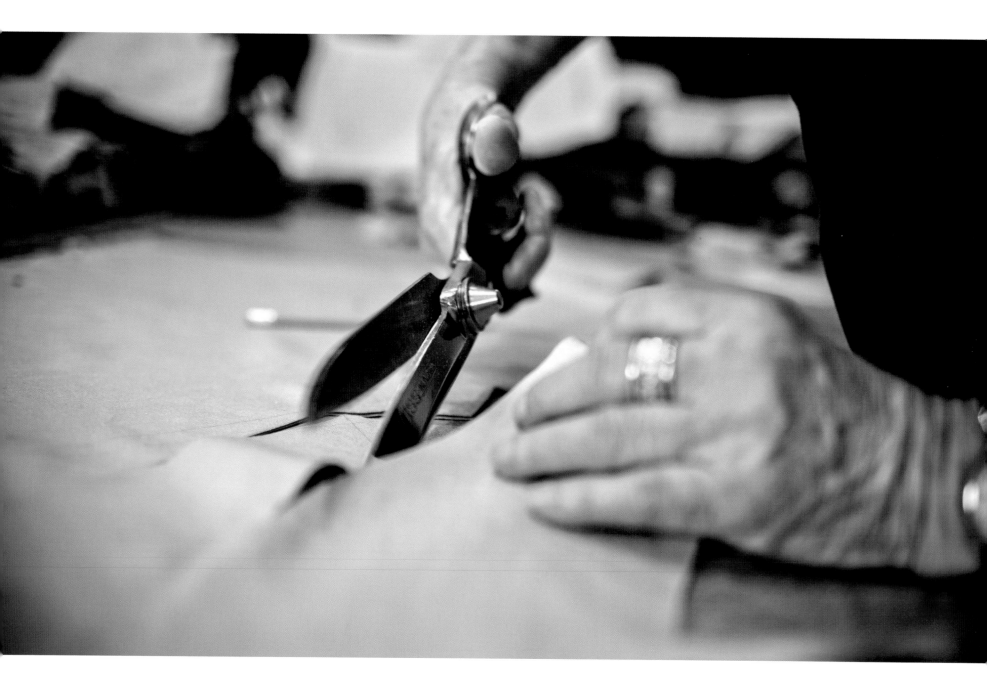

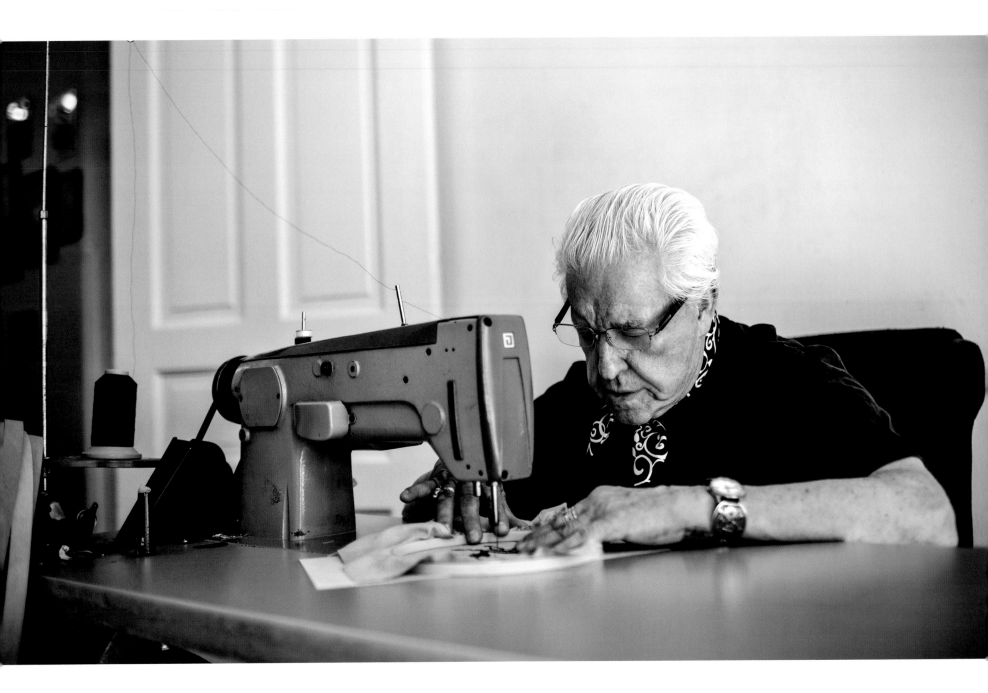

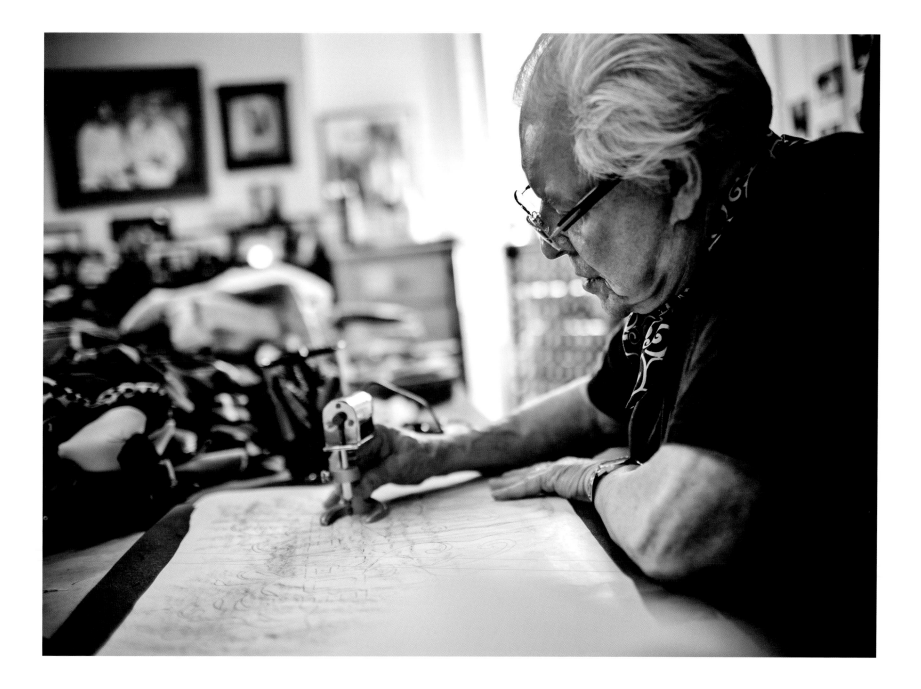

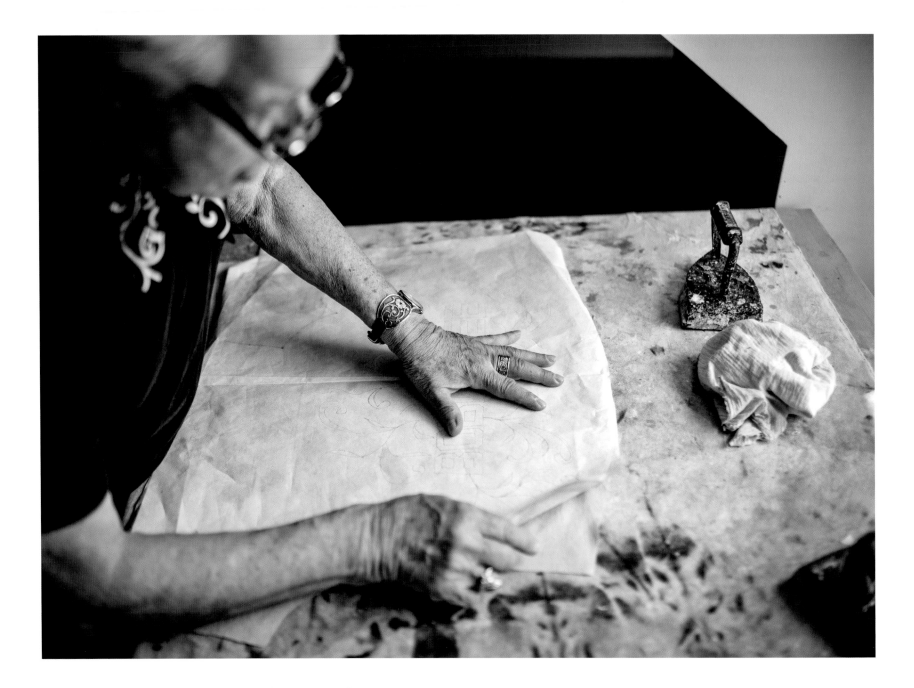

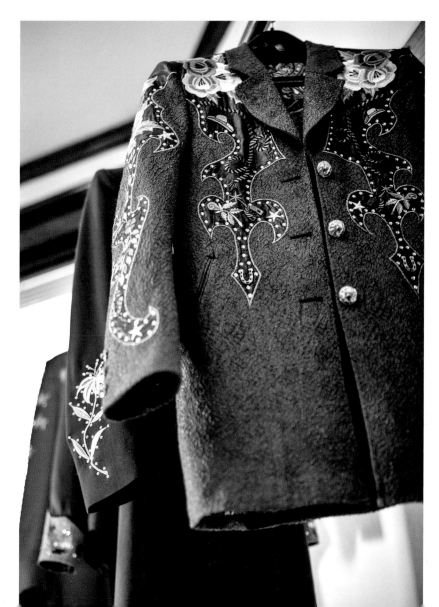

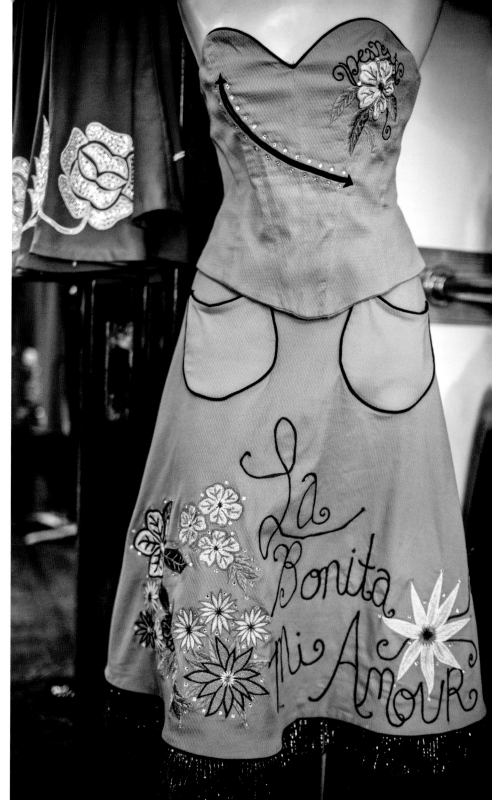

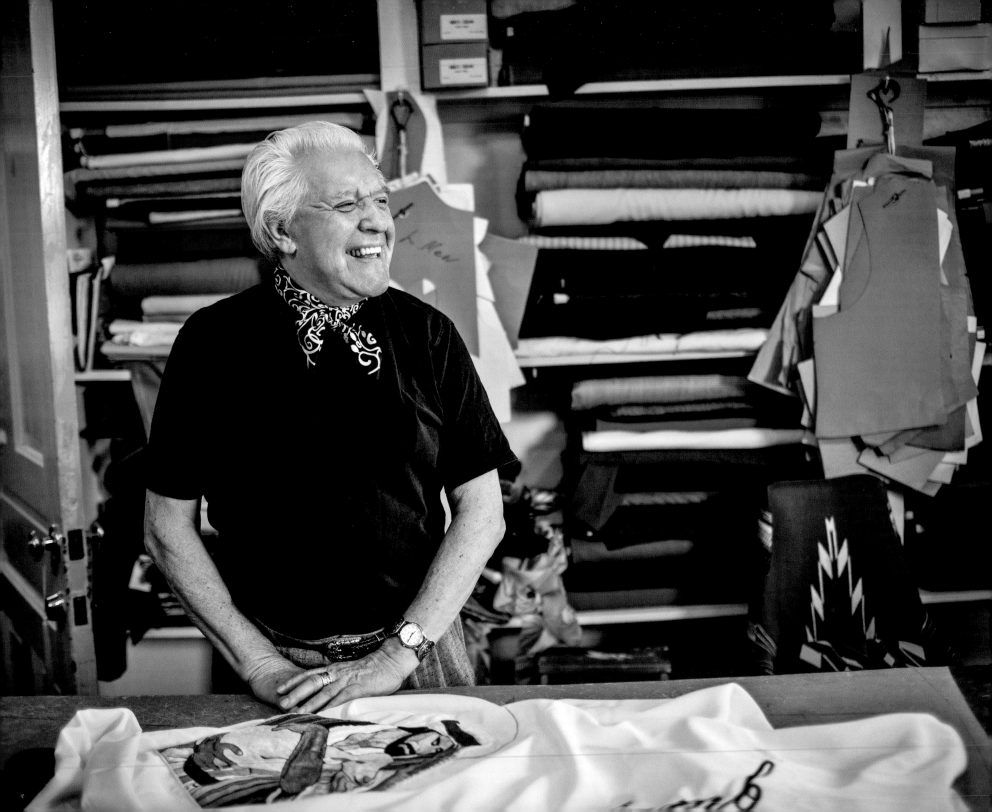

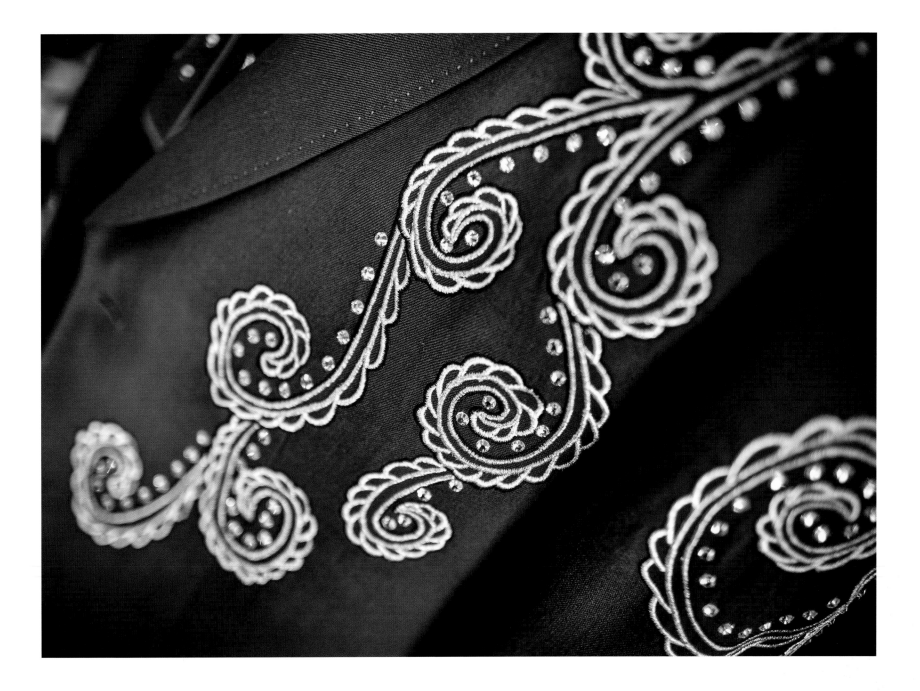

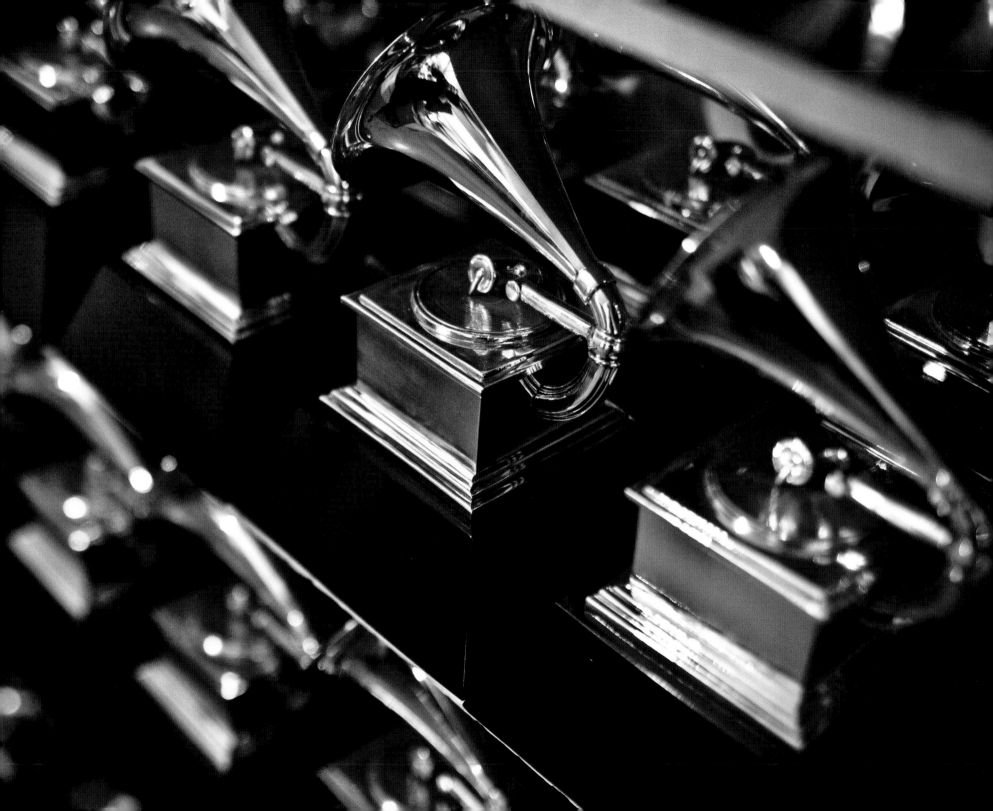

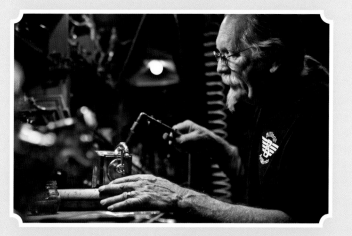

BILLINGS ARTWORKS

RIDGWAY, COLORADO

★

Robert Graves was near the end of his life, dying from cancer, when he asked a favor of his protégé, John Billings. It was 1984 and Graves, a master mold-maker, had been creating each Grammy award since the first ceremony in 1959, when it was called the "gramophone award." Billings had been Graves's loyal apprentice for seven years.

Billings recalls: "Bob said to me, 'I want you to promise you'll never give up those Grammys.'"

Nearly thirty years later, Billings, now a master mold-maker himself, has kept his promise, still making every Grammy awarded. Billings bought the

business from Graves's widow and moved it to his garage. Today he operates out of a small studio in Ridgway, Colorado, where he and his team craft more than six hundred Grammy awards a year.

"I've carried on a tradition that was handed to me," Billings says. "I really don't do this for the money. There are times they've *cost* me money. People tried to outbid me for years. But I made that promise to Bob."

Billings carries on the tradition in other ways. For one, he works "inside-out"—the details apparent in the finely constructed trophy are fashioned in the bronze mold, not on the object itself after it is cast. This means the mold details are "backward," as though seeing them in a mirror, so that they appear correctly on the Grammy itself. As an example, Billings describes a mold he's been chiseling, filing, and chasing (hammering and pressing designs) for the past three months. It's a slow, meticulous process.

Billings spends much of his time making molds—about thirty a year—designed to refresh or update the Grammy award, as well as updates to the intricate molds for the John Wooden Award (given to college basketball's top player) and the Annie Award (the highest achievement in animation).

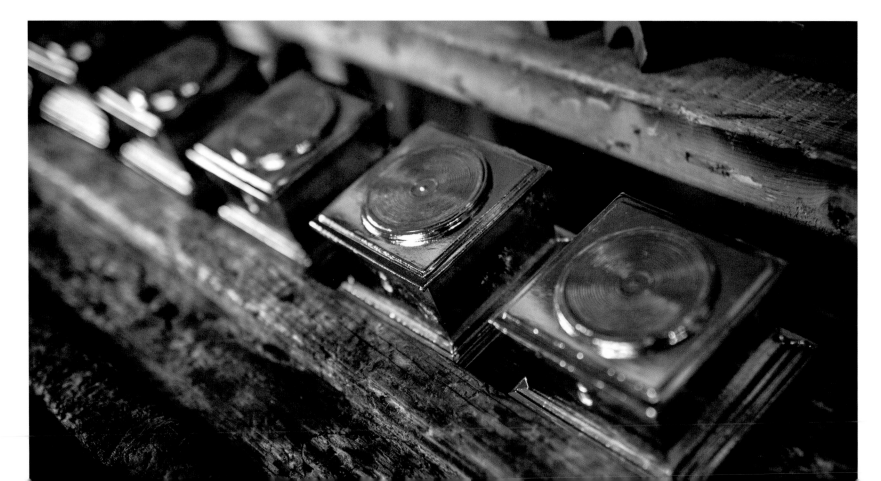

Once the Grammy mold is ready, he goes to his three-hundred-pound cauldron of "grammium" (a proprietary alloy of aluminum, zinc, and secret metals) and ladles it into one of the four bronze molds. The hand filing and belt-sander grinding is also a slow process, because "we have to strive for perfection," Billings says. The awards are polished on a buffing wheel, then the bases are attached and lacquered. In all, one Grammy takes about fifteen hours to make.

Billings drives all the awards to Hollywood himself to ensure they don't break. (He often is asked to repair or replace awards that stars have damaged.) In 1990, when he made the award 30 percent larger (for television audiences), he addressed some of the original design's weaknesses that made it break easily at the arm of the gramophone.

Billings has three people who work with him now, because the number of trophies he produces keeps rising. He plans to teach one of them to take over the business from him someday, just as he did from Bob Graves.

Because for Billings, the work draws its meaning from that line of craftsmen. A German mold-maker taught Bob Graves, who taught him. In fact, Billings still uses a chasing hammer that belonged to the German master. It's more than a hundred years old, with a small handle that fits like a bulb in his hand. It's delicate and balanced, the perfect tool for the job. He'll pass it on someday. And the craft, like the music his work honors, will play on.

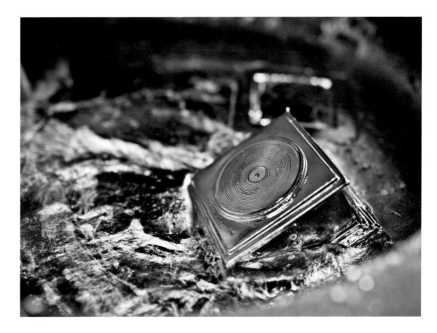

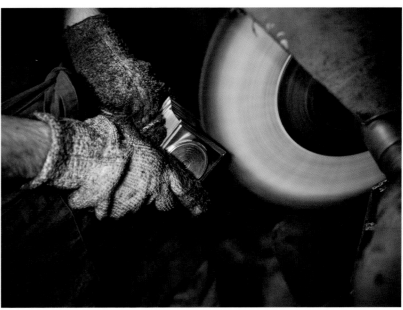

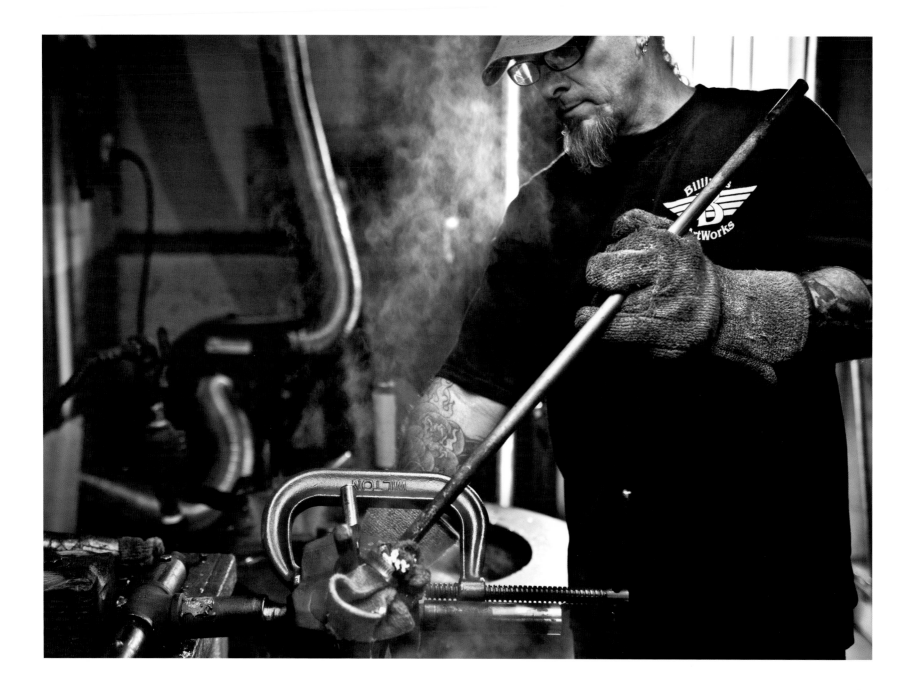

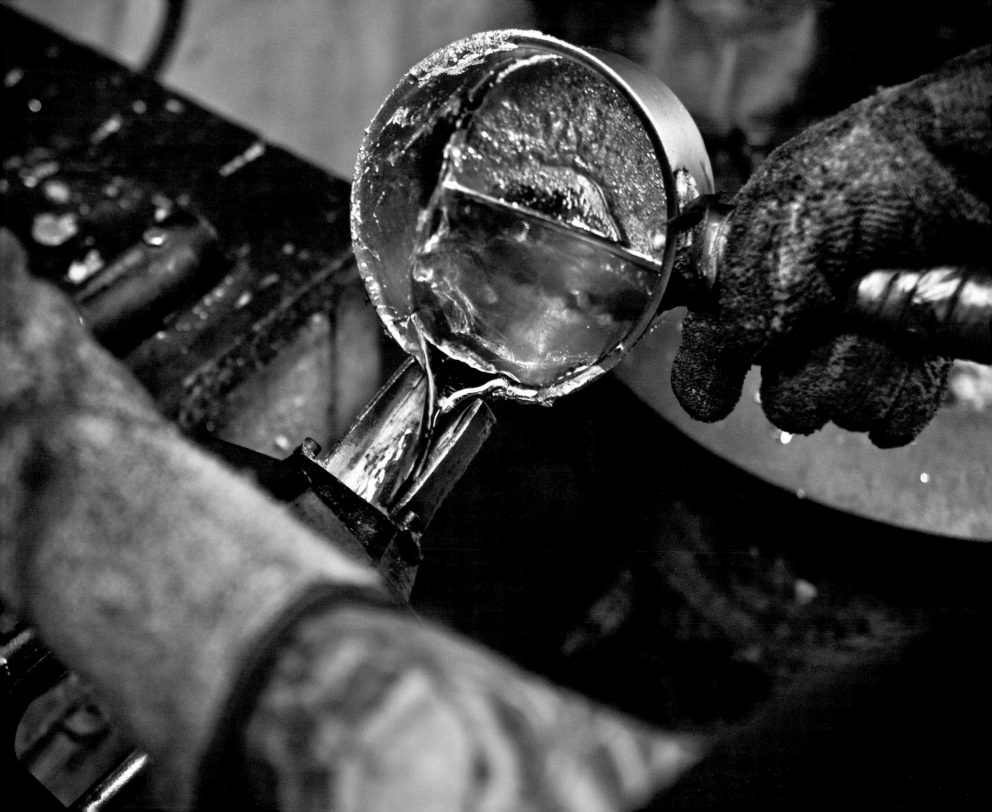

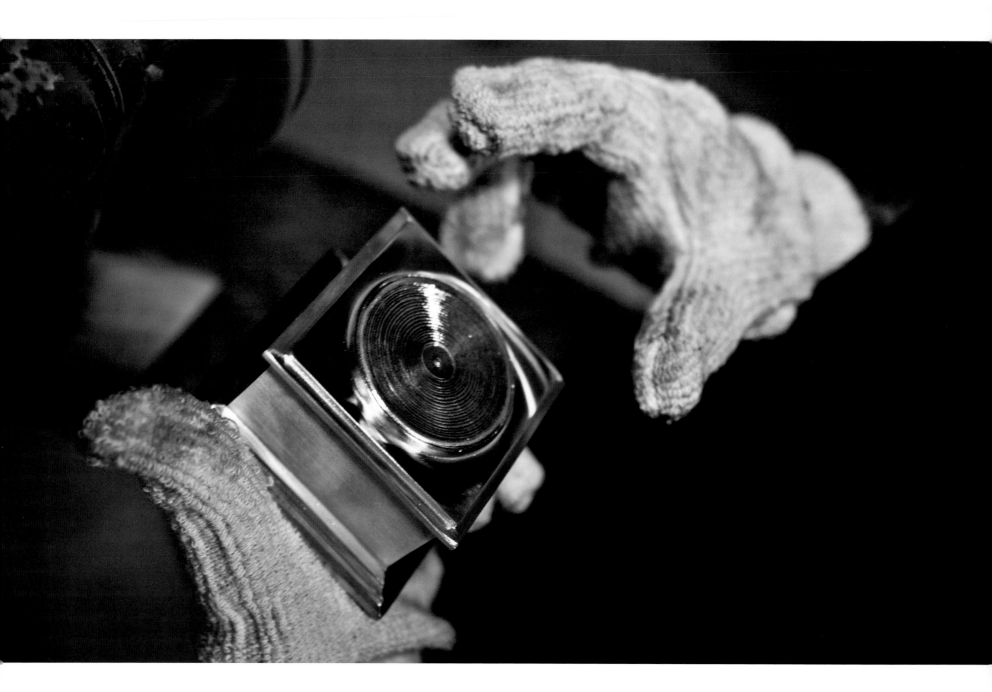

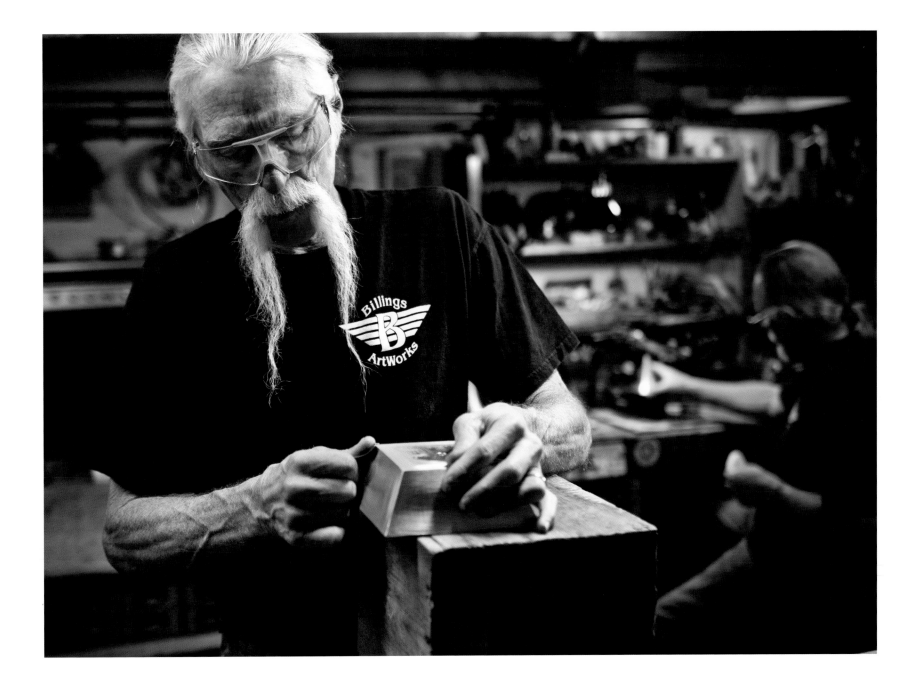

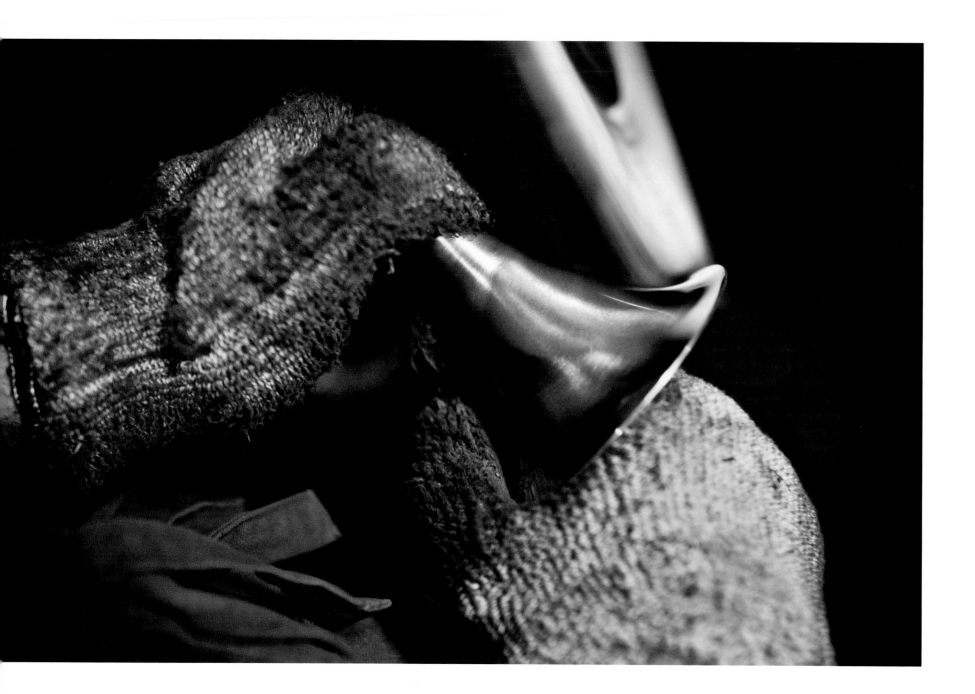

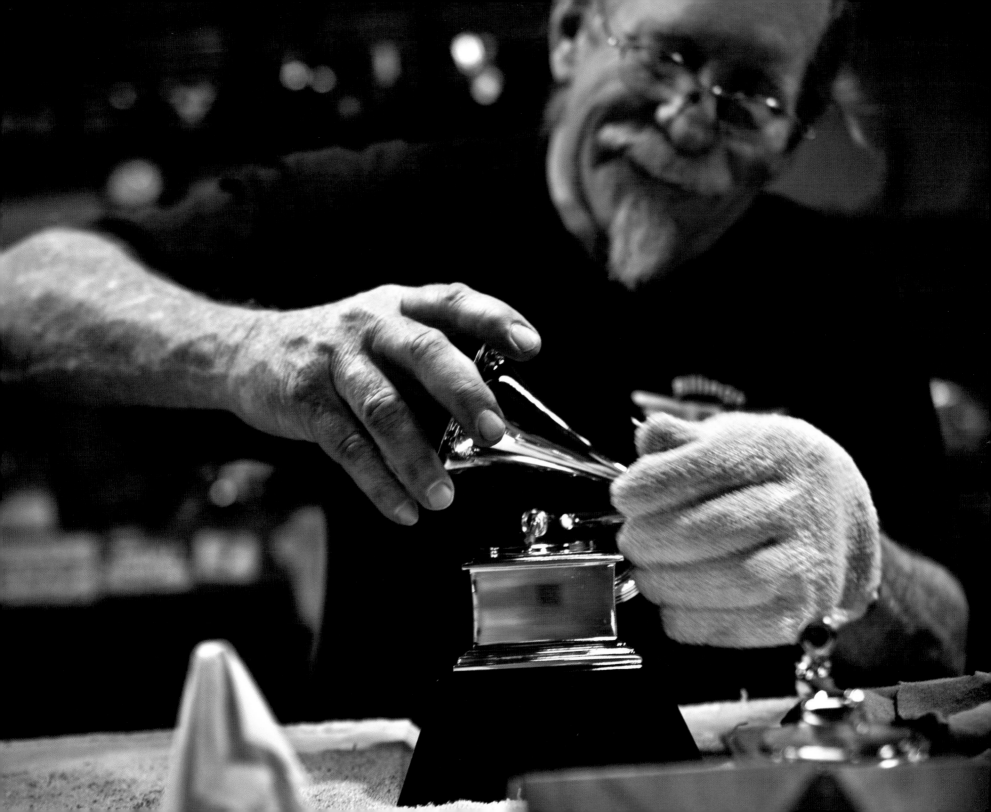

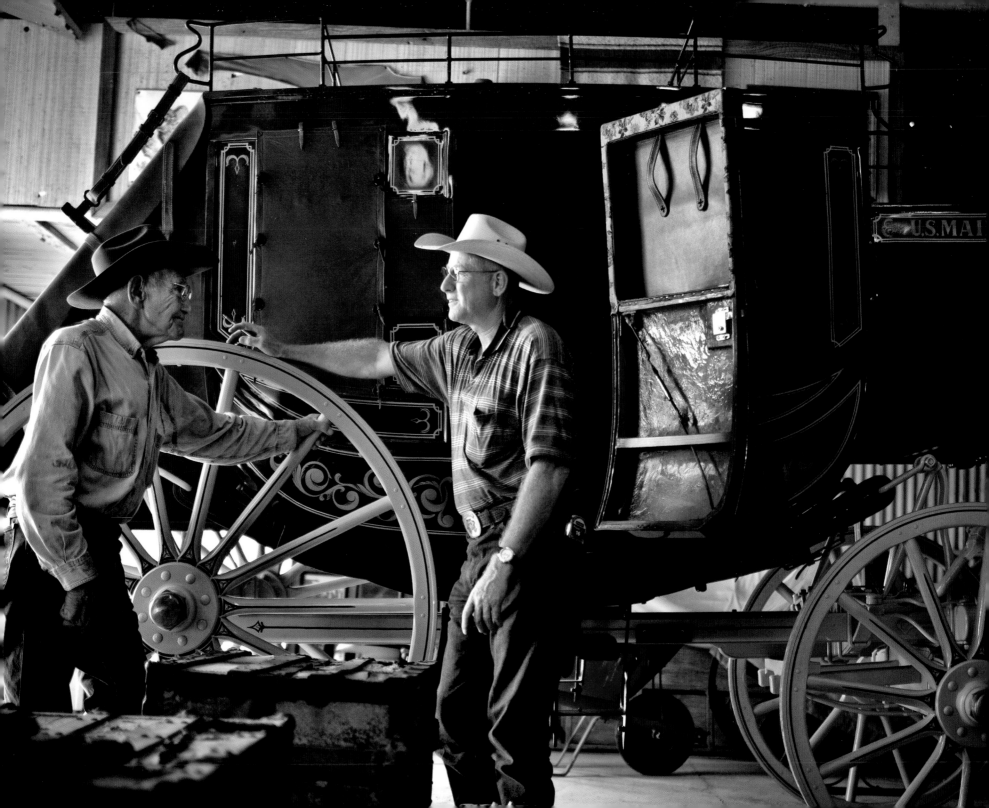

J. WILSON STAGECOACH WORKS

Paradise, Texas

⸳⸳⸳⸳⸳⸳⸳⸳⸳⸳⸳⸳⸳⸳⸳⸳⸳⸳⸳⸳⸳⸳⸳⸳⸳⸳⸳⸳⸳⸳⸳⸳⸳⸳⸳⸳⸳ ★ ⸳⸳⸳⸳⸳⸳⸳⸳⸳⸳⸳⸳⸳⸳⸳⸳⸳⸳⸳⸳⸳⸳⸳⸳⸳⸳⸳⸳⸳⸳⸳⸳⸳⸳⸳⸳⸳

It was 2007 and Jimmy Wilson's mentor told him he was ready.

Jay Brown—Wilson's father-in-law, owner of Jay Brown Stagecoach Works, and maker of sixty stagecoaches—asked Wilson to take over the business.

"Jim-boy," Brown told Wilson, "I'm tired of making stagecoaches. I'm gonna let you have the orders."

Wilson felt the rush of pride and responsibility Brown's decision gave him; he had been learning the craft for years alongside Brown, who first fell in love

with stagecoaches when he drove one for a hold-up scene in a Wild West show at Six Flags Over Texas. Not long after, Brown was coincidentally asked to do restoration work on one. Brown began studying the history of stagecoaches and working on his own designs; he eventually was asked to build one. Brown would describe it as "a hobby that got out of hand."

Not for long. It soon was a full-fledged business. Wilson had been helping his father-in-law in his spare time for decades, first building buckboards (four-wheeled wagons pulled by a horse, like on *The Rifleman*) and finishing his own coach in 1992. "You have to make every piece and part," Wilson says. "There are no stagecoach parts at Home Depot."

Over the next twenty years, while keeping his day job doing custom millwork, Wilson "tooled up," stocked his own shop, and helped Brown as much as possible. When he took over making the coaches, he quit his day job, of course, as it takes many months to build a single coach.

The wheels are still built by Amish tradesmen, but everything else today is handmade by Wilson. He makes a Concord, or western-style, stagecoach: "the Cadillac of coaches." Once the wheels are ordered, he begins the ironwork to construct the running gear (the base of the coach). It's an exacting process of assembling for fit, then disassembling to prime and paint, then reassembling.

Next he makes the leather straps that cradle the body (the cabin area) on the running gear. It works better than springs for shock absorption (the idea came to a stagecoach designer watching a baby carriage on a bumpy sidewalk). The body is constructed either out of fiberglass for durability or wood for authenticity.

Once the body is built and painted, he completes the interior upholstery work (usually leather). The painting and pin-striping artwork on the wheels, running gear, and body are the final touches before the coach is "born."

Wilson built two stagecoaches for Wells Fargo last year. They were Brown's best customer, and when he passed away in 2011, the company signed a contract with Wilson. He's working on his fifth coach now, waiting on his next order. Hollywood is always a possible customer—Brown's coaches have been seen in movies like *Maverick* and *Night at the Museum*.

Wilson says he takes great pride in how "square and true" his coaches ride. "On level ground, you can pull that coach with two fingers," he says. "Jay always stressed that. Square and true."

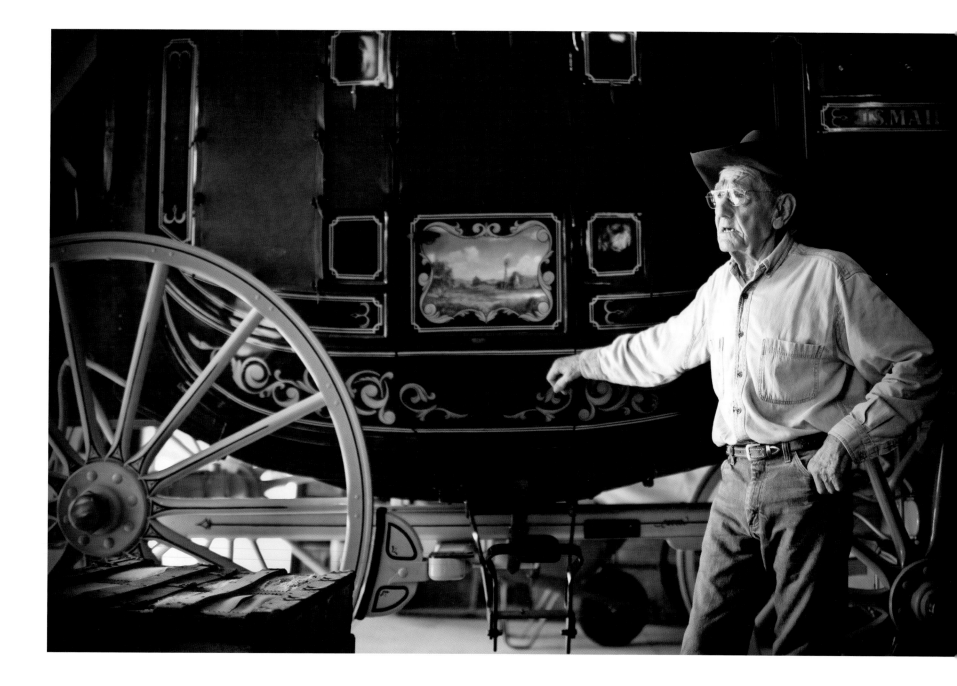

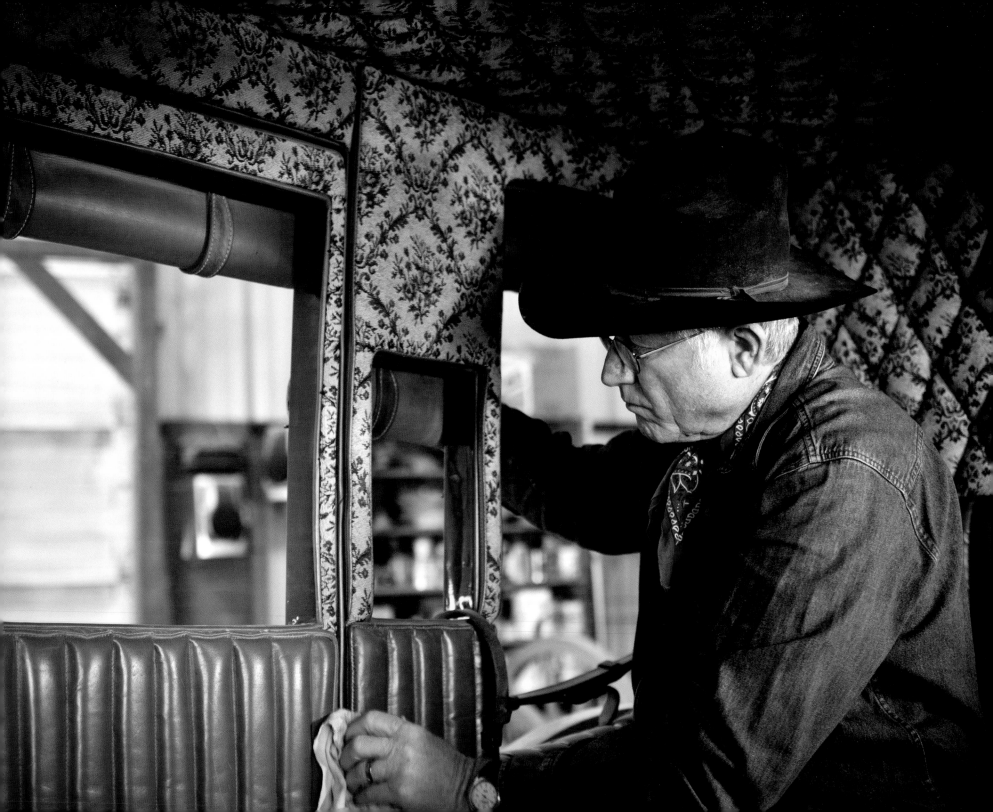

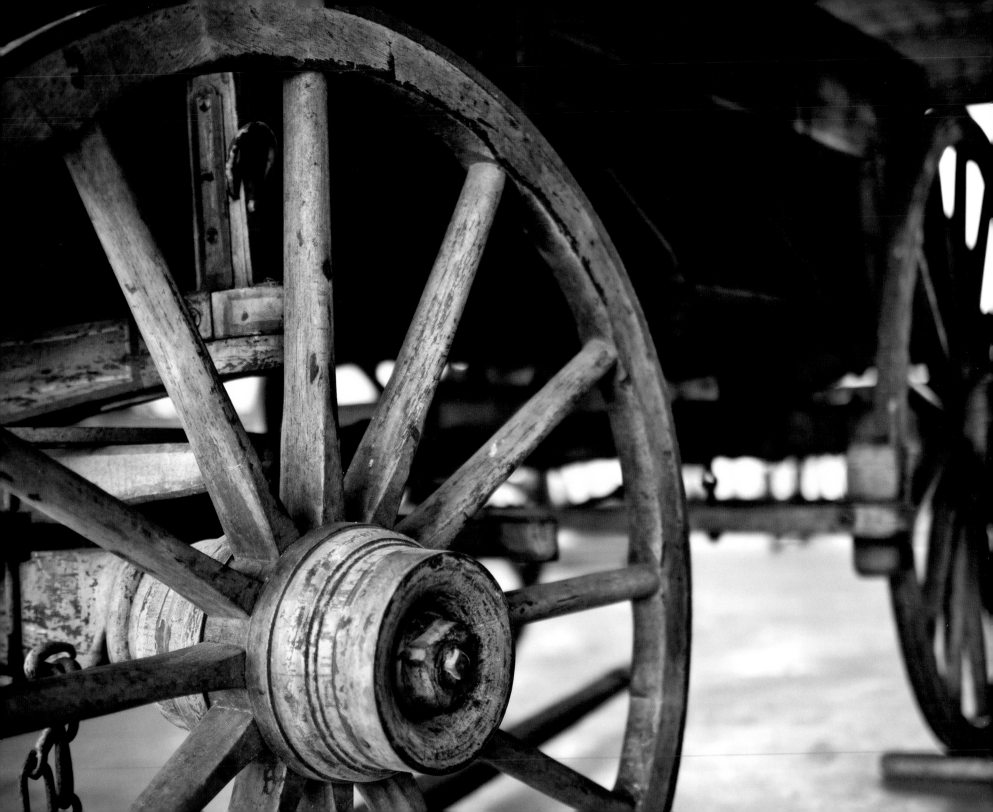

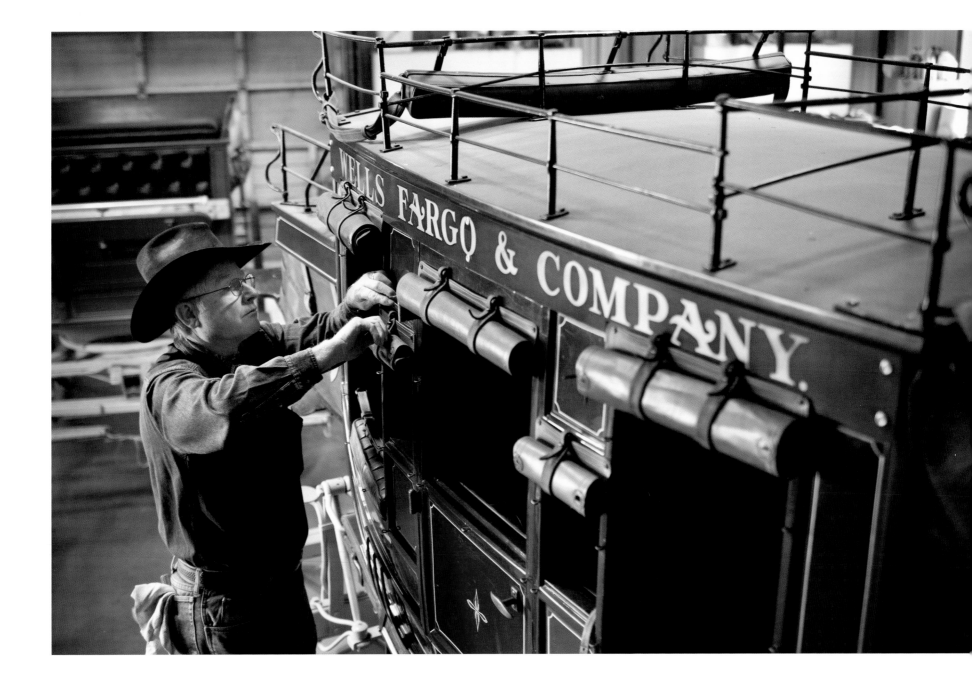

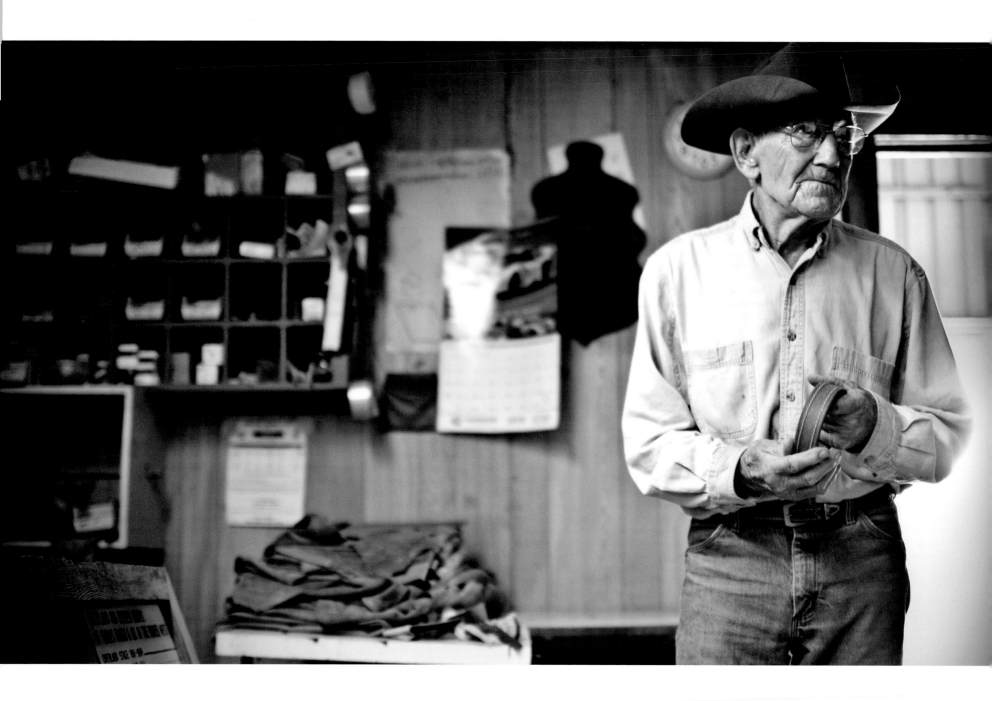

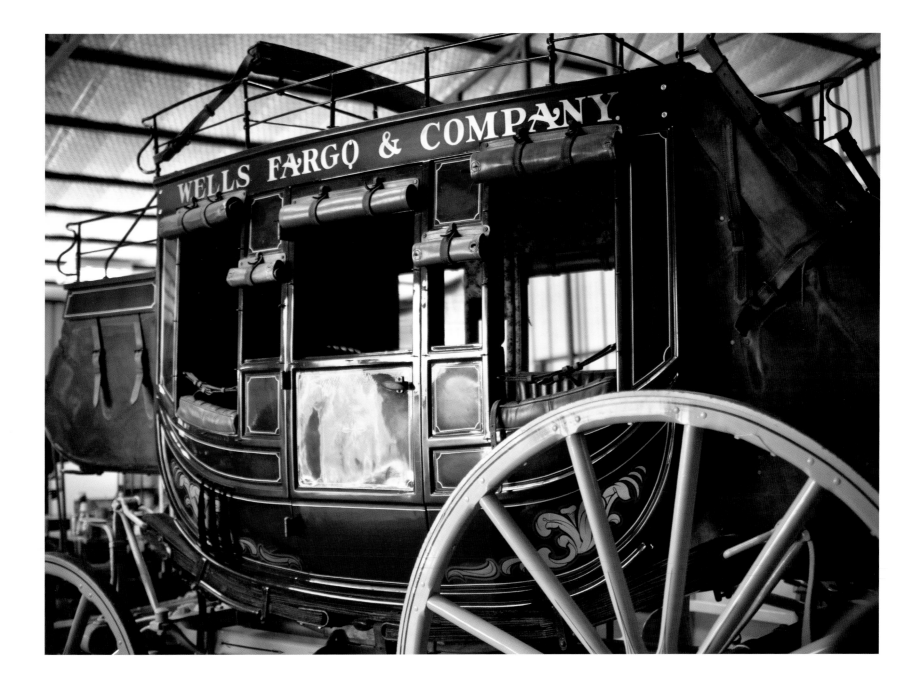

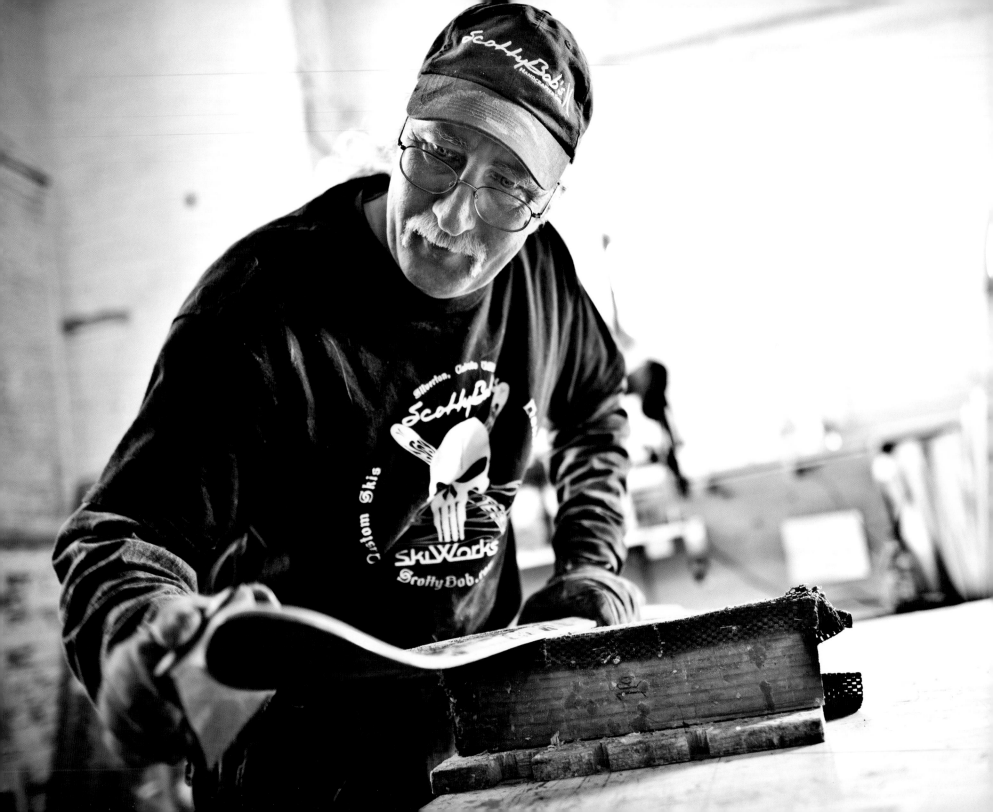

SCOTTYBOB SKIWORKS

SILVERTON, COLORADO

⋯⋯⋯⋯⋯⋯⋯⋯⋯⋯⋯⋯⋯⋯⋯⋯⋯ ★ ⋯⋯⋯⋯⋯⋯⋯⋯⋯⋯⋯⋯⋯⋯⋯⋯⋯

The name is what everyone asks about, and what everyone remembers. "How did you come up with ScottyBob?" they ask Scott Robert Carlson. It's a two-part story.

Carlson was a ski instructor at Arapahoe Basin in the Rocky Mountains. A young woman asked him for his middle name. When he told her, she proclaimed, "Scotty Bob!" It stuck in Carlson's mind.

Not long after, Carlson was busing skiers around resorts in the area, getting angry at how the dispatcher would use the drivers' first and last name when asking for their location. (*Scott Carlson, what's your 10-20?*).

Carlson didn't like the guests to know his last name. Then they hired a woman who was going through a divorce, so she was allowed to use her first and middle name.

"I was mad as hell," Carlson says, laughing. "I said, 'Why can she do that?' I told them from now on, damn it, I'm Scotty Bob!"

And so he was, so much so that when Carlson, fed up with traditional symmetrical-style skis, began making his own skis, there was never much doubt as to what they'd be called.

Today ScottyBob skis are known for their craftsmanship, style, and functionality. Carlson, a lifelong skier and ski instructor, had long preferred the "telemark" style of ski binding (heel free of the ski) as opposed to the alpine style (heel locked in place). But he was dissatisfied with the design rigidity of all skis. Finally, he took a hacksaw to a pair of standard manufactured skis and created the inspiration for ScottyBob skis.

In broad terms, Carlson took a telemark binding (telemark skis were traditionally "skinny and flimsy") and connected it to a firmer, better alpine ski.

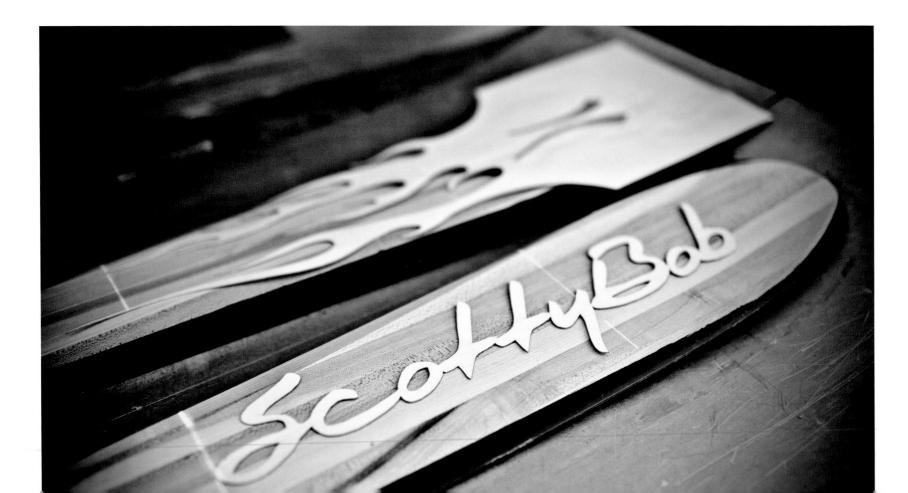

But that was just the first challenge. Then came reshaping the skis to be less symmetrical, more flexible to the skier and terrain. "The first thing I did was just cut the tails off a pair of skis," Carlson says. "I knew it from the first turn. This was better."

Carlson isn't one to talk in detail about his craftsmanship. He won't reveal, for example, how long it takes to make a pair of skis. ("Less time than you think, but it takes a long time to learn how to do it," is all he'll say.)

He uses a sugar maple core for his skis, not the cheaper poplar or aspen. "It has a good binding retention," he says. "The bindings don't rip out, and it has more springback than those woods. And the skis never snap in two."

Which is why, even though he doesn't make a ski until it's ordered, customer orders come into his two-thousand-square-foot shop from all over the world: Norway, France, Spain, Germany, Japan, and the United States. Because they know the quality never wavers.

"We don't change too much," Carlson says. "It's the 'keep it simple stupid [KISS]' method. We just keep it ScottyBob."

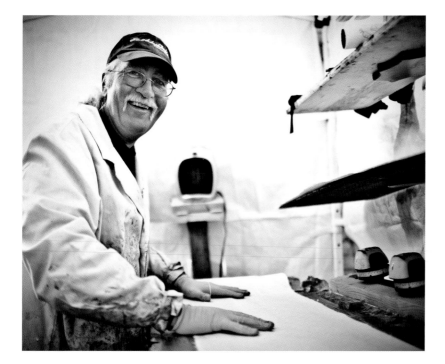

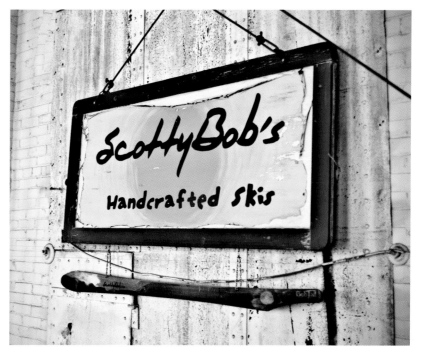

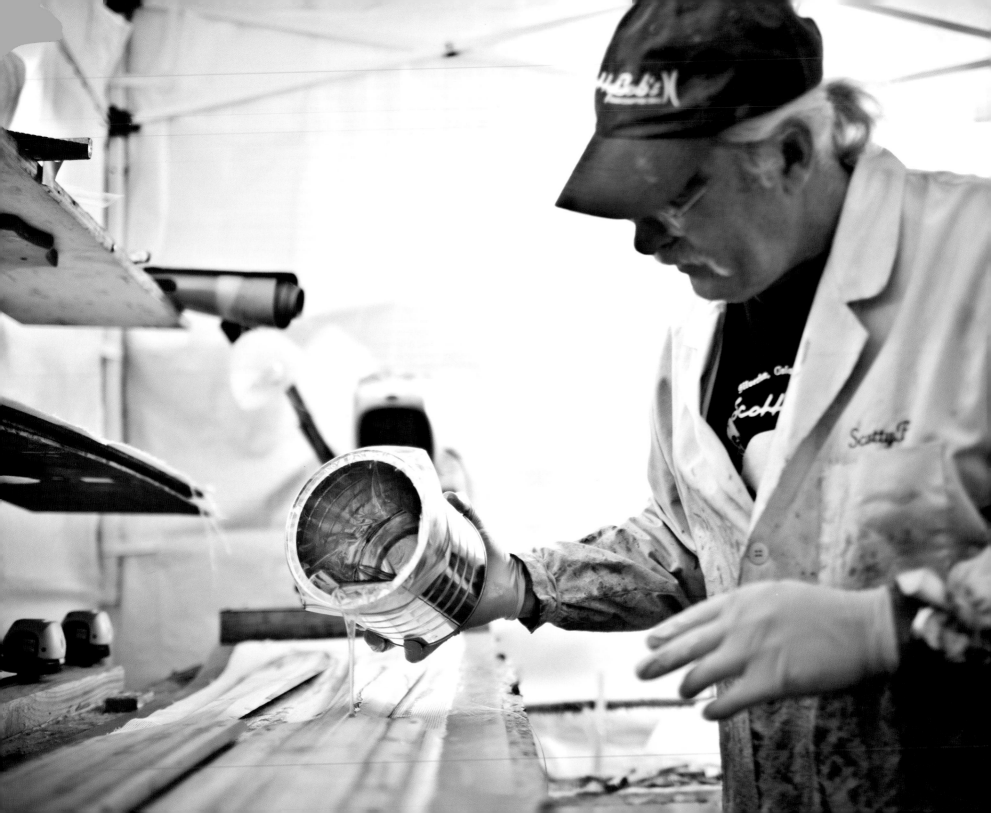

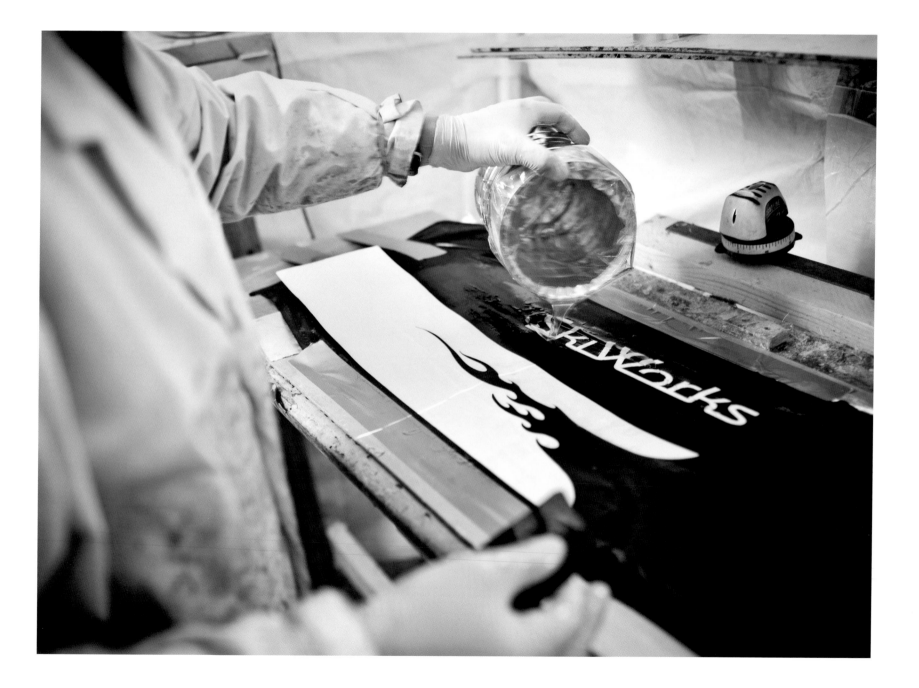

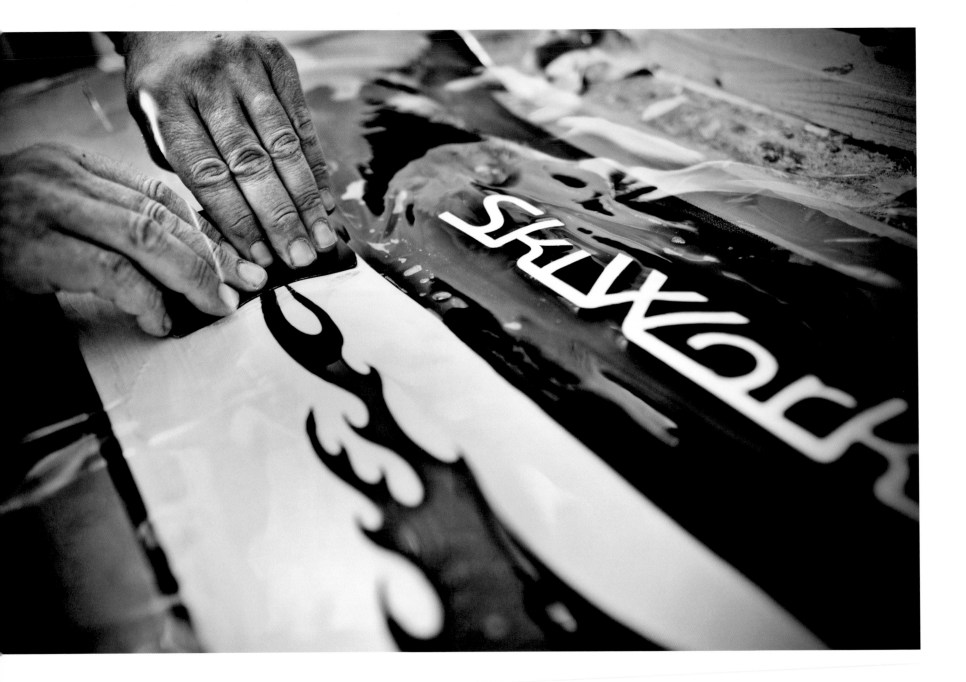

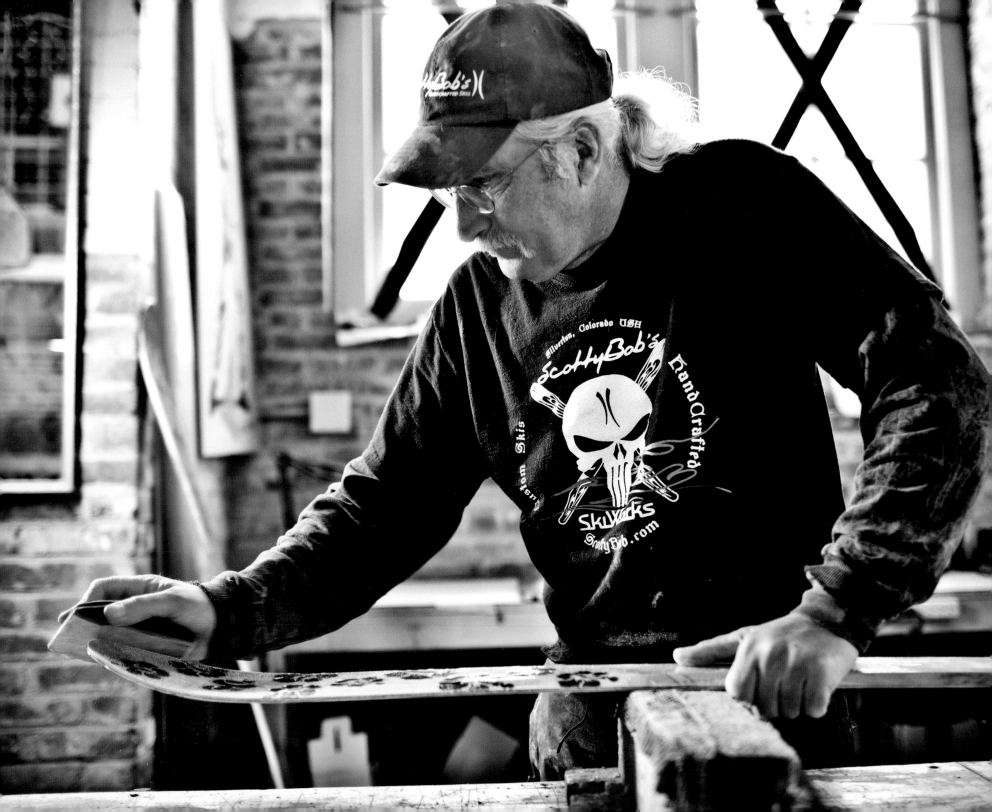

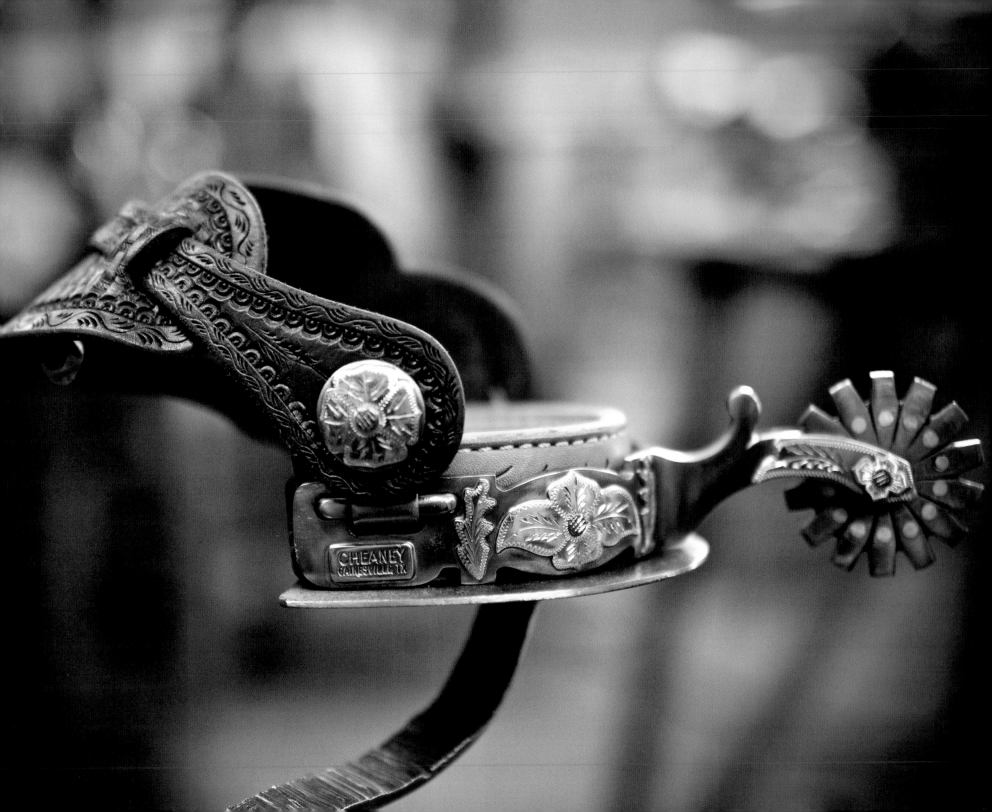

CHEANEY
GAINESVILLE, TX

CHEANEY CUSTOM SADDLES, BITS, AND SPURS

GAINESVILLE, TEXAS

· ★ ·

Though saddles were in Bruce Cheaney's blood, spurs came to him later in life—in a flash of inspiration.

Cheaney's great-grandfather set up a saddlery in Gainesville in 1877, which he ran until he passed away in 1906. Cheaney's grandfather took over the shop, followed by Cheaney's father and two of his uncles. Cheaney was raised in the store where his dad built custom saddles and his mother made western clothing, boots, and hats.

He would work in the shop in the afternoons after high school, and in the early 1970s Cheaney was

ready to learn the saddle-making craft himself. By the late 1970s, when he could make a complete saddle by himself, he opened up a shop. But he had taken an interest in metalwork, so he wanted to make spurs and horse bits as well.

One type of spur in particular eluded him: the one-piece spur, a complete boot spur constructed out of one billet (a metal rod or bar). In August 1980 he and his new wife and infant son visited a man who'd made fifty such spurs. Standing next to his baby carriage in the man's backyard, Cheaney was inspired: "I knew as soon as I saw him making one that I could do it, too."

More than three decades later, Cheaney is so adept at the process, he has YouTube instruction videos on how to transform a piece of metal into a work of cowboy art. While still known for his saddles, Cheaney is clearly proud of the spurs he learned to make only after he'd opened his store.

"The first trick is finding the right metal," he says. He prefers Model T axles, though they're tough to find, as their carbon content makes for a durable spur. (He also likes an aircraft alloy known as 4130.)

To make a pair of spurs, he cuts the metal into two 6.5-inch billets, then splits them lengthwise with a cutting torch. The billets go in the propane forge (or, if needed, a coal forge), then he hammers flat the shank—the end that sticks out from the boot and holds the rowel. Once he gets the split ends hot in the forge, he places the split over an anvil and hammers down to split the billet to make the heel band.

Then comes the long process of shaping the shank and heel band before he goes to work on making and attaching the rowels (which by themselves go through *seven* sanding procedures to get a proper finish). Using extremely delicate tools, Cheaney then carves and designs the spurs and rowels as needed, adding artisanal touches until the spur is complete— and a far cry from where it began.

It normally takes him a week to complete a pair. But he's been known to get them done in a few days when needed. "Sometimes a carload of people will pull up and say, 'We're only here a few days!' I tell 'em I can get them a pair if I really hustle."

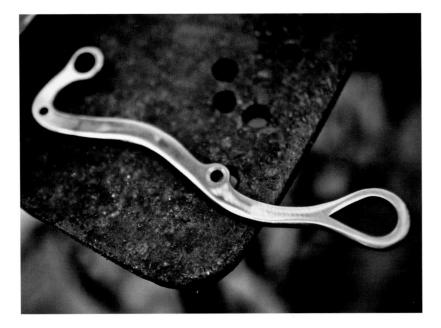

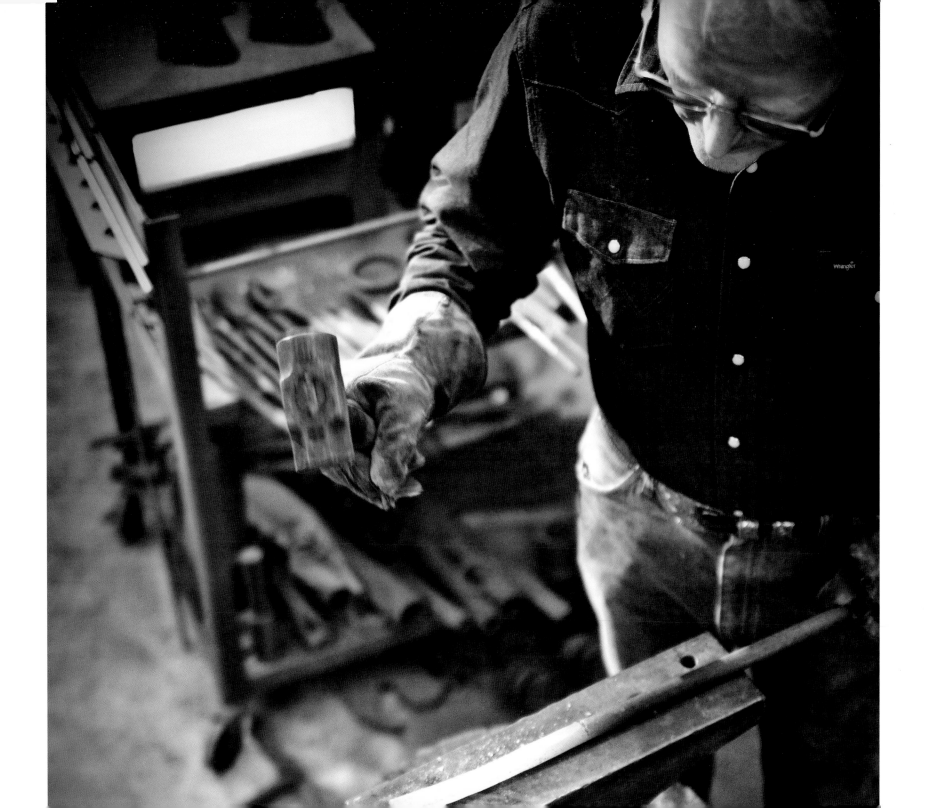

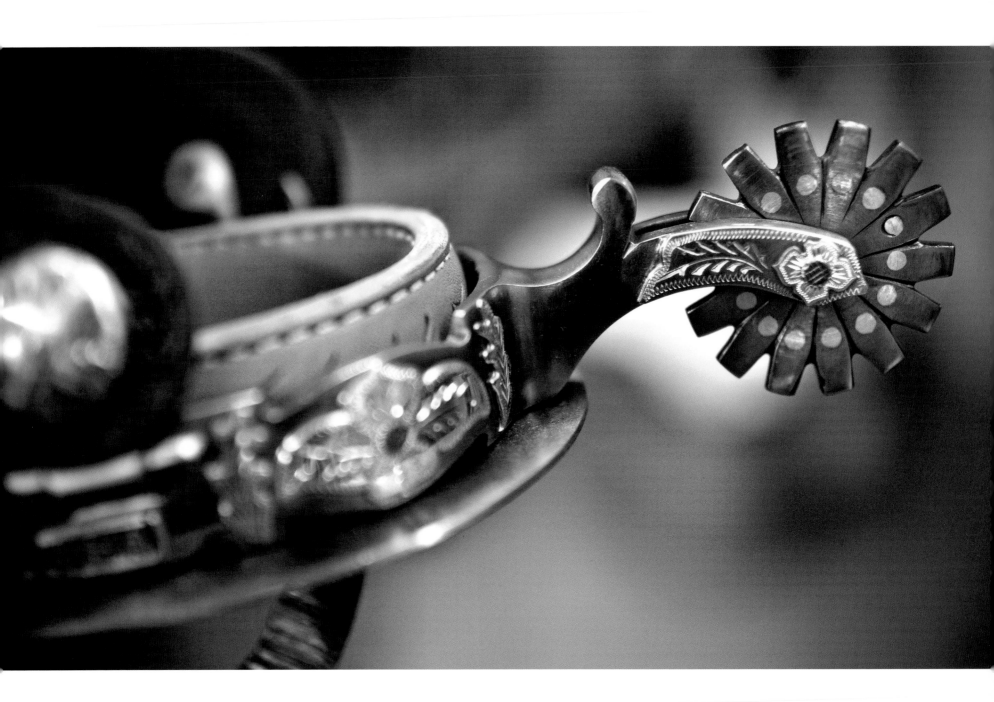

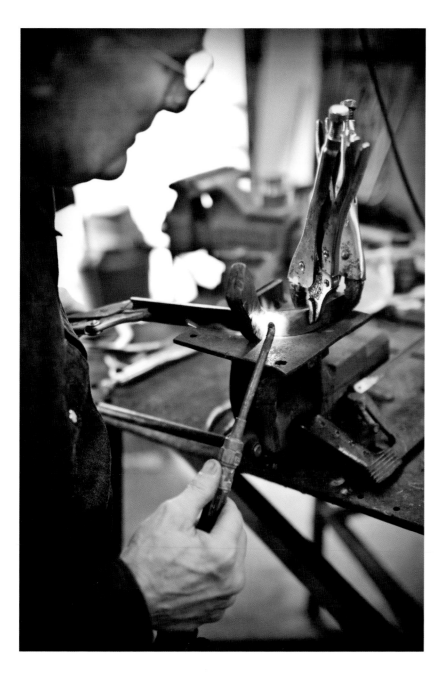
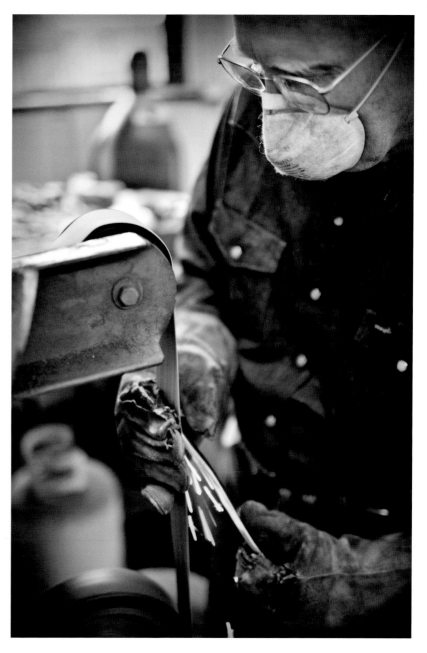

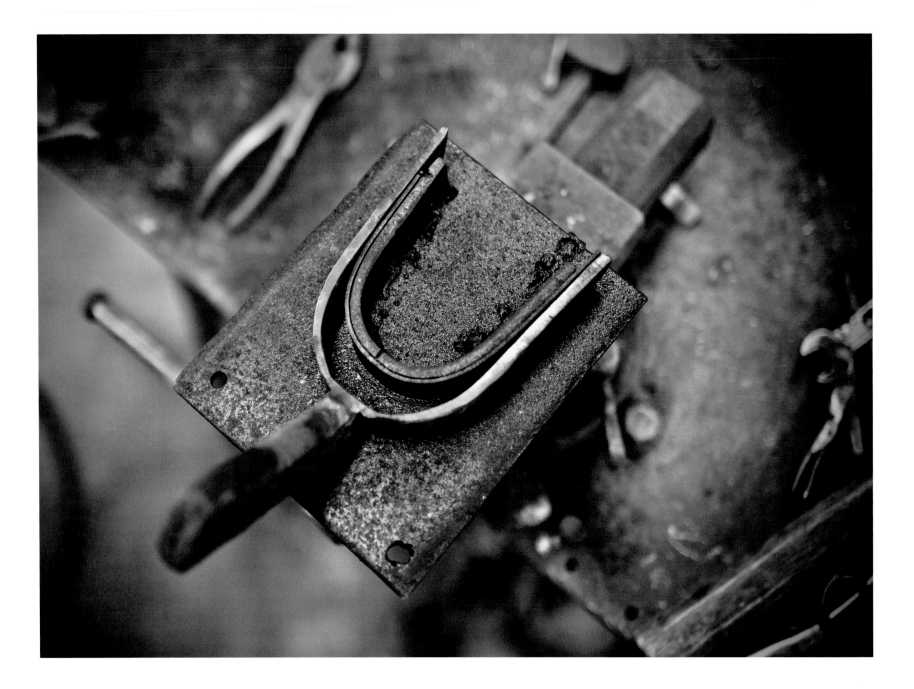

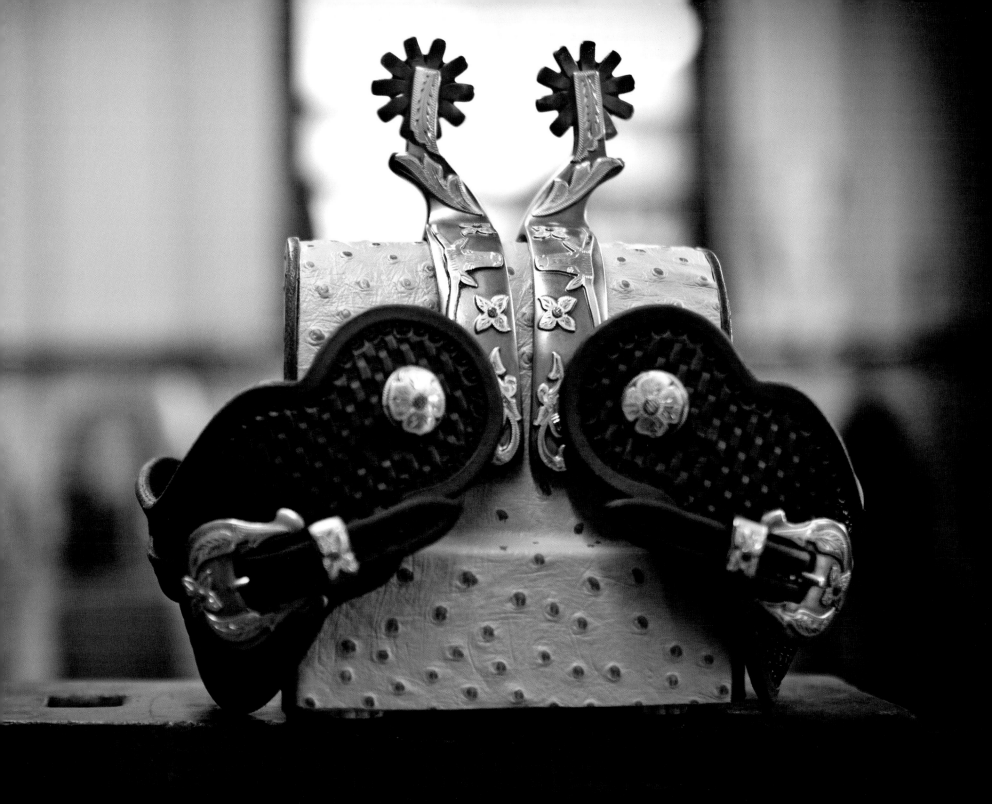

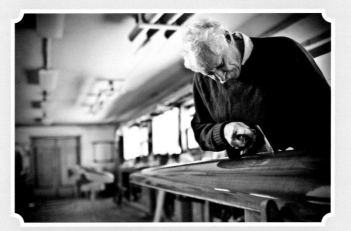

KING BOAT WORKS

PUTNEY, VERMONT

⋯⋯⋯⋯⋯⋯⋯⋯⋯⋯⋯⋯⋯⋯⋯⋯ ★ ⋯⋯⋯⋯⋯⋯⋯⋯⋯⋯⋯⋯⋯⋯⋯⋯

The first time Graeme King saw "a real live 8"—an eight-oared rowing shell, or boat—was in Adelaide, South Australia, when he was fourteen years old. He'd been fascinated with them as a small child ever since he saw them in newsreel recaps of shell races. "I was pretty impressed when I saw it," he says. "And I just told myself, 'I'd like to make one of those one day.'"

He got his chance a few years later, when he picked up some World War II surplus plywood for twenty-five cents a sheet and built one from scratch with just the hand tools he had available. "I guessed

pretty wrong at the internal structure," he says, laughing softly. "But I learned a lot."

Others began to ask him to build shells—one of which, a "single" (for one rower), won its owner a national championship. After that King joined the Harvard rowing program in America, then returned to Australia to start a business building shells—instead of going into railroad engineering as planned. The decision was made for him when he sat down to take his engineering exams and fifty more students took their seats. "I realized no one was building shells, but there were a lot of engineers," he says.

When he moved back to the United States in 1980, King Boatworks took up its current home in Vermont. For much of his career, he has made shells out of wood instead of carbon fiber, thanks to a weapons research scientist who told him early on: "If you make them out of carbon fiber, you'll make more money; if you make them out of wood, you'll have more fun."

King says the art of building wooden shells is what makes them beautiful, while the science behind their construction is what makes them fast. After building the pieces for the framework, he assembles it on a jig, then gives it a coat of varnish. After that he shapes the framework so it can hold the plywood layers that make up the hull. The plywood is one-sixteenth of an inch thick, and it's stretched and shaped carefully over the form, then attached to the framework before the interior is varnished. Adding the other elements he's constructed—seats, riggers,

fittings—comes last. It takes 130 to 140 hours to complete a boat that'll last for decades.

Much of his work with wooden shells these days is refurbishing. And he has expanded his work to include carbon fiber boats as well.

"People are confused when they first see one of these boats, unsure if it's a piece of modern art or some lethal missile," King says. Rowing shell design is ever-changing, he adds, and advanced design work is where he spends much of his time now. Not surprising, since he's still an engineer at heart. An engineer who happens to love real live 8s.

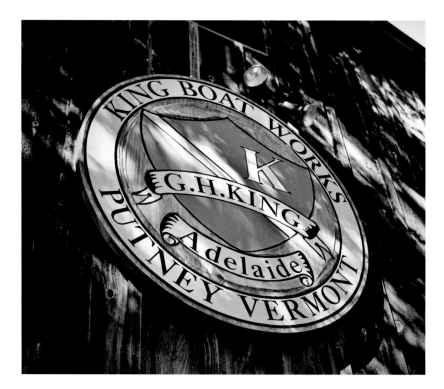

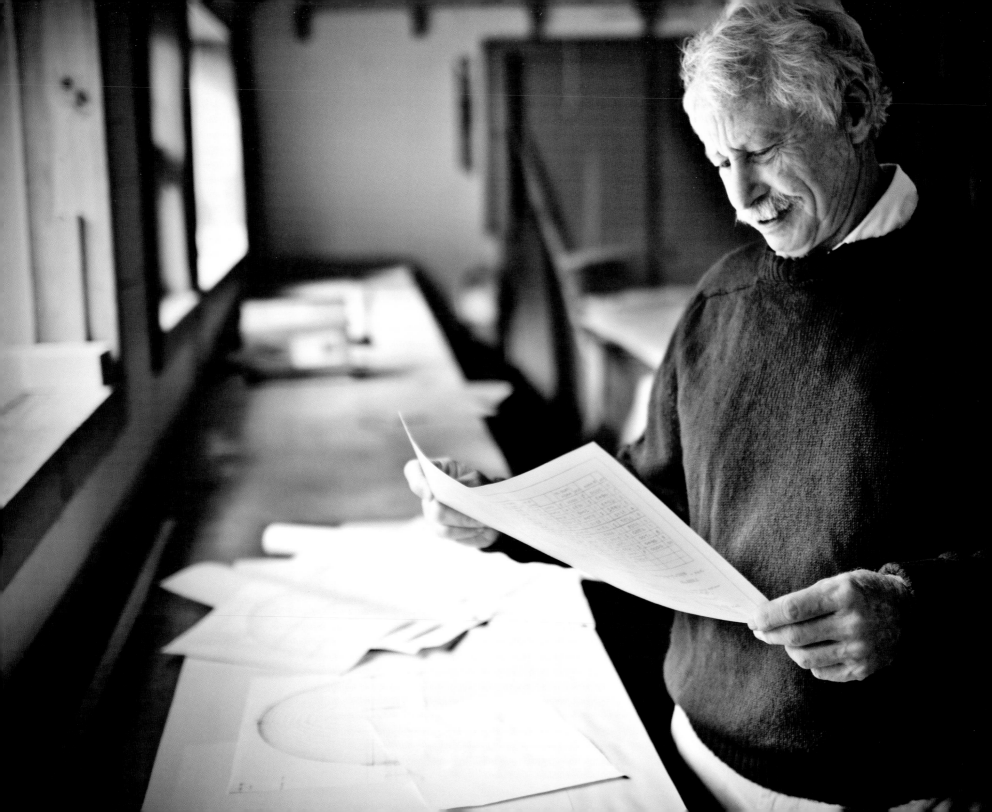

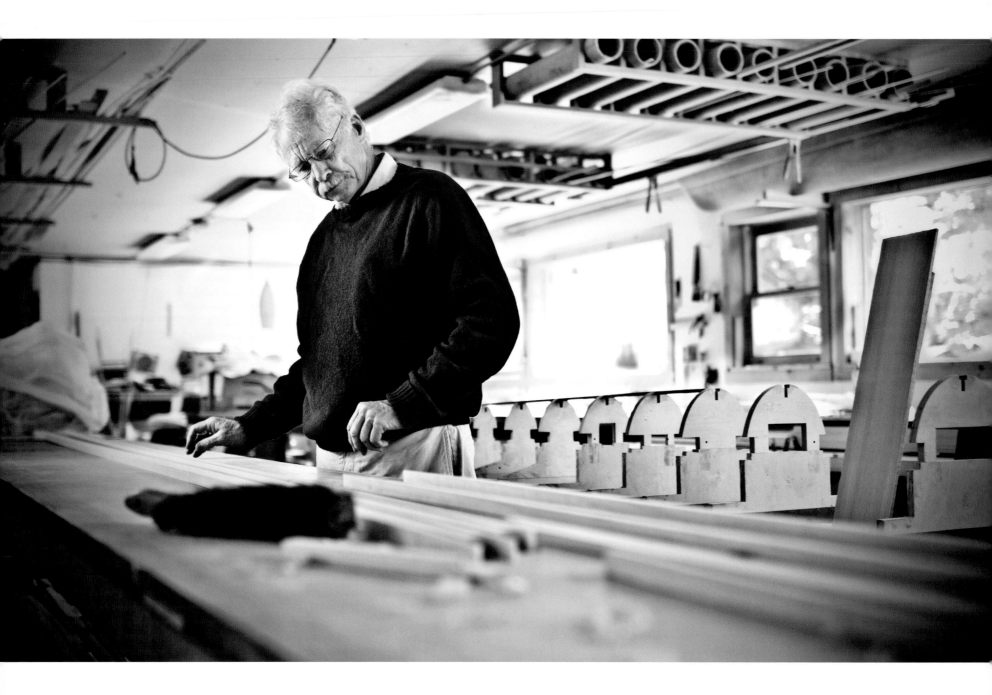

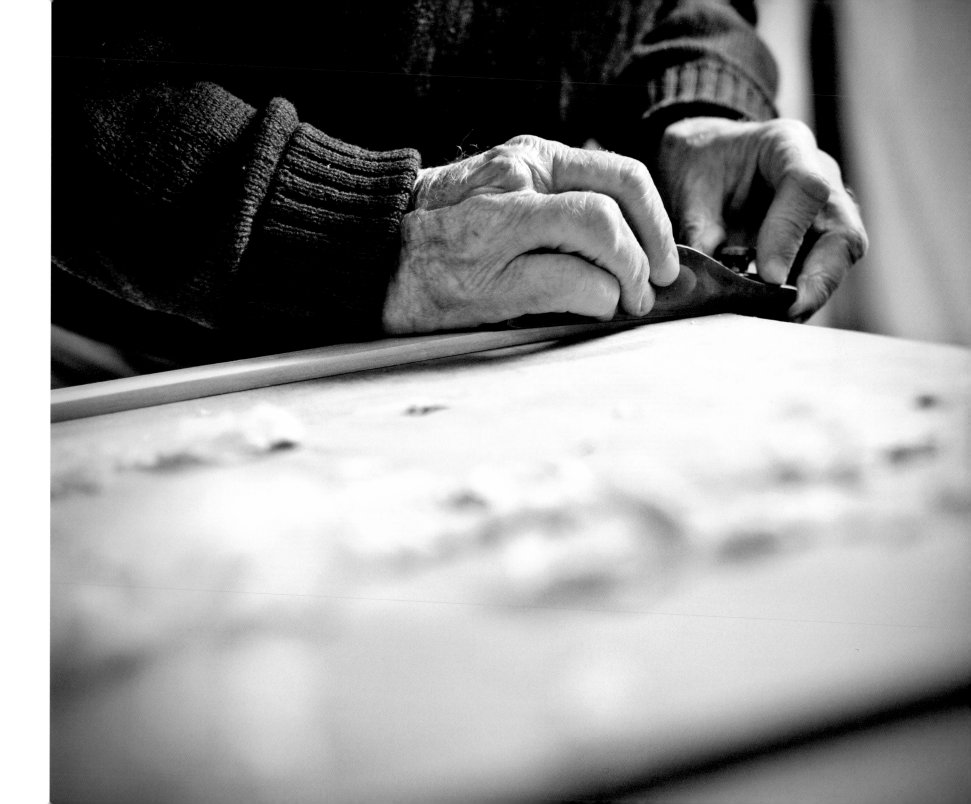

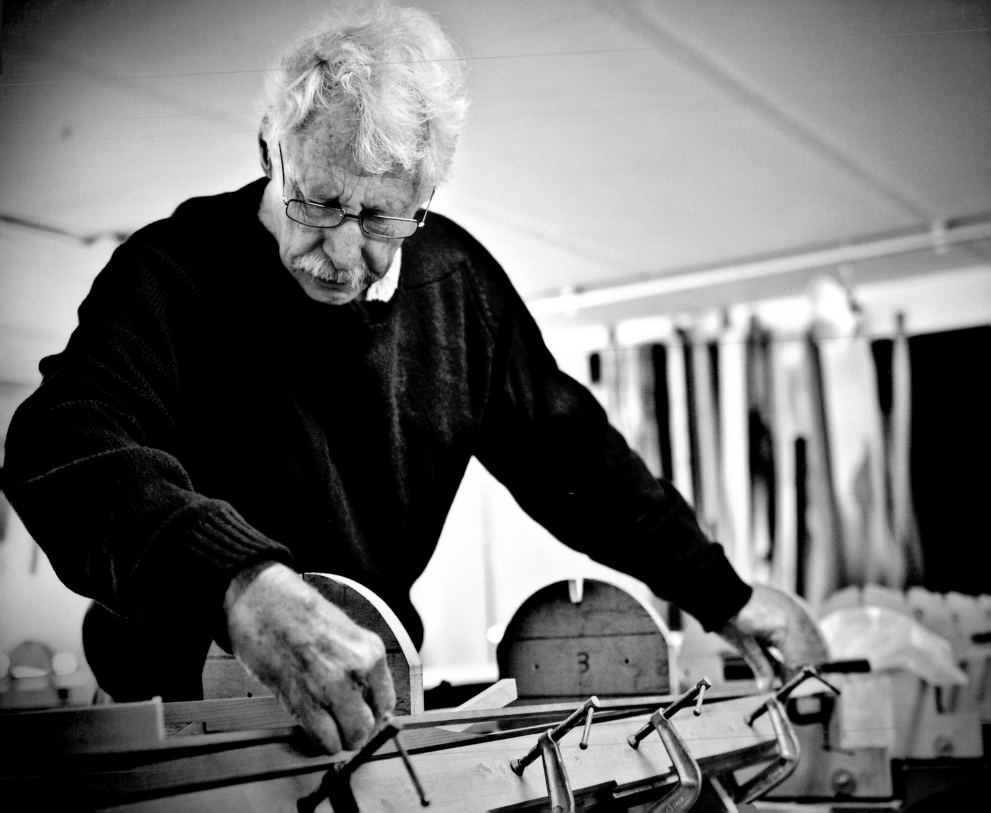

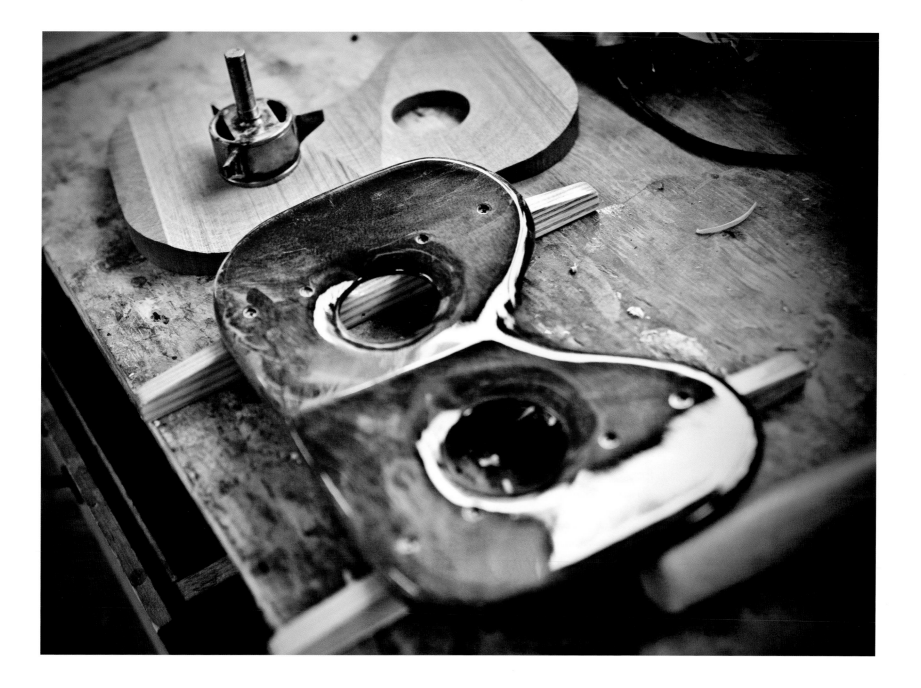

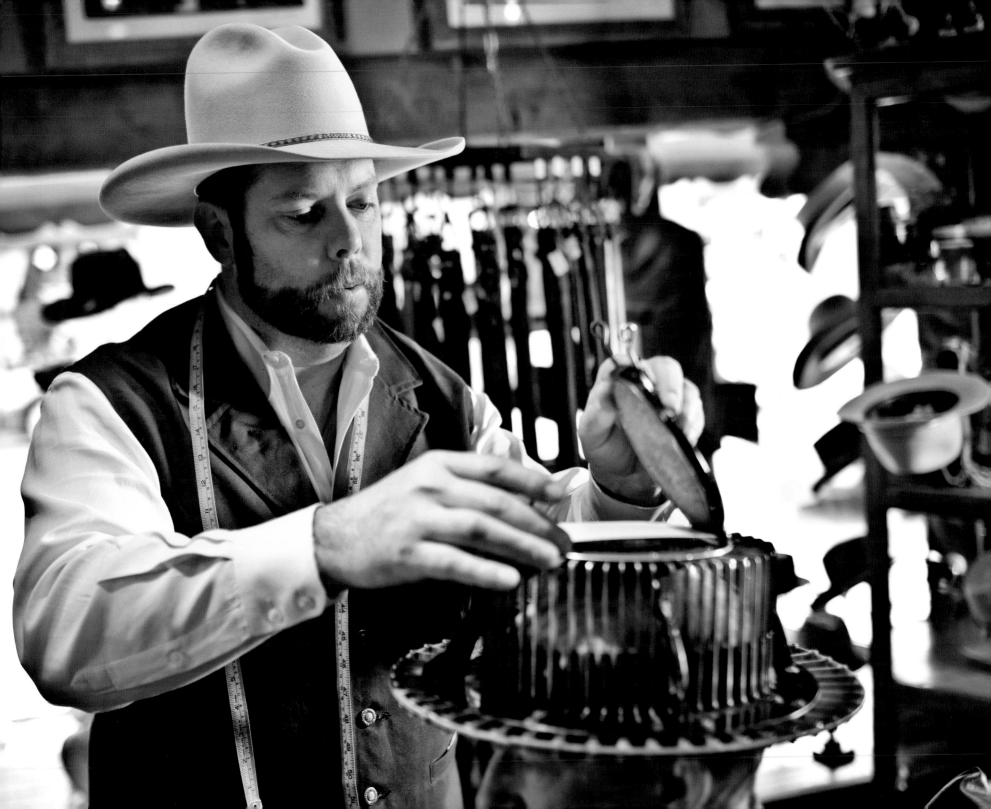

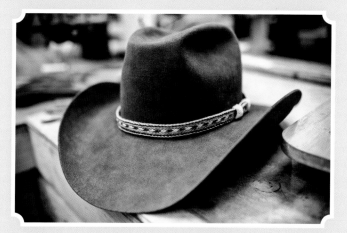

O'FARRELL HAT COMPANY

SANTA FE, NEW MEXICO

• ★ •

It was the Idaho winters of the late 1970s that led to Kevin O'Farrell's career as a master hatmaker. That's because O'Farrell's first trade was building houses in Coeur d'Alene, in the state's far northwest corner. In 1979 the average minimum January temperature was just above eight degrees Fahrenheit.

People tend to buy homes when it's nice outside, so there wasn't much for him to do in the winter.

So after apprenticeships in Texas with some of the best-known cowboy hatmakers of his day, O'Farrell moved to New Mexico and opened up his own western hat-making store. He continued learning the craft

and acquiring classic hat-making equipment, including the item that most customers still remember today: the Conformateur, a mid-nineteenth-century metal hat-fitting machine that, when placed on the head, produces a "punch card" outline of the customer's head shape.

"My dad had a big head, and he had a hard time finding a hat that fit him," says Kevin's son, Scott O'Farrell, who took over the business when his dad passed away in 2006. "So we make sure we get the fit right, because 99 percent of the time, the stock size won't fit right."

Scott O'Farrell says he continues to make his cowboy hats in the manner of his father: "as true as we can to the way it's supposed to be done." First he guides the customer to find the qualities of hat that work best for him or her, from the crown and brim style and shape (the creases on the crown, for example, can be shaped, with scores of subtle differences between hats) to the color and feel of the felt.

Once the hat material is chosen—pure beaver fur, or a beaver and European hare blend—the crown and brim of the hat is blocked (shaped) by steaming the felt, which gives it elasticity. It's then ironed to make the felt denser and more durable. The hat is sanded and brushed to a fine finish before the sweatband is sewn in by hand, the interior satin is added, the final contours of the hat are put in place by the creaser, and the custom hatband is fit around the crown.

Scott O'Farrell says he offers many styles of hats, but he thinks the company will always be best known

for the sort of cowboy hats his father learned to make in Texas.

"You know, I wasn't interested in Dad's job at first," he says. "I would do chores around the store, work there on and off, but I was a typical young squirt and went off to do my own thing. But when he passed away, I knew I couldn't let the legacy go to waste. He'd established the name, and it was our name. And now, of course, I do love it."

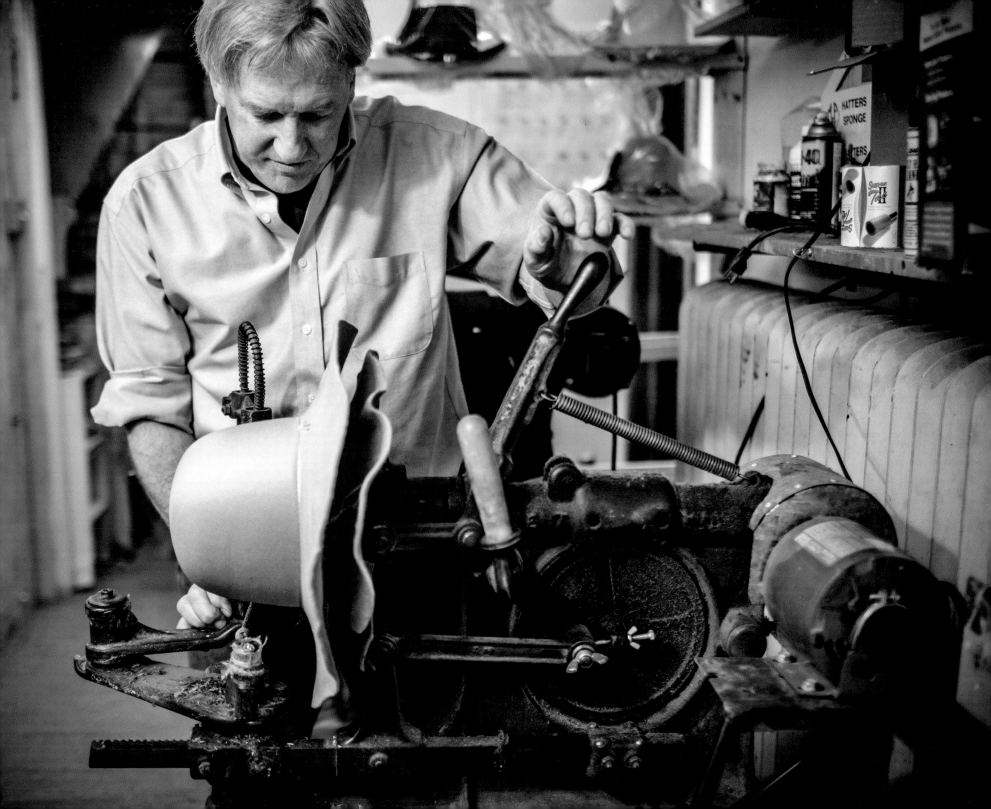

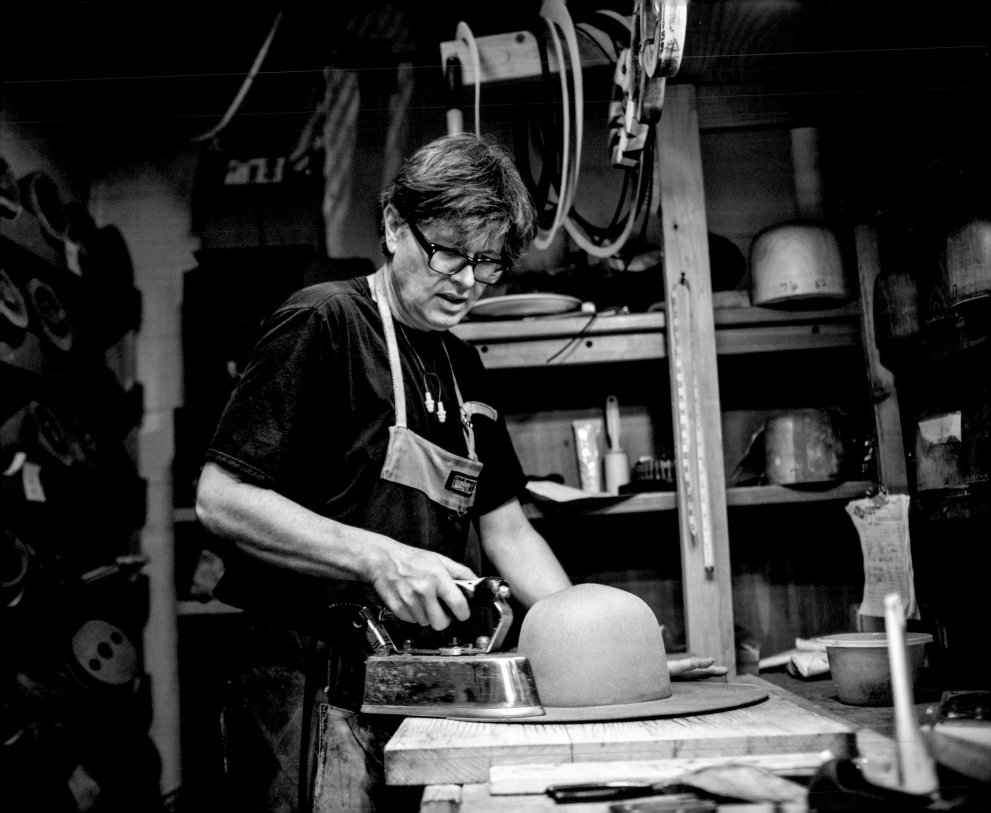

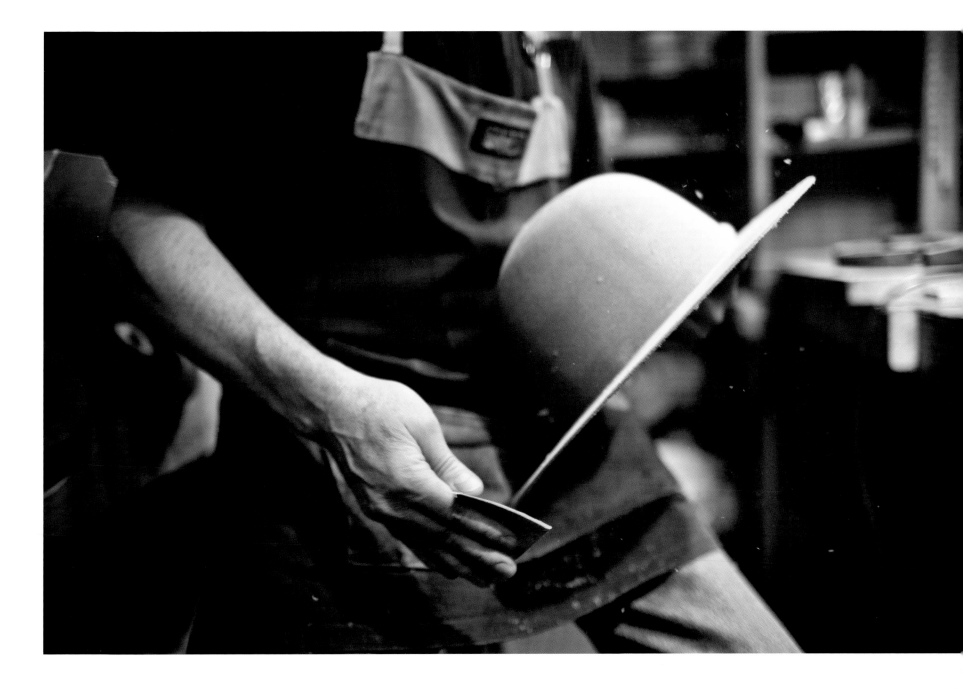

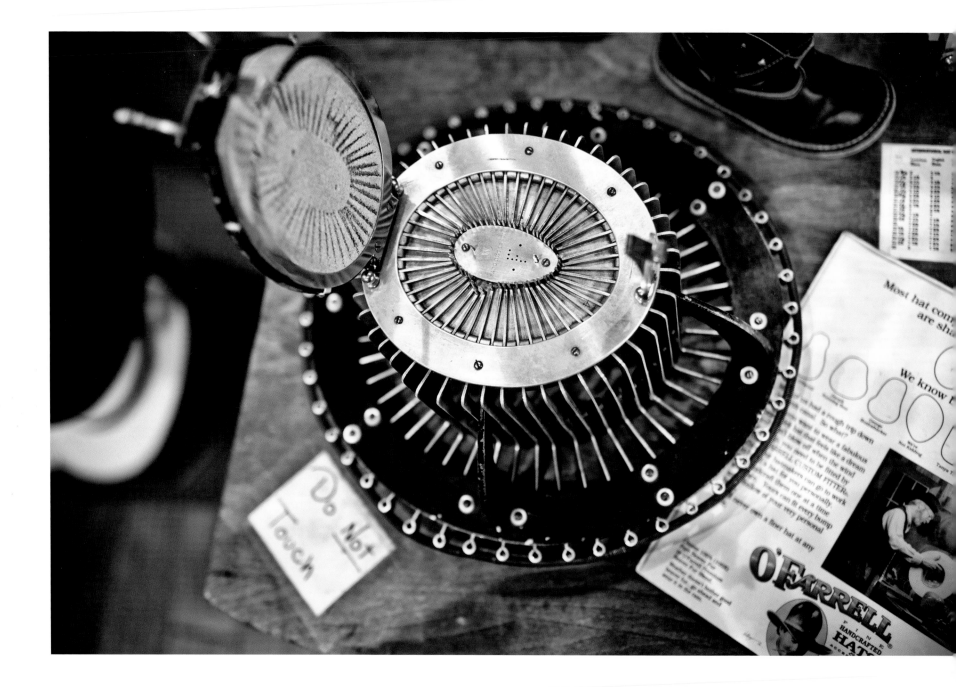

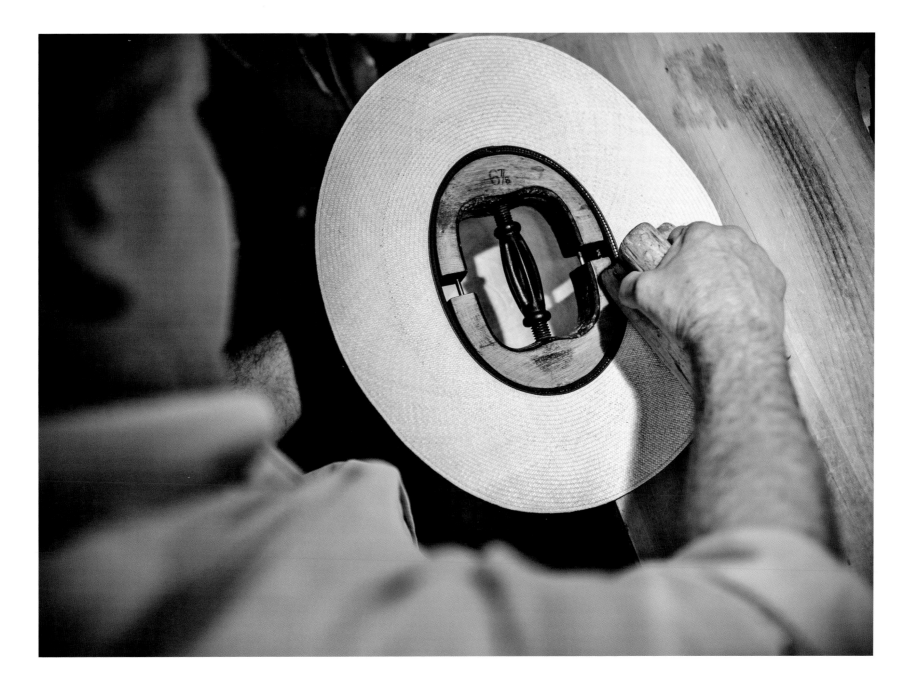

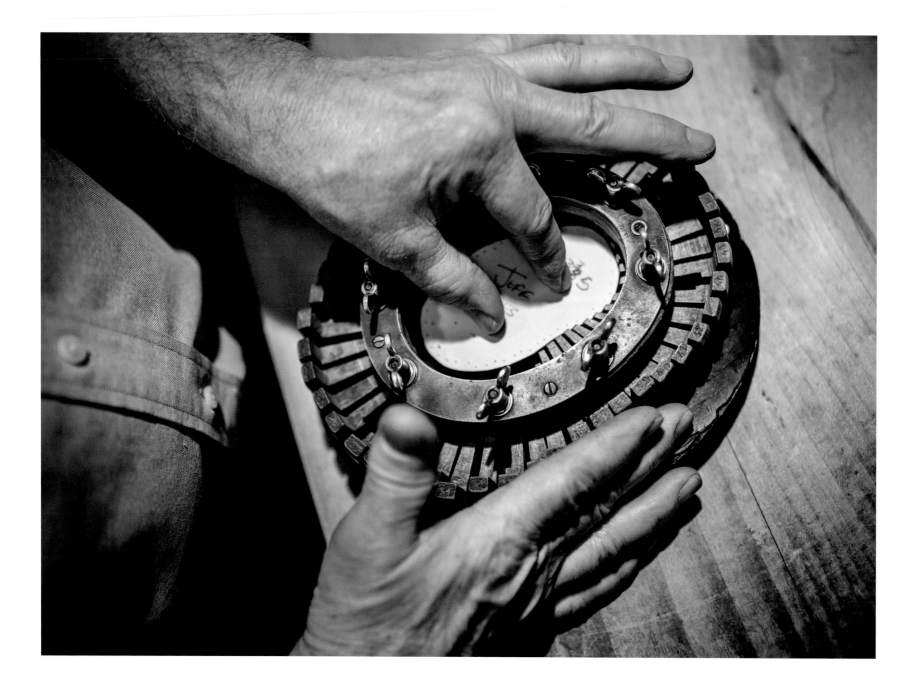

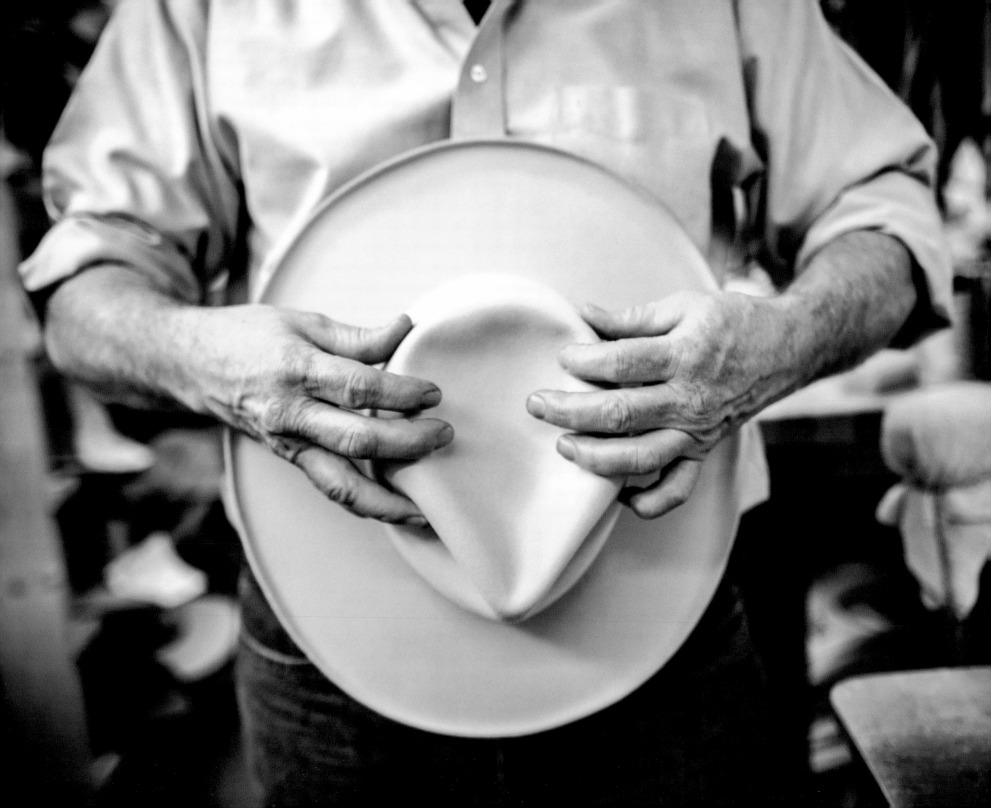

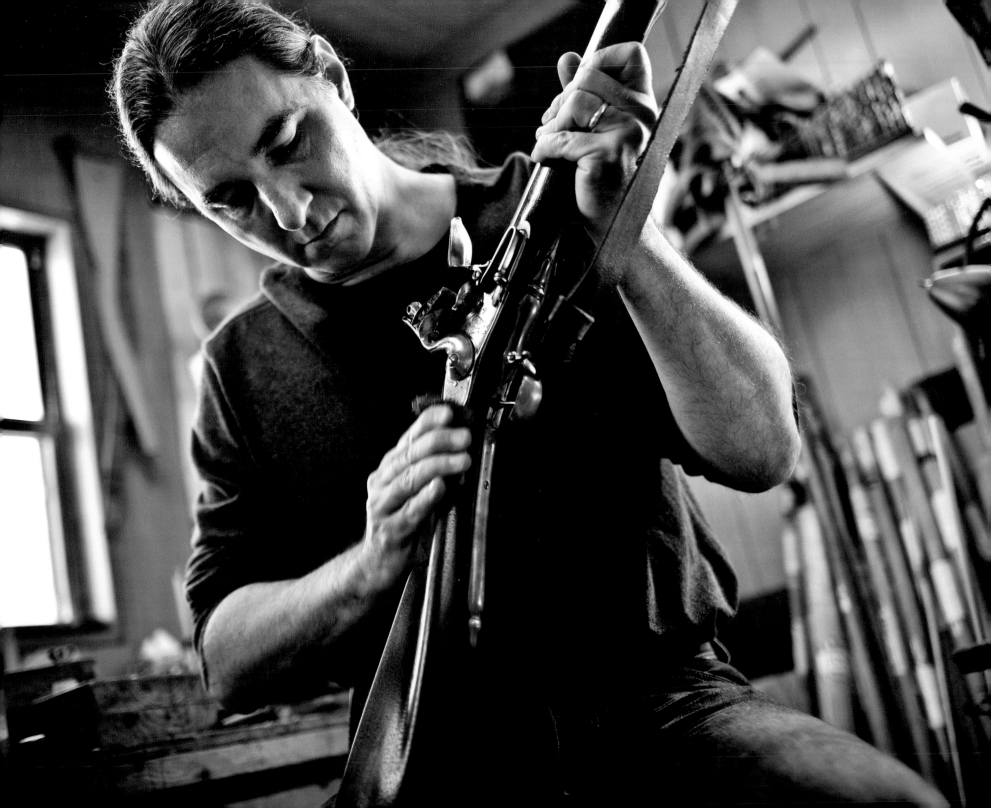

MILLER LONG RIFLES

PADUCAH, KENTUCKY

......................... ★

When Mike Miller met the person who would change his life, he didn't know enough to be embarrassed.

Miller was a thirty-three-year-old police officer, married with a daughter, when he met a man at a gun range who shared his passion for muzzle-loading rifles. Miller taught himself how to build his first American long rifle from a Connecticut Valley Arms kit by himself when he was twelve. It was a "sad reproduction of a Kentucky long rifle. I'm lucky I didn't blow anyone up," he said. When he was fifteen, Miller took a barrel, lock, and a board

his dad had cut from the family sawmill and gave it another go.

Miller brought his guns over to the man's house, where the man showed him two guns made by two of the best long-rifle makers in the country. This, the man said, is what such guns are *supposed* to look like. "I considered throwing mine in the fire," Miller says.

Instead he asked the man for mentorship, which he and several other master gunsmiths provided. "I had the very best teachers I could get," Miller says. "When God puts someone in front of you who will make you better, you shut up and listen to him."

Miller listened and practiced until he became a master gunsmith; now he earns his living making custom muzzle-loading guns. Miller makes pistols, too. He became well known when he was included in a gunsmith video as a pistol maker, which helped him go from three to four orders a year to thirty or more. Now he builds about one gun a month—and has a substantial backlog of orders.

Miller interviews his potential clients up front before he even considers making a gun for them. Much of his work comes from meeting people at muzzle-loading shoots or gun battle reenactments. "I'll ask them a lot of questions: 'Do you reenact? If so, what time period? What do you do with your gun, target shoot or hunt? Do you hunt big or small game? Where are you from?' Virginia style is different from

Tennessee, for example," Miller says. "If he's rich, I can make it fancy. If he's a farmer, and he just needs it to shoot a hog, that's the kind I'll make him."

Once Miller knows what caliber is required, he'll order the barrel and gather the wood, locks, and mounts. When it's time to complete the rifle, he first assembles the plate, trigger guard, and other elements. He'll draw a pattern on the wood, shape the stock, and finish with screws and bolts he's made himself. For authenticity he rarely will sand it smooth. Most of his finishing techniques are period specific, like using a bundle of reeds to burnish and sand the wood.

Other than test-firing it, he doesn't have to do too much else before he turns the gun over to its new owner. "The cool thing about muzzle-loader people is they're tinkerers," he says. "They can't leave stuff alone. Whatever else they want done to customize it, they'll do it themselves. We're independent people."

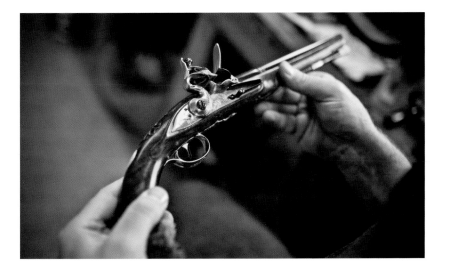

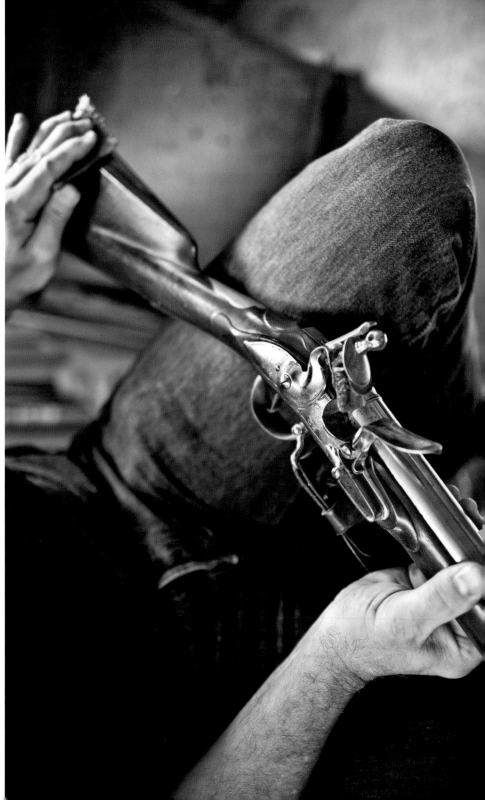

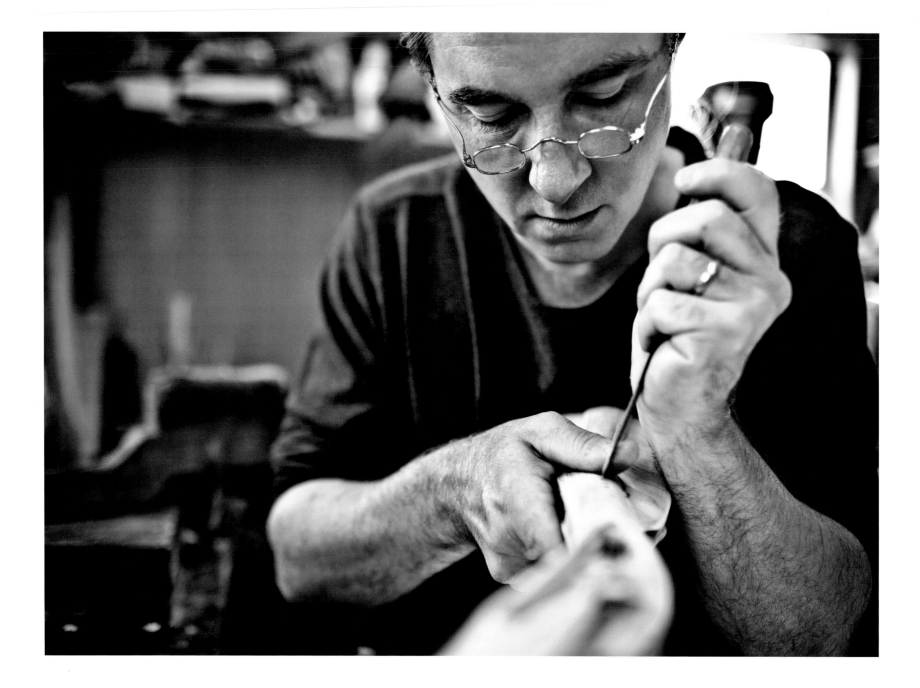

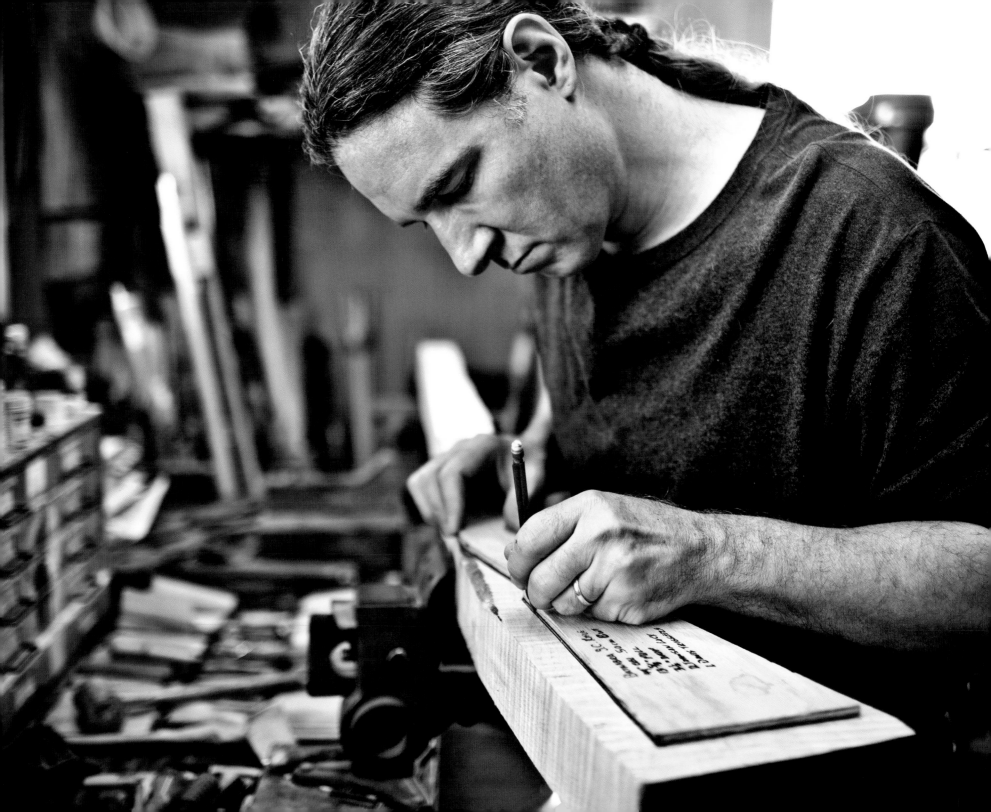

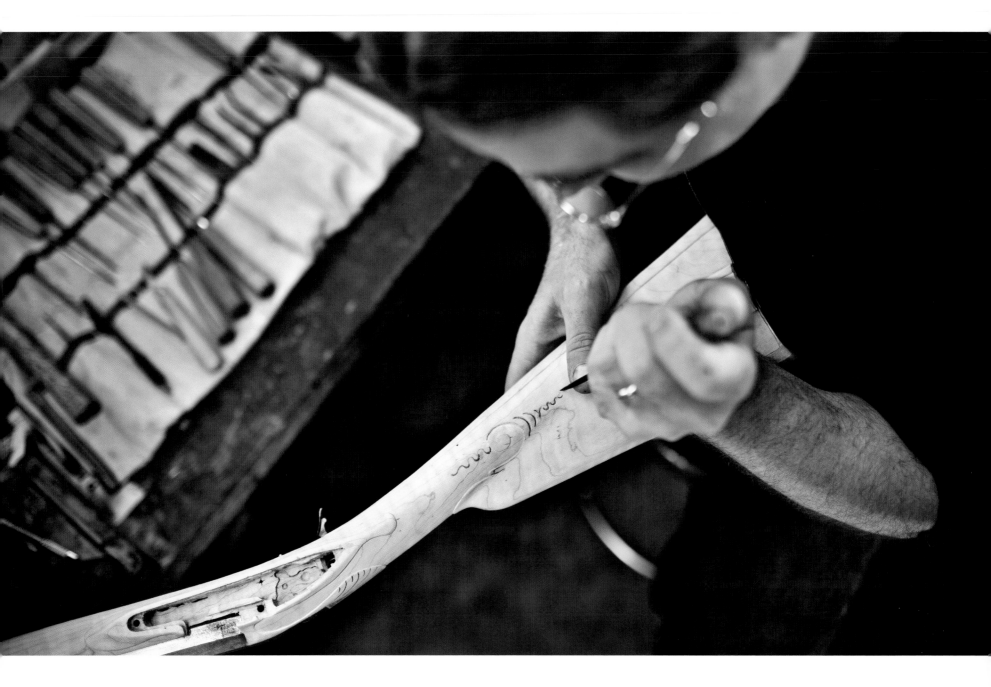

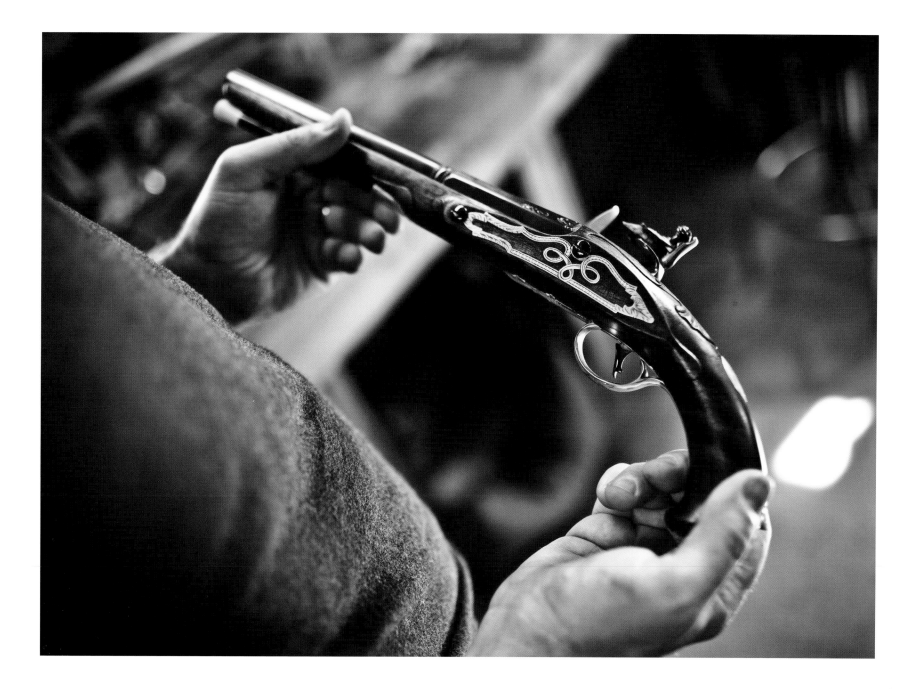

DANNER BOOTS

PORTLAND, OREGON

⋯⋯⋯⋯⋯⋯⋯⋯⋯⋯⋯⋯⋯⋯⋯ ★ ⋯⋯⋯⋯⋯⋯⋯⋯⋯⋯⋯⋯⋯⋯⋯

By the time a Danner boot is completed, more than a hundred hands have touched it. However, it all begins with selecting the hide. All the work is for naught if the hide doesn't speak to that very first pair of hands. "Every hide is a puzzle," says Danner creative director Haven Anderson. "It's our job to figure out the pattern."

Many manufacturers test every fifth or tenth hide, but at Danner each piece is inspected using seven criteria before a pair of hands rubs, bends, and pulls at it to find the perfect pattern. Once a live person determines which part of the hide is best for which part of the boot—harder leather for the toe, softer for the tongue—a pattern is cut.

The decades of fingers probing—of hands speaking to each piece of leather—is reflected in the crevices in each worker's hands. You can see it in those who do the stitching—the lines around the knuckles deepen as they carefully steer a portion of the boot across the needle's stitch to ensure handmade quality with clean lines. The result is the envy of any machine.

You can see it on all one hundred hands: those who clean up, brand, stitch the liner, attach the midsole and the outsole, trim, and finish. "It's a commitment to quality that has led us everywhere we've been as a company," Anderson says. It's what convinced Charles Danner in 1936 to move his four-year-old boot-making business from Wisconsin to Portland, Oregon. He believed the logging industry would pay for the high-grade, durable, water-resistant boots he was producing.

In the 1970s, as hiking became more popular, Danner knew that people would pay for the same waterproofing and durability that loggers in the Pacific Northwest required. In the 1980s, law enforcement officers and US soldiers approached the company, requesting work boots that offered the same mix of lightweight strength and comfort that they knew from their Danner boots at home. The military took notice and eventually contracted with Danner to outfit soldiers of all stripes—especially once they began regular operations in new-terrain areas like Afghanistan.

Danner has grown into a model of how to combine the craftsmanship of skilled artisans with the efficiencies of a worldwide business. Yes, they've gone from taking a week to make a pair of boots to less than a day. But they also "re-craft" every boot possible, as many customers ship their worn Danners to the company to be revitalized; it's a time-consuming process but one that strengthens the bond between company and customer.

As more consumers across the country search for local flavor and authenticity, "we've seen the US flag on the outside of our boots as something people really wanted," Anderson says. "There's a lot of loyalty and dedication to the product, a real connection the consumer has to our product. People want durable goods. Society doesn't want disposable. That's an important part of our story."

In fact, that pride is not just in their hands, or beaming from their face. They wear it on their feet. "Most of us own several pairs," Anderson says, laughing. "I have one pair I only put on to put up and take down my Christmas tree."

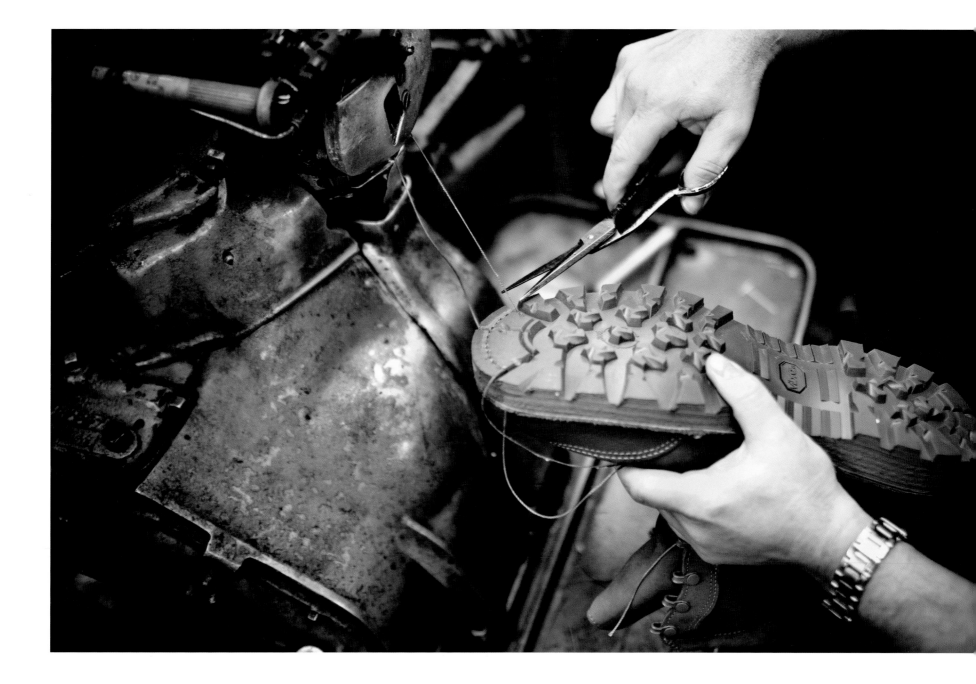

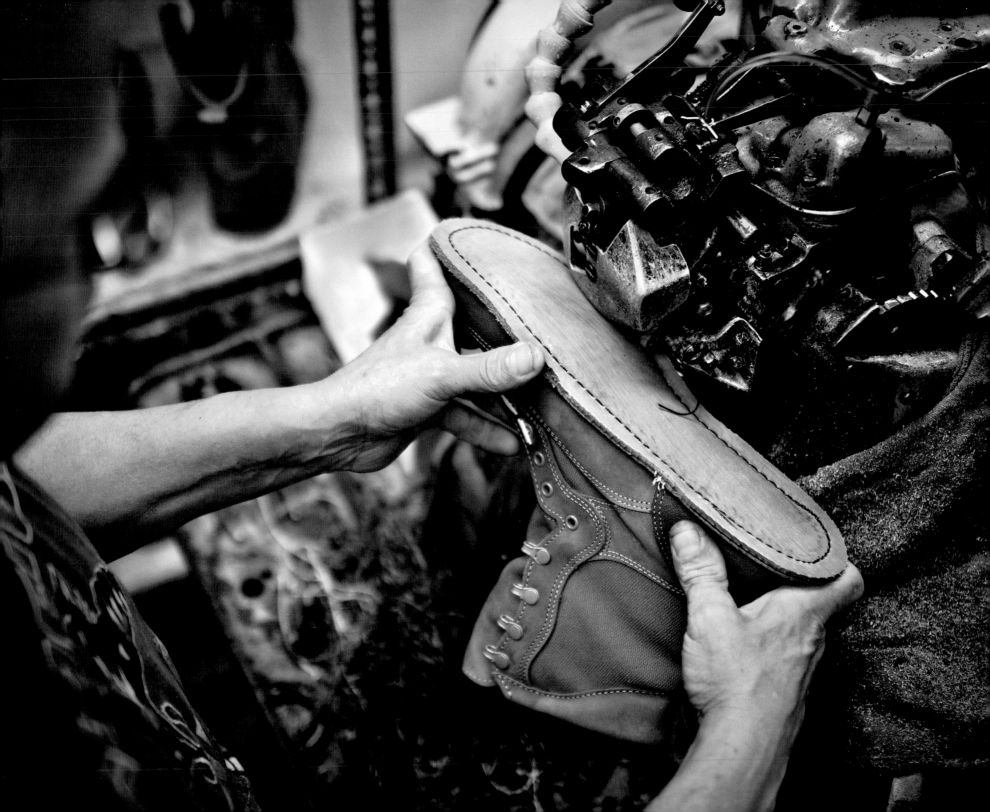

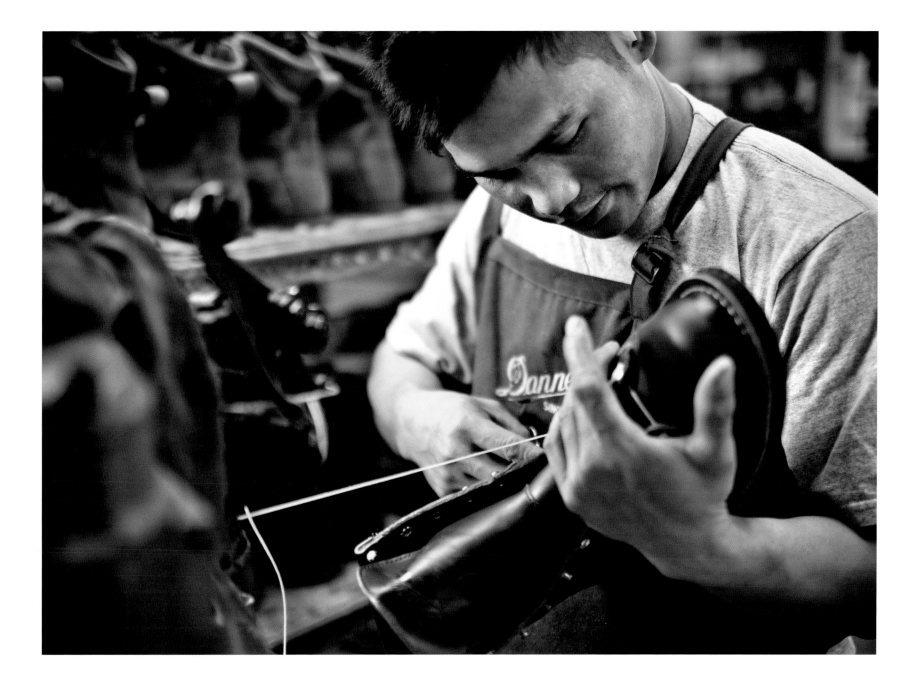

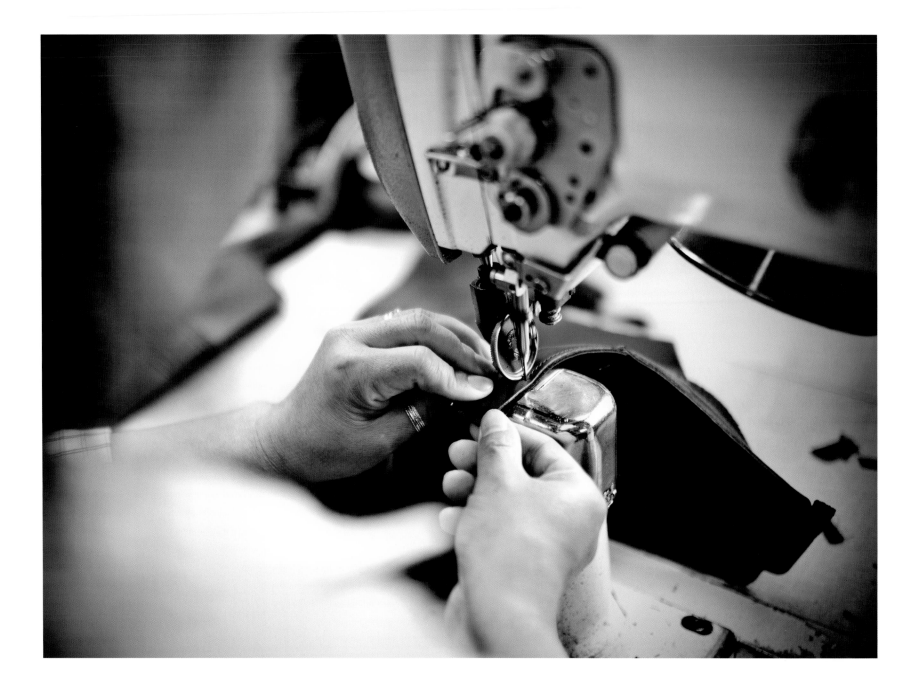

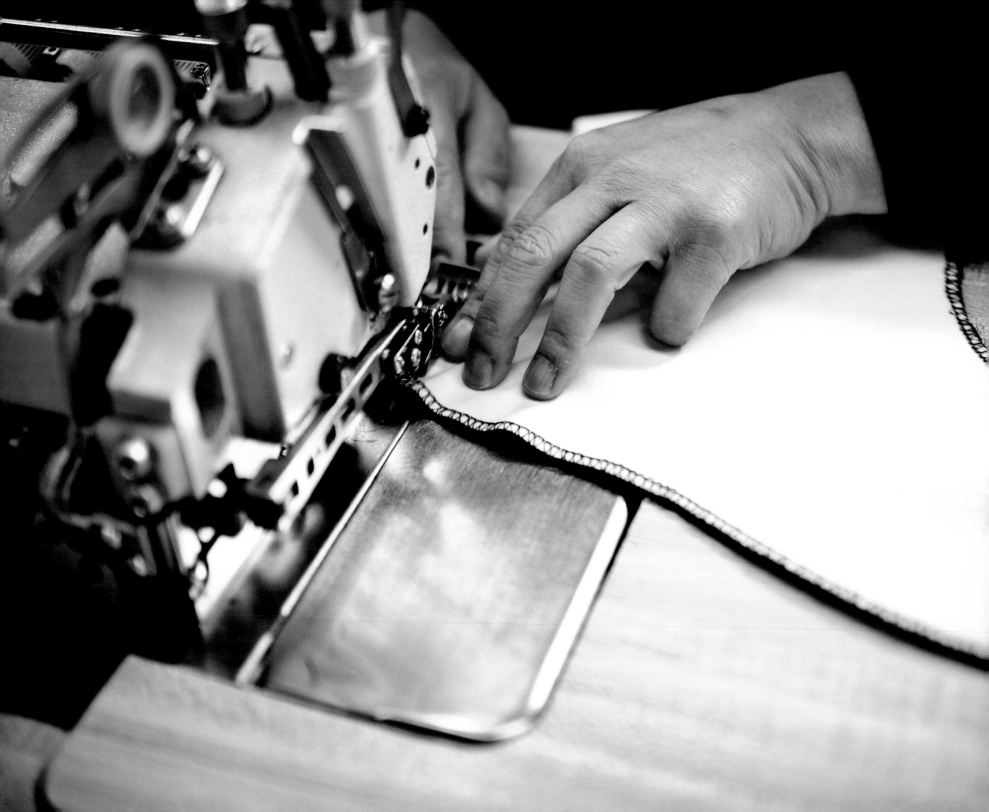

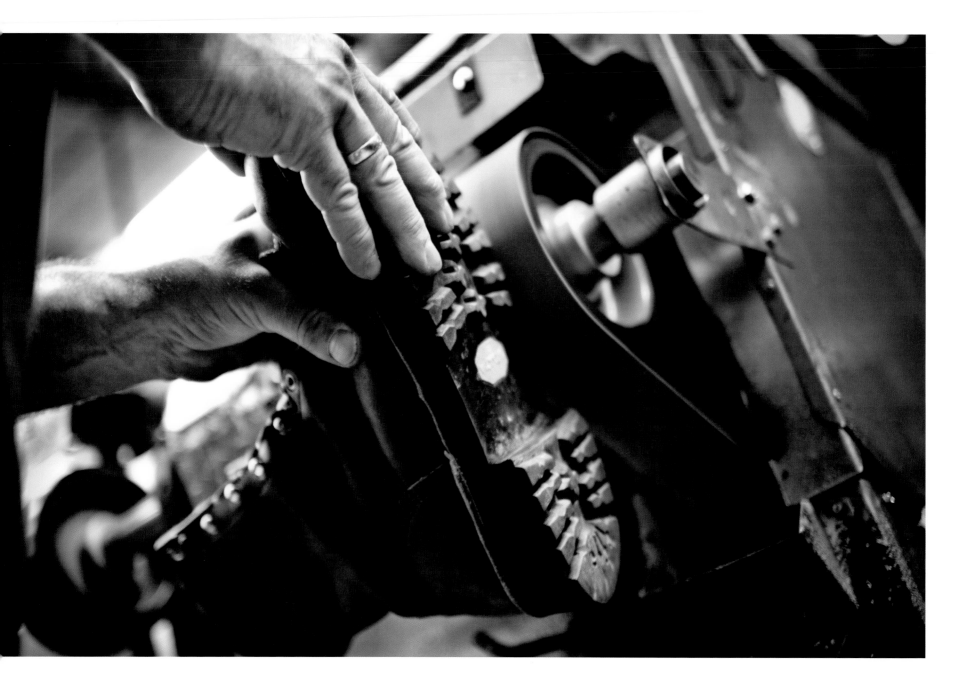

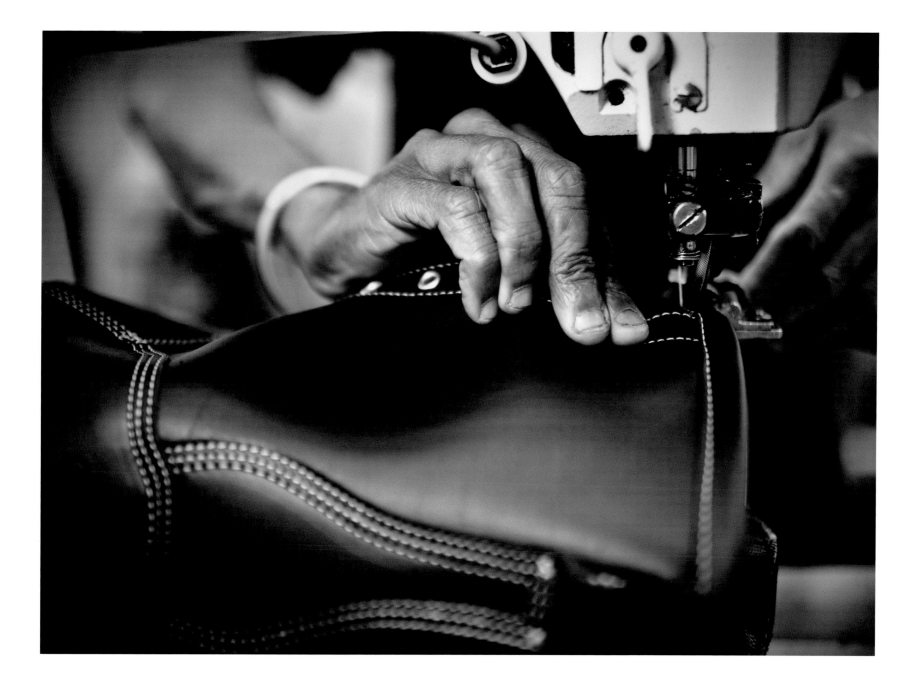

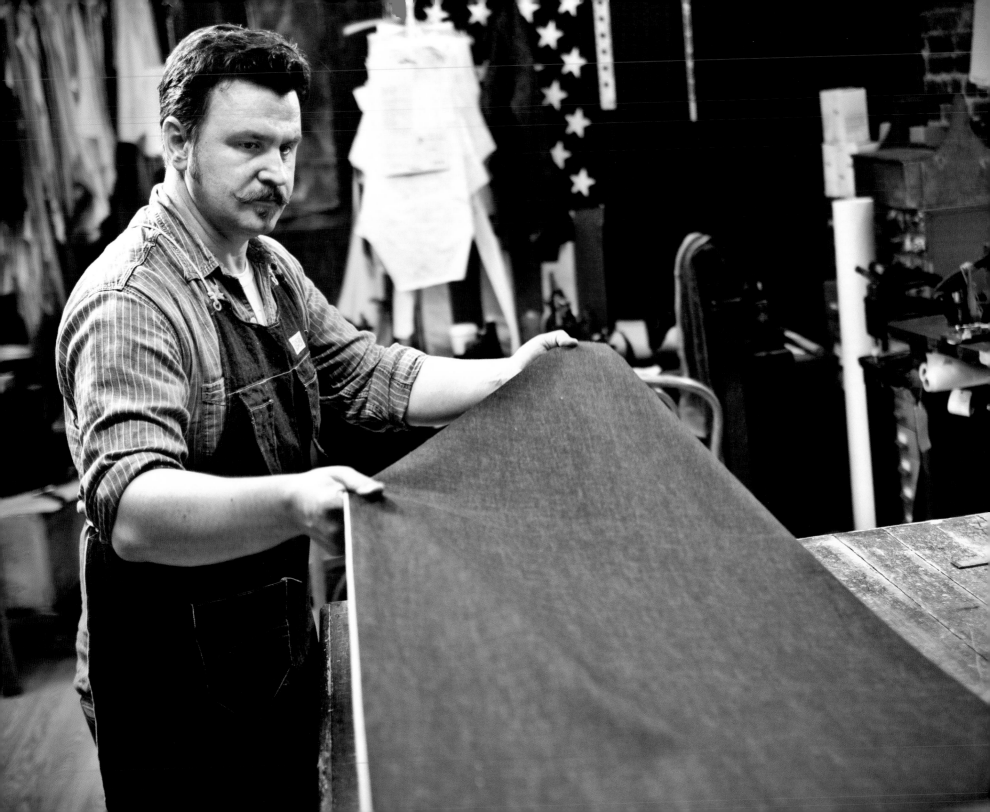

RISING SUN JEANS

Los Angeles, California

⋯⋯⋯⋯⋯⋯⋯⋯⋯⋯⋯⋯⋯⋯⋯⋯⋯⋯⋯⋯ ★ ⋯⋯⋯⋯⋯⋯⋯⋯⋯⋯⋯⋯⋯⋯⋯⋯⋯⋯⋯⋯

Mike Hodis's moment of clarity came when his daughter was born fourteen years ago. Hodis, then a design executive for a clothing company in Los Angeles, considered how the decisions he had made in life had been driven by financial concerns instead of personal ones.

"I started thinking about life beyond working for a typical clothing company," Hodis says. "I wanted to take the next step, start planning a phase of my life that had more meaning."

That next step? Collecting old sewing machines. Hodis loved tinkering with vintage technologies—and

not just garment-making tools, but also bikes and cars from the 1930s. He surrounded himself with the trappings of craftsmen from decades past. They made him feel grounded in a time when most items were made by hand, not mass manufactured.

"It gave me a sense of something real, which I craved after she was born," he says. "When all was said and done, I could come home from work, go in my garage, and just tinker. Just that machine and me."

Eventually that garage, his "safe haven," became very much like a 1920s tailor shop. It then morphed into Rising Sun Jeans, a workshop and store where Hodis makes some of the finest denim garments in the world. The shop exudes the same aesthetic as Hodis's jeans: timeworn, durable, and unique.

A trip for custom jeans today begins with a fitting session to adjust existing patterns to precise measurements. This involves pinning garments on the customer (easier than using a tape measure). A week or so later, after the first adjustments have been made to the sample, a first fitting tells Hodis where more-exact adjustments are necessary.

Then the construction begins, using methods from a century or more past. The steps to making a great pair of jeans can change depending on customers' choices like what type of denim is preferred, or if they want the fabric raw unwashed or washed. One example: a garment's "stitch-per-inch count," in which a slower sewing machine making more stitches per inch of fabric indicates a sturdier, higher-quality pair of jeans. The norm is six or seven per inch; Rising

Sun garments usually feature eleven to twelve stitches per inch.

The finish also shows a level of craftsmanship not found in jeans at department stores. For one, the rivets are hammered into the fabric to give them a weathered look.

Hodis says his company tries to fight modern means of production not because he's against progress, but because the old methods produce garments that reward handling and wearing.

"The sum of all these details is it has a human touch," he says. "You can feel the craft behind it. . . . People get that more and more. The reason we're here is partly because there is in the consumer an awareness and reawakening to the value of what we do. People want to feel like they're putting their shoulder to the wheel in their own way."

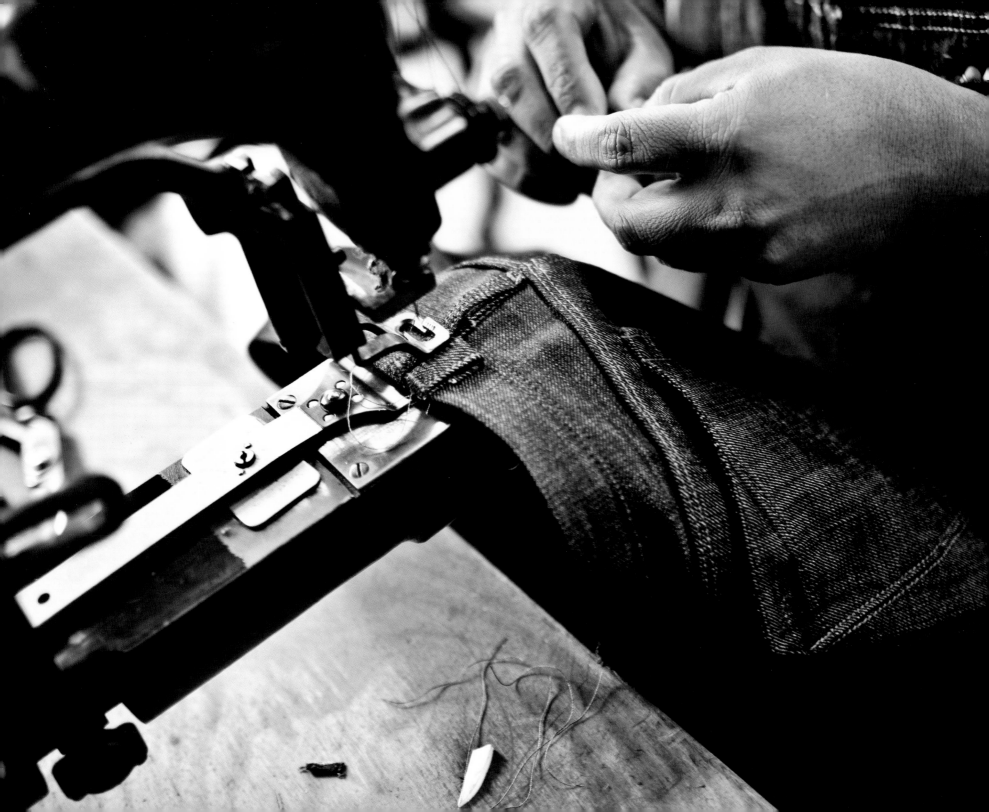

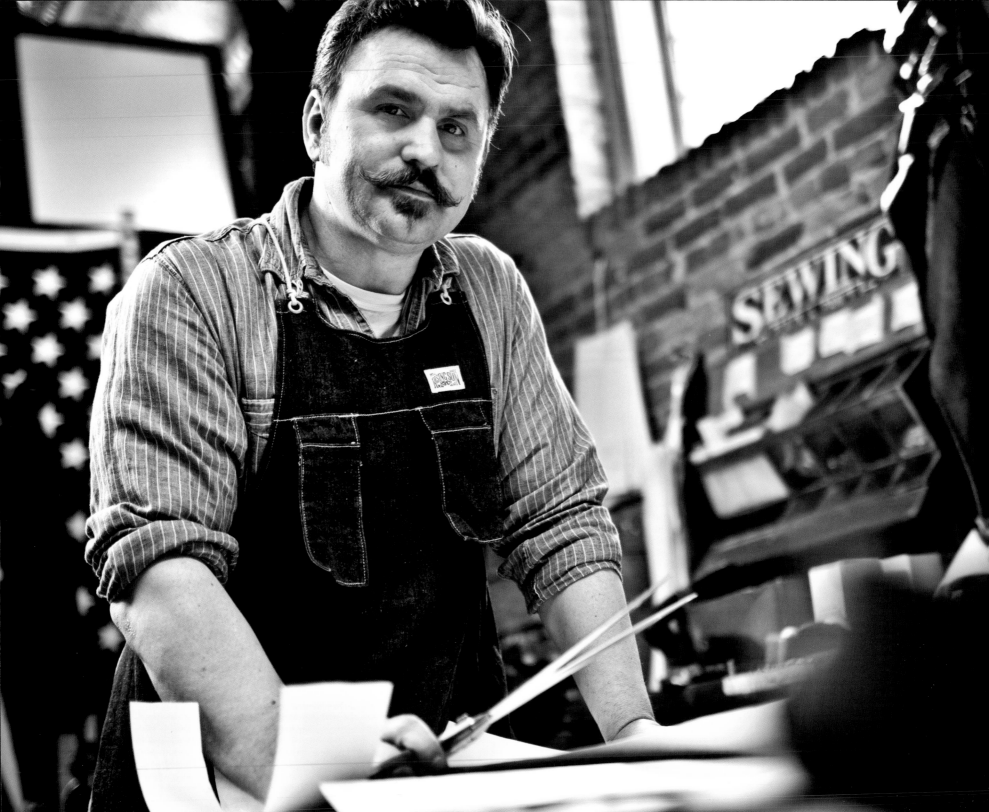

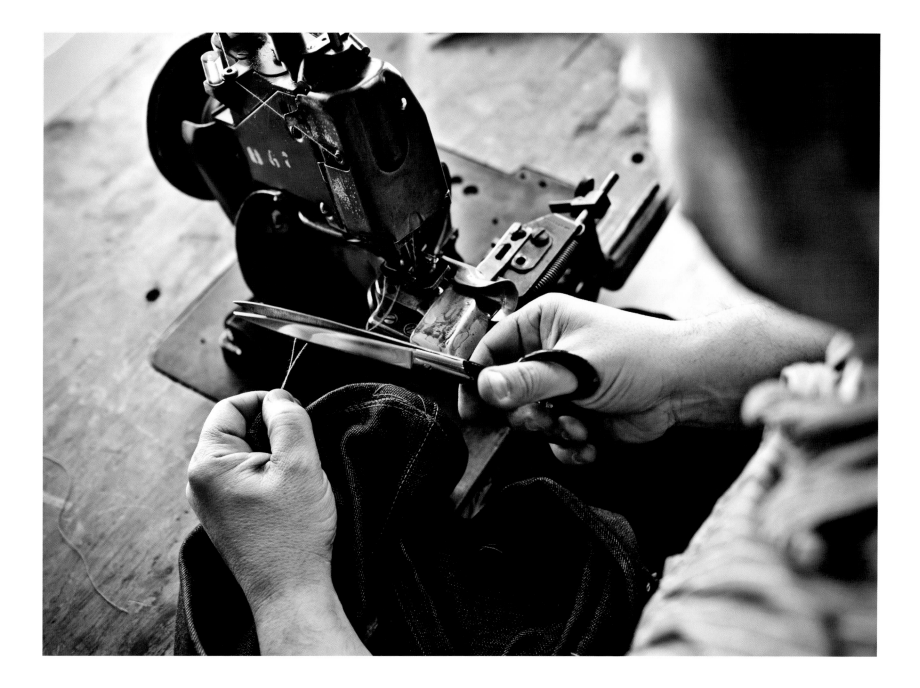

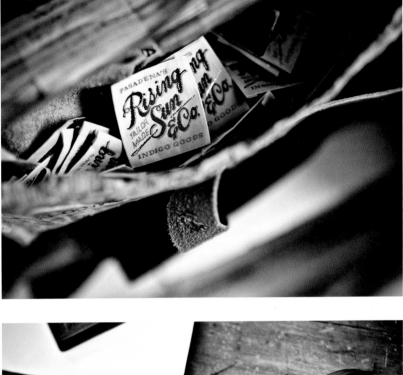

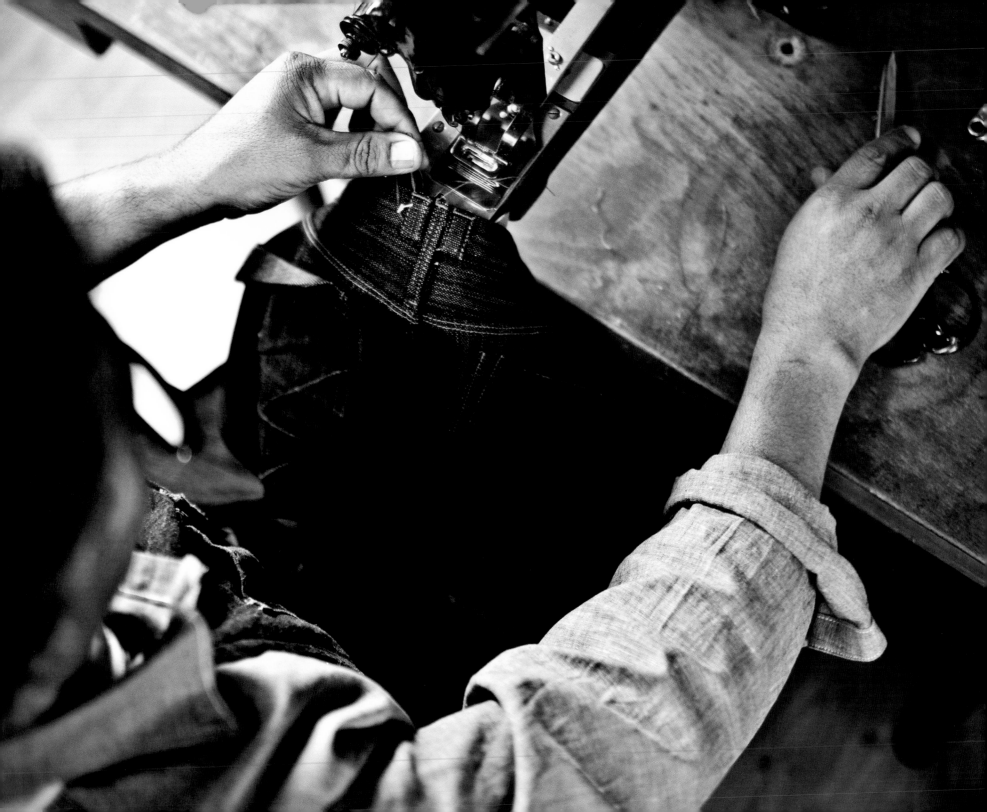

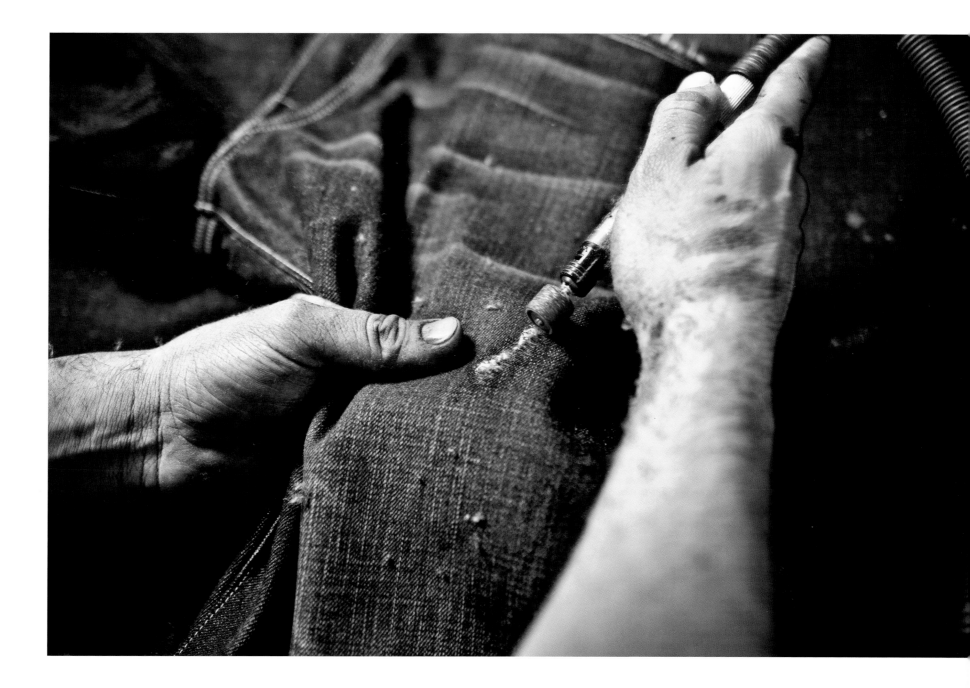

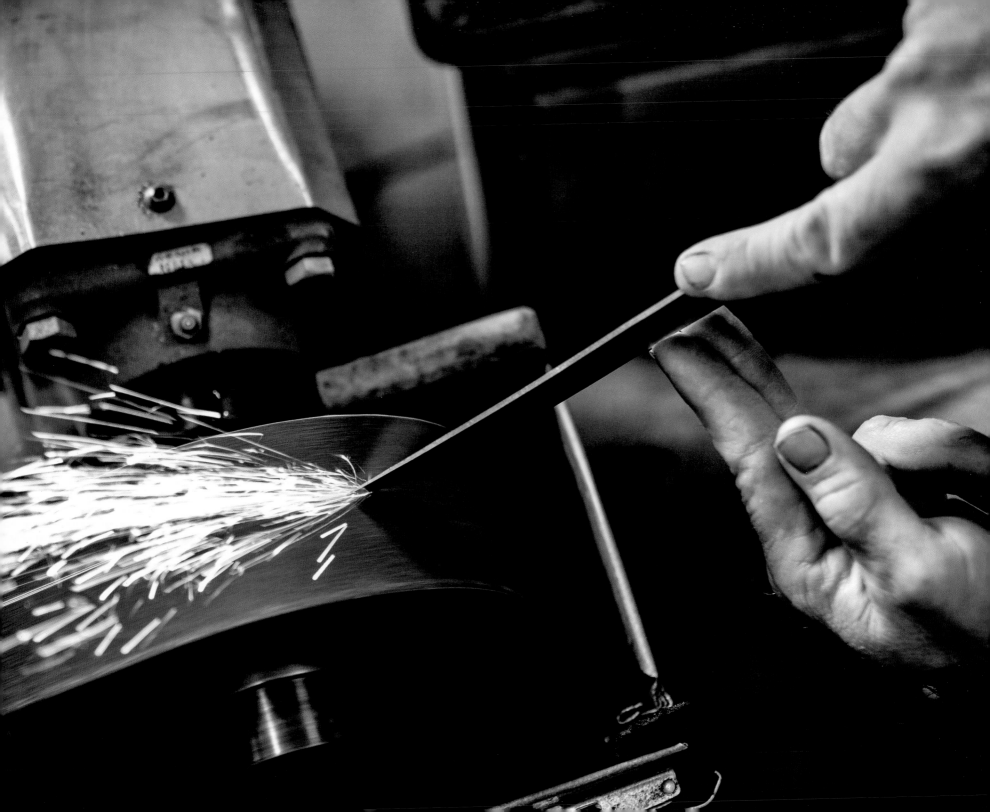

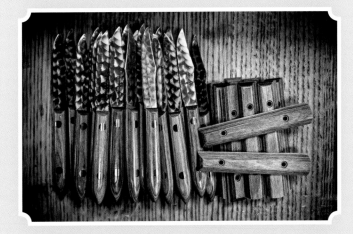

WARTHER CUTLERY

DOVER, OHIO

★

Ernest "Mooney" Warther had been using pock-etknives to whittle for at least a decade when he decided he'd had enough. He liked to shave hardwoods like walnut, as well as bone, ebony, and ivory, but the knives he'd been using since he was a small child had proved incapable of holding an edge for long. So he taught himself what kind of steel made for excellent knives and experimented with how to better temper and sharpen the metal into a proper whittling instrument.

His mother asked Mooney to make her a kitchen knife from his blades, which he presented to her on Mother's Day 1902. She asked for another—as did her friends. A knife company was born.

Mooney quit his steel mill job in 1923 to carve and make knives full-time. He taught his two sons the business, and in 1945 (just after the war) his son Dave took over E. Warther & Sons. In the 1960s Dave taught his oldest son, Dale, the business; in 2011 Dale, the last of the Warther line, passed away. But Mooney Warther's unique style and commitment to American-made craftsmanship still lives within Warther Cutlery.

Steve Cunningham—who married into the family—runs Warther now, and he says the process has not changed much from the early 1900s.

"We're still a lot more hands on than most knife-making companies," he says. "We touch each knife thirty-two times from start to finish, which is unheard of among mass production. We stay true to the original style in many ways."

Some things had to change: Mooney Warther used a hacksaw to cut his blades; now the "blanks" are laser-cut. In 1912 he heat-treated the blades in a fireplace in his shop; now heat-treatment companies do that in advance.

But when it comes down to how Warther grinds and polishes its kitchen knives, Cunningham says, "It's the same way Mooney did it."

Cunningham explains that the Warther difference begins with a vertical grind. Instead of moving the blade horizontally across an abrasive belt, it is moved up and down—which takes more time and skill to master. After that the blades are given a radius grind (thinner at top and bottom, thicker in the middle) rather than a flat or hollow grind. This helps with the friction and drag when food is sliced. Then it goes through nine hand polishes.

After the polishes are done, the knife is at a near-mirror finish. That's when the blade is "spotted"—using an oil mixture, the multi-circle texture is hammered by hand. This is tradition: Mooney Warther used this technique, which hid imperfections in the steel of the early 1900s.

Cunningham is proud that, even though they produce twenty-five to thirty-five thousand knives a year, Warther still makes sure it only uses American-made steel. In fact, he makes service calls to ensure his suppliers only use American products.

"We're passionate about our knives, and our legacy," Cunningham says. "We stay true to it. Other knives don't have our story."

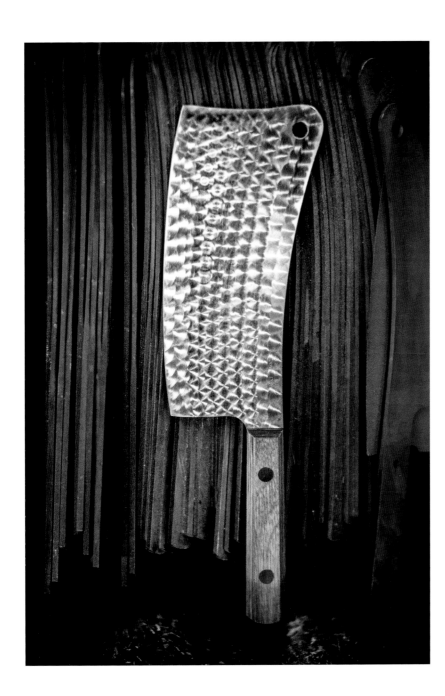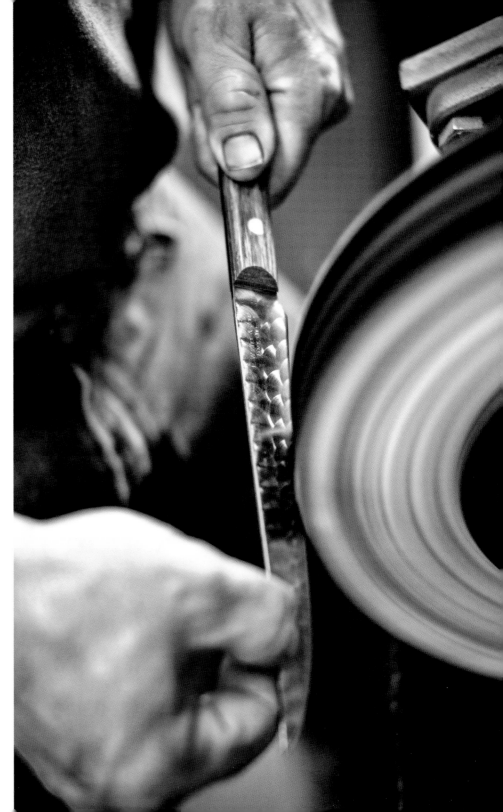

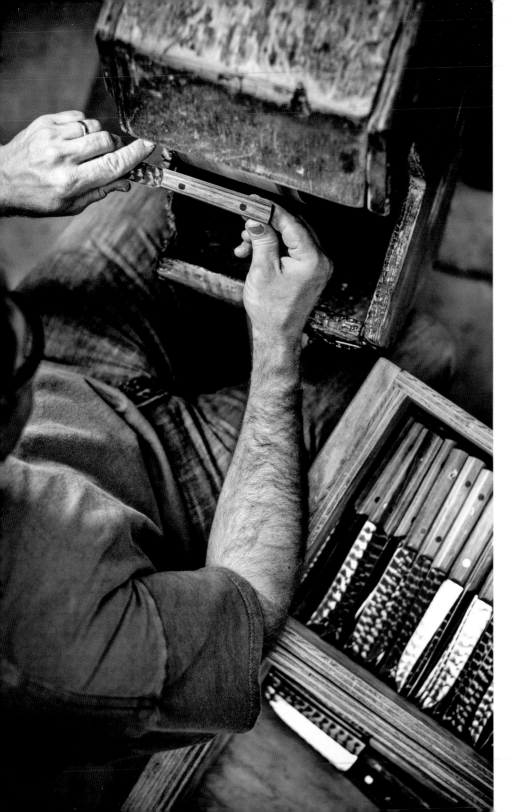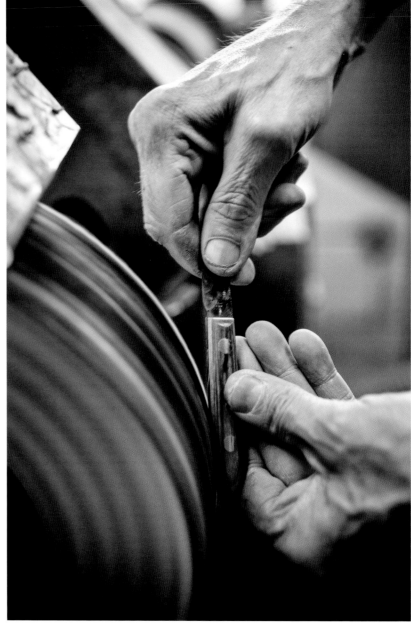

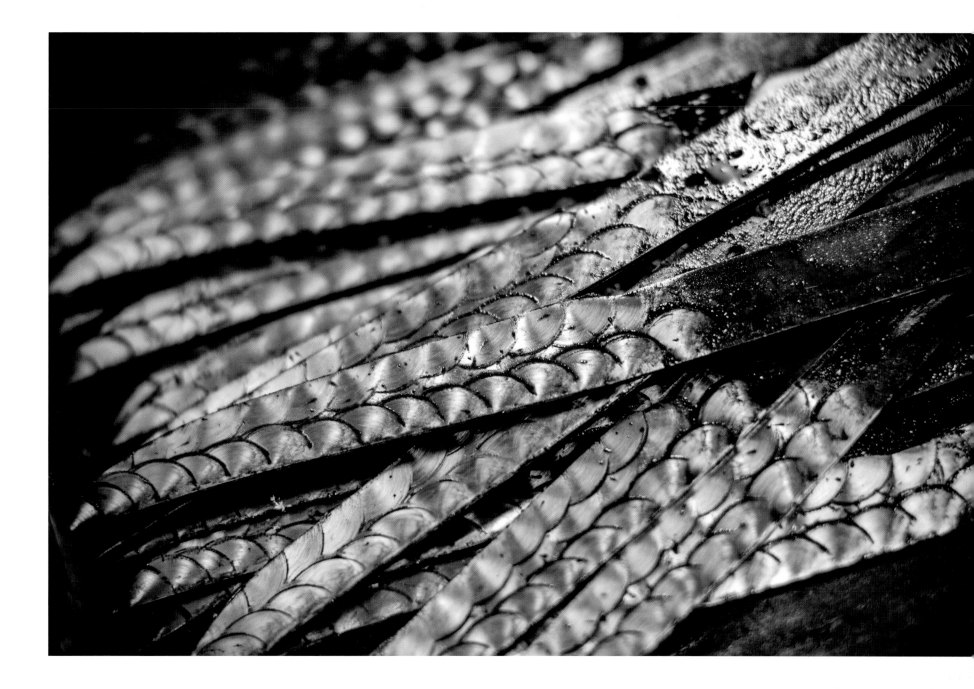

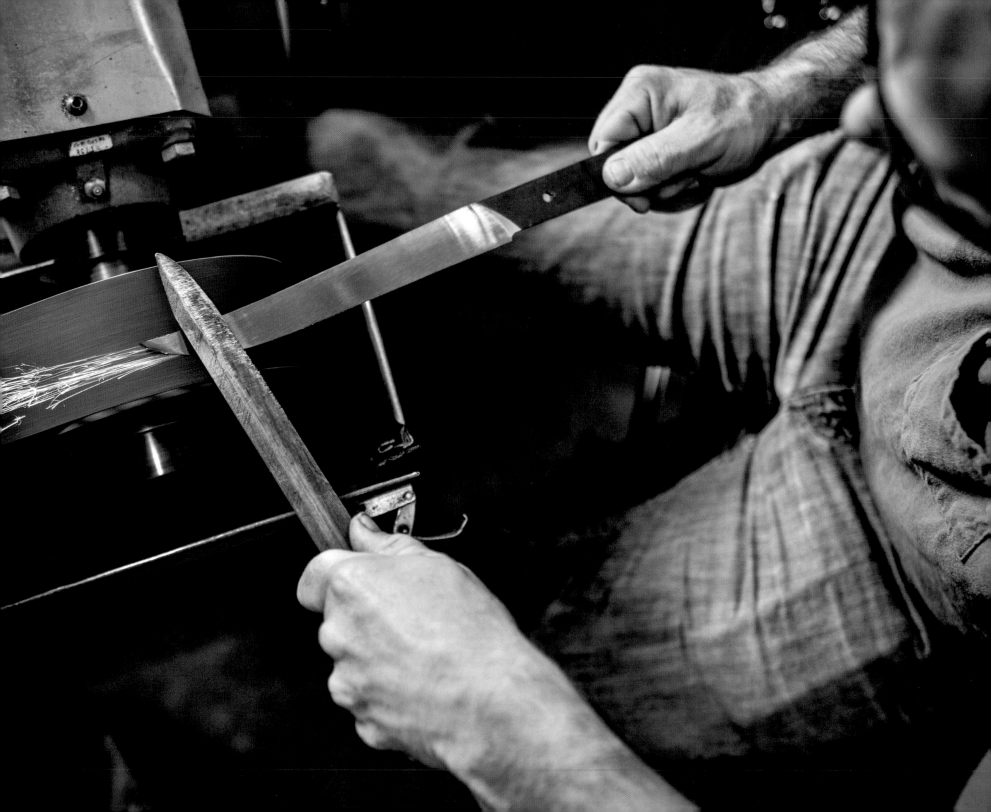

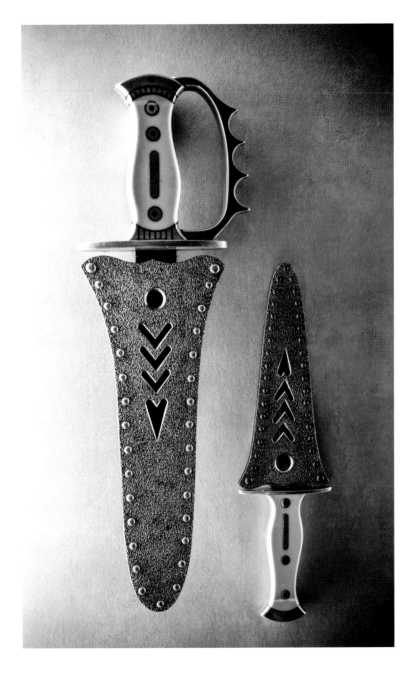

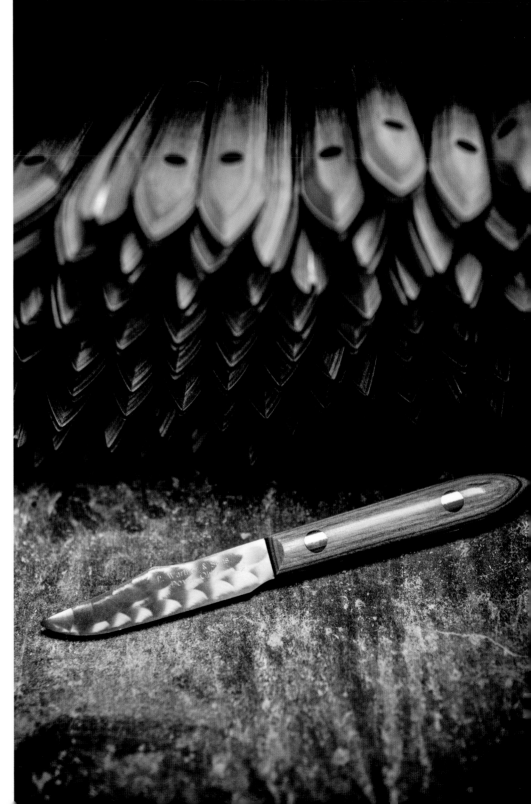

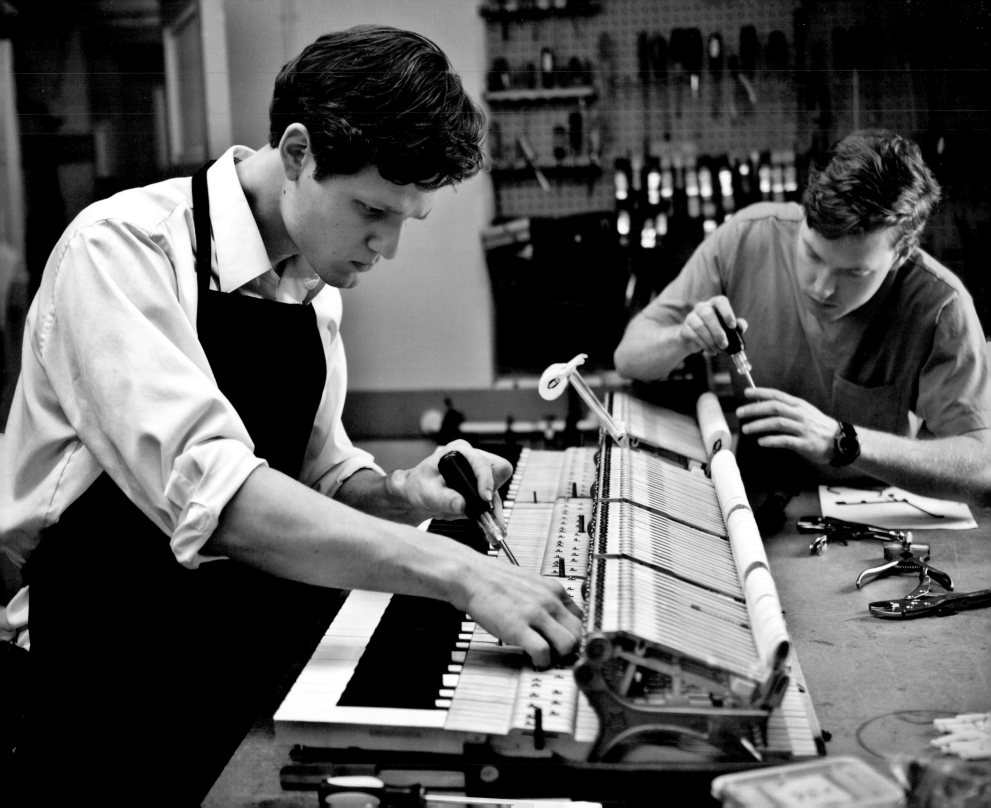

NORTH BENNET STREET SCHOOL

BOSTON, MASSACHUSETTS

★

Miguel Gómez-Ibáñez has been called "an evangelist" for his cause: preaching the value of teaching hand skills. That's partly because the institution of which he is president, the North Bennet Street School, has been teaching manual labor skills for more than a century to people who turn that into honest work. But it's also because he believes the benefits of learning carpentry or book-binding or violin making extend beyond the practical.

"There is a perception that high-tech training programs are relevant and responsive to the needs of society but not manual training skills," he says. "But

there is a growing consensus that training in hand skills is relevant to conceptual skills.

"When you become involved in the creative work of making useful, beautiful objects and gain a personal understanding of what is meant by the intelligence of the hands, it transforms who you are and how you think."

Those skills are taught in eight areas of concentration at the school: carpentry, locksmithing, cabinet and furniture making, bookbinding, jewelry making and repair, violin making and repair, piano technology, and preservation carpentry. It continues a tradition going back to 1885, when the school was founded to help North End immigrants gain the skills needed to find employment in America. Through the years the school has transformed to meet the needs of its community, expanding into social services and other vocational training.

Today the school trains 150 full-time students (there are part-time programs, too) to be serious craftsmen and women, championing and passing along a love of traditional American craftsmanship. A small majority of the students, who range in age from eighteen to sixty, usually come from Massachusetts, but many come from outside the Northeast, some even from overseas. Their unifying characteristic is that they do not look at the craft as a hobby—it's serious work for those who have shown the ability or the talent to learn hand skills at the highest level. (Most students stay well past school hours, as they cut and bind and shave and polish well into the evening.)

After moving the carpentry programs off campus about eight years ago, the school's focus now is bringing everyone under one roof as renovation continues on a new site for the campus—a printing plant near the original school.

What will not change is the "sloyd" approach the school takes toward instruction (a Swedish system of manual training that means "hand skills" or "craftsmanship"). The school today continues the tradition of believing hand-skills training is integral to one's mental and physical development. "It's what makes the school so special," says Nancy Jenner, the school's director of communications. "We're teaching craftsmanship at the highest level, but we're really teaching so much more."

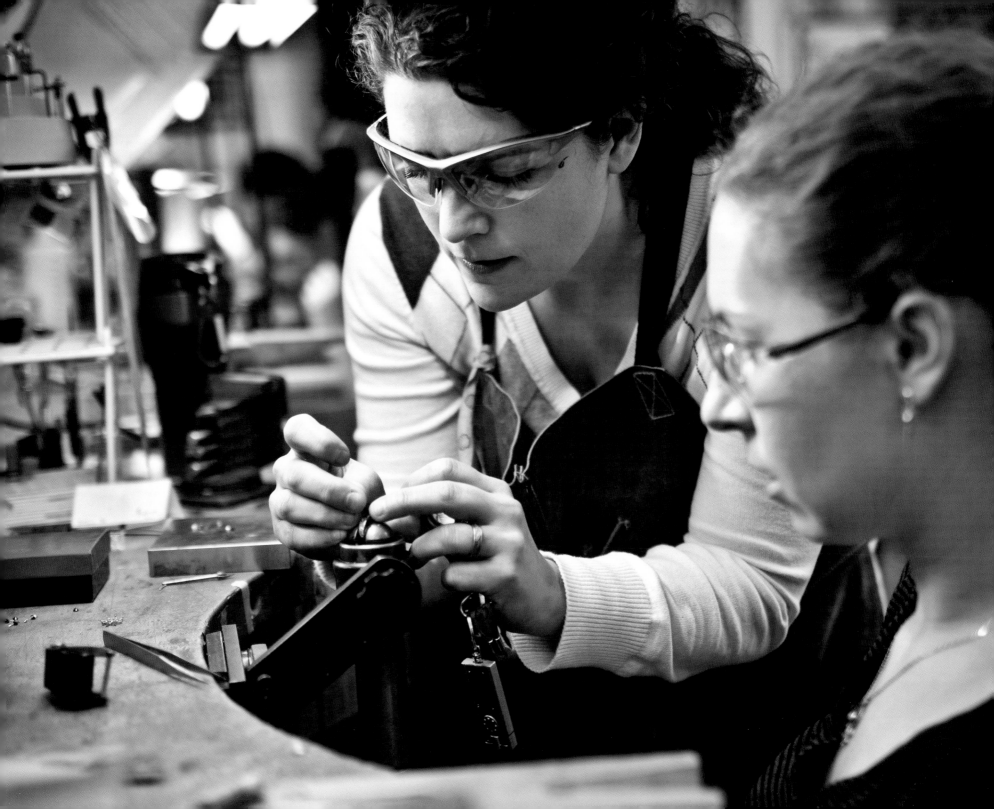

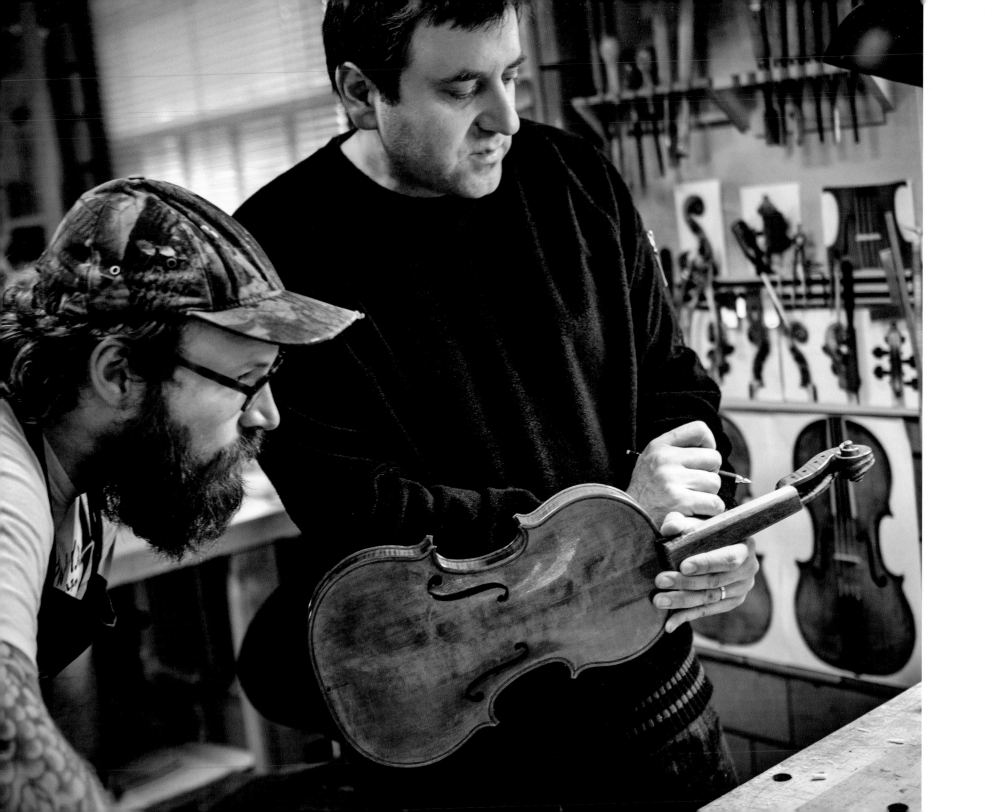

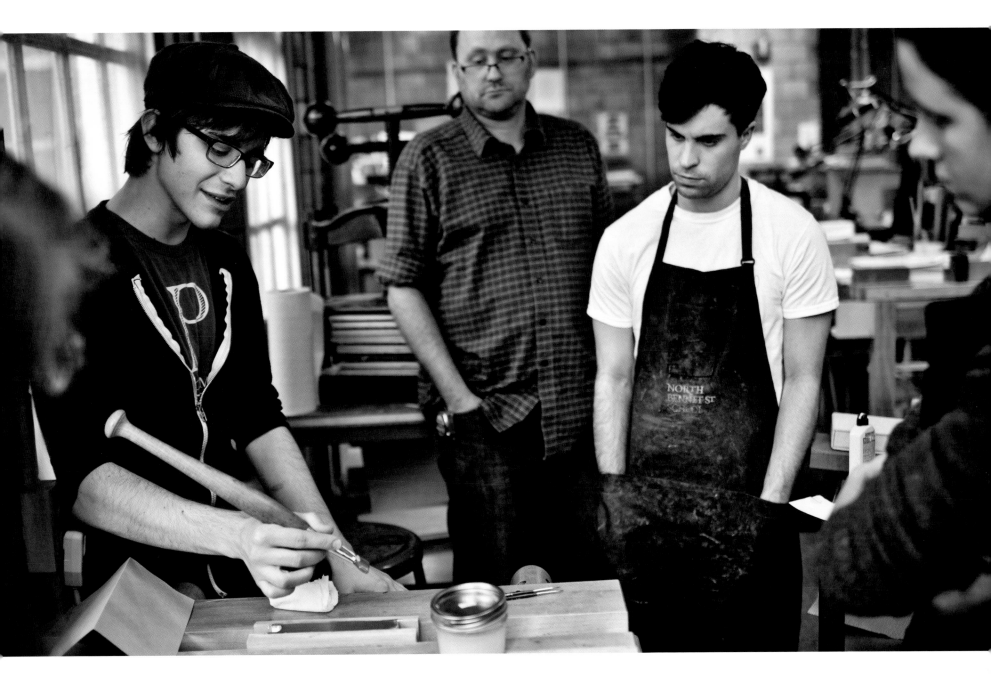

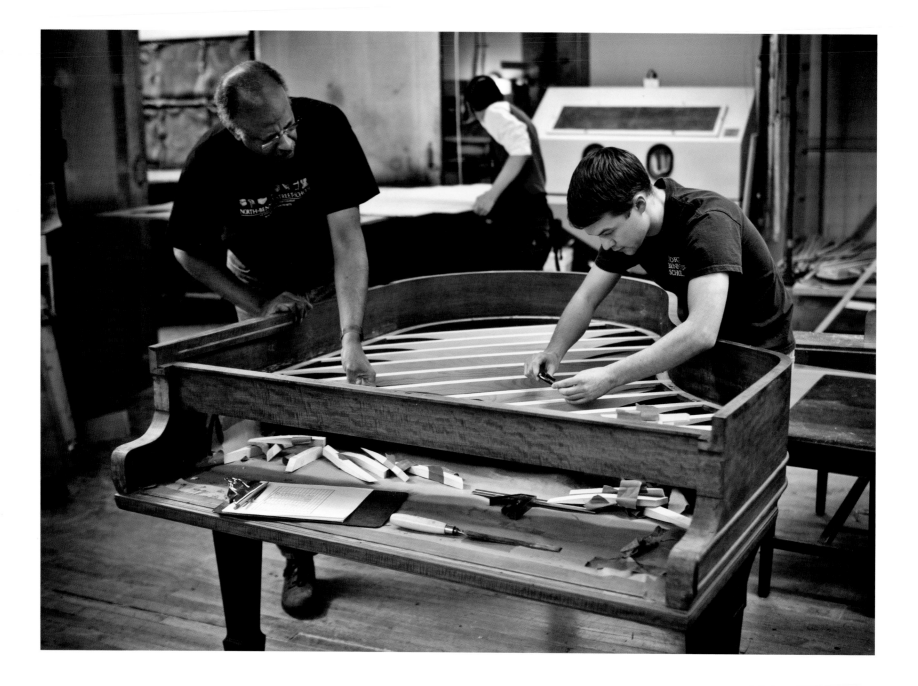

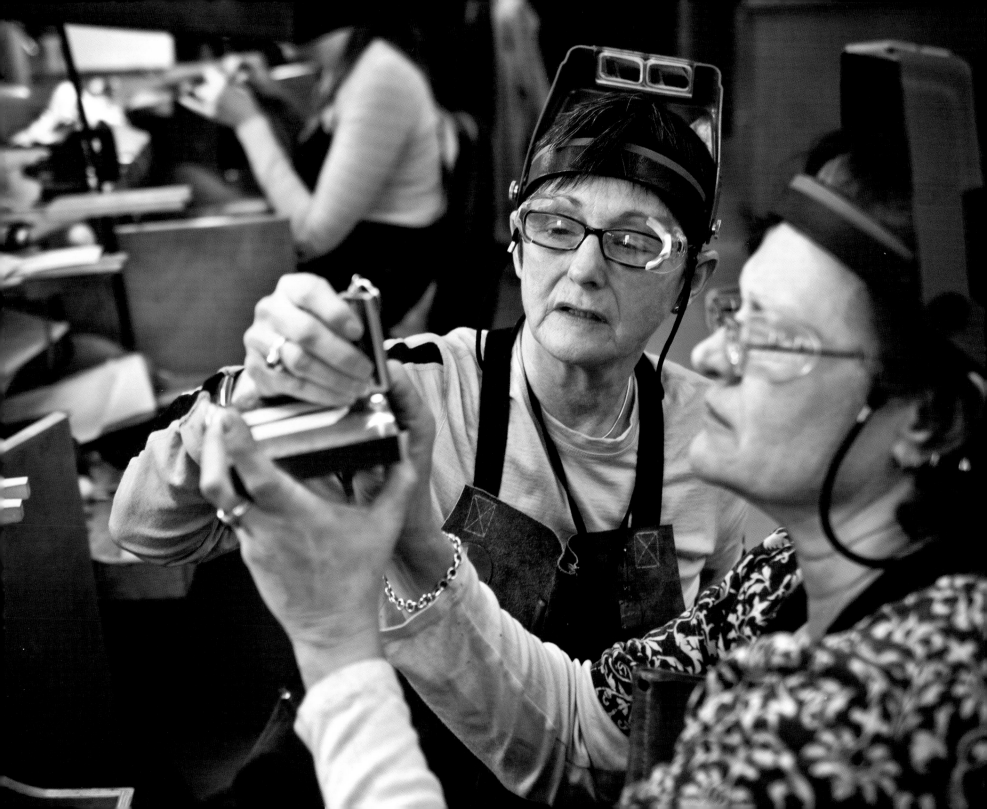

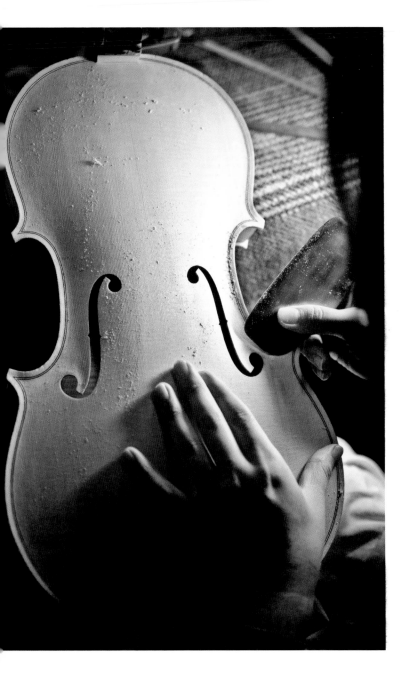
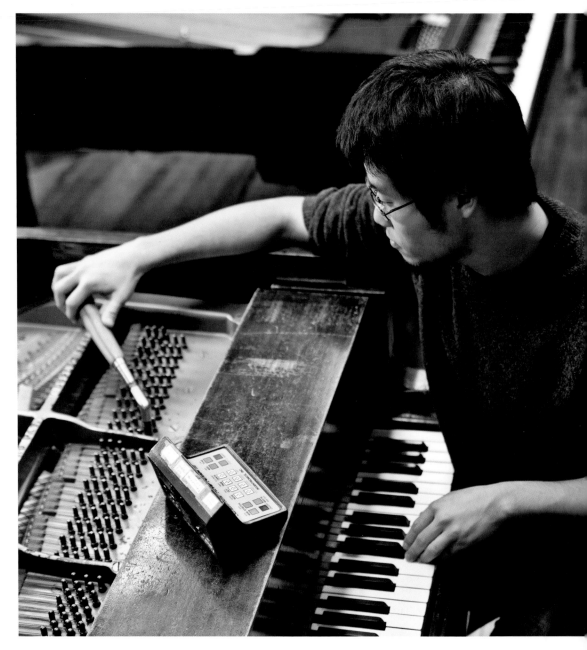

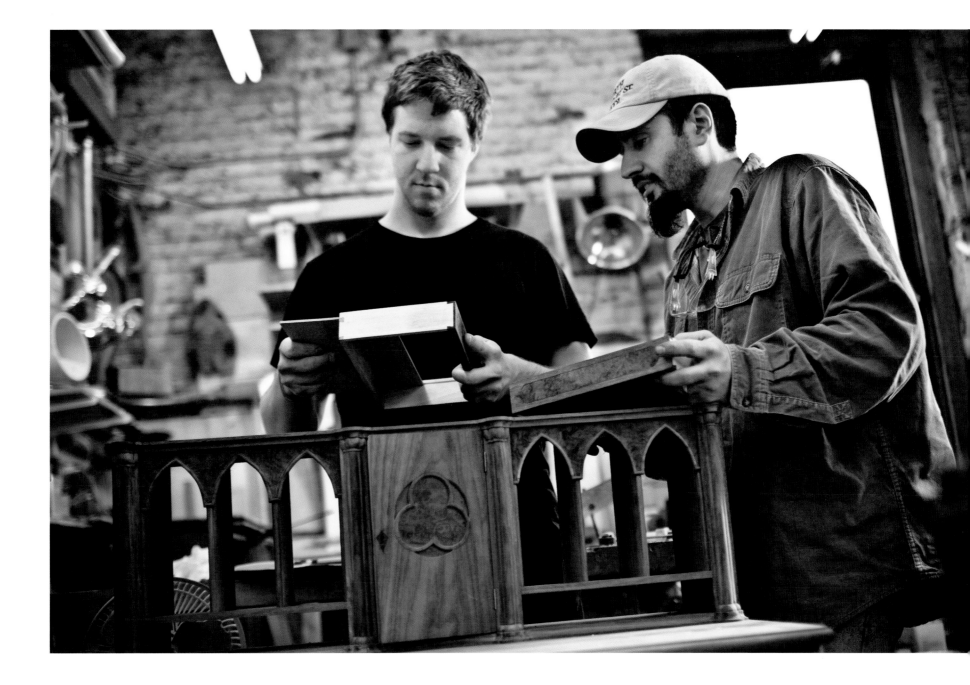

Company Index

Acadian Accordions

4413 Hwy. 190
PO Box 941
Eunice, LA 70535
P: (337) 457-9563
E: savoy@savoymusiccenter.com
W: www.SavoyMusicCenter.com
Page: 127

Bessell Surfboards

515 Westbourne St.
La Jolla, CA 92037
P: (858) 344-7080
E: tim-info@bessellsurf.com
W: www.BessellSurf.com
Page: 89

Billings ArtWorks

609 Clinton St.
Ridgway, CO 81432
P: (970) 626-3860
E: grammydude@billingsartworks.com
W: www.BillingsArtWorks.com
Page: 173

The Carousel Works

1285 Pollock Pkwy.
Mansfield, OH 44905
P: (800) 785-8283
E: info@carouselworks.com
W: www.CarouselWorks.com
Page: 61

Cheaney Custom Saddles, Bits, and Spurs

PO Box 1425
Gainesville, TX 76241
P: (940) 668-8607
E: prosaddles@hotmail.com
W: www.ProSaddles.com
Page: 201

Chuck Lee Banjo Company

112 Silverwood Dr.
Ovilla, TX 75154
P: (972) 617-5576
E: chuck@chuckleebanjos.com
W: www.ChuckLeeBanjos.com
Page: 1

Danforth Pewter

52 Seymour St.
Middlebury, VT 05753
P: (802) 388-8666
E: info@danforthpewter.com
W: www.DanforthPewter.com
Page: 143

DANNER INC

17634 NE Airport Way
Portland, OR 97230
P: (877) 432-6637
E: info@danner.com
W: www.Danner.com
Page: 235

FISK KNIVES

10095 Hwy. 278 W
Nashville, AR 71852
P: (870) 845-4456
E: jerry@jerryfisk.com
W: www.JerryFisk.com
Page: 71

HASTINGS HOLSTERS

502 Norman Rd.
Corinth, MS 38834
P: (662) 415-7031
E: hastingsholsters@gmail.com
W: www.HastingsHolsters.com
Page: 99

HENSON BROOM SHOP & GENERAL STORE

1060 St. Rt. 348 E
Symsonia, KY 42082
P: (270) 851-8510
E: rnh@hensonbrooms.com
W: www.HensonBrooms.com
Page: 109

HULL HISTORICAL-ARCHITECTURAL MILLWORK

201 Lipscomb St.
Fort Worth, TX 76104
P: (817) 332-1495
E: bhull@hullhistorical.com
W: www.HullHistorical.com
Page: 153

JAMES AVERY JEWELRY

145 Avery Rd. N
Kerrville, TX 78028
P: (800) 283-1770
E: customerservice@jamesavery.com
W: www.JamesAvery.com
Page: 53

J. WILSON STAGECOACH WORKS

372 CR 3592
Paradise, TX 76073
P: (817) 773-0609
E: wilsonstagecoach@earthlink.net
W: www.JWilsonStageCoaches.com
Page: 183

KING BOAT WORKS

PO Box 234
Putney, VT 05346
P: (802) 387-5373
Page: 209

MANUEL AMERICAN DESIGNS

1922 Broadway
Nashville, TN 37203
P: (615) 321-5444
E: info@manuelcouture.com
W: www.ManuelCouture.com
Page: 163

MAPLE LANDMARK WOODCRAFT

1297 Exchange St.
Middlebury, VT 05753
P: (802) 388-0627
E: thefolks@maplelandmark.com
W: www.MapleLandmark.com
Page: 117

MILLER LONG RIFLES

4020 Minnich Ave.
Paducah, KY 42001
P: (270) 210-6014
E: riflemaker@aol.com
W: www.MillerLongRifles.com
Page: 227

NOKONA ATHLETIC GOODS COMPANY

105 Clay St.
Nocona, TX 76255
P: (800) 433-0957
E: info@nokona.com
W: www.Nokona.com
Page: 35

NORTH BENNET STREET SCHOOL

150 North St.
Boston, MA 02109
P: (617) 227-0155
W: www.NBSS.edu
Page: 263

O'FARRELL HAT COMPANY

111 E. San Francisco St.
Santa Fe, NM 87501
P: (505) 989-9666
E: kpo@ofarrellhatco.com
W: www.OFarrellHatCo.com
Page: 217

OPTIMO FINE HATS

Downtown:
320 S. Dearborn St.
Chicago, IL 60604
P: (312) 922-2999
Southside:
10215 S. Western Ave.
Chicago, IL 60643
P: (773) 238-2999
E: info@optimohats.com
W: www.OptimoHats.com
Page: 25

OxxFORD CLOTHES
1220 W. Van Buren
Chicago, IL 60607
P: (312) 829-3600
E: custserv@oxxfordclothes.com
W: www.OxxfordClothes.com
Page: 45

PAWLESS GUITARS
118 Pawless Ln.
Gainesville, TX 76240
P: (972) 816-6139
E: vince@pawless.com
W: www.Pawless.com
Page: 135

RISING SUN & CO.
2246 Fair Park Ave.
Los Angeles, CA 90041
P: (323) 982-9798
E: mhodis@risingsunjeans.com
W: www.RisingSunJeans.com
Page: 245

ScottyBob SkiWorks
1250 CR #2
PO Box 776
Silverton, CO 81433
P: (970) 946-7065
E: info@scottybob.com
W: www.ScottyBob.com
Page: 193

SORRELL CUSTOM BOOTS
217 E. Oklahoma Ave.
Guthrie, OK 73044
P: (405) 282-5464
E: customboots@aol.com
W: www.LisaSorrell.com
Page: 81

STEINWAY AND SONS
1 Steinway Place
Long Island City, NY 11105
P: (718) 721-2600
E: info@steinway.com
W: www.Steinway.com
Page: 17

TODD M. JOHNSON PIPES
3653D Trousdale Dr.
Nashville, TN 37204
P: (615) 517-0594
E: toddmjohnsonpipes@gmail.com
W: www.Todd-M-Johnson.com
Page: 9

WARTHER CUTLERY
327 Karl Ave.
Dover, OH 44622
P: (330) 343-7513
E: info@warthers.com
W: www.WartherCutlery.com
Page: 255